GEORGE GERSHWIN and MODERN ART

A RHAPSODY IN BLUE

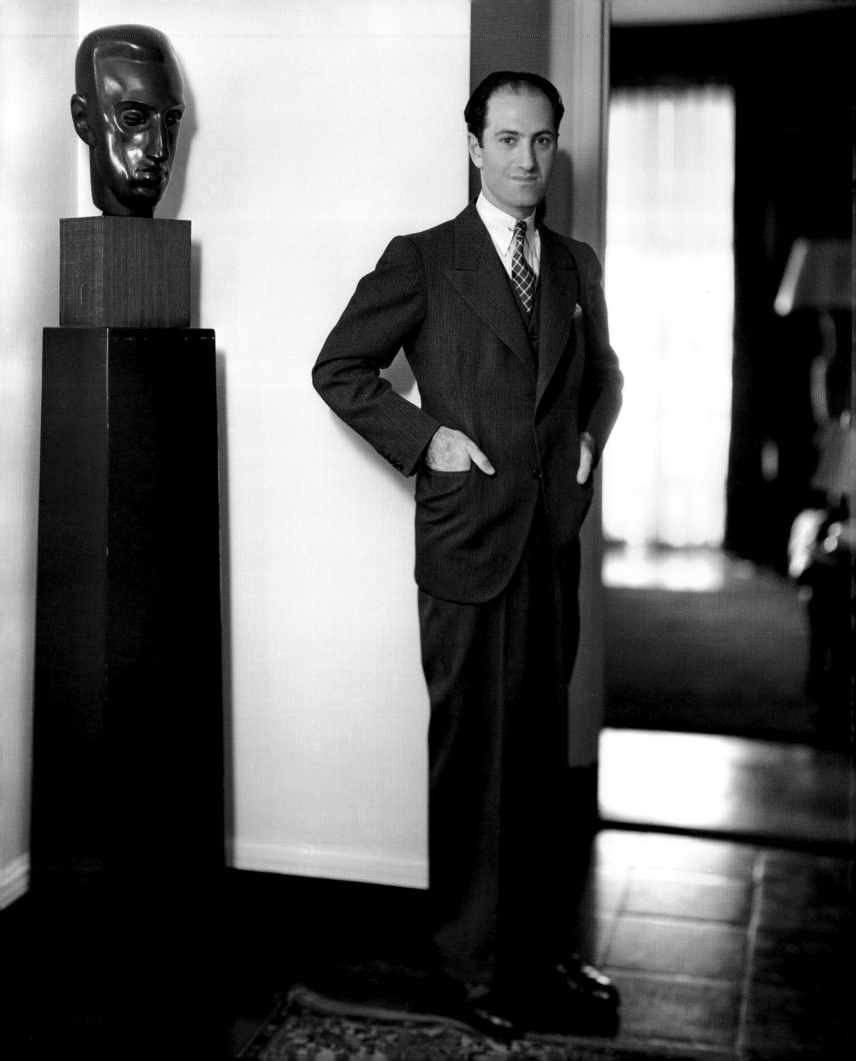

GEORGE GERSHWIN and MODERN ART

A RHAPSODY IN BLUE

OLIVIA MATTIS

with contributions by
KATHLEEN VAN BERGEN, ALEXANDER SHELLEY,
and COURTNEY A. McNEIL

Artis—Naples

*Home of The Baker Museum
and the Naples Philharmonic*

SCALA

Artis—Naples, The Baker Museum
In association with Scala Arts Publishers, Inc.

Published on the occasion of the exhibition *George Gershwin and Modern Art: A Rhapsody in Blue*, on view from February 10 to June 16, 2024, at The Baker Museum, Naples, Florida.

The exhibition is organized by Artis—Naples, The Baker Museum and curated by Olivia Mattis, PhD, guest curator, and Courtney McNeil, museum director and chief curator.

This exhibition is generously sponsored by the Collier County Tourist Development Council, Commerce Trust, Roger and Kathy Marino, Waterside Shops, and Jeri L. Wolfson.

First published in 2024 by Scala Arts Publishers, Inc.
1301 Ave of the Americas, 10th Floor
New York, NY 10019
www.scalapublishers.com

ISBN 978-1-78551-539-2

Editor: Erin Barnett
Design: Benjamin Shaykin
Typeset in LL Brown and LL Prisma
Printed and bound in China

Frontispiece: George Gershwin at his 132 E. 72nd Street apartment in New York with his 1929 portrait by Isamu Noguchi, 1934.

Library of Congress Cataloging-in-Publication Data:
Names: Mattis, Olivia, McNeil, Courtney A., Shelley, Alexander, authors
Title: George Gershwin and Modern Art: A Rhapsody in Blue, in association with Scala Arts Publishers, Inc. New York.
Description: Exhibition at The Baker Museum, Naples, Florida. Catalog dedicated to George Gershwin's engagement with visual art through his collection of modern art, artwork he created, and art inspired by his music.
Identifiers: LCCN 000000000 | ISBN 978 1 78551 539 4 (HB). 78551 535 4 (HB).
Subjects: Art. Museums. George Gershwin.

The works indicated by * are included in the exhibition *George Gershwin and Modern Art: A Rhapsody in Blue* at Artis—Naples, The Baker Museum from February 10–June 16, 2024.

CONTENTS

6 CEO AND PRESIDENT'S FOREWORD
Kathleen van Bergen

7 LENDERS TO THE EXHIBITION

8 ARTISTIC AND MUSIC DIRECTOR'S STATEMENT
Alexander Shelley

11 **GERSHWIN'S EYE**
Olivia Mattis

47 **"A PAST THAT IS MINE":
GERSHWIN'S LEGACY IN THE VISUAL ARTS**
Courtney A. McNeil

53 **CORRESPONDENCE BETWEEN
GEORGE GERSHWIN AND HENRY BOTKIN
AND RELATED DOCUMENTATION**
Compiled and edited by Olivia Mattis

81 **THE GEORGE GERSHWIN COLLECTION
OF MODERN ART**
Compiled by Olivia Mattis

202 BIBLIOGRAPHY
Compiled by Olivia Mattis

209 NOTES

215 CURATORS' ACKNOWLEDGMENTS

217 ARTIS—NAPLES LEADERSHIP

218 PROGRAMMING

220 CONTRIBUTORS

221 INDEX

227 PHOTO CREDITS

CEO AND PRESIDENT'S FOREWORD

An American in Paris, *Porgy and Bess*, *I Got Rhythm*, *Rhapsody in Blue*—the list of iconic musical gems makes one want to snap, tap, and sing. George Gershwin excelled in a multitude of fields, and yet maybe the most defining characteristic of this legend is that of *collaborator*. He partnered with others to bend musical genres. He blended forms to revolutionize and expand. He broadened the perspective and possibilities of classical music. And although lesser known than his other talents, he experimented with the visual arts— again in a varied embrace—as a painter, collector, and wildly cultured eye.

George Gershwin was at his most prolific during the Roaring Twenties, and February 2024 marks the centennial of *Rhapsody in Blue*. Looking historically at the 1920s, it was a time of remarkable innovation, exploration, creativity, and even rebellion. Three great visual arts movements came out of the '20s: surrealism, expressionism, and art deco. Musically, the end of the Romantic era was declared—and Modernism enthusiastically encouraged—by Richard Strauss, Béla Bartók, and Igor Stravinsky. Ragtime, Dixieland, and the blues became major influences on popular culture, securing the prominence of jazz, heard everywhere from nightclubs and dance halls to living rooms via radio. Talkies, toasters, and traffic signals were all newfangled, and the world had not yet experienced the novelty of television, the blessings of penicillin, the playfulness of the yo-yo, or the gratification of the Polaroid. One hundred years later, our culture remains connected to and directly impacted by this roaring, powerful, artistic period.

As the centennial of *Rhapsody in Blue* approaches, and with this exhibition as our impetus, our collective efforts aim to celebrate the veritable story of Gershwin. We hope to enlighten the public through the visual arts, orchestral concerts, chamber music, popular presentations, dance offerings, and lectures. While we have utilized themes as our inspiration across the organization, this commitment marks the first time we have made an artistic figure our focus. And who better to explore such a complex and ingenious soul than the creative, talented, and dedicated teams of Artis—Naples? George Gershwin embodies our multidisciplinary mission. And I am confident that, after experiencing, learning, listening, viewing, thinking, and maybe even singing, we will all agree: *'S Wonderful*.

Kathleen van Bergen
CEO and President
John and Joanne Fisher Chair
Artis—Naples

LENDERS TO THE EXHIBITION

The Andy Warhol Museum
 Pittsburgh, PA
Artis—Naples, The Baker Museum
 Naples, FL
Dallas Museum of Art
 Dallas, TX
Michael Feinstein
Adam Gershwin
Marc Gershwin
Elaine Godowsky
Israel Museum
 Jerusalem, Israel
Jewish Museum
 New York, NY
Library of Congress, Music Division
 Washington, DC
McNay Art Museum
 San Antonio, TX
Museo de Arte Latinoamericano de Buenos Aires (MALBA)
 Buenos Aires, Argentina
Museum of Fine Arts, Boston
 Boston, MA
Museum of the City of New York
 New York, NY
Nelson-Atkins Museum of Art
 Kansas City, MO
Philadelphia Museum of Art
 Philadelphia, PA
Picker Art Gallery, Colgate University
 Hamilton, NY
Private Collection (2)
Ronald Feldman Gallery
 New York, NY
Vatican Museums
 Vatican City
Wadsworth Atheneum Museum of Art
 Hartford, CT

ARTISTIC AND MUSIC DIRECTOR'S STATEMENT

"...music must repeat the thought and aspirations of the people and time. My people are Americans. My time is today." —George Gershwin

In a sense, the modern world, and the globalized, multicultural society of our era, was forged in the fires of George Gershwin's time. Born in 1898, just as the skin of the late nineteenth century was being shed, its perceived decadence was eliciting reactions that would send cultural and political earthquakes through the coming decades. Gershwin's teenage years played out against the devastating destruction and mechanized brutality of the First World War. By the year of his death in 1937, fin-de-siècle cynicism and war had led to the *années folles* of the 1920s, the Great Depression and, ultimately, the rise of fascism.

Gershwin's great and enduring importance lay in his ability to serve as a cultural bellwether and artistic visionary, bridging the gap between tradition and subversion, old and new, decadent and fresh, replete and lean. He embodied the fusion of cultures that was to define the stresses, strains, and opportunities of his time and of ours. And as we, a century later, grapple with so many of those same challenges, much can be gleaned from an exploration of how this brilliant man molded a new way forward and projected his towering influence onto the art, artists, and culture of the future.

Few composers have so indisputably captured and defined the spirit of their own era and culture more successfully and enduringly than George Gershwin. With the blaring horns of *An American in Paris*, the swooping clarinet howl of *Rhapsody in Blue*, the seductive charm of *Embraceable You*, and the dramatic psychological punch of *Porgy and Bess*, he reaches out to us across the century, conjuring the mood, the sound, the swing of the Roaring Twenties.

I have been a Gershwin fan for as long as I can remember. As a jazz lover, I have deep admiration for the structural subtleties, harmonic sophistication, and creative craft of his work. As a classical musician, I relish the opportunity that his music gives us to bring unforgettable melodies and foot-tapping, pulse-quickening rhythms onto the symphonic stage. By any measure, he was a great genius. That he in his all-too-brief thirty-eight years of life left such a towering influence on the century that would follow is testimony to the depth of that genius.

With my recent appointment as artistic and music director of Artis—Naples and the Naples Philharmonic, I am truly brimming with anticipation and excitement for the coming years, not least because of the remarkable experiences such as *George Gershwin and Modern Art: A Rhapsody in Blue* that this inspiring arts organization creates and hosts. It is precisely the sort of multidisciplinary artistic celebration that inspires us all and opens doors to new knowledge, experience, and fulfillment. I, for one, have already expanded and deepened my appreciation of Gershwin's wider artistic personality through the insightful and perceptive curation that my friend and colleague Courtney McNeil and her co-curator, Olivia Mattis, have invested in this exploration.

Researching the images and objects that will be exhibited and reading Olivia Mattis's brilliant essay ahead of writing this foreword have been revelatory. I have learned about Gershwin the painter, the collector, the commissioner, the photographer. I have reveled in his correspondence. I have realized with greater clarity that, not solely in music, but in all things, this was an artist and a man fascinated by stories, by people, by life. Fascinated by color—both sonic and visual. In all that he did, he manifested that deeply artistic trait: to capture the most vital and vivid experiences and truths of life and reflect their essence back to us through a poetic, human lens.

As we celebrate Gershwin's visual art, of course we also celebrate his music through a variety of Naples Philharmonic and other musical programs that juxtapose some of Gershwin's most renowned music with other masterpieces of his era.

His was a time in which travel was becoming cheaper, easier, and faster, and as such, it was also a moment of divergence in music history. The world

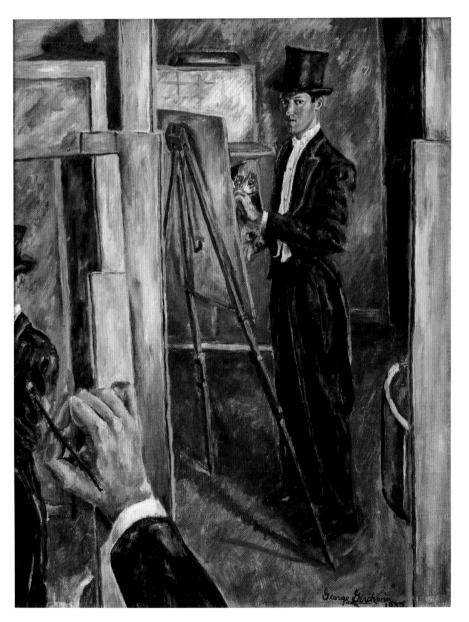

Fig. 1. George Gershwin. *Self-Portrait in Evening Clothes*, 1932.
Oil on canvas, 25¾ × 19⅞ in. Collection Marc Gershwin

opened up, and so did the sound of "classical" music, as evinced by four contemporaneous but very different works that we will be presenting in conjunction with Gershwin's music on the Naples Philharmonic Masterworks series: Schoenberg's Chamber Symphony No. 1 and Five Pieces for Orchestra, Ravel's *La Valse*, and Stravinsky's *The Firebird*.

An undeniable hub during this defining moment of cultural globalization, Paris was a city that drew artists from across the world like moths to its flame. No exception to this attraction, Gershwin made his own pilgrimage, rubbing shoulders with the great and the good, capturing the spirit of the city in his immortal, self-referential musical postcard, *An American in Paris*.

The work is vibrant, bright, and uplifting. Indeed, if I were pressed to describe this great man's output in a single word, it would be just that: uplifting. There is a charm, an ebullience, an insouciance to his work that puts a smile on the face and a skip in the step.

I hope that I will have the opportunity to meet many of you in person at The Baker Museum, in Hayes Hall, or elsewhere on the Kimberly K. Querrey and Louis A. Simpson Cultural Campus as we celebrate these great qualities and explore together the artistry, life, and times of one of America's great cultural icons.

Alexander Shelley
Sharon and Timothy Ubben
Artistic and Music Director Designate

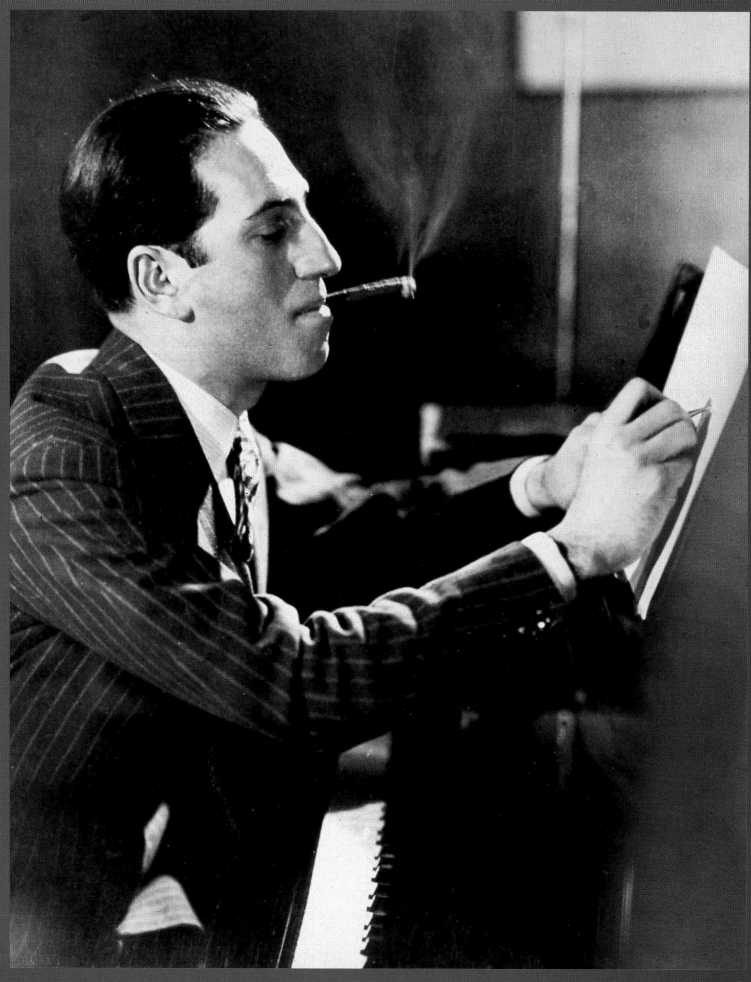

GERSHWIN'S EYE
OLIVIA MATTIS

George Gershwin—the legendary composer of *An American in Paris*, *Rhapsody in Blue*, *The Man I Love*, *Porgy and Bess*, and so much more—had a refined musical ear. But audiences are unaware that he also had an eye—as both a collector and a practitioner of art. "What a great advantage painting has over composing!" he told his cousin, the artist and illustrator Henry Botkin. "When I finish a canvas it's there. That's the end. But a composition . . . after writing it, I have to assemble sixty musicians, and make arrangements of the music before I can hear the results of my efforts."[1] "Of course I can paint!" Gershwin told Rosamond Walling, an aspiring landscape painter. "If you have talent, you can do anything. I have a lot of talent,"[2] he added. Gershwin produced paintings, drawings, and photographs and assembled a substantial modern art collection comprised of paintings, drawings, sculptures, and decorative objects.[3] Fellow composer Kay Swift recalled, "[George] turned to painting and turned back to music, and it was all rhythmic."[4] Botkin confirmed the back-and-forth nature of Gershwin's two activities. He recalled, "[George] first stopped composing to paint, and then he finally stopped painting to compose."[5]

"He was in love with color," recalled the book designer and impresario Merle Armitage, "and his palette in paint closely resembled the color of his music. Juxtaposition of greens, blues, sanguines, chromes, and grays, fascinated him."[6] And he was also in love with Paris. Gershwin's art collection included works by École de Paris artists Marc Chagall, André Derain, Pinchus Krémègne, Amedeo Modigliani, Jules Pascin, and Chaim Soutine, along with Pablo Picasso's depiction of an absinthe drinker in the demimonde of Montmartre, Max Jacob's depiction of the Parisian

theater, and Henri Rousseau's tender portrayal of the Eiffel Tower, a bridge, and the Seine below, as seen from the Île de la Cité. Allusions to the collection appear throughout the whimsical illustrations by Constantin Alajálov in *George Gershwin's Song-Book*, published in 1932.

Given the fact that Gershwin's cultural impact was so vast, encompassing classical music, popular music, musical theater, opera, and jazz—not to mention the concept of representing American musical identity—it should not be surprising that he influenced the visual arts as well, both during his life and later. He posed for some of the leading photographers of his day and

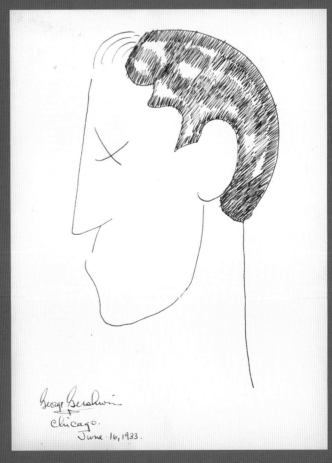

Fig. 2,* opposite. Edward Steichen (American, 1879–1973). *George Gershwin*, January 19, 1927

Fig. 3,* right. George Gershwin's self-portrait ink drawing in copy of *George Gershwin's Song-Book* owned by Bobsy Goodspeed, director of the Arts Club of Chicago and organizer of the Gershwin exhibition there in 1933. Collection Michael Feinstein

Fig. 4.* Carl Van Vechten (American, 1880–1964). *Portrait of George Gershwin,* March 28, 1933

The correspondence between music and visual imagery is a subject that has preoccupied composers and scientists for well over three hundred years. In his *Opticks* of 1704, Isaac Newton was the first to argue that there are seven colors in the rainbow, paralleling the seven notes of the musical scale. In the eighteenth century, the mathematician and philosopher Louis-Bertrand Castel presented his *clavecin oculaire,* a harpsichord that would project a color each time a key was struck.[9] This device was one of numerous "color instruments" that have been documented.[10] In the early twentieth century, Russian composers Nikolai Rimsky-Korsakov and Alexander Scriabin believed that specific keys corresponded to specific colors, e.g. E-flat Major = blue and D Major = golden brown. The modernist pioneer Arnold Schoenberg was another visually minded composer. A prolific amateur painter, he composed a "color crescendo" for *Die Glückliche Hand* and produced "Farben" (colors) as the central movement of his opus 16 orchestral work.

French composer Olivier Messiaen's synesthesia is well known. "When I hear music," he says, "—and it was already like that when I was a child—I see colors. Chords are expressed in terms of color for me—for example, a yellowish orange with a reddish tinge." Jazz legend Duke Ellington, composer of *Black, Brown and Beige, Mood Indigo,* and the *Black and Tan Fantasy*, referred to his band as his palette and his performances as paintings.[11] In England, composer Arthur Bliss composed *A Colour Symphony* in which each movement represents a hue. And in the 1980s American composer Michael Torke began creating color pieces such as *Ecstatic Orange* and *Bright Blue Music* in which "different shades of paint splash around the orchestral forces."[12]

How does George Gershwin fit into this lineage? In short, how "blue" is the *Rhapsody*? Using primarily unpublished documents housed at the Library of Congress, the Archives of American Art, and other collections, and considering Gershwin's statements, his surviving artwork (both collected and created) and the accounts of his closest friends, this exhibition catalogue takes a tour through Gershwin's visual dimensions to open up new ways of thinking about the composer and his creative impulses.

Gershwin's art collecting was ambitious. An observer in 1933 remarked that Gershwin "collects pictures as an intelligent painter might—choice little things from this studio or that, with an individuality—a little touch of the unusual that sparkles."[13] One art dealer said of the composer, "He had innate good taste, that sixth sense which enables a collector to distinguish a superior from a representative example of a painter's work."[14] For the most part, Gershwin acquired figurative works such as nature scenes, cityscapes, theatrical scenes, portraits, figure studies, and still lifes, but as he progressed in his collecting he added abstractions by Vassily Kandinsky, Paul Klee, Fernand Léger, and Abraham Walkowitz. Among his figurative works were cubist still lifes by Georges

was an active partner in the creative process. These photographers included most notably Cecil Beaton, Grancel Fitz, Nickolas Muray, Edward Steichen, and Carl Van Vechten. On January 19, 1927, Steichen snapped the iconic profile portrait of the composer seated at the piano, his chin upturned, a lit cigar in his mouth—a photo that was Ira's favorite image of his brother and that appears on the cover of countless record jackets and books (fig. 2).[7] Another portrait from this sitting is a witty yet completely unknown play of shadows (fig. 42).

And his music inspired artworks by major artists. In the 1920s Arthur Dove created three paintings based on his compositions: *George Gershwin—I'll Build a Stairway to Paradise* (fig. 5), *Rhapsody in Blue Part I* (fig. 22), and *Rhapsody in Blue Part II* (1926–27), and Miguel Covarrubias painted *Rhapsody in Blue* (1927) and *George Gershwin, An American in Paris* (1929, fig. 12). In 1935 the stage designer Sergey Sudyekin, who had designed the set for Igor Stravinsky's *The Rite of Spring* and other *Ballets Russes* productions, created "Catfish Row" for *Porgy and Bess* and painted several canvases on the subject (fig. 28). In 1980 Andy Warhol included Gershwin in his series of DayGlo-colored screen prints depicting ten famous figures of modern Jewish history—his so-called "Jewish geniuses."[8] And in 2013, Kara Walker published an updated libretto to *Porgy and Bess* with twenty original prints presenting the opera's characters in her hallmark silhouetted style (figs. 56, 59–62).

Braque and André Masson. The sizes of the artworks range from miniatures to large museum pieces.

The actor Edward G. Robinson—himself a celebrated art collector—described a visit to an art exhibition with Gershwin: "We would stand quietly enough before the paintings we were watching, but inwardly . . . we felt we were fellow travelers into the very life of the picture, and partners in the inspiration of the artist who painted it."[15] In addition, Gershwin commissioned three important works of modern art: Isamu Noguchi's totemic bronze portrait of George Gershwin (plate 39), Henry Botkin's grandiose and colorful screen, *An American in Paris* (plate 8), and David Alfaro Siqueiros's large mural-like painting *Portrait of George Gershwin in a Concert Hall* (plate 55).

As an artist, Gershwin produced paintings, drawings, and photographs. In 1924, the same year as *Rhapsody in Blue*, he exhibited a now-lost watercolor entitled *Titus* at the 22nd Annual Water Color Exhibition sponsored by the Pennsylvania Academy of the Fine Arts and the Philadelphia Water Color Club. Gershwin occasionally gifted artworks to friends, both his own creations as well as pieces by artists in his collection. "Before Maurice Sterne became well known, George bought two of his paintings and presented me with one which still hangs in my drawing room,"[16] said the journalist and socialite Kay Halle, who had introduced him to the sculptor Isamu Noguchi. To the "other" Kay in his life—the composer Kay Swift—he gifted an Othon Coubine landscape and a Raoul Dufy still life (plates 18 and 22).

Joseph Schillinger, a Russian music theorist and professor who arrived in New York in 1928 and became Gershwin's friend and mentor, sought to establish a unified mathematical basis underpinning all of the arts in all media and all periods of history. His monumental tome *The Mathematical Basis of the Arts* (published posthumously) sought to codify his findings.[17] "Painting and music spring from the same sources," Gershwin told a reporter in 1929 in Schillingeresque language. "All of the arts have the same thing as a basis. Many composers have done well with painting. I never tried it until recently, and perhaps I may continue it just as a means of breaking the monotony of writing music. Perhaps I shall continue it seriously."[18]

Gershwin had tremendous facility in making line drawings. He also collected line drawings by Amedeo Modigliani and other artists. The museum director Charles Cunningham, of the Wadsworth Atheneum, considered that Gershwin "had a sensitivity to line comparable in some respects to Matisse."[19] Gershwin considered the act of line drawing to be the equivalent of composing a melody. "Music is design—melody is line; harmony is color,"[20] he asserted. Consider the simple rising line of the four-note melody "I Got Rhythm," for example, that immediately becomes its own mirror image, going back down to the original note before rising again and seeking the end of the phrase. The supporting chords provide the "color,"

while the combination of line and color, according to Gershwin, becomes the musical "design." A similar simplicity of construction can be seen in the opening of Serena's aria "My Man's Gone Now" from *Porgy and Bess*.

Art was a passion that Gershwin shared with Rosamond Walling, a young student to whom he was related through his brother's marriage.[21] In November 1927 George gifted her with a Steichen photo of himself inscribed with a few bars from the climax of *Rhapsody in Blue*.[22] On June 18, 1928, on his return from Europe, he gave her "the first modern art object in my life," she recalled—an art deco cigarette case "in black and white, with an eggshell inlay in cubist design."[23] One day they went together to an art supply store. "George went nuts in the paint store," Walling recalled. "He bought a huge empty box and filled it with a complete assortment of Grumbacher or Malfa oils, whichever cost most, in the biggest tubes. Then he chose sable brushes, a palette, and some big canvas boards."[24]

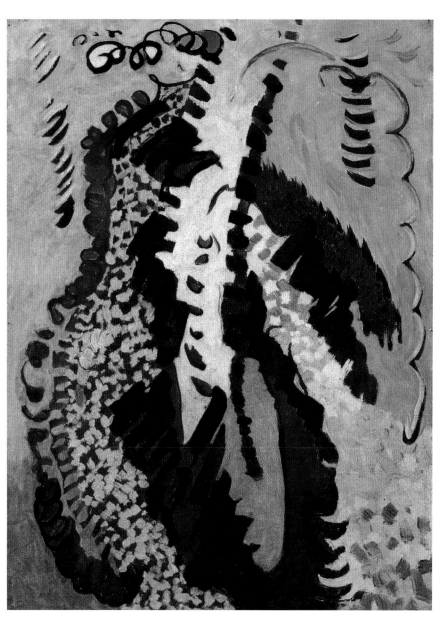

Fig. 5. Arthur Garfield Dove (American, 1880–1946). *George Gershwin—I'll Build a Stairway to Paradise*, 1927. Ink, metallic paint, and oil on paperboard, 20 × 15 in. Museum of Fine Arts, Boston, Gift of the William H. Lane Foundation, 1990.407

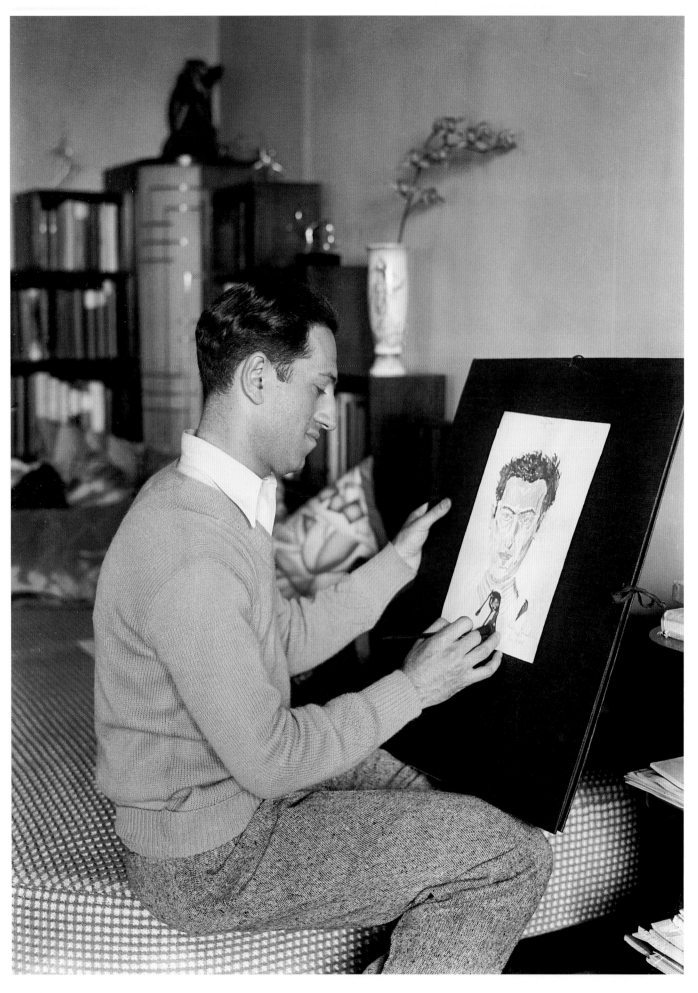

Fig. 6. George Gershwin sitting on the edge of his custom-made art deco day bed, probably designed by Paul Frankl, drawing. Atop the bookcase is an unidentified art deco sculpture of two figures dancing.

When Gershwin moved into the New York penthouse apartment at 33 Riverside Drive in January 1929, he carefully curated his surroundings. He commissioned custom art deco furniture to be built, most likely designed by Paul Frankl, inventor of the "puzzle desk," the "skyscraper bookcase," and other innovative modern designs. At that time, Gershwin's Ziegfeld Follies musical *Treasure Girl*, starring Gertrude Lawrence, had just closed on Broadway, and he was writing *Show Girl*, with its ballet sequence set to *An American in Paris*. He wrote to Walling, "The new show & the apartment are keeping me very busy these days but I seem to thrive on it as I haven't felt better in a long time. I've chosen all the materials & colors for the apartment & also the silver. All that remains now is to choose the china. It is really exciting, all this business. I went to the factory yesterday & saw my furniture being made. The detail of the whole thing amazes me."[25]

Penthouse living was all the rage in those heady days, before the stock market crashed in October 1929. As *The Forward*, the Yiddish newspaper, reported in April of that year, "Much of the life of the New Yorker is spent up in the air. The latest fad among the elite is the roof apartment and such men as George Gershwin and Larry Hart have apartments high up in the sky, from which they can gaze down upon New York spread out before them like a mystic and lovely futuristic rug. The penthouse apartment or room has come into its own, and even little dismal garrets in Greenwich Village are getting exorbitant rents because of their height. New York is looking up."[26]

"The penthouse is simply a grand & inspirational thing," Gershwin wrote to Walling on April 29. "Of course it has its drawbacks—what hasn't?—but in spite of those, it never ceases to be beautiful to me. The Hudson River & the sunsets over the Palisades, the little tugboats & the ocean liners, the funny looking phut-phut-phutters, the graceful birds & the imitating aeroplanes—an ever-changing picture. . . . Believe it or not—3 weeks ago I started to draw pictures in pencil & watercolor and discovered a hidden talent. Unlike other beginners, I started out by drawing heads & several of my severest critics detect a professional touch. I have already drawn Lou, Emily, Pop Gershwin, Bill Daly, Mabel & Bob Schirmer, Martin Loeffler, cousin Botkin & a dozen others."[27] He enclosed with the letter a photograph from the April 20, 1929, edition of the *New York Times* showing Botkin giving him a painting lesson on his penthouse balcony.

"He was my pupil and we were like brothers,"[28] recalled Botkin. "When I saw George's new apartment on Riverside Drive, I said, 'George, the walls are bare! How about some paintings?' He said, 'Fine. How do we start?' Just like that. I said, 'George, I tell you what. We'll make it our business to go around to the galleries and see a lot of painters' work who we don't even know. Make a note of the painters you like and when I get back to Paris I can get them.' And I said something else: 'You know, in order to appreciate someone else's painting, do a little *shmeering* on your own.' And I'll be damned. The next day when I came over, there was George with the canvas and paints all going."[29]

In fact, the collection was begun more than a year earlier. On February 17, 1928, Gershwin acquired five lithograph prints by the American artist George Bellows from Emma Bellows, the artist's widow. Among them were *Dempsey Through the Ropes* (plate 3) and *Between Rounds #2* (plate 2), depicting the legendary world championship fight between Jack Dempsey and Luís Angel Firpo held on September 14, 1923, when the Argentinian Firpo knocked the American Dempsey out of the ring with a left hook to the jaw, and Dempsey came back into the ring and won the bout. Gershwin, an avid sportsman and admirer of Jack Dempsey, had a punching bag in his home gym and a personal trainer with whom he sparred (fig. 69). He told Walling that as a boy he had aspirations "to be a great prize-fighter."[30] She described "a sort of Rube Goldberg gym next to his bedroom, where he could box and exercise."[31] Gershwin met Dempsey, who gave the composer an autographed photo. Gershwin's own painting *Prize Fighter* (fig. 70), now in the collection of the Museum of the City of New York, is clearly related to the Bellows images. In addition, one of the Gershwin brothers shot a home movie of a prize fight between unidentified opponents that is available to be seen online.[32]

Gershwin sought out art collecting advice from various members of New York's cultural scene including *Vanity Fair*'s editor Frank Crowninshield, himself a prolific art collector. On April 16, 1929, Gershwin bought a handful of inexpensive "starter" artworks at the estate auction of the American artist Arthur B. Davies, who had been one of the organizers of the famous 1913 Armory Show, which introduced Americans to the work of European avant-garde artists. Gershwin's acquisitions were lot 10, *Study in Pencil* by George E. Luks, 5 × 3 inches, described in the catalogue as "A small girl depicted at full-length," for $35; lot 11, *Pencil Sketch* by Georges Braque, 7½ × 3 inches, described as "Cubistic rendering of a female figure. Executed upon a fragment of paper," for $20; lot 50, *Pencil Sketch* by André Derain, 14½ × 18 inches, described as "a basket, a bowl of eggs and a glass," for $60; lot 74, *Pen Drawing* by Fernand Léger, 12 × 18 inches, an abstraction described as an "imaginative composition in lines and planes" for $75; and lot 79, *Lithograph* by Henri Matisse, 19½ × 13 inches, described as "Head and shoulders portrait of a young girl," for $50. The next day he returned to the sale and bought lot 444, *Small Crouching Nude without an Arm* (1908), by Matisse, 5 inches in height, a tiny Rodin-like partial figure titled in the Davies catalogue as *Bronze Statuette* and described there as "Impression of a half-kneeling figure. Marble base," for $90 (plate 34). He then used the tiny statuette as an artist's model, drawing the figure from all sides.

Then his ambition grew, and over the next eight years Gershwin spent many thousands of dollars

Fig. 7, above. Installation view of small gallery. *Exhibition of the George Gershwin Collection of Modern Paintings*, Arts Club of Chicago, November 10–25, 1933

Fig. 8, right: Alexander Calder (American, 1898–1976). *Varèse*, ca. 1930. Wire, 15 × 11¾ × 12½ in., Whitney Museum of American Art, New York, 50th Anniversary Gift of Mrs. Louise Varèse in honor of Gertrude Vanderbilt Whitney, 80.25

acquiring masterpieces. Like the European artists whose paintings he collected, Gershwin was also interested in traditional African sculpture for its aesthetic value and purchased a number of masks and other sacred objects that abstracted the human figure. Additionally, he owned a large number of East Asian ivory carvings.[33] Gershwin's collection was first exhibited in 1933, at the Arts Club of Chicago, and then in 1936 at New York's Museum of Modern Art (MoMA). The MoMA show was presented anonymously as *A Group from a Private Collection, New York*, as the Museum's policy at that time was to focus the public's attention on artists only, and not on collectors.[34] The Chicago show ran from November 10–25, 1933 (figs. 7, 23, 73, 78, 79, 93), and the MoMA show ran from July 27–September 6, 1936. MoMA also borrowed individual pieces from Gershwin for various themed exhibitions.

After Gershwin's untimely death in 1937 at age thirty-eight, MoMA's then-director Alfred Barr wished to exhibit the composer's collection again—this time with his name attached. According to Botkin, "Alfred Barr was so enthusiastic about the entire collection he asked me to get the family interested in a museum show. This was after George had passed away, but since most of the paintings and the estate was tied up in some legal difficulties, I was unable to arrange it."[35] In 1959, a selection from Gershwin's collection was presented for a one-month period, July 9 through August 9, at the Wadsworth Atheneum in Hartford, Connecticut. The exhibition, called *The Music Makers*, included highlights from Gershwin's collection among other artworks lent by his sister Frances "Frankie" Gershwin Godowsky, along with the art collection belonging to the songwriter Richard Rogers.

GERSHWIN AND NOGUCHI

A few generations ago, all young piano students (certainly including Gershwin) collected busts of their favorite composers such as Bach, Beethoven, Brahms, Chopin, Liszt, Mozart, and Wagner and placed them on their pianos for inspiration. This traditional practice was in keeping with the "great man" view of music history that prevailed at the time, according to which music evolves each time a new musical genius comes along. In 1929, Gershwin commissioned a bust of himself by Isamu Noguchi, who would become one of the twentieth century's most critically acclaimed sculptors. Gershwin, unlike most composers in history, had the financial means to commission works of art and even provided emergency funds to Noguchi and other artists in his circle.

Noguchi's totemic bronze bust of Gershwin is one of several important modernist composer heads from the period that updates the time-honored "great composer" bust. Another example is Auguste Rodin's 1911 portrait bust of Gustav Mahler—cryptically titled *Mozart*—that was commissioned by Mahler's circle of friends.[36] The finished product is a massive head emerging from a block of marble like Venus arising from the sea. "I find his features remarkable," Rodin said of Mahler. "There is a suggestion not only of the Eastern origin, but of something even more remote, of a race now lost to us—the Egyptians in the days of Ramses."[37] Another example of an updated composer bust is the ethereal wire sculpture portrait of Edgard Varèse by Alexander Calder (1930), now in the collection of the Whitney Museum of American Art (fig. 8).

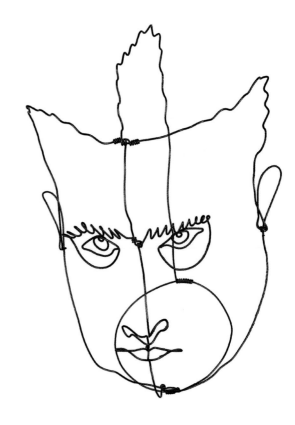

NOGUCHI ON GERSHWIN, 1938

Searching in memory for the face of someone we have known often requires considerable concentration, especially if asked to describe or draw his picture. In our attempt to give reality to such a person, who may even be our closest friend, we are obliged to call up a duplicate image who talks and acts differently to each of us, yet is our only perception of reality. Imagination can create a particular situation, characteristic gestures, the voice, the place, till suddenly time stops and we are there with our friend in the past.

The timely yet timeless quality of all great art may spring from this very human sense of reality given by the perspective of memory. Let me say that imagination seems to project time so that the present is already a part of history. The past is made alive through art.

In my own work, I have found this true. I have also found that in portrait sculpture it is pleasant to work with other artists for they better understand this necessarily objective attitude. The problem is indeed one of trying to avoid having any opinion whatsoever of the sitter so as to let that image emerge which is as complex and as simple as life.

Such an ideal situation existed when George Gershwin posed for me in 1929. I had barely met him. I neither liked him, nor did I dislike him, as a friend of his recently intimated.

True, like most men, he came rather anxious and antagonistic, though curious. But then neither did he have preconceptions of himself or prejudices in art.

This head remains. An exterior of self-assurance verging on conceit does not hide the thoughtfulness of a rich and sensitive nature. I was especially fortunate for I do not believe that at any other time did the impression he created so nearly correspond to what he meant to the world—with the added significance to many of us that he was not only a representative of the twenties but through his music a symbol of our youth. His was that rare gift of being able to transfix in such a slender song as *Oh Lady Be Good* the timely, yet timeless image of an era, poignant still.

Why Gershwin, at the pinnacle of success in an idiom of which he was part and parcel, should yearn for the larger forms of music is quite understandable—his courageous ambition to overcome the limitations of his early training—even his seeming disparagement at times of his native genius. How natural that with all the adulation he received, he felt a responsibility to "deliver" the "great American opera—symphony—ballet." Here was that quality of idealism and striving which raised him far above success—success or failure was immaterial, he was an American, he aspired, he was our own.

That Gershwin also involved himself in the study of painting to the extent that he did is completely astonishing to me. Did he doubt the adequacy of music as a complete expression, or was it a divertissement? Perhaps fleeing from the exorbitant expectations which are heaped upon genius in the "public eye" painting was his solace.

His deep-rooted appreciation of the artist behind art is nowhere better shown than in his interest in collecting their paintings. To him the painting was the artist, their work a study and a joy. He was forever trying to explain such things to his friends.[1]

Fig. 9, above: Louise Dahl-Wolfe (American, 1895–1989). *Portrait of Isamu Noguchi*, 1955

Fig. 10,* right: Isamu Noguchi (American, 1904–1988). *Portrait of George Gershwin*, 1929 (see plate 39)

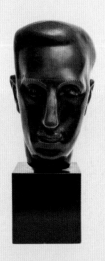

Rosamond Walling was present during one of the portrait sittings Gershwin did with Noguchi. "George loved posing," she wrote in an unpublished reminiscence, "and was absorbed in the craft of the young sculptor, who worked in rhythm, kneeling and rising and looking and correcting the clay in silence." George told her after the sitting that he had ambitions to begin making sculptures himself. "Look at my hands," he bragged to her. "They're made for clay, or carving. I love the *feel* of the materials. Look, my hands can do everything."[38]

The National Portrait Gallery in Washington, DC, featured the Gershwin bust as the cover image of the catalogue to their 1989 exhibition on Noguchi's portrait sculptures. Nancy Grove, the curator of that exhibition, wrote that Gershwin "apparently met Noguchi through Kay Halle, who sold him a small Noguchi sculpture. . . . Gershwin's acquaintance with Noguchi endured. In the mid-1930s he hosted small dinner parties, to which he invited Noguchi and other friends such as Kay Halle and Buckminster Fuller. . . . Years later, when Noguchi was carving the *Billy Rose Sculpture Garden* (1960–65) out of a Jerusalem hillside for the Israel Museum, he received permission from the Gershwin family to make a second cast of the head to give it to the newly opened museum."[39]

STEINWAY COLLECTION

The stunning painting *George Gershwin, An American in Paris* (fig. 12) by Miguel Covarrubias was commissioned by the Steinway piano company as part of their series of paintings based on famous pieces of music. It is now in the collection of the Museum of Latin American Art in Buenos Aires, Argentina. Another Gershwin-themed Steinway commission is Earl Horter's *Rhapsody in Blue* (fig. 11), now in the collection of the Philadelphia Museum of Art, that is a parody of the famous 1912 Italian futurist canvas *Dynamic Hieroglyphic of the Bal Tabarin* by Gino Severini that now hangs at MoMA. Both the Covarrubias and the Horter were used by Steinway in their advertisements printed in such magazines as *Vanity Fair*, *Vogue*, *McCall's*, and the *Saturday Evening Post*.

The Steinway Collection of Paintings by American Artists was begun in the early twentieth century to draw the public to the company's New York showroom. A catalogue of the collection, published in 1919, well before the commissioning of the Covarrubias and Horter works, includes stunning illustrations of paintings by N. C. Wyeth and other American artists and illustrators of the composers Beethoven, Berlioz, Chopin, Handel, Liszt, Mendelssohn, Mozart, Edward MacDowell, Schubert, Verdi, Wagner, and the pianist Anton Rubinstein. As the musicologist James Huneker explains in the "Prelude" to the catalogue, "It was an admirable idea of Steinway & Sons to enlist the sympathetic cooperation of certain American artists in the creation of pictures that would evoke musical

visions; for music is visionary, notwithstanding its primal appeal to the ear."[40]

In the brightly colored Covarrubias painting, the blue-eyed American man in a gray suit and blue tie is seated outside the Café Pigalle in Montmartre, cigarette in hand, with a wine glass and a folded *New York Herald Tribune* on the café table beside him. Meanwhile, on the street, an open-topped tour bus passes a billboard for the Folies Bergère with the Eiffel Tower in the distance. The painting evokes the chaos and bustle of the French capital and its café culture. In addition to this painting, Covarrubias also depicted *Rhapsody in Blue* and drew a charming caricature of the composer at the keyboard, hair slicked back and fingers flying.

BOTKIN'S SCREEN, *AN AMERICAN IN PARIS*

George Gershwin commissioned the screen *An American in Paris* by Henry Botkin (plate 8). This work, now lost, measured approximately ten feet in width by eight feet in height and was described by the art critic Emily Genauer as "a magnificent screen, a riot of brilliant color and pattern."[41] Unfortunately, the only surviving clear image of the work is in black and white, although some faded color snapshots in the Gershwin Collection at the Library of Congress give some hints as to the color scheme. In this work, Botkin combines cubistic faceting and stenciling with Chagall-like whimsy. The work dominated Gershwin's bedroom in the Riverside Drive apartment (fig. 72).

The screen depicts a large central figure, the American man, with a hat, a cane, and a cape-like topcoat hovering atop the tree-lined Champs-Elysées,

Fig. 11.* Earl Horter (American, 1880–1940). *Rhapsody in Blue*, 1927. Opaque watercolor and graphite on board, 21⁷⁄₁₆ × 27½ in. Philadelphia Museum of Art: Bequest of an anonymous donor, 2003, 2003-162-1

from the Place de la Concorde in the foreground—with its two lion statues—to the Arc de Triomphe in the distance. In the road are cars, taxis, and horse-drawn buggies, five abreast, traveling in disarray. Below this floating dreamlike scene sits the rest of the city, with the Eiffel Tower to the left, the Concorde Obelisk and the Vendôme Column to the right, and other landmarks in between such as the Basilica of Sacré-Coeur, Notre Dame Cathedral, and the Jardin des Tuileries with its recognizable fountain. Rising up from the bottom of the screen through the center of the image, and supporting the American man's feet, is the armature of the Eiffel Tower, whose spire is visible just to the right of his head. Across the bottom section are numerous scattered musical notes and four stenciled words: JAZZ—TAXI—VIN—TAXI. To the left and right of the screen, halfway up, are laurel leaves jutting from the edges towards the American man, signaling his triumphant arrival.

Fig. 12.* Miguel Covarrubias (Mexican, 1904–1957). *George Gershwin, An American in Paris*, 1929. Oil on canvas, 28¹⁵⁄₁₆ × 35⁷⁄₁₆ in. MALBA Collection, Museo de Arte Latinamericano de Buenos Aires, 2001.54

THE GERSHWIN-BOTKIN CORRESPONDENCE

The extensive exchange of letters between Gershwin and Botkin, presented here for the first time (pages 53–80), gives us a window into the collecting partnership between the two men.[42] Botkin spent considerable time each year in Paris, and he became Gershwin's agent there from 1931 to 1933. During that period, he sent long letters to the composer describing available paintings, detailing their use of color, and enclosing black-and-white photos. Botkin began the project full of optimism for the task ahead. "Here's to the new collection & I have an idea that the next new wing at the Metropolitan will be named after you."[43]

Gershwin was delighted by the arrangement and wrote in one of his early replies: "I think you are swell to go to all the trouble that you are going to, in order to start me on my long-wanted collection of pictures."

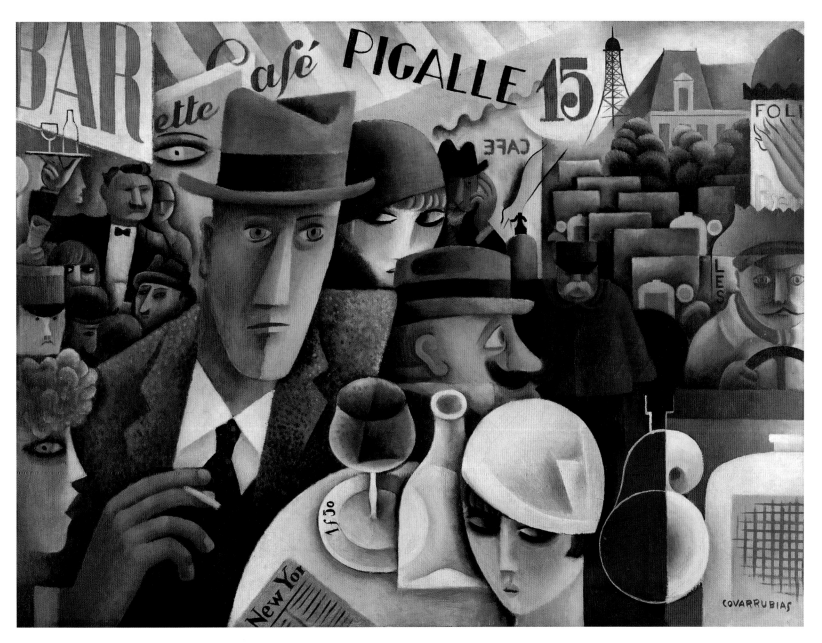

19

CATALOGUE PREFACE, 1933

Fig. 13. George Gershwin. *Portrait of Henry Botkin with Pipe*, n.d. Library of Congress, Washington, DC

Much has been written about George Gershwin's eminence as a composer but little has been known about George Gershwin the collector. As one who has been close to him and has observed the progress of this interesting artistic adventure from the beginning, I am glad of this opportunity to comment on both collector and collections.

A number of years ago Gershwin experienced his first thrill from a contemporary painting and promptly purchased it with great enthusiasm. At that time he never considered himself a collector or a champion of modern painting. He bought the canvas because he liked it and wanted it about. It was this irresistible impulse that led to further purchases and the beginning of a most significant collection. Our frequent visits to the galleries and studios of various artists here and abroad displayed

Gershwin's intense feeling and joy in pictures and painting. The spirit of his music and its relation to art became more and more evident. He realized that his rhythms and their rhythms had many common factors. He has always striven for examples that seemed to be the most vital and the most stimulating. The careful patterning, the subtle rhythms, together with the somber power and fine sentiment found in the various canvases have produced a deep, spontaneous artistic excitement for the collector. During our many years of close relationship I have noted how the special quality of his extraordinary music has given proof of the similarity of imaginative tendencies and strong spiritual kindship to these many striking achievements in paint. The collection has resulted in the assimilation or aesthetic nourishment for his musical genius.

Gershwin being essentially an American composer displayed his interest in American painting from the beginning. This was manifested in his early purchase of a great many important works of the dominating personalities in the American art world. The painters, Max Weber and Maurice Sterne, are close friends of Gershwin and many of the canvases have a definite relation and affinity to his music. This is especially true in the canvas shown here called *Invocation* by Max Weber. The painters, Picasso, Weber and Rouault, have a special interest to him and have enriched and strengthened his admiration and love for painting. I have also found that the linear factors of an arrangement by Picasso or Kandinsky have music in common with the linear counterpoint of a Gershwin composition.

Gershwin himself began painting in 1929 and after some encouragement and assistance on my part revealed a profound and genuine talent. In his work shown here he displays how the specific moods of his musical compositions have given a vital form and emotional strength to his pictures. The intense, dynamic impulse of his own music has become the dominating force in his painting. He is interested only in such material as has a strong connection with his own creative energy and daring.

The collection makes no pretense to completeness and is still very young. It contains, however, some of the greatest examples of contemporary painting as further witness to Gershwin's powers of discrimination and real feeling. Many of the paintings shown here reveal a strong sensitive selection and are perhaps some of the finest canvases to be found in this country. This is especially true of his Webers, Rouaults and Utrillos. Gershwin has never collected a list of names—it is only the quality of the individual canvases that counts. This is proven by the presence of a great many of the most interesting works shown here that are products of the unknown younger painters and not of the men whose names are so familiar to us. They have a definite place in the collection and Gershwin has championed and assisted them at all times. In lighter mood he has gathered a most varied group of lithographs, drawings and watercolors; among them we find Weber, Sterne, Bellows, Rouault and Dufy.

Gershwin has never confined himself to the paintings of any one group or country. He has turned

his attentions and interests to the various schools and movements in art. Although this collection has outgrown several apartments, overflowing into the homes of his friends, he eagerly carries on as in my opinion, the most intrepid of the younger American collectors of today.[1]

ON MY COUSIN GEORGE GERSHWIN (UNDATED)

George himself began painting in 1929 and after some encouragement and insistence on my part revealed a profound and genuine talent. As his painting progressed, he displayed how the specific moods of musical compositions had given a vital form and emotional strength to his paintings. The intense, dynamic impulses of his music became the dominating force in his painting. He was a good student, and as his talent began to assert itself he spent more and more time in the art galleries and the museums. He permitted himself to become soaked in the culture of painting and made many visits to the studios of painters so that he could acquaint himself more fully with the different principles and techniques. He strove constantly to master the same bold combination of accessories that he possessed as a composer.

He always made me believe that painting was a little in advance of music in expressing ideas and moods. If he was interested in the modern trends in art, it was because that they had the same qualities as the music with which he was concerned. He once told me, "I am keen for dissonance; the

obvious bores me. The new music and the new art are similar in rhythm, they share a somber power and fine sentiment."

When we lived on Folly Island near Charleston and George was busily engaged in writing *Porgy and Bess*, he would abandon his piano often to rush out and join me in painting the picturesque Negro shacks. He painted and made sketches during his travels, and his sketch box and easel were always part of his baggage. His work was at all times serious and not a composer's pastime, and every effort showed an earnestness and sincere love.

To the world at large George Gershwin will always be known as one of the foremost exponents of modern American music. He also will be remembered as a man who possessed an almost feverish and unquenchable enthusiasm for the fine arts. It was always evident to me that he aspired to equal his achievements as a composer. He was on his way to that goal, and from tactile apperception he was able to move steadily toward a truly optical vision that would have enabled him to create a personal style in keeping with his temperament. The task that he was unable to bring to fruition bears the indelible imprint of his genius and personality.[2]

BOTKIN ON GERSHWIN, 1973

Returning to my relationship with George Gershwin—we were more like brothers than cousins. We also possessed a bond of kindred interests and challenging endeavors. It was described as a

restless emotional dynamism. Over the last ten years of Gershwin's active life, I was constantly in his company. As one writer stated, "Art gripped Gershwin and he was really smitten." It served as a stimulant to greater conquests. In reminiscing about his career Gershwin stated that two men had influenced his life, one was his first teacher of the piano and the other was his cousin Botkin who "opened my eyes to art." To quote Frank Crowninshield, "George had a way of regarding his painting and his music as interchangeable phenomena. . . . one emerging as sight and the other with sound; the first to be shaped with a brush and the second with a goose quill."[3]

Fig. 14.* George Gershwin. *Harry Botkin*, ca. 1930. Museum of the City of New York, 1968.97.26

In the same letter he explained his goal: "Please remember this, for future reference: I would rather pay a little more money for a good work of a master than a little less for a good work of a second rater. I would like to have nothing but the best, even if I do not have many pictures. . . . If you come across a good Modigliani, Matisse, Picasso, Renoir or any of these first men—even if they are expensive—I would like to hear about them."[44]

Botkin's first five acquisitions for Gershwin, in May and June of 1931, after considerable back-and-forth by letter and telegram, were a landscape and four portraits: André Derain's *Moïse Kisling* (plate 20), Jules Pascin's *Portrait of a Young Man* (plate 41), Maurice Utrillo's *The Suburbs* (plate 61), Georges Rouault's *Clown* (plate 45), and a painting attributed to Amedeo Modigliani, *Bust of a Young Woman* (plate 37). The Derain, Pascin, Utrillo, and Rouault were all bought from Galerie Van Leer in Paris. The painting attributed to Modigliani was purchased from Léopold Zborowski, the artist's dealer in Paris who trafficked in both authentic and fake works following the artist's death in 1920.

According to the receipt (fig. 81): "I, the undersigned, recognize having sold to Mr. Botkin a painting by Modigliani bust of a young woman made in 1919 for the amount of 48,000 francs plus the frame 500 francs. I guarantee authenticity of this painting. Zborowski. From [Romain] Rolland Collection. Paris 11 May 1931."[45] The work was later included in the landmark 1961 Modigliani retrospective that was shown in Los Angeles and Boston. It was not included in the authoritative catalogue raisonné on the artist by Ambrosio Ceroni, although there is an ongoing project that is successfully adding non-Ceroni works to the accepted canon through a series of rigorous criteria.[46] In one of the illustrations by Constantin Alajárov in *George Gershwin's Song-Book* of 1932, we see *Bust of a Young Woman* hanging on the wall (fig. 20).

The five paintings were shipped from Paris on June 6, 1931, and arrived in New York ten days later. "THRILLED WITH PICTURES,"[47] Gershwin telegrammed upon receipt. Of the Utrillo painting he exclaimed: "It seems to throw out its own light. I am crazy about it."[48] He described the neoclassical portrait of artist Moïse Kisling by Derain as "a masterpiece of simple color"[49] and chose to hang it in a place of honor above his piano. Botkin described the work as "a very important painting . . . fine in tone & a decidedly excellent museum piece."[50] The Derain painting shares many features with the iconic portrait of Bach by Elias Gottlob Haussmann—the direct gaze, the muted coloring, and the position of the hand holding the tool of the subject's trade (fig. 16). In the Bach portrait from 1746, the composer is pictured holding a piece of his own music, the six-voice Riddle Canon, BWV 1087 (formerly BWV 1076). "I'm thinking a great deal about the masters,"[51] Derain stated during the period when he made the Kisling portrait.

In a nod to the Bach portrait, Gershwin had himself photographed by Grancel Fitz holding a page from Liszt's transcription of Schubert's *Erlkönig*, albeit in a playful art deco pose, and with a Hélène Sardeau figurine at his feet (fig. 17).[52] While Botkin was making purchases in Paris, Gershwin was making his own acquisitions in New York. He acquired Maurice Sterne's tender painting *Mother and Child, Bali* (1913) directly from the artist, and loaned it to the Museum of Modern Art in January of 1933. That work is now in the collection of the Wadsworth Atheneum in Hartford, Connecticut (plate 58).

Gershwin's second buying spree with Botkin took place in late October of the same year. Gershwin insisted that Botkin find him a Soutine, and as a result, Botkin proposed *Woman in a Red Blouse* (ca. 1919), now in the collection of the Metropolitan Museum of Art (plate 57). Botkin cabled: "FOUND IMPORTANT SOUTINE GIRL RED DRESS EXCELLENT SIZE BEAUTIFUL EXAMPLE IMMEDIATE CASH TRANSACTION FIVE HUNDRED UNUSUAL BARGAIN CABLE MONEY IMMEDIATELY SAILING VERY SOON." (fig. 64)[53]

In addition to the Soutine painting, this second group included Marc Chagall's *L'Abattoir* (plate 15), Maurice de Vlaminck's *14 Juillet*, Raoul Dufy's *Cérès au Bord de la Mer* (plate 23), and works by Raymond Billette, Pinchus Krémègne, and Pierre Laprade. Botkin described the Dufy as: "One of his recent & best as well as most expensive periods—gorgeous blue green & purple with lemon yellow & violet—absolute bargain 15,000 [francs]. *Grab it*,"[54] Botkin advises. *L'Abattoir (The Slaughterhouse)* is a horizontal canvas depicting a singing *shochet* (kosher butcher) in Vitebsk and his dancing wife clad in red, moments after the ritual slaughter of a cow, while a young coworker goes about his business in the room next door.

Fig. 15. George Gershwin's penthouse apartment at 33 Riverside Drive, New York, living room. On the wall are Derain's *Portrait of Kisling* and Chagall's *Untitled (Old Man with Beard)*.

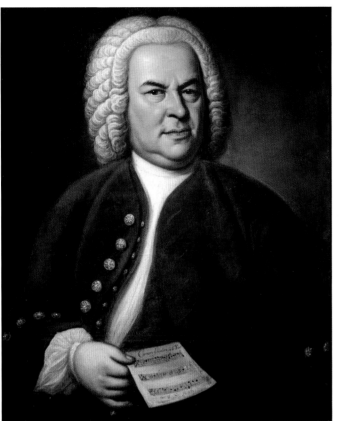

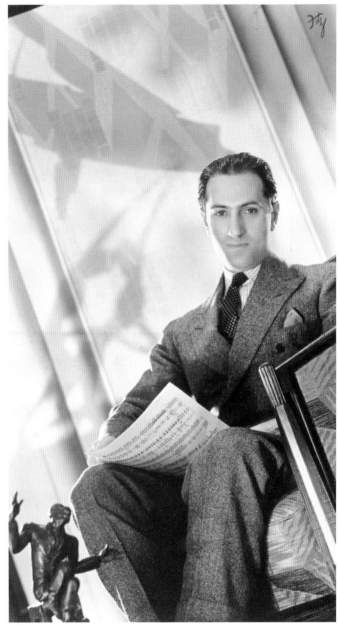

After the arrival of the second shipment, Gershwin turned his attention to pressing musical matters. His musical *Of Thee I Sing* (which would later win the Pulitzer Prize in Drama—first time ever for a musical) opened at the Music Box Theatre on Broadway on December 26, 1931. Then Gershwin's ambitious *Second Rhapsody* for piano and orchestra had its premiere in Boston on January 29, 1932, under the baton of Serge Koussevitsky, with the composer at the piano.

After those two major musical events, Gershwin focused again on the acquisition of art. With Botkin now back in New York, they could comb the galleries together. And they had fun! "We would go into some gallery," Botkin later recalled, "and I'm not speaking of a little gallery but a big one. Do you think he was satisfied in seeing the show that hung on the walls? No! When he went through there, they had to open the whole place and pull everything out. He just couldn't wait. He wanted more, and more, and more."[55] Among the galleries they frequented was the Downtown Gallery, owned by Edith Hulpert, from whom Gershwin bought Ben Shahn's *The Beach* (fig. 85), which is now in the collection of the Wadsworth Atheneum (plate 52).

When Botkin got back to Paris in March 1932, he set to work immediately hunting for paintings. Gershwin was keen to own a Picasso, and Botkin cabled him excitedly with some important news on April 30: "FOUND LARGE RARE PICASSO WOMAN ABSINTH [sic] DRINKER 1902 IMPORTANT COLLECTION YOUR ROUAULT SIZE BLUE WITH RED SIMILAR PLATE FOUR RAYNAL PICASSO BOOK FIVETHOUSAND DOLLAR PICTURE PRICE AROUND EIGHTEENHUNDRED UNUSUAL BARGAIN."[56] In the follow-up letter describing numerous paintings in detail, he adds at the end, almost as an afterthought: "George—my best congratulations to you & Ira on the Pulitzer prize."[57] Gershwin responded on May 11: "I am happy to know that you are so enthusiastic about the Picasso I bought. I feel my collection would be much more complete with that fine picture. I can't wait till I see it. Are you going to send it or bring it with you?"[58] The next day Botkin writes: "The Picasso you have is an absolute masterpiece."[59]

Picasso's *The Absinthe Drinker* of 1901 (plate 42, figs. 83, 84) became and remained the crown jewel of George Gershwin's collection. Picasso painted this work at age nineteen when he first arrived in Paris from Spain. The painting dates from the beginning of Picasso's so-called Blue Period (1901–4) and depicts a sorrowful drinker in the nightlife of Montmartre, all dressed in red and nursing a drink of brilliant green. *The Absinthe Drinker* has an illustrious pedigree, being one of the works included in Picasso's very first

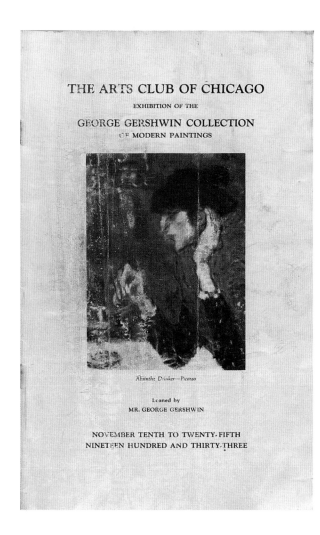

Paris exhibition—the now legendary 1901 show at the Galerie Ambroise Vollard.

According to the catalogue *Picasso: The Blue and Rose Periods* accompanying a pair of exhibitions in 2018 and 2019 at the Musée d'Orsay and the Beyeler Fondation in Basel, Switzerland, that exhibited the painting, *The Absinthe Drinker* "displays an Impressionist style, which is particularly apparent in the painting of the woman's dress and the patches of bright color emerging from the nocturnal ambience. . . . With its Mannerist treatment of the face and the exaggeratedly elongated hands, the work also stands at the point of transition to the Blue Period. . . . It was shown to the American public for the first time in 1933, when Gershwin lent the picture to the Museum of Modern Art, in New York, for its Summer Exhibition: Painting and Sculpture."[60]

When Gershwin's collection was displayed in Chicago after the close of the MoMA show, this work was featured on the catalogue cover (fig. 18). Gershwin tried in vain to add a Rose Period (1904–6) Picasso oil painting to his collection. "I am very much disappointed at not being able to get a pink Picasso," he wrote in a letter to Botkin. "I am simply crazy about those pictures," he added. Gershwin did manage to acquire a Rose Period work on paper, a drawing of a nude man on horseback. According to an unsigned memo in the Gershwin archives, this

work was bought from a certain Neuman, a Picasso expert who challenged the authenticity of Gershwin's *Absinthe Drinker* painting and prompted the composer to confirm the painting's authenticity with Picasso. An amusing anecdote about the ensuing correspondence was published as "Famous Fables" (page 158).[61]

On the same shopping spree that netted Picasso's *Absinthe Drinker*, Botkin bought for Gershwin Chagall's *Untitled (Old Man with Beard)* (plate 16); landscapes by Othon Coubine and André Derain; three paintings by Georges Rouault: *Bathers* (plate 44), *Dancer with Two Clowns* (plate 46), and a "peasant" image; and a Modigliani drawing of a nude male; along with two paintings by Émile Lahner. Gershwin was attracted to Chagall's paintings and sent instructions to Botkin in May of 1932 to get another one: "I would love to have you get, if possible, one of the Rabbi pictures of Chagall. I'd like to own another picture by this mystic painter."[62] It was this request that prompted Botkin's acquisition for Gershwin of *Untitled (Old Man with Beard)* which the composer hung on the far wall of the living room of his Riverside Drive penthouse apartment (fig. 75). This is the work that Gershwin saw in front of him every day when he went to sit down at the piano. He lent the painting for exhibitions in 1933 and 1936 under the title of *Rabbi*.

According to the Jewish Museum, which now owns *Untitled (Old Man with Beard)* and featured

the work in its *Masterworks of the Jewish Museum* catalogue, this painting "depicts the outsize figure of a Jew standing alone in a snowy landscape before the backdrop of a Russian village. Wearing a Russian visored cap and dark caftan, the figure projects an aura of meditation. The depiction of a religious Jew derives from Chagall's store of images of Russian shtetl life. But the image is generalized and timeless without iconographic specificity and is rendered with a modernist vocabulary fused with folkloric elements and an odd disjunction of figure and houses behind.

"The remarkable dominance of the figure in the space, the tilt of the head, the hand gesture, and the houses that frame the head suggest that the artist continued to make use of various stylistic devices that he had employed previously. From Chagall's early years in Paris, his fantasy world was occupied with the ordinary figures of Vitebsk. The old man with the beard in The Jewish Museum painting is a subject derived from one of the poor Jews whom he saw in Russia and used as models for his cycle of Old Jews. As Chagall states in *My Life*, his models were old beggars or itinerant Hasidic rabbis."[63]

Gershwin studied the "rabbi" painting closely and used it as a model for his own artwork. His imaginary portrait of his grandfather as a young man, painted in 1932, was an updated version: the American Jew, dressed sharply in a morning coat, with his beard neatly trimmed, his hat and eyes upturned, ready for what the future may bring. Behind him is the new

shtetl, the Lower East Side. The red curtain on the right gives the painting a theatrical aspect (fig. 32). Gershwin's portrait of his mother, also from 1932, likewise shares visual traits with the Chagall work—it depicts a large central figure whose home, a self-standing house with a tree, is in the distance. And Gershwin's own pose, in his stunning and dramatic photograph *Self-Portrait with Irving Berlin*, is very clearly modelled on Chagall's rabbi. Everything is planned down to the detail in this photograph: the lighting, the hands, the eyes, and the position of the heads (fig. 76).

In addition to the Kisling portrait, Gershwin's Derain acquisitions included a cubist landscape and a neoclassical landscape (both acquired in 1932), a still life (acquired in 1933), and at least one drawing. The cubist landscape was painted in Martigues, a small fishing village west of Marseille, during a period when Derain was heavily influenced by Cézanne and Picasso. While the rich Mediterranean sky is visible at the top of the painting, the foreground of the work uses muddy earth tones to portray a landscape flattened against the picture plane using the basic geometric shapes of cubism (plate 21).

Gershwin lent his name to art institutions. He served for a period of time on the Advisory Board of the Museum of Modern Art and he is listed as one of the "honorary patrons" of an exhibition of portraits of artists organized by the Nicholas Roerich Society, to which he loaned his Derain portrait of Kisling. In April and May of 1932, he was an "Officer" of the *Theatre in Art* exhibition at the Sidney Ross Gallery in New York, and his name appears on the exhibition's letterhead (fig. 21). At the end of the exhibition run, the works—depicting theatrical scenes—were auctioned for sale, and it's on this occasion that Gershwin purchased *Burlesque* (plate 6) by Thomas Hart Benton. According to Benton scholar Jake Wien, "*Burlesque* . . . demonstrates Benton's fascination with the performing arts and popular culture, with the female figure, and with satire. The work shares with Gershwin a musicality, not only in its rhythmic forms and shapes but in its being grounded in the 'Low.'"[64]

Another theatrical painting acquired by Gershwin is the pastel-hued *Plaza Theater* of 1915 by the American artist Louis Michel Eilshemius, now in the collection of the Santa Barbara Museum of Art (plate 25). Another is *La comédie française* by Max Jacob, the French poet and painter who would later be murdered in the Holocaust as a Jew despite his conversion to Catholicism (plate 28). In all these works, the action in the audience is at least as interesting as anything that may be happening on stage. Also purchased at the *Theater in Art* sale was the Max Weber lithograph *Wind Orchestra Barrère* (1928), depicting the avant-garde musical ensemble led by the French flutist Georges Barrère (plate 65).[65]

Several commentators have remarked that Rouault was Gershwin's favorite painter. As Botkin recalled, "The work of Rouault was especially close to him and he was constantly enthralled by the life and spirit that animated his work. He wanted his own pictures and

Fig. 21. Invoice from the Sidney Ross Gallery for artwork George Gershwin purchased at the *Theatre in Art* exhibition auction, May 27, 1932. The doodles were added by Gershwin.

music to possess the same breathtaking power and depth. . . . He once told me when we were discussing the French painter Rouault, 'I am keen for dissonance; the obvious bores me. The new music and the new art are similar in rhythm, they share a somber power and fine sentiment.'"[66]

"Oh, if only I could put Rouault into music!"[67] Gershwin would tell his friends. Rouault's *Dancer with Two Clowns* (plate 46) is now in the collection of the Metropolitan Museum of Art in New York. The watercolor *Deux Soldats Prussiens* (plate 47) was also acquired for Gershwin by Botkin. The two hand-colored etchings, *La Pauvre Eglise* (plate 49) and *La Pauvre Famille* (plate 48), were selected personally by Gershwin at Weyhe's Gallery in New York. "They are very lovely pictures, with extremely bright color,"[68] Gershwin wrote to Botkin. "I am very anxious to get a few more Rouaults, as I feel he is one of the most powerful painters living," he continued. Gershwin wished to commission Rouault to paint an image of *The Last Supper*, but this never came to pass.

In March of 1933, in his final Paris shopping spree, Botkin came across a small but powerful portrait of Gauguin, and he advised Gershwin to grab it (plate 1). Gershwin agreed, and this portrait became one of the most colorful paintings in his collection, with its riot of pink, orange, yellow, blue, green, red, and black. Both Gershwin and Botkin thought that this painting was a Gauguin self-portrait, and it was exhibited as such by the Museum of Modern Art, the Wildenstein Galleries, and the Wadsworth Atheneum. Later the attribution was changed to another Pont Aven artist, Charles Filiger, and this is the attribution given by Sotheby's when the work was sold in 1999. Today the Charles Filiger Catalogue Raisonné project, led by André Cariou, denies the attribution to Filiger, so the authorship of this painting remains uncertain.

In the same buying spree Botkin selected Vassily Kandinsky's brightly colored abstract painting *Linie-Fleck (Line-Spot)* of 1927 (plate 29). "I just had to buy an abstract picture to start you!"[69] he explained. This painting was a far cry from the portraits and landscape of the first buying spree of two years before. But the composer was ready for the challenge. This late-period work, now at the Santa Barbara Museum of Art, caused a sensation when his collection was exhibited at the Arts Club of Chicago in November of that year (fig. 79).

There was a natural kinship between Gershwin and Kandinsky, who addressed similar concepts in their writings on music and art. "Color is a power which directly influences the soul," states Kandinsky in his 1911 manifesto, *On the Spiritual in Art*. "Color is the keyboard, the eyes are the hammers, the soul is the piano with many strings. The artist is the hand which plays, touching one key or another, to cause vibrations in the soul,"[70] Kandinsky famously wrote. Compare this statement to Gershwin's words in his 1930 essay "The Composer in the Machine Age": "Music sets up a certain vibration which unquestionably results in a

physical reaction. Eventually the proper vibration for every person will be found and utilized. I like to think of music as an emotional science."[71] Kandinsky says: "The choice of object [in a painting] . . . must be decided only by a corresponding vibration in the human soul."[72] Gershwin's statement that "music is design; melody is line; harmony is color" is very close to language used in Kandinsky's 1926 treatise, *Point and Line to Plane*. Gershwin speaks in his *Song Book* of weaving "a filigree of counterpoint" like a thread and of playing staccato in "almost a stenciled style."[73]

Gershwin also admired Paul Klee. Merle Armitage recalled watching Gershwin looking intently at a Klee watercolor. "After studying a Klee watercolor with a magnifying glass," Armitage recalled, "[Gershwin] stopped abruptly and exclaimed that his music would not stand up under that kind of scrutiny."[74] Armitage and Gershwin might have been discussing the work *Albumblatt für einen Musiker* (album leaf for a musician) of 1924 that Armitage purchased for him from the Los Angeles-based art dealer Galka Scheyer, which is now in the collection of the Hiroshima Prefectural Art Museum in Japan (plate 30).

Fig. 22. Arthur Garfield Dove (American, 1880–1946). *Rhapsody in Blue, Part I*, 1926–27. Oil and metallic paint on aluminum with clock spring, 10½ × 8¾ in. Private collection

The central vertical lines depict the opening clarinet glissando of Gershwin's piece. The oval companion painting, *Rhapsody in Blue, Part II*, depicts Gershwin's "kaleidoscope of America."

Both Kandinsky and Klee were artists who consciously sought to "paint music" onto the picture plane. This concept was at the very heart of the abstract revolution in painting that both artists—along with others such as Arthur Dove, Kazimir Malevich, Piet Mondrian, and Francis Picabia—helped to bring about. Let us pause for a moment to discuss the concept of abstract art as "painted music." When the English art and literary critic Walter Pater states that "all art constantly aspires to the condition of music"[75] (a concept embraced by abstract artists) what exactly is music's "condition"?

Musicologists are puzzled by the question, as after Beethoven's death in 1827, there was a profound split within European musical culture, and the divide lasted well into the twentieth century. One camp, seeing its point of departure in Beethoven's Sixth Symphony ("The Pastoral") saw the highest form of instrumental music as being that which tells a narrative story or depicts a visual image, as exemplified in the "symphonic poems" (also called "tone poems") of Hector Berlioz, Franz Liszt, and Richard Strauss, among others. This was "program music."

The other group, seeing its point of departure in Beethoven's Fifth Symphony, venerated a type of music, exemplified in the symphonies of Franz Schubert and Johannes Brahms, that was complete in and of itself, with no extramusical references at all. This was "absolute music" whose pieces are typically titled with the genre (symphony, sonata, concerto) and the key ("in C-Major" or "in b-minor").

Gershwin's *Rhapsody in Blue* and *An American in Paris* fall squarely inside the program music camp. While the title of *Rhapsody in Blue* is a hat-tip to the naming tradition of "absolute" music, Gershwin revealed the "program" of the work to his first biographer, Isaac Goldberg:

It was on the train, with its steely rhythms, its rattle-ty bang, that is so often so stimulating to a composer (I frequently hear music in the very heart of the noise) when I suddenly heard—and even saw on paper—the complete construction of the rhapsody, from beginning to end. No new themes came to me, but I worked on the thematic material already in my mind and tried to conceive the composition as a whole. I heard it as a sort of musical kaleidoscope of America, of our vast melting pot, of our unduplicated national pep, of our metropolitan madness. By the time I reached Boston I had a definite *plot* of the piece, as distinguished from its actual substance.[76]

Similarly, Gershwin ascribed an explicit program to his "rhapsodic ballet," *An American in Paris*, namely "the impression of an American visitor in Paris, as he strolls about the city, listens to various street noises and absorbs the French atmosphere."[77] Certainly, Gershwin's use of actual taxi horns in the score of *An American in Paris* is an extreme example of bringing external elements into music, akin to the composer

Erik Satie bringing a typewriter into the score of his Dadaist ballet *Parade* (1917) or to Edgard Varèse using actual sirens in his large orchestral work *Amériques* (1921). And Gershwin wrote some "absolute music" too, as for example his Concerto in F and his Three Piano Preludes.

Yet Pater saw *all* music as "abstract" or "absolute." And when abstract artists sought to make art that aspired to the "condition of music," they were conceiving of music in the same way as Pater, thereby ignoring this central debate within the concert world. All the "extramusical" layering in the musical source drops away.

A case in point is Arthur Dove's two paintings *Rhapsody in Blue, Part I* (1926–27) and *Rhapsody in Blue, Part II* (1926–27), which were painted in reaction to the two-sided 78 rpm abridged recording that Dove owned. In the first painting (fig. 22), the vertical black lines in the center correspond to the opening clarinet glissando of the piece, while the rest of the painting is constructed around that opening stroke, with the first theme represented on one side of the canvas and the second theme on the other. An overall calm presentation with subdued colors is punctuated by three large swirls of color. In the second painting, which is in an unusual oval format, the vibrancy of the color and the intensity of the brushstrokes correspond to the closing whirlwind and excitement of the last few minutes of the score. As Dove's wife, the artist Helen Torr, described the process in her diary, "After supper, [Arthur] did handsome spirited 'music' with almost everything in sight to Gershwin's *Rhapsody in Blue*."[78] Yet both paintings remain abstract. There is nothing in them that overtly "represents" America—its multiculturalism ("our vast melting pot"), its jazz ("our unduplicated national pep"), and its skyscrapers ("our metropolitan madness")—in the way that Gershwin's work explicitly does. Dove paints the music's "substance" but leaves Gershwin's "plot" by the wayside.

After Gershwin's musical *Pardon My English* (a critical flop) closed at the Majestic Theater in February 1933, Gershwin turned once again to his home surroundings. He decided to move out of his 33 Riverside Drive penthouse and into a less modern but more spacious fourteen-room duplex at 132 East 72nd Street, between Park and Lexington Avenues, mainly to make room for all the art he now owned. Here he curated his space again. In *The Memory of All That: The Life of George Gershwin*, author Joan Peyser described the apartment as follows: "[The] large living room was flooded with light in the afternoon. The rug was taupe, the walls gray, the draperies wine, a window seat green. There were large comfortable couches on either side of the fireplace and chairs distributed throughout the space. Two concert grands stood on one side of the room. . . . In his music studio he had a third piano and a desk he had designed himself, tilted at an angle he found most comfortable, with sliding shelves and racks and a pencil sharpener that disappeared when not in use."[79] This

desk, probably made in consultation with the art deco furniture designer Paul Frankl, is now on permanent display in the Gershwin Room at the Library of Congress on the ground floor of the Thomas Jefferson Building.

Gershwin continued adding to his collection and was interested in the Polish-born American artist Max Weber, who wrote to Gershwin on May 31, 1933: "Whether you acquire any of my work for your splendid collection or not does not matter. Your environment is already rich and charming with excellent painting. . . . I admire profoundly your love of art, and wish you continued and increasing happiness and growth in your splendid effort to ennoble and spiritualize your already fine home atmosphere."[80] Just a week later, on June 7, Gershwin acquired Weber's *Invocation* (1919), a 7 × 5 foot cubist work (plate 64). Weber said of this work: "Sculpturesque, dynamic form was sought for in this picture, but the chief aim was to express a deep religious archaic spirit in fitting attitudes and gestures."[81]

This work commanded Gershwin's living room in his 72nd Street apartment, where it hung in its own arched niche. Gershwin loved this work, which he described as "a deeply wrought picture, tremendously felt" in which "the distortion increases its feeling and adds to the design. Technically," Gershwin said, "it is a composition of triangles, and in it there is strict absence of line, only color against color. And in the whole there is great movement,"[82] he adds. This sense of movement causes the viewer's eye to jump from color to color, taking in the red, blue, yellow, green, white, brown, and black. This evocative work is now in the collection of the Vatican Museums in Rome.

Invocation was presented as one of the pillars of Gershwin's art collection when the *George Gershwin Collection of Modern Paintings* was displayed at the Arts Club of Chicago from November 10 through 25, 1933. It was given its own room (fig. 93) and was one of only three works illustrated in the catalogue, the others being the Picasso *Absinthe Drinker* and the portrait of Gauguin. There were sixty-nine pieces in the show: forty-nine paintings, seventeen works on paper, and three sculptures. It was Elizabeth "Bobsy" Goodspeed, the Arts Club Director, who begged the composer to let her mount the show.

"We are terribly eager and serious in wishing to have your collection as the opening exhibition of the Arts Club this year," she wrote to him on October 7,

Fig. 24,* right. George Gershwin. *Portrait of Ruby Elzy*, ca. 1936

Fig. 25,* lower left. Carl Van Vechten (American, 1880–1964). *Ruby Elzy as Serena in Porgy and Bess*, December 30, 1935. Gelatin silver print, Image and sheet: 9¹⁵⁄₁₆ × 7¹⁵⁄₁₆ in. Philadelphia Museum of Art: Gift of John Mark Lutz, 1965, 1965-86-4001

Fig 26,* bottom center. Carl Van Vechten (American, 1880–1964). *John Bubbles as Sportin' Life in Porgy and Bess*, December 27, 1935. Gelatin silver print, Image and sheet: 9¹³⁄₁₆ × 7⅛ in. Philadelphia Museum of Art: Gift of John Mark Lutz, 1965, 1965-86-2647

Fig. 27, far right. George Gershwin. *Negro Child*, n.d. Oil on canvas, 21⅛ × 14½ in. Collection Marc Gershwin

1933, in a telegram. "It will be a great deal not only to the Arts Club of Chicago but also to the cause of art and collectors at large to be able to see and study so beautifully selected and assembled a group of paintings. Please remember that in loaning us your picture[s] you are helping to broaden the scope of education in modern art. Can you let us know as soon as possible if we are to be lucky at last and if so at just what date we can expect them to leave New York. We would like to open about November fifth."[83] On October 10, Goodspeed and Gershwin spoke by telephone, and the exhibition was agreed. Arrangements then needed to be made quickly to ship the works, write the catalogue, print it, and install the show.

Gershwin wrote to Goodspeed on November 14, 1933: "As this is the first time my collection has ever been shown I am naturally very anxious to know all that has been said and written about it, so please be good enough to send me all clippings and reprinted photographs. If this is too much trouble I would be happy to have you enlist the services of a clipping bureau at my expense. I would like to hear from you just how the show looks and the general reaction."[84] The six installation photos from the Chicago show reveal a display that was classically conceived, using the principles of symmetry and balance (figs. 23, 73, 78, 79, 93). The Noguchi portrait bust was placed on

one side of an archway, while a similarly sized and hued African mask provided the counterbalance (fig. 7).

Of all the pieces in the collection, the most controversial to Chicago audiences was not the racy Benton *Burlesque* but rather the abstract yellow Kandinsky. This they found impenetrable. Gershwin's Kandinsky painting was described by the art critic at the Chicago Tribune in a review of the show as "decidedly in the manner of the American Indian."[85] A critic at the Chicago Herald Examiner described it as "brown triangles on a yellow background with dots and dashes and whatnot. . . . 'You could put that picture down on your piano and play it,' said Daniel Catton Rich, explaining George Gershwin's collection of modern paintings to a fashionable Arts Club audience yesterday morning, as he pointed to one of Kandinsky's expressionistic paintings."[86] To expand publicity about the collection, Botkin anonymously authored an article called "A Composer's Pictures: George Gershwin, the Musician, Is a Collector of Modern Paintings."[87]

Gershwin was more than a collector of modern paintings; he was supporting working artists. Following the Chicago exhibition, Gershwin added multiple canvases to his collection by the "wild man of art"[88]—David Burliuk. Born in Ukraine in 1882, Burliuk was a cofounder, together with Mikhail Larionov and others, of the Russian futurist movement. A hallmark of his style is the vibrancy and kaleidoscope of color

with which he animates his paintings' skies—a feature present in the Gershwin-owned works including *Countryside* (plate 11), *Keansburg, N.J.* (plate 12) and *Red Horse* (plate 13). "The skies that Burliuk paints are not the skies that you and I see," wrote the art critic Henry Saltpeter. Burliuk, like Gershwin, was in love with color, and in many of his paintings including those in Gershwin's collection he "squeezed fat tubefuls of paint directly on canvas so that certain areas look like high reliefs of blatant color."[89] Beginning in 1931, Burliuk and his wife Mary published an arts journal called *Color and Rhyme*, whose issues can be seen online.[90]

In June of 1934, Gershwin and Botkin traveled together by train from New York to South Carolina. There they took up residence in a four-room cottage on Folly Island, at the invitation of the author DuBose Heyward, from nearby Charleston, author of the 1925 play *Porgy*. In South Carolina, Gershwin sought out encounters with the Gullah Geechee community to nurture his already-begun composition of *Porgy and Bess*. He heard African American spirituals at a church on nearby James Island, where he witnessed the traditional hand clapping, foot stomping, and swaying movements that accompanied them. As this new Gershwin work would be the hoped-for first great American opera, its title needed to reflect the operatic naming tradition of such works as *Orpheus and Euridice*, *Tristan und Isolde*, or *Pelléas et Mélisande*.

Billed as a "folk opera," *Porgy and Bess* was premiered at New York's Alvin Theater on October 19, 1935, with Todd Duncan and Anne Brown in the title roles. The role of Serena was performed by the soprano Ruby Elzy (figs. 24, 25), and the character of Sportin' Life was played by the vaudeville player John Bubbles (fig. 26). To counteract the still-current tradition of minstrelsy (given prominence on the big screen by Al Jolson and even Fred Astaire), Gershwin stipulated that all the singers in the opera be African American, rather than white singers in blackface.[91]

Porgy and Bess has launched the careers of countless singers of color, from Ruby Elzy to Leontyne Price to Angel Blue, and its individual arias such as "Summertime" and "My Man's Gone Now" have become staples of both the jazz and classical repertories. Yet it is important to know that charges of racism and cultural appropriation have bedeviled the opera since it was new because of the negative stereotypes attached to several of the opera's characters.[92] The contemporary visual artist Kara Walker, who illustrated the libretto with a series of twenty woodcuts, has taken a nuanced view of the work (figs. 56, 59–62). "I think *Porgy and Bess* lives in a murky place in popular culture and personal reflection," she says. "Music softens the lines, obscures the racism in the text until it looks very much like what it is—a folk tale of its age."[93]

During their five-week stay in the Folly Island cottage, Gershwin spun melodies at the upright

Fig. 28.* Sergey Sudyekin (Russian, 1882–1946). *The Hurricane Scene, Act II, scene 4, in Porgy and Bess*, ca. 1935. Oil on canvas, 16 × 28 in. Collection of the McNay Art Museum, Gift of the Tobin Theatre Arts Fund, 2017.244

piano in his room or filled music paper at a folding card table outside, while Botkin sketched or painted nearby. Occasionally the composer took breaks to make watercolor paintings alongside his cousin. Botkin recalled: "When we lived on Folly Island near Charleston and George was busily engaged in writing *Porgy and Bess*, he would abandon his piano often to rush out and join me in painting the picturesque Negro shacks. He painted and made sketches during his travels, and his sketch box and easel were always part of his baggage."[94] In one of Gershwin's watercolors he depicts his Folly Island room with its wash basin in the bottom left corner, its old-fashioned honky-tonk piano (brought in specially for Gershwin from Charleston) pushed against the right wall, the unmade iron bed by the window in the center of the image, and a bare lightbulb hanging from the ceiling (fig. 29). A watercolor by Botkin owned by the Library of Congress inserts Gershwin into the same scene from a slightly different angle.

Returning to New York after the richly creative summer spent in the south, Gershwin resumed his art collecting. In November of 1934 he acquired Modigliani's *Portrait of Doctor Devaraigne* at an auction sale held at Anderson Galleries at 30 East 57th Street and organized by the American Art Association (plate 36). In the catalogue to that sale, the work is featured on its own page and described as a "Bust-length portrait of a bearded man in blue coat with decoration, his ruddy complexion set off by a russet wall at right."[95] Sotheby's, which later twice sold the painting, called it a "quintessential example of the artist's expression. . . . Modigliani has rendered his sitter in a most delicate manner. The signature almond shaped eyes, long nose, and button mouth highlighted by luminous brushwork are features unique to Modigliani's oeuvre."[96]

The painting, from 1917, shows a mustachioed doctor in a World War I French soldier's blue-green uniform with a red and gold collar standing between a gray wall and a wooden door painted in a deep orange red. His facial proportions are widened, a feature that Gershwin particularly loved. "Dissonance in music is like distortion in a painting,"[97] Gershwin said to Botkin. Gershwin studied this painting closely,

and used Modigliani's hallmark, the two-toned gray and orangy-red background, as the background to his own *Self Portrait in a Checkered Sweater* (fig. 33), a painting that hangs in the Gershwin Room at the Library of Congress. When Gershwin's life story was posthumously presented on the big screen with actor Robert Alda playing the composer, this Modigliani was one of five artworks lent by Ira Gershwin to be used as props in the film (fig. 30).[98] This painting in particular appears in several scenes, each time in a new location.[99]

In early 1935, the Marie Harriman Gallery in New York held an exhibition of the sculptures of Isamu Noguchi in which fourteen new works were shown. Gershwin attended the exhibition and purchased *Black Boy* (1934). This life-size (4½ feet tall) figure of a child in ebony, with one arm draped over his head, creates a long clean line from heel to elbow on one side of the figure and a rhythmic interplay between positive and negative space on the other (plate 38). Noguchi had urged Gershwin to purchase a different work in the same exhibition, the contorted and disturbing *Death* (1934), originally titled *The Lynching*, but Gershwin preferred the serene and elegant work he selected.[100] Noguchi was deeply interested in the African American experience, and spent time in Harlem in the mid-1920s with African American artists and performers. As a Japanese American, he understood the impact of racism; he voluntarily stayed in an internment camp with other Japanese American citizens during World War II.

On a trip to Mexico in 1935 Gershwin took color photo portraits of the artists Diego Rivera, Frida Kahlo, and Miguel and Rosa Covarrubias (figs. 34–36).[101] During this visit, Rivera offered to draw Gershwin's portrait, but the composer turned the tables and instead drew a sketch of the painter, which remains in the Gershwin family (fig. 86). It was on that trip that Gershwin first met the muralist David Alfaro Siqueiros. Gershwin brought back a Mexican costume, selected with the advice of Kahlo, and then he painted a portrait of Emily Paley, Lee Gershwin's sister, as a Mexican *señorita* (fig. 37).

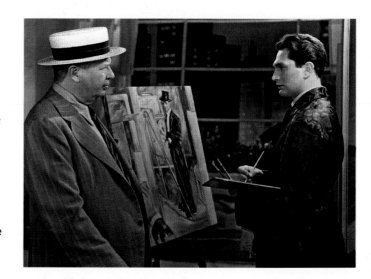

Fig. 29, above. George Gershwin. *Room on Folly Island*, 1934. 13⅛ × 21⅛ in. Collection Marc Gershwin

Fig. 30, right. Robert Alda as George Gershwin in a film still from *Rhapsody in Blue*, 1944. Ira Gershwin loaned George Gershwin's *Self-Portrait in Evening Clothes*, along with four other works from his collection, to be used as props in the 1944 film.

Fig. 31, right. Gershwin at 1019 Roxbury Drive, Beverly Hills, California, March 1937, with Modigliani's *Portrait of Doctor Devaraigne* beside him. Photo by Rex Hardy. Gershwin Collection, Library of Congress, Washington, DC

Fig. 32, below left. George Gershwin. *My Grandfather*, 1933. Location unknown

Fig. 33, below right. George Gershwin. *Self-Portrait in a Checkered Sweater*, 1936. Library of Congress, Washington, DC. This self-portrait by Gershwin was inspired by Modigliani's *Portrait of Doctor Devaraigne*.

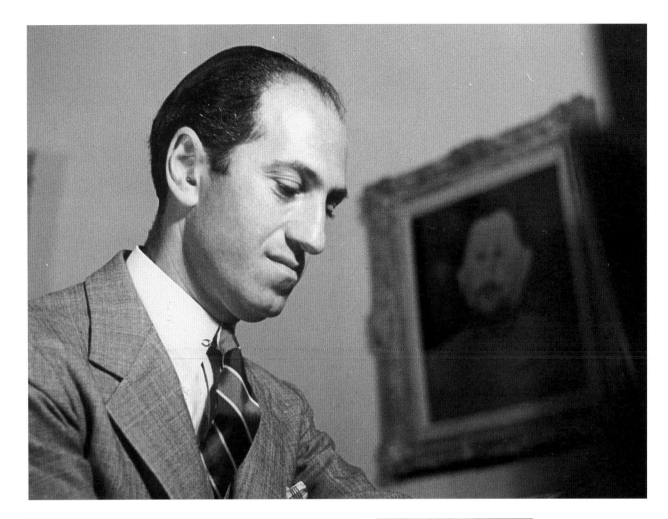

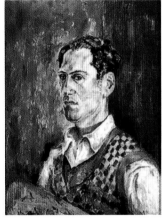

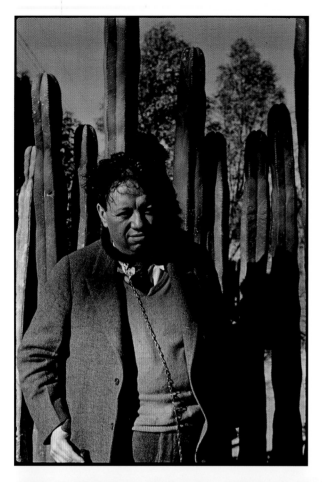

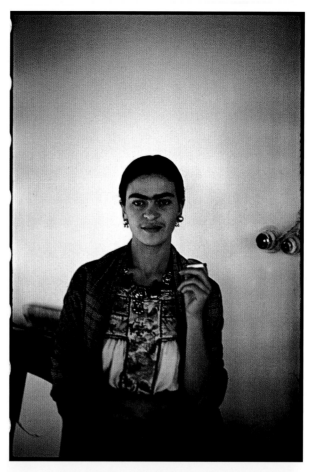

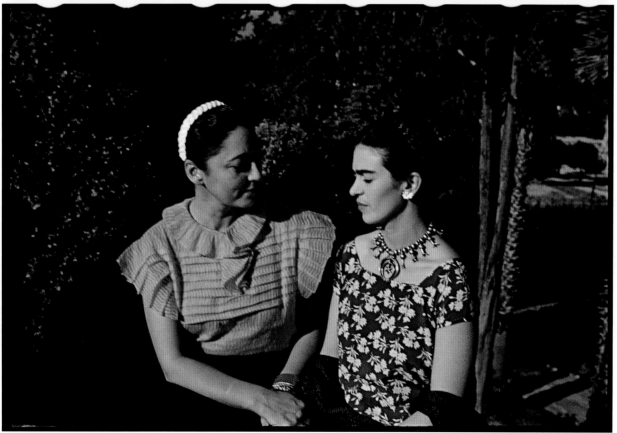

Photographs taken
by Gershwin in
Mexico, 1935.

Fig. 34, above left.
Diego Rivera

Fig. 35, above right.
Frida Kahlo

Fig. 36, left.
Rosa Covarrubias
and Frida Kahlo

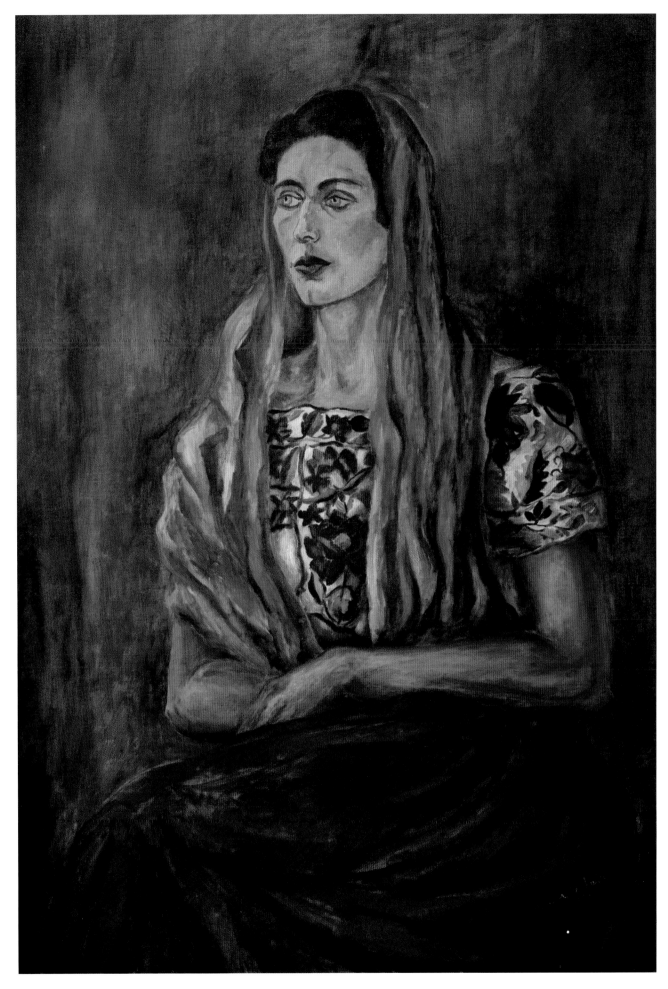

Fig. 37. Frida Kahlo
helped Gershwin
select the Mexican
outfit that was then
used in his portrait
of Emily Paley
from around 1936.
Oil on canvas,
39⅜ × 27⁷⁄₁₆ in.
Private collection

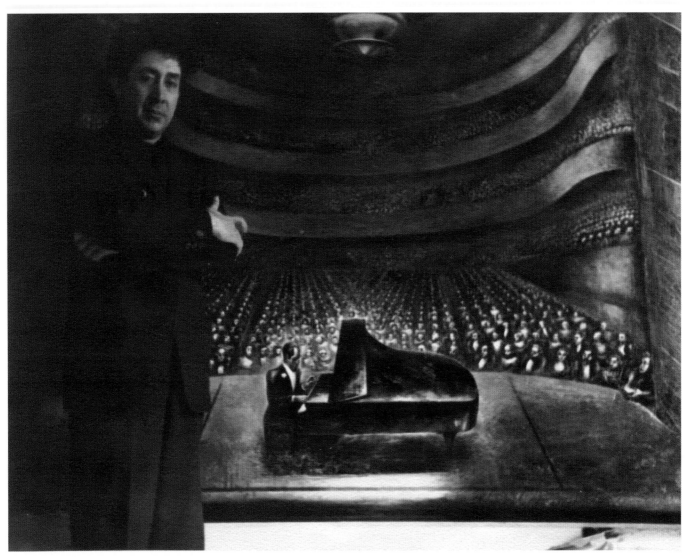

Fig. 38. Photograph of David Alfaro Siqueiros standing in front of his painting *Portrait of George Gershwin in a Concert Hall*, taken by George Gershwin in 1936. As with other Gershwin photographs, it is printed in mirror image.

GERSHWIN AND SIQUEIROS

The large horizontal canvas *Portrait of George Gershwin in a Concert Hall* (1936) by David Alfaro Siqueiros is another important work of art commissioned by the composer (plate 55). Siqueiros, a member of the Mexican Communist Party, would become one of the most famous Mexican muralists of the twentieth century. According to the art historian Laurance P. Hurlburt, author of *The Mexican Muralists in the United States*, Gershwin was the "most important private patron" that Siqueiros ever had.[102] In 1936, the artist was running leftist political art workshops while working on the Gershwin commission in the painting studio of the composer's spacious duplex apartment at 132 East 72nd Street. Gershwin was therefore able to watch the work take shape. The work fit well into Gershwin's collection, alongside the other theatrical scenes by Benton, Eilshemius, and Jacob, and perhaps was inspired by their presence in the apartment. The large-scale mural-like horizontal portrait is a pictorial biography of the composer, containing micro-portraits of many of the most important people in his life, all seated in the first and second row of the audience. It

hung for years outside the reading room of the Harry Ransom Humanities Research Center at the University of Texas, which owns the work, but regrettably it is no longer on view there but instead lives in a storage room and does not travel.

Siqueiros wrote: "I cannot recall exactly, even if it seems incredible, how I and Gershwin, the famous American composer, became friends. We were very good friends and the difference of our opinions about painting and the composition or arrangement for orchestra, I believe, played a big role in our relationship. Without any doubt, between polychromy, rhythm, movement in painting and sound exists a very close relationship. The words dynamic and static can be used in both descriptions."[103]

Gershwin and Siqueiros shared synesthetic tendencies. "Many times Gershwin and I heard sounds in my paintings and also we saw colors and shapes in his music. Often we were surprised to note that a mixture of reds was equivalent almost mathematically to a determinate harmony, and even a specific syncopation."[104] Like Siqueiros, Gershwin was a committed political leftist. He was a staunch supporter of the Spanish Republicans and the international brigades fighting

SIQUEIROS ON THE GENESIS OF THE PAINTING

George Gershwin asked me to paint his portrait. First he just wanted his head painted, so the next day I went to his elegant apartment on Park Avenue [sic] in New York, carrying with me a canvas of 40 × 60 cm. After looking at the canvas for a moment, George told me: "I was thinking last night that I want a full-figure portrait instead"—to which I replied, "I will have to come back tomorrow with a canvas of at least 1.8 × 1.2 meters."

I ordered the canvas. In the United States it was very easy to procure a canvas of any size. When I arrived at Gershwin's home, George again had changed his mind. "Do you know what?"—he said—"I would like you to paint my portrait playing the piano, and if possible for it to be on stage in a concert hall." "George," I replied, "what you really want is a small mural . . . but we will do it."

On a canvas measuring 3 × 2 meters, I finally began painting the portrait of George Gershwin. I spent many months painting it in a small room in his apartment. I painted Gershwin playing the piano on an enormous stage in a theater, and I also painted the rest of the theater. The theater I painted was one of the largest in the world, with a seating capacity of 50,000 spectators. I described it to George as a "theater of the masses," and his face would glow with joy.

In fact, with an impressionistic technique, I painted multitudes upon multitudes, until I ran out of space on the canvas to place even a small dot representing the head of a single spectator. Of course, in that huge complex of seating levels and spectator boxes, the portrait of George Gershwin, along with the piano, could not be larger than ten or fifteen cms.

When this portrait was finished, Gershwin, who in my opinion was the most discerning person in the world, told me: "Siqueiros, your painting is magnificent! Surely, not even the greatest painter in the world would be able to add anything to it. But I—your musician friend, who am also a talented painter, as you have said yourself—would like to ask you for a favor. In the first few rows of the audience, I would like you to paint all the members of my family: my father who is already deceased, my father's brother who is the most beloved of my uncles and who is also deceased, my mother who is still living, the dear wife of my beloved uncle who is also deceased, my brother the spendthrift, my cousin the swindler, and the other one who was studying to become a rabbi but ended up as a gigolo. And, if you still have any paint left, two of the managers I have had over the course of my long career, because the others are thieves. If you paint them, please depict them in a very odd way.

I had a monumental task ahead of me. We began looking for photos of the deceased, those who had the right to be in the painting. Later on we made appointments for sittings with those who were still alive, among them of course his mother. With the photos of the deceased and the portrait sessions with the living, I worked, worked and worked, almost like a miniaturist, as most of the figures were no more than two inches tall.

When I finished his portrait, Gershwin almost went wild with joy. The event had to be celebrated in the best possible way, according to the way we both felt about it, and the best way, according to both of us, was to have a banquet with thirty girls, where Gershwin and I were the only men. And that is what we did. The banquet was held at the Waldorf Astoria Hotel in New York. Gershwin's fame naturally guaranteed the presence of thirty gorgeous beauties, who after a few drinks were having fun caressing us in a way one cannot imagine. It was a bacchanal, where our masculine potency was undoubtedly proven . . . we did not even know which way to turn.

Almost shaking, George Gershwin told me at that time: "Never before in the history of the world have two flies drowned in honey as we did. . . ." Nonetheless, Gershwin's mind that night was still on his portrait. At one point he asked me to come into the hallway, and I thought he wanted us to run away from the almost unbearable paradise.

Once we were in the hallway, Gershwin said to me in an almost pleading tone: "Siqueiros, something is still missing from the portrait." I responded, almost exasperated, "What, George? There are 50,000 spectators, and since you are already playing, the doors are already closed, and no one else is allowed in, even by the fire marshals! No, George, I would be the first one to stop anyone who wants to interrupt you." I was wondering what in hell could be missing. And, now, during the banquet to celebrate the completion of the work, he tells me this.

Then, in a soft, deliberate tone, he tells me: "You are missing." At first I could not understand what he was trying to tell me. I was quite offended, and said, "Does it seem to you that the painting is not a work of mine?" "No," he said. "You are missing in person—you yourself. Your portrait is missing." I jumped up and said—"Where do you want me to put it? There is no room for even a Pekinese dog underneath a seat."

But George Gershwin insisted. I was missing, and I had to paint myself. Violating all the basic rules of the theater, I had to put my head at the corner of the stage, next to the footlights that burn brighter than a gas stove. Whoever looks at the portrait will have to look very hard to find me in that ultramonumental concert of George Gershwin, in an imaginary concert hall and surrounded miraculously by all his relatives, dead or alive (plate 55).[1]

against Franco's fascist government. An artist friend wrote to Henry Botkin in January 1937 that he was headed to Spain at the invitation of the International Alliance of Intellectuals Against Fascism to design posters for the anti-fascists. "It is a duty which I cannot refuse, a duty which you and my very fine friend George Gershwin will understand."[105]

In the Siqueiros work, it was Gershwin who selected which of his friends and family members (dead or alive) should populate the front rows of the audience. But, as Katharine Weber insightfully points out, "just as the Dutch Masters painted arrangements of flowers that could never have actually bloomed simultaneously, Gershwin was able to transcend the sad limits of reality and assemble for this fantasy concert the perfect dream audience of the friends and family . . . who were most significant in his life."[106] In addition to the "overflowing audience of a mostly faceless adoring public"[107]—here are the twenty people depicted individually in *Portrait of George Gershwin in a Concert Hall* by David Alfaro Siqueiros:

1. George Gershwin
2. David Alfaro Siqueiros
3. Mabel Schirmer, friend and confidante of George, cousin of Lou Paley
4. Leopold Godowsky Jr.., brother-in-law of George
5. Frances "Frankie" Gershwin Godowsky, sister of George
6. Dr. Gregory Zilboorg, psychoanalyst of George
7. Leonore Gershwin, sister-in-law of George
8. Ira Gershwin, brother of George
9. Leopold Godowsky Sr., pianist, inventor, and father-in-law of George's sister
10. Unidentified Woman. According to Katharine Weber, "If Gershwin did ask Siqueiros to demote Oscar Levant (No. 18), it is probable that Levant was moved from this seat and replaced by this generic audience member. Though she does bear a faint resemblance to various women Gershwin knew, including the songwriter Ann Ronell and the lyricist Dorothy Fields, her identify remains a mystery."[108] The woman might have been Julia Van Norman, according to a letter her daughter sent to *The New York Times*.[109]
11. Morris Gershwin, father of George
12. Rose Gershwin, mother of George
13. Arthur Gershwin, brother of George
14. Emily Paley, sister of Leonore Gershwin
15. Lou Paley, husband of Emily Paley
16. Kay Swift, composer, mistress of George, and wife of Edward Warburg
17. William Daly, conductor, pianist, arranger, and friend of George
18. Oscar Levant, pianist and friend of George
19. Henry Botkin, painter, cousin of George, and his art advisor
20. Max Dreyfus, music publisher who gave George his first big break

GERSHWIN AND PHOTOGRAPHY

Gershwin, one of the most photographed men of the 1920s, was also an accomplished photographer who took many pictures of his friends and family members throughout the 1930s using his Leica III camera. Having sat for portraits by Edward Steichen and numerous other photographers, he was particularly sensitive to this art form and its tricks of the trade. Gershwin's most stunning photograph is the *Self-Portrait with Irving Berlin*, discussed earlier. Another captivating photograph is his *Self-Portrait with Andrea Warburg* of 1934, taken in a mirror, his camera obscuring his face (fig. 40). The writer Katharine Weber, daughter of Andrea Warburg, wrote an entire article about this image.[110] "He is seeing and being seen, but he is also concealing himself,"[111] she observes perceptively. This is one of several photographs Gershwin took of Andrea and Kay Warburg (fig. 43), two of the three daughters of the composer Kay Swift, in which he uses devices such as candles and shadows to enhance the visual drama (fig. 41). Gershwin gifted the twelve-year-old Andrea with a Leica III, the same camera as his own, and "instructed her in the basic darkroom techniques . . . how to enlarge, how to crop, how to think about contrast and composition."[112] These lessons made a deep impression on Andrea, who maintained a lifelong interest in photography.

Other props Gershwin used in his photographs included pipes and cigars. In Gershwin's iconography, a pipe typically (though not always) signifies a painter whereas a cigar connotes a musician. The iconic Steichen photo from 1927 of Gershwin seated at the piano secured the visual association between the composer, chin upturned, and his lit cigar, with its rising smoke. In many of his self-portrait photographs, Gershwin portrays himself as a painter, often wearing a smock or literally appearing inside a picture frame, and either holding or smoking a pipe (fig. 87). Likewise, his portraits of his painter friends often include pipes (fig. 13).

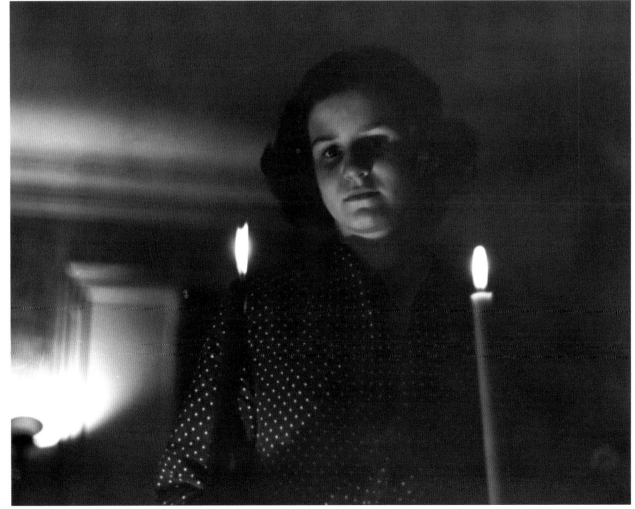

Fig. 40, above.
Self-portrait of
George Gershwin
with Andrea Warburg,
photographed
in 1934

Fig. 41, right.
Photograph of Kay
Swift's daughter
Kay Warburg taken
by George Gershwin
in 1934

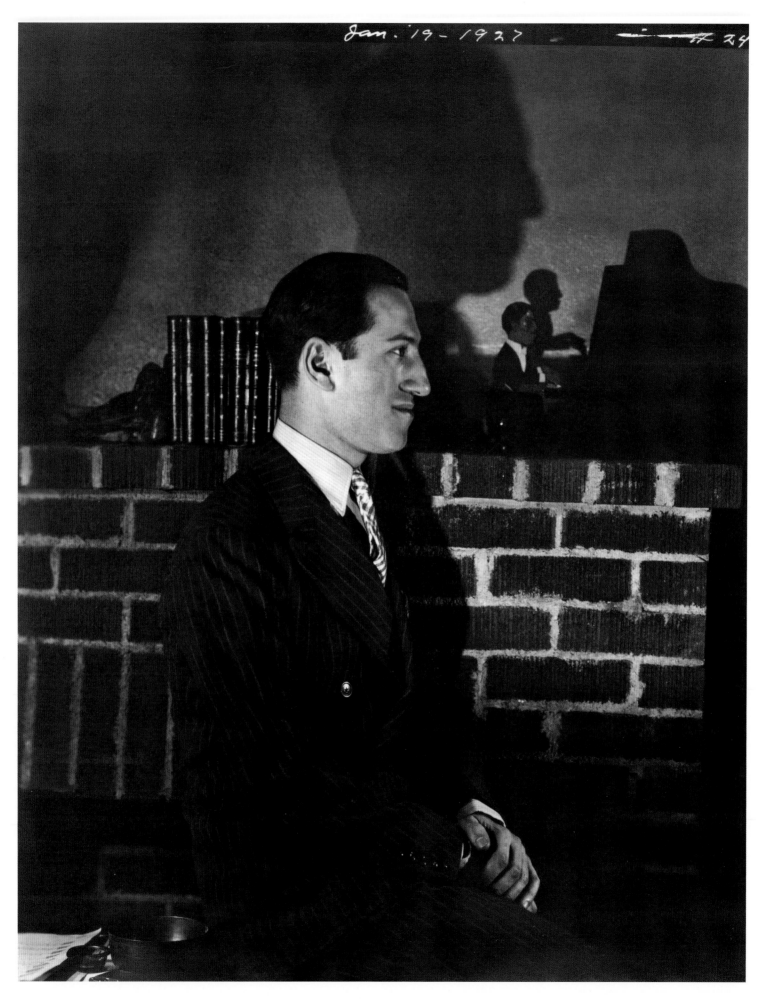

Jan. 19-1927

40

A poignant and melancholy photograph Gershwin took of the American lyric soprano Ruby Elzy reflects her performance as Serena in *Porgy and Bess* (fig. 24). Her solo aria in that opera, "My Man's Gone Now," with its famous two-octave wail, can be seen as the emotional climax of that work, an emotion that Gershwin captures in this image—one of several portraits he made of her. In this photograph, as in a number of others, Gershwin lit his photographic subject from below, creating the dramatic effect of footlights.

The literary critic and portrait photographer Carl Van Vechten, who had attended the premiere of *Rhapsody in Blue* in 1924 and taken numerous photos of the composer in 1933, was highly encouraging of Gershwin's photographic pursuits. He remarked after seeing one of Gershwin's photos of Elzy: "I foresee you'll be exhibiting pictures before long and you should certainly get something into the next number of *US Camera*." Then he added a p.s.: "I have long held a theory that if a person does one thing well, he can do another equally well, if he really has the desire."[113]

GERSHWIN AND NON-WESTERN ART

Gershwin, typical of the art collectors of his day, and interested in the beauty of the abstracted human forms that inspired Picasso, Modigliani, and so many other European artists he admired,[114] amassed a considerable collection of African and Mesoamerican objects[115] including masks, figurines, and statues. Such sacred objects, which had been pilfered by Europeans since the fifteenth century, were readily available in the Paris art market. Like most Americans, Gershwin did not have first-hand knowledge of Africa, nor did he know how these sacred figures were originally used by the people who created them.[116] The works in the composer's collection were bought for him

inexpensively by Botkin, sight unseen, as evidenced by their correspondence reproduced in this volume.

Gershwin showed one of the larger African objects from his collection in the November 1933 exhibition at the Arts Club of Chicago (fig. 7). Later, in January 1936, the composer was one of the lenders to the landmark *Exhibition of Sculptures of Old African Civilizations* organized by the painter and ethnographer John Graham at the Jacques Seligmann Gallery in New York.[117] Gershwin lent checklist #38: Ivory Coast, large animal mask, Baoulé; #53: Gabon, Bakota tribe, brass mask of "great finesse"; formerly Paul Guillaume Collection; and #62a: Gabon, Bakota brass mask. Among the other lenders to the show were Gershwin's friends Frank Crowninshield, editor of *Vanity Fair*, and the Mexican painter and caricaturist Miguel Covarrubias.

One object in Gershwin's collection was a carved wooden Fang reliquary guardian figure from Gabon, fourteen inches in height. According to Sotheby's, which sold the piece, "This small Fang figure was acquired by the great American composer George Gershwin [at] a time when Fang (then most often called "Pahouin") sculpture enjoyed a particular vogue among avant-garde American collectors, with the 1932 exhibition of Paul Guillaume's collection at the Durand-Ruel Gallery in New York (*Early African Heads and Statues from the Gabon Pahouin Tribes*), and the historic *African Negro Art* exhibition at the Museum of Modern Art in 1935."[118]

HOLLYWOOD PERIOD

On August 10, 1936, summoned by Warner Brothers, George and Ira Gershwin relocated to 1019 North Roxbury Drive in Beverly Hills, California, where they wrote the score for the Fred Astaire–Ginger Rogers film *Shall We Dance* and then a second film, *A Damsel in Distress*. Again, the composer sought to curate his surroundings. He asked his assistant Zenaide Hanenfeldt (a Russian immigrant and a well-known performer on the theremin) to send fifteen of his artworks from New York to Beverly Hills. "We can use these paintings for our walls and I wish you would attend to this right away," he wrote to her. "Send out the paintings by railroad freight as I imagine that's the best way. Call Siqueiros & try to get the new picture from him which I paid for. Send it out if you can get it."[119] In addition, he asked her to help fulfill a request from the English art historian R. H. Wilenski to supply images of some works from his collection for a forthcoming monograph on modern French art.

Lastly, he asked her to send out his painting supplies, including his paints, his brushes, some unfinished canvases, and his easel. "I have decided to do a little painting out here,"[120] he explained. On September 10, she sent him the fifteen works he had requested: Benton's *Burlesque* (plate 6), Chagall's

L'Abattoir and *Untitled* (*Old Man With Beard*), Derain's *Road Through the Forest* (plate 19), André Dunoyer de Segonzac's *La Marne*, Jacob's *Fête religieuse*, Modigliani's *Portrait of Doctor Devaraigne* (plate 36), Pascin's *Girl with a Kitten*, Picasso's *The Absinthe Drinker*, Henri Rousseau's *Île de la Cité* (plate 50), Siqueiros's *Niña Madre* (plate 54), Utrillo's *Moulin à Ouessant, Bretagne* (plate 60), *Bust of a Young Woman* attributed to Modigliani, the portrait of Gauguin, and his own painting, *My Grandfather* (fig. 32).

Girl with a Kitten, now in the collection of the Metropolitan Museum of Art in New York (plate 40), features prominently in a famous series of photos taken in March 1937 of George and Ira Gershwin side by side, Ira seated at a card table, George at the keyboard, with the little girl on the wall behind them (fig. 45). The photographer was Rex Hardy, a young *Time* magazine stringer sent on assignment. Hardy took fourteen photos, eight of George alone and six of the brothers together. One of these photographs was used as the basis for the famous Al Hirschfeld caricature that is widely reproduced (fig. 46).

"I remember the occasion vividly," Hardy wrote years later to Lawrence Stewart, Ira Gershwin's assistant and co-author with Edward Jablonski of *The Gershwin Years*. "It did indeed take place at the Roxbury house (I knew Beverly Hills quite well, having graduated from

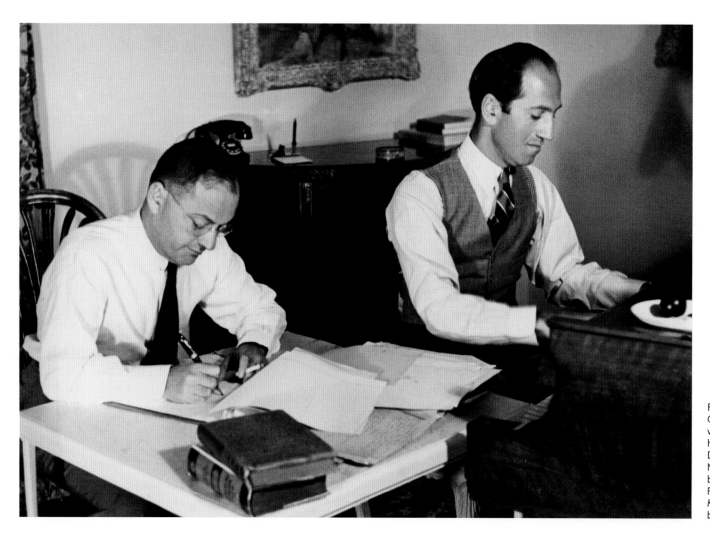

Fig. 45. Ira and George Gershwin working in their home, 1019 Roxbury Drive, Beverly Hills, March 1937. Photo by Rex Hardy. Pascin's *Girl with a Kitten* is on the wall behind them.

Beverly Hills High School only four years earlier!). It was an especially memorable occasion for me, as I was (and still am) an enthusiastic admirer of Gershwin's music, and I felt thrilled at the opportunity to meet the great composer. . . . George Gershwin was serious, formal, and courteous (almost courtly) and was completely cooperative, but obviously not fully enjoying the experience. His attitude was in complete contrast with that of his brother, who was extremely cordial. Ira Gershwin seemed enthusiastic and very friendly. I can well believe, looking back, that George Gershwin was affected by his tragic illness."[121]

In Los Angeles, Gershwin continued to add works to his collection, acquiring John Carroll's *Black Venus* (1936), a purchase that made the news because of the painting's racy and racialized subject matter as well as the price paid (plate 14). He also purchased a major work by Oskar Kokoschka, *Pyramids at Gizeh* (1929), now in the permanent collection of the Nelson-Atkins Museum of Art in Kansas City (plate 31). In a letter to Mabel Schirmer dated March 19, 1937, Gershwin wrote: "I recently bought 2 paintings. One by Kockoshka [sic] the Austrian & the other 'Black Venus' by John Carroll."[122] The Nelson-Atkins describes the Kokoschka work as follows: "The famous Egyptian pyramids of Menkaure, Khafre, and Khufu rise against the deep blue sky at Gizeh (Giza). At center looms the giant Sphinx, while camels, horses, and people move about the golden desert sands. . . The artist's quick, sketchy brushstrokes contrast with the timelessness of his subject."[123] Both *Black Venus* and *Pyramids at Gizeh* are large major works by their respective artists.

More importantly, the Kokoschka purchase may have saved a life. Berta Sanders, a Jewish woman from Mannheim, was stuck in Nazi Germany, but the sale of this painting very likely allowed her to escape the Reich. She had surely lost her German citizenship in 1935, like all German Jews, under the increasingly severe Nuremberg laws. Her conductor brother Sigmund Sanders, who was already in New York, had written a series of letters to Gershwin urging him to allow Berta to acquire artwork for him, and adding that he himself was in desperate need of musical employment. "I know I am as good as the others and am willing to work twice as much as the others, but I can't get connected."[124]

Gershwin, suffering at that time from the brain tumor that would ultimately claim his life, responded politely but noncommittally. "Received your letters with the enclosed pictures by Kokoschka and must say I appreciate very much your efforts in trying to locate one that would interest me . . . [Kokoschka] is such a vivid colorist and slaps the paint on very thickly," he wrote. "I must tell you that at present I am not in a picture buying mood and a painting will have to be an extraordinary one for me to interest myself in purchasing it. In other words, I desire only the very best work of the best painters," he added. As for a job offer for Sigmund, Gershwin assured him that "you may be sure I will keep my eyes wide open for such a spot."[125]

Fig. 46. Al Hirschfeld (American, 1903–2003). *George and Ira Gershwin*, 1955. This famous caricature is based on the series of photos taken by Rex Hardy in 1937.

Gershwin ultimately decided to purchase the canvas even though it was unlike anything else in his collection. The surviving purchase receipt indicates that Berta Sanders purchased it for 6000 Reichsmarks on February 1, 1937, from Galerie Buck in Mannheim, Germany. One can imagine that the financial transaction helped her materially and facilitated her exit. Subsequently she boarded the ship Manhattan in Hamburg on February 24 with the painting and arrived in New York harbor safe and sound. The painting was then shipped to Gershwin in Beverly Hills. Meanwhile Kokoschka himself, whose art had been labeled as "degenerate" by the Nazi regime, had fled from Vienna to Prague in 1934 and would ultimately escape to London.

In California, Gershwin painted two stately and reverent portraits of his idols Jerome Kern and Arnold Schoenberg, paintings now owned by the Library of Congress. Gershwin had been in the audience for the US premiere of Schoenberg's landmark composition *Pierrot Lunaire* in 1923, and the two men were neighbors, tennis partners, and social friends in Hollywood in 1936 and 1937. Gershwin made both of these paintings based on photographs, with the Schoenberg portrait snapped by Edward Weston as part of a series (figs. 48, 49). Notice how much Gershwin adds in his painted version of the Weston photograph, including color, texture, and a beam of light that appears to radiate upward from the subject's forehead, creating a sort of halo. A similar halo appears in the Kern painting as well. In an oft-reproduced photo, we see Gershwin, not painting the

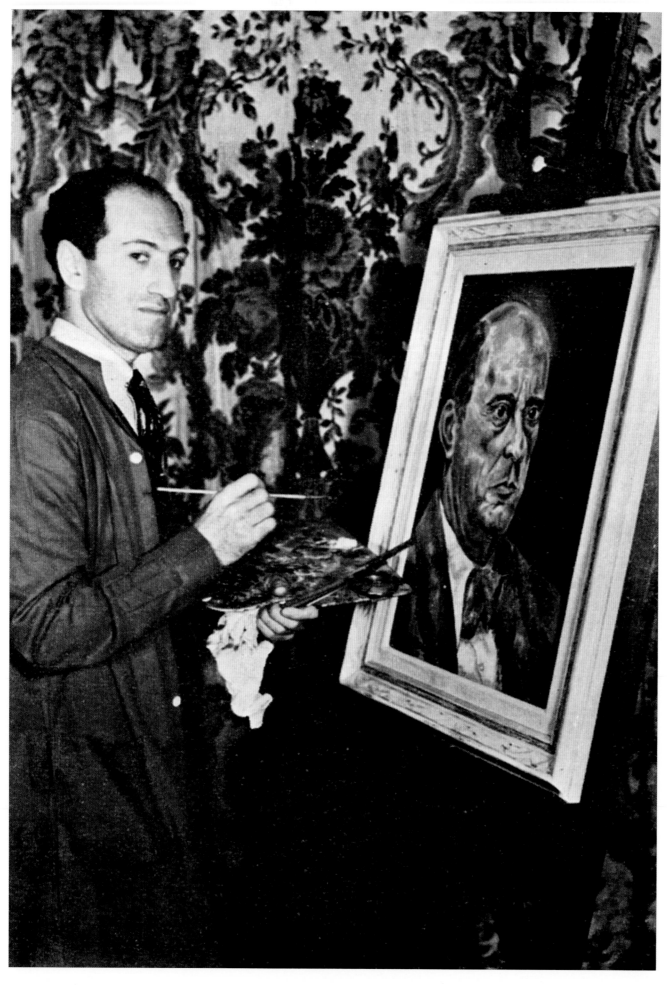

Fig. 47. George Gershwin poses in his home at 1019 Roxbury Drive in Beverly Hills with his finished and framed *Portrait of Arnold Schoenberg*, 1937.

Schoenberg portrait—as his smock and paintbrush would suggest—but rather posing with the portrait already completed and framed (fig. 47). These are the last paintings the composer is known to have made. His tender and masterful photograph *Self-Portrait with Irving Berlin* also dates to this final period (fig. 76). Gershwin died in California on July 11, 1937, following a failed brain surgery.[126]

A MUSICAL KALEIDOSCOPE

George Gershwin collected art, he created art, he supported art institutions, and he commissioned works of art into existence. These activities nourished his musical practice and expanded his creative outlook beyond that of most composers in history. One could dismiss these activities of Gershwin's as simply part of his attempt to be highbrow, or, as Leonard Bernstein put it, "to cross the tracks"[127]—but there's more to it than that. The artworks in Gershwin's collection such as Picasso's *The Absinthe Drinker*, Modigliani's *Portrait of Doctor Devaraigne*, Chagall's *Untitled* (*Old Man with Beard*), and Max Weber's *Invocation* were not trophies to the composer, mere symbols of his financial success. On the contrary, they were deeply meaningful objects to him with which he spent a great deal of time and from which he drew sustenance and inspiration. "He was in love with color,"[128] as Armitage affirmed.

But what about color in Gershwin's music? What does color mean in any music? Regardless of whether a piece of music is "programmatic" or "absolute," the term "color" is applied to music in three basic ways. "Tone color" (also called timbre or waveform) refers to the acoustical properties of a given musical instrument—allowing the listener to differentiate between a clarinet, a violin, a trombone, or even a taxi horn. There is also "harmonic color"—the way any two or more notes blend or conflict when played at the same time, such as an open fifth, a minor ninth, or a "Tristan chord." The term "chromatic"—or "pertaining to color"—describes the melodic placement of notes a half-step apart, such as two adjacent notes on the piano. As an extension of this third category, sometimes the term "ultrachromatic" is used to describe even smaller intervals such as quarter tones, glissandi, or "blue" notes (the slight lowering of an expected pitch).

Quite apart from these standard musical meanings there is a further way that music can have color. As mentioned at the beginning of this essay, there is a psychological phenomenon—synesthesia—that is a linkage between two or more types of sensory perception. Synesthetes see actual visual colors when they hear sounds. Among composers, the two most famous examples were Alexander Scriabin and Olivier Messiaen. Was Gershwin a synesthete too?

Recall Gershwin's statements to Botkin that "Music is design—melody is line; harmony is color."[129] Or: "Dissonance in music is like distortion in a painting."[130]

Here he is talking about harmonic color because dissonance is a harmonic property. Chromaticism is present throughout Gershwin's oeuvre, most strikingly in the wailing climax to Serena's aria "My Man's Gone Now" in *Porgy and Bess*, in the opening clarinet glissando in *Rhapsody in Blue*, and in his pervasive use of "blue" notes. Yet Gershwin's descriptions go further. His statement that painting and music "spring from the same elements, one emerging as sight, the other as sound"[131] tantalizingly suggests synesthesia. And recall Siqueiros's statement that "Many times Gershwin and I heard sounds in my paintings and also we saw colors and shapes in his music."[132]

In light of such evidence, I would like to propose that we consider giving a synesthetic reading to Gershwin's only major work with an explicit color reference, *Rhapsody in Blue* (1924). But it's complicated to do. While the work's palette of tone colors is truly dazzling, the orchestration is by Ferde Grofé, and not by Gershwin. And while its title is a clear embodiment of synesthetic values, it was proposed by the composer's brother Ira in homage to the painter James McNeil Whistler whose canvases bore names such as *Symphony in White*.

Fortunately, we have Gershwin's own description of the work as "a kaleidoscope of America" composed in a blaze of synesthetic creativity, combining sound and sight. "It was on the train with its steely rhythms, its rattle-ty-bang that is so often so stimulating to a composer. . . . And there I suddenly heard—and even saw . . . —the complete construction of the rhapsody from beginning to end. . . . I heard it as a sort of musical kaleidoscope of America."[133] Perhaps we can try to *see and hear* the "musical kaleidoscope" in action in this work, whose opening clarinet glissando represents the initial turn of the aperture and whose climax, a loud, long dense chord appearing just before the final peroration, can be seen as a flash of blinding light. And if we accept the assertion by Siqueiros that there are "colors and shapes" to be found in Gershwin's music, then logically this fact would apply to his entire compositional *oeuvre*. In other words, let us try to lend an ear to Gershwin's eye.

Fig. 48,* right. George Gershwin. *Portrait of Arnold Schoenberg*, 1936–37. Gershwin Collection, Library of Congress, Washington, DC

Fig. 49,* far right. Edward Weston (American, 1886–1958). *Arnold Schoenberg*, 1936. Gershwin Collection, Library of Congress, Washington, DC

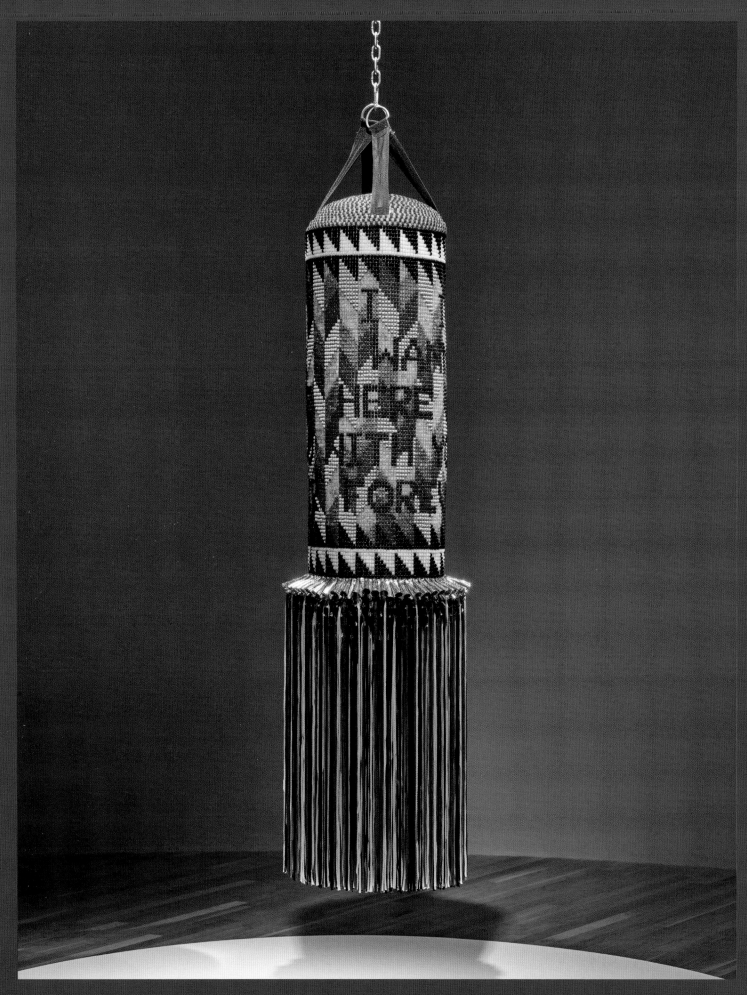

"A PAST THAT IS MINE": GERSHWIN'S LEGACY IN THE VISUAL ARTS

COURTNEY A. McNEIL

Olivia Mattis's comprehensive essay *Gershwin's Eye* (pages 10–45) documents for the first time the depth of George Gershwin's engagement with the visual arts as a collector, creator, and source of inspiration to his contemporaries in the visual arts. Gershwin was a member of sophisticated cultural circles that included leading painters, illustrators, and photographers such as Miguel Covarrubias, David Alfaro Siqueiros, Edward Steichen, Carl Van Vechten, and, of course, his cousin Henry Botkin.

However, we cannot fully consider the topic of Gershwin's engagement with the visual arts without also examining an important aspect of his legacy: his continuing influence on visual artists since his untimely death in 1937. What place has he and his music occupied in the collective artistic imagination in the recent past? The Baker Museum is a particularly appropriate institution to take on this inquiry, as it exists at the unique intersection of music and visual art as part of Artis—Naples, a multidisciplinary arts organization that is also home to the Naples Philharmonic. This essay will describe artistic responses to Gershwin—both the man and his music—by American artists Andy Warhol, Kara Walker, and

Fig. 50,* opposite. Jeffrey Gibson (American Mississippi Choctaw/Cherokee, b. 1972). *I WANNA STAY HERE WITH YOU FOREVER*, 2019. Repurposed punching bag, repurposed wool army blanket, glass beads, metal studs, tin jingles, artificial sinew, nylon fringe, and steel, 80 × 14 × 14 in. Dallas Museum of Art, TWO × TWO for AIDS and Art Fund, 2019.87

Fig. 51, right. Photograph of George Gershwin, 1934.

Fig. 52,* far right. Andy Warhol (American, 1928–1987). *George Gershwin*, from *Ten Portraits of Jews of the Twentieth Century*, 1980. Graphite on paper, 31⅜ × 23½ in. Courtesy of Ronald Feldman Gallery, New York

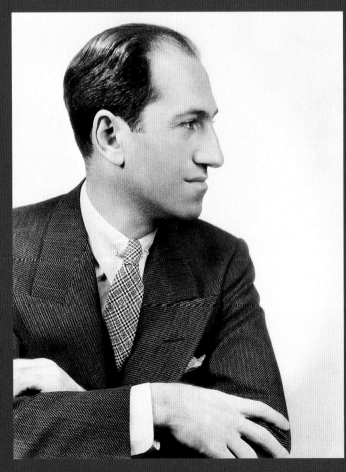

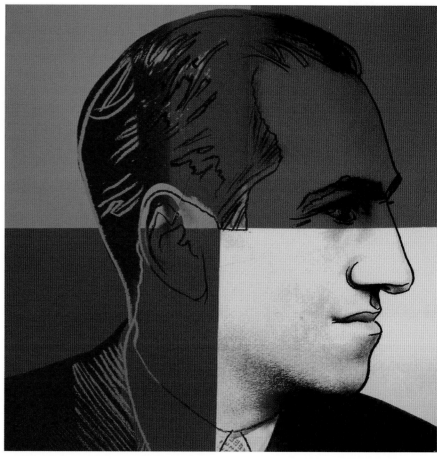

Jeffrey Gibson. While these artists' responses vary widely, they each demonstrate how Gershwin has assumed a symbolic status, deeply influential and personal to each artist. Gershwin may belong to the past, but, as stated by Kara Walker, any one of these artists might claim that it is "a past that is mine." Gershwin's legacy is a complex expression of American identity that continues to resonate with contemporary artists today.

In 1980, more than forty years after Gershwin's death, one indicator of his continued stature within public consciousness was his inclusion in Andy Warhol's portfolio *Ten Portraits of Jews of the Twentieth Century*, which Warhol undertook in consultation with New York gallerist Ronald Feldman.[1] Warhol employed his signature technique of combining appropriated photographs with screenprinting, drawing, and painting to create images that are instantly recognizable as iconic works by the Pop Art giant. He began each portrait with a source photograph—in the case of the Gershwin portrait, a publicity photograph from 1934 by an unknown photographer—which Warhol enlarged and simplified into a line drawing (figs. 51, 52). Warhol then combined his drawing with elements of the source photograph and overlaid a variety of large, geometric planes in different colors, creating at least twenty-five different color proofs before selecting the composition that would be published in the *Ten Portraits* screenprint portfolio in a final edition of two hundred (fig. 53).

The final arrangement selected by Warhol for the Gershwin portrait featured prominent areas of ochre, pink, magenta, deep green, and cerulean blue. After creating the suite of screenprints, Warhol screenprinted his portraits onto canvas to create five unique 40-by-40-inch paintings of each subject, which, like the trial proofs of the prints, were overlaid with different combinations of color (fig. 54).[2]

The debut of Warhol's *Ten Portraits* in an exhibition at the Jewish Museum in New York in 1980 was met with lively criticism in the art world (fig. 55).[3] Art critic Hilton Kramer appeared particularly unimpressed, describing the series as vulgar and exploitative in his *New York Times* review, stating, "It reeks of commercialism, and its contribution to art is nil. The way it exploits its Jewish subjects without showing the slightest grasp of their significance is offensive—or would be, anyway, if the artist had not already treated so many non-Jewish subjects in the same tawdry manner."[4] Kramer was similarly uninspired by the artistic technique employed in the portraits: "Mr. Warhol applies his standard repertory of effects—smeary surfaces, random panels of color and illustrational drawing—with his customary insouciance."[5] In *Artforum*, critic Carrie Rickey memorably described the series as "Jewploitation," stating that "its only *raison d'être* was to penetrate a new market: the synagogue circuit."[6] Despite this critique, Rickey ultimately found the work to be successful: "Unlike the Warhol portraits shown at

the Whitney earlier this year, which were superficial treatments of superficial people, the paintings of Jews had an unexpected mix of cultural anthropology, portraiture, celebration of celebrity, and study of intelligentsia—all at the same time."[7]

Warhol had been dead for more than twenty years by the time this work was thoughtfully reexamined in the 2008 exhibition *Warhol's Jews: Ten Portraits Reconsidered* at the Jewish Museum, New York, curated by Richard Meyer.[8] This postmortem reconsideration of Warhol's work situated the *Ten Portraits* within the context of Warhol's practice as a self-proclaimed "business artist." It also detailed the process of the selection of the subjects for the ten portraits included in the portfolio, chronicling how these decisions were made and laying out evidence that Warhol's involvement was deeper than had previously been believed. Warhol's sometimes-controversial confluence of popular culture with what was traditionally considered "high art" calls to mind Gershwin himself, known for his synthesis of popular musical styles with the "highbrow" art forms of piano concerto and opera.

Perhaps no work by Gershwin better exemplifies his synthesis of broad-ranging sources of musical inspiration than his 1935 folk opera *Porgy and Bess*, for which he composed the music, and his lyricist brother Ira Gershwin coauthored the libretto with DuBose Heyward, a South Carolinian of European descent.[9] It demonstrates Gershwin's focused study of jazz, African American spirituals, and his fascination with life in the Gullah communities of coastal South Carolina. Gershwin, and later the Gershwin estate, maintained a contractual requirement that all authorized productions of the work would be performed by an all-Black cast, with the goal of avoiding the then-popular practice of white actors performing in blackface. When it debuted, some celebrated it as a story of life in a historically Black community performed by Black artists during an era of limited visibility and opportunities for such stories, while others noted the irony of this landmark American opera focusing on stories from Black America, yet having been produced by an all-white creative team.[10] In an essay by Gershwin published in 1935, the year in which *Porgy and Bess* made its debut, Gershwin described his ambition of writing the first great American opera and how *Porgy*'s combination of dramatic intensity and humor led him to choose this particular story: "No story could have been more ideal for the serious form I needed than 'Porgy and Bess.' First of all, it is American, and I believe that American music should be based on American material."[11] Gershwin's paternalistic and overly generalized views of Black Americans throughout his essay show him to be a product of his time, however well-intended his choice to tell this story was.[12]

Both praise and critique of *Porgy and Bess* have continued vigorously over the nearly ninety years since the opera debuted. More recently, contemporary scholars including Daphne A. Brooks and Ellen Noonan have authored insightful and nuanced analyses of how the opera can serve as a vehicle for understanding the role of popular culture in American racial politics.[13]

Despite this complicated history, or more likely because of it, *Porgy and Bess* has also inspired a variety of visual artwork by several of the leading contemporary artists of our time. One such artist is Kara Walker, who is renowned for her utilization of the silhouette to create subversive and often shocking compositions that address themes of violence, race, and American history (figs. 57, 58). Walker created sixteen original illustrations and a portfolio of four related lithographs for a newly reissued libretto of *Porgy and Bess* published by Arion Press, San Francisco, in 2013. In her artist's statement accompanying the work, Walker describes how the music of *Porgy and Bess* permeates her childhood memories and reminds her specifically of time spent listening to the opera with her mother. "For me, like so many listeners," Walker states, "*Porgy and Bess* belongs to 'The Past,' not a balmy southern thing, but a past that is mine."[14]

Walker elaborates on her approach to the complicated legacy of *Porgy and Bess*, saying, "It's hard to claim ownership of these characters, and impossible to wrest them away from their archetypal status. They are archetypes beyond the grand opera theme of 'star crossed lovers'; they've become archetypes of another no less grand drama, that of: 'American Negroes drawn up by white authors, and retooled by individual actors, amid charges of racism, and counter charges of high-art on stage and screen, in the face of social and political upheaval, over generations.' Because they are fraught, I chose to simply let them be paper cut-out caricatures whose full dimensions are alluded to by rubbing."[15]

The style employed by Walker for these libretto illustrations, which is not as clean edged as her typical silhouettes, certainly does evoke the look of a transfer

Fig. 55. Bernard Gotfryd (American, b. Poland, 1924–2016). *American Artist Andy Warhol at Exhibition of His Ten Portraits of Jews of the Twentieth Century*, ca. 1980

Bess

I loves you, Porgy. Don' let him take me. Don' let him handle me an' drive me mad. If you kin keep me, I wants to stay here wid you forever. An' I'd be glad.

Porgy

There, there, Bess, you don' need to be afraid no mo'. You's picked up happiness an' laid yo' worries down. You goin' to live easy, you goin' to live high. You goin' to outshine every woman in dis town. An' remember, when Crown come that's my business, Bess.

Bess

I loves you, Porgy. Don' let him take me. Don' let him handle me with his hot han'. If you kin keep me, I wants to stay here wid you forever. I got my man.

Porgy

What you think I is, anyway, to let dat dirty houn' dog steal my woman? If you wants to stay wid Porgy, you goin' stay. You got a home now, honey, an' you got love. So no mo' cryin', can't you understan'? You goin' to go about yo' business, singin', 'cause yo' got Porgy, you got a man.
(Porgy and Bess exit. Clara enters.)

Maria

Why you been out on that wharf so long, Clara? You got no cause to worry 'bout yo' man. Dis goin' be a fine day.

Clara

I never see de water look so black. It sits there waitin', holdin' its breath, list'nin' for dat hurricane bell.

Maria

Hurricane bell! Lawd chile, dere ain' goin' be no hurricane. I's gettin' ole now, an' I ain' hear dat bell but fo' time in my life. Go 'long to de baby now an' quiet down.

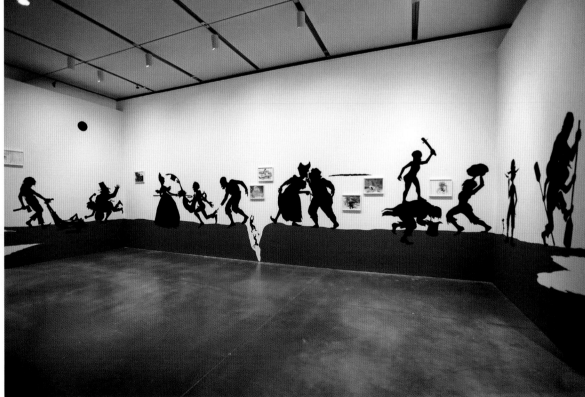

Fig. 56,* opposite top. Kara Walker (American, b. 1969). *Porgy & Bess*, 2013. Johannot paper, Japanese paper, goatskin leather, calico cloth and board, book closed: 12¹⁵⁄₁₆ × 10¹⁄₁₆ × 1³⁄₈ in. Artis—Naples, The Baker Museum, Museum purchase with funds provided by Gerald Lippes, 2023.3.1.5

Fig. 57, opposite below left. Kara Walker

Fig. 58, opposite below right. Installation view of work by Kara Walker in *First Light* at the ICA Boston, 2016.

Figs. 59–62*, this page. Kara Walker (American, b. 1969). top left: *Porgy and Bess, embracing*. 2013. top right: *Porgy and Crown*, 2013. bottom left: *Strawberry Woman*, 2013. bottom right: *Sailboat in Storm*, 2013. Lithographs on Somerset paper, 15 x 18 in. ea. Artis— Naples, The Baker Museum. Museum purchase with funds provided by Gerald Lippes, 2023.3.1.1–4

rubbing, leaving viewers with the feeling that they are seeing just a translated fragment of the story that can only suggest the rich, unknowable depths of these characters (fig. 56). The four lithographs that accompany the libretto appear less scratchy and have a more inky, loose appearance. The compositions, identifiable but intentionally undetailed, give monumental treatment to their subjects: a strawberry seller, a boat in a storm, the overlaid profiles of Porgy and Crown, and Porgy and Bess embracing (figs. 59–62).

Just as Walker sees the characters of *Porgy and Bess* as archetypes that defy simple categorization, many of Gershwin's individual songs within the opera have become icons of popular music, and they have notably been performed by many of the best-known singers

of every generation from 1935 to the present.[16] "I Loves You, Porgy," in which the character of Bess describes her fear of being forcibly separated from the man she loves, is one such song. The recording of this song by singer, songwriter, and civil rights activist Nina Simone in 1958 became her first major hit and would endure as her most commercially successful song.[17] Simone's recording of the song would become so widely known that, to many listeners, her association with it is now even stronger than its association with its authors.

One such listener is Jeffrey Gibson, a contemporary American artist of Cherokee and Mississippi Choctaw heritage. Gibson is known for his mixed media sculptures and paintings incorporating materials, patterns, and colors inspired by Indigenous craft and culture (fig. 63). One of his best known bodies

Fig. 63. Jeffrey Gibson, 2019

of work is his ongoing series of life-sized beaded punching bags, adorned with designs paying homage to garments made and worn by traditional members of Indigenous communities. Specifically, he was interested in the aesthetics of intertribal events, such as the powwow, in which dancers participate in deep-rooted tradition, but in a form that also allows the dancers to innovate and express their individual, modern identities. Gibson's punching bags are emblazoned with words referring to issues of race, gender, and sexual orientation. While these issues are deeply personal to the artist, Gibson quickly found that viewers were connecting these works profoundly with their own personal struggles and obstacles.[18]

For Gibson's 2019 bag *I WANNA STAY HERE WITH YOU FOREVER* (fig. 50), he specifically cites the inspiration of Nina Simone's rendition of the song "I Loves You, Porgy."[19] To him, the song's lyrics evoke emotions associated with the violence and discrimination faced by marginalized groups in society: "The title also speaks to histories of removal, histories of relocation, histories of families being torn apart, and histories of relationships that have been disallowed historically and currently. I hope that viewers will be able to project their own stories onto the bag. I hope that they will consider the traumatic histories of relocation, of boarding schools, of Removal Acts, within native and indigenous histories. And I hope that they will begin to understand why it is important for people who wish to stay with their own communities to continue to fight for their rights."[20]

It is beyond the scope of this essay to conclusively define the legacy of *Porgy and Bess* within American culture, but consideration of the contemporary artwork the opera has inspired can elucidate some of the many layers of meaning the work has had to succeeding generations. The Gershwin-inspired artwork described in this essay, created by Andy Warhol, Kara Walker, and Jeffrey Gibson, speaks to the complexities of American identity and demonstrates how the creative energies of contemporary artists can continue to add new dimension to our understanding of the music of the past.

CORRESPONDENCE BETWEEN GEORGE GERSHWIN AND HENRY BOTKIN AND RELATED DOCUMENTATION

COMPILED AND EDITED BY OLIVIA MATTIS

MARCH 1931

Henry Botkin to George Gershwin,
18 villa Seurat, Paris, March 27, 1931
Dear George:

Was really very happy to get your letter & to hear from you. Needless to say, I have been hearing bits of your doings & have been very happy that all at the Coast went so well. I am certain that the picture & your music will be a genuine hit. Incidentally I am so anxious to hear the new rhapsody.

I am hard at work & am plugging away as usual, & with results. You will see the great progress I have made & am sure [you] will like it. Someday I hope you will be proud of your cousin Harry, & incidentally I will need an occasional boost from you. That bit in the Journal with the reproduction of the screen was fine & I appreciate it very much.[1]

Now as to buying some paintings George, let me explain: Nobody is more anxious & interested in seeing you build a collection that would eventually rate as one of the finest. I assure you with your knowledge & enthusiasm & real proven love for painting this could be accomplished. I realize on a past trip when you made a similar request, I was a bit troubled as I was not so sure that you really were hot on it. Now I see that you are & will show every possible interest to advise & aid you.

You must begin at once as pictures are mounting from month to month in price. This temporary business depression has *not hit* the genuine dealers & artists. The big men whose work you want have plenty of dough—some are millionaires in dollars & don't give a darn about selling—but at that are constantly boosting prices. I bought about $5000 worth for a friend last year & in most cases each canvas has mounted from 35 to 50 percent as I bought them cheap.

I have spent the past three days consulting the more important dealers & collectors & though it's hard to write about my findings in this letter, I can say that *bargains* are few—except in a few instances. People

hold on for big figures & know enough that the picture collecting game is not as weak as some people would like to believe.

I do not know what you wanted to spend as a beginning but I could get you a small fine collection including a few of the very best—for about $5000. You could have an important Derain, a small fine Renoir, a Vlaminck, a Chirico, Pascin (small example), Chagall, Lhote, Lurçat, Gromaire, Rouault, Kisling & Goerg. If you told a picture dealer about this he might say I was crazy as one Derain portrait is about $4000 in New York today.

I have one Derain—(A) a large canvas about the size or larger than the large watercolors in Ira's home— that is a *museum piece*. It was painted in 1913, & was one that made Derain's rep. It is absolutely a find & a bargain & can be had for about 2400 dollars. It may seem like a lot but the day it arrives in N. Y. Dudensing[2] or Crowninshield[3] will prove to you that it's worth $5000. It's a fine subject & excellent in color, & perfect for your home, with a real Negroid touch to it.

The photo or clipping I enclose gives you a very small idea of it. Ask your friends what they think of its value & satisfy yourself on the idea. *I advise you to grab it* as this is a bargain. A lovely head (E) can be had for $1000 by the same artist.

I have listed many various works to give you an idea of prices, & most of these are cheap. Any real Matisse or Modigliani starts at $8000 or more. Picasso is about the same. The first important man after that is Derain & his work will go up rapidly. I suggest you buy several Derains—if you really want a find. But if you chose to vary the idea, one or more important works & a few lesser ones would make a great start.

I hunted for a nude knowing you once wanted one, but they are hard to find & expensive. Pascin would be the best & a good one is about $1500 (double of what I paid last year). If you have certain preferences— particular artists & subjects—let me know.

I have an option on the Derain for about two weeks. It has been in many museums all over the world.

If you are interested cable me George & I will hold on.

Pictures next year will be more expensive—so start now ol boy.

Just go around & ask Dudensing or Reinhardt[4] & get their prices, to compare with the enclosed. Don't let subject matter influence you, George. It's the quality & value of the canvas.

I hope this all helps you & is not too complicated & trust you see it the way I do. I am positive you will not regret it, & to spend $5000 is nothing but a good investment.

Tell Ira I will write soon & remember me to Mother & Dad & Lee & the rest.

Rhoada is having a marvelous time & sends her love to all. This goes from Toinette also.

Let me hear from you, & cable me if you are interested as these pictures listed were taken from many collections & am holding them till I hear from you.

With the best of bestest to my famous cousin from Harry

APRIL 1931

Gershwin to Botkin,
33 Riverside Drive, New York, April 9, 1931
Dear Harry:

It was so nice of you to take all the trouble you apparently took in looking at the pictures and sending me the details in your last letter. It was very interesting to me to note the prices of the various items and I wonder how some of them actually look.

For instance, the small Renoir called the *Guitariste* for fourteen thousand francs. It seems like a very good buy to me. Isn't that very cheap for a Renoir, or is the picture just a poor example of his work?

I am very much interested in your suggestion for a small collection for me for about five thousand dollars. Times, as you know, are very bad but if I could get some pictures that I could love, I would consider it a wise investment—even at this time.

The unfortunate thing about buying pictures this way is that no two people's tastes are exactly alike, so I will try to tell you which of the pictures you mentioned seem interesting to me—and if there would be any way of your sending photographs or detailed descriptions, I would be everlastingly grateful.

The large Derain *Femme aux Fruits* is a very interesting picture, but it leaves me a little cold. I would imagine it has beauty in color, but I would rather start with something that perhaps falls a little easier on the eye.

Do you think it is better to buy a group of small pictures by the various artists you mention, or do you think it would be wiser to buy just one or two important ones by famous artists?

Another question: Is there any duty on pictures or is it just on picture frames? If I bought any pictures would you bring them over when you came? When are you coming?

The Gauguin you describe for one hundred and fifty

thousand francs must be a beautiful thing. Would you advise buying one picture like this as against seven or eight of the smaller ones?

If there were only a way that I could see some of these pictures, I wouldn't hesitate to tell you to go ahead but you must admit that it is a little difficult doing it this way, because I wouldn't like to stack up on things that I really didn't love.

I don't suppose it is possible to get anything at all of Van Gogh? And are all Modiglianis so terribly expensive?

Here is a list of the pictures—without seeing them or without knowing anything about it—that seem to be the most interesting:

The Renoir
Paysage by Bonnard
The Picasso (if it is a good example of his)
The Pascin
An important Derain
The Gauguin

Of course, some of the others might be just as good—and interesting—but, without seeing them, these seem the most interesting to me.

Please try to answer as many of these questions as you can, as soon as you can, so that I will know what to do.

New York is about the same since we have come back from California. I am orchestrating a new Rhapsody with the possibility of having it played in Carnegie Hall if I like it, when it is finished.

Our California trip was very interesting and Ira and I look forward to going back there some time.

My mother and father got back last week from Florida and my mother seems to be feeling a little better.

Everything else is about as usual.

Times are very depressing for most people, but life must go on—and a certain amount of gaiety creeps in.

I am glad to know you are happy with your new wife, and I hope you are all well.

Sincerely,
Cousin

Botkin to Gershwin,
18 villa Seurat, Paris, April 21, 1931:
Dear George:

Got your letter about four days ago & have been working on your project for a collection or at least the purchase of a few fine pictures.

I would like to say George that your attitude & suggestions as to photos together with your ambition to invest in some fine paintings are all admirable & I truly insist that you are in a position, with your natural taste & liking for the things beautiful to own & enjoy a collection that will eventually be one of the finest. I can prove without any trouble that all the things I have selected—especially the ones I recommend as the present best bets—are *excellent museum examples* (no junk) & at the same time *bargains*—in some cases one half of what they can bring in N.Y. I have covered the ground with about eight of the most important

54

galleries & *marchands* & they have all hunted around to give me the best the market can offer at present. You truly have a glorious opportunity I am sure.

To go back to your letter—there is no tax on frames or paintings to be paid, and your first expense will be your last. I can ship the pictures or insure them & store them until I leave in September & bring them along.

I have photos under separate cover coming to you & in the cases of most they do not begin to do justice to the painting, as they were taken hurriedly at my request. In almost all the cases the frames add almost 8 to 12 inches to the size of the painting itself & most frames are perfect beauties—old original antiques— adding greatly to the paintings.

To give you an unusual opportunity to compare I have sent many by the same artists—this gives you the difference in size, subject & price.

My best & most beautiful examples found are Nos. 10, 25, 22, 21, 28, 12, 30, 20, 18, 14, 19, 9, 26, 11—all marked in large Xs.

My personal choice is as follows:

Renoir No. 21. Renoir—a first-rate example—nothing better in the Louvre—green background, violet white waist, purple black hair, gorgeous frame, *a rare bargain* 72,500 francs.

Derain No. 25. Derain—a small gem, most unusual in quality, old antique frame, beautiful ochre, Van Dyke brown color, a perfect dandy almost for nothing—13,000 francs.

Modigliani No. 9. A beautiful example, best possible for money, fresh color (color description in back)— 55,000 francs.

No. 14 is smaller, very good however & much cheaper—good one to start with. Can be had for about 25,000 francs.

Pascin. This man will be $400 to $600 more next year. Buy now, if you want a Pascin.

No. 22. One of his best, easy to hang, beautiful pastel coloring, a gorgeous piece for your room. The nude you always wanted, a big one & a peach.

No. 26. A fine sensitive Pascin beautiful in color. Cheap at 22,000 francs.

Have two other canvases—large—about as nice as you can find, about 32,000 francs (no photos).

Gromaire No. 20. A wonderful chance to buy one of the finest of this man, done in 1923, absolute peach, at about half price 8,500 frs.

Dufy No. 28. One of his recent & best as well as most expensive periods—gorgeous blue green & purple with lemon yellow & violet—absolute bargain 15,000 [francs]. *Grab it.*

For the eye—Kisling No. 18. I don't like Kisling, but this is his best & a fine nude (if you don't buy Pascin)— gorgeous flesh & red background, very large, 100 × 81 unframed 14,000 frs.

Matisse No. 10. Very hard to find, better than Bonnard, beautiful color very reasonable for Matisse 85,000 frs.

De Chirico No. 12. A good one for the collection, fine contrast & cheap 6,000 frs.

Utrillo No. 30. A good thing for subject, size & color, very cheap at 9,000 frs.

From all these George, or the others you can take your pick. I have chosen the finest for size, subject (thinking of your taste) & value.

The little Renoir I mentioned is terribly small (No. 24), is worth the money but not as good a bet as others. It's about 14 inches high framed.

This is a possible scheme for about your investment—

Renoir No. 21
Pascin No. 22 or Kisling No. 18
Derain No. 25
Gromaire No. 20
Dufy No. 28 & if you can
Modigliani No. 9 or No. 14

I can say this as a summary—

Buy now if you truly want to have some paintings. These are *bargains*—all fine examples & a marvelous investment. With me in Paris for all time I can pick up bargains & each year you can add. I have picked pictures for your *home* & *taste* & I trust all is clear.

Gaugin [sic] is a bit too expensive to start with. The Picasso you want costs over $5000.

Write immediately regarding all this & send *all photos back*, as I have to return them. I also must pay for eleven pictures $80 that I had taken.

I hope to be in Paris about 2 or 3 weeks before going south so please *answer promptly*.

Hope the new Rhapsody is a hit & that all is well & make a lot of money & buy pictures.

Will write Ira & Mother soon.

Best from us all,

Harry

p.s. Go to a few galleries George & compare these prices. Don't hesitate to show the photos & get their opinions. I want you to feel confident of it all.

Here's to the new collection & I have an idea that the next new wing at the Metropolitan will be named after you.

p.s. One thing more—should you send a check, please make it a certified one, something I can present at a bank & cash at sight. Shall send full guarantees for proof that all are authentic pictures, with bills etc. etc. I have in most cases bargained for these prices.

Since many of these pictures have been pulled out of collections etc. could you *cable* me the word *INTERESTED* so I can tip off the various people.

MAY 1931

Gershwin telegram to Botkin, New York, May 4, 1931:
WILL BUY DERAIN NINETEEN MODIGLIANI TWENTY NINE PASCIN TWENTY SIX WIRE ME IF THESE TRULY FIRST RATE EXAMPLES WOULD LIKE FINE EARLY UTRILLO

SENDING CASH ON RECEIPT YOUR CABLE REGARDS
 GEORGE

Botkin telegram to Gershwin,
Paris, May 5, 1931:
PURCHASED DERAIN PASCIN PORTRAITS MEN FINE
EXAMPLES FIVE DEALERS RECOMMEND RENOIR
TWENTYONE NOT UNSIGNED MODIGLIANI CHOSEN
POOR INVESTMENT NUMBER NINE BETTER SENDING
UTRIILLO PHOTOS CABLE REGARDS
 HARRY

Botkin to Gershwin,
18 villa Seurat, Paris, May 5, 1931:
Dear George:

 Got your cable this morning & have been down to
the various dealers to carry out your instructions.

 I am most pleased with your selection except in the
case of Modigliani. The Derain of the painter Kissling
[sic] (19) is a very important painting & is reproduced in
several of the most important books that I shall name
later. It's fine in tone & a decidedly excellent museum
piece. The Pascin is unusual as he has done about four
men, & is extremely well painted. The nude by Pascin
(22) is more pleasing perhaps as a picture but not so
unusual. Usually paintings of men are worth a bit less
than the women but this is not important. So far I
am trying to cut down a bit in each purchase though
originally they were given at the lowest figures. In this
way I may have enough to present you with an extra
canvas—one little gem I have in mind.

 Now about the Modigliani George, he is not nearly
the artist or investment as the Renoir. A Renoir will
constantly go up in value & Modiglianis are always
dropping. I have talked with a half dozen experts who
own both men & they don't hesitate saying it's a foolish
choice. As a thing of beauty Renoir has it over the other
& as an investment there is no possible comparison. The
one you selected is unsigned, but this is not important
as many are that way. The Modigliani No. 9 is signed
& though a bit smaller, better in quality. I can get this
cheaper than the price quoted if I bargain some more.

 Buy the Renoir 21 even though it's a bit more. You
will never regret it. Renoir is the man to buy now. Were
you advised about the Modigliani or do you personally
prefer him to Renoir? Remember the Renoir photo
does not begin to do justice to the picture.

 I have found some marvelous Utrillos most unusual
in quality & price. In most cases done in 1912, his best &
most valuable period.

 I have made notes on a separate piece of paper
as to what I prefer & what have the most value as an
investment. The early Utrillos are terribly expensive
as No. 1 (St. Denis) $5000 (may get a bit off) but this
is perhaps his most famous piece. But in the others
I have better prices, in fact unusual bargains for the
same period. Consider all of these but buy one as it
will make a fine contrast with your other pictures.

 I want to congratulate you George on your start
& let this be the beginning of a most marvelous

collection. I am proud to represent you & trust all will
be satisfactory. I am awaiting a letter as to when you
will want them & also other details. Am getting special
frames & all details attended to.

 Am sending a cable tonight on the other details.
 Best regards to everyone & write soon,
 Hurriedly,
 Harry
 [p.s.] Cable what you want of the Utrillos. Some of
your other paintings chosen by me were sold before
arrival of your cable. Bargains for you are good buys
for others & they go quickly.

Botkin telegram to Gershwin,
Paris, May 8, 1931:
SEND SEVENTY THOUSAND FRANCS IMMEDIATELY
SHIPPING PICTURES SHORTLY MAILING NEW
PHOTOGRAPHS SORRY ABOUT RENOIR BARGAIN
WRITING
 HARRY

Gershwin to Botkin,
33 Riverside Drive, New York, May 8, 1931:
Dear Harry:

 I think you are swell to go to all the trouble that you
are going to, in order to start me on my long-wanted
collection of pictures. I hope that you are deriving
some pleasure out of choosing the pictures you have
chosen for me.

 You will notice that the two pictures that I have
chosen, namely, the Derain and Pascin, although
modern in feeling, were a little more understandable
than some of the others you sent, and I think, for a
while, my tastes will run along these lines.

 I wish you would send me a detailed description of
the pictures I bought, so far as color and treatment
are concerned, as I can hardly wait until I see them.

 Please remember this, for future reference: I would
rather pay a little more money for a good work of a
master than a little less for a good work of a second
rater. I would like to have nothing but the best, even if
I do not have many pictures.

 Mrs. Lewisohn[5]—of the Lewisohn family who have
the famous modern collection in New York—is a friend
of mine and promises to get me a good Matisse from
the man himself this summer when she goes abroad.
She has also arranged for me to buy a beautiful
picture of a fine American painter, Maurice Sterne.

 Are there any other things that you have seen in
Paris that you would like me to know about?

 I believe my friend Josie Rosinsweet, who is in Paris,
is coming to America the first of July. Would it be
simpler for her to bring my pictures over, or is it just as
easy to send them? If you send them, is there much
trouble getting them through the Customs?

 Please let me know about all of this.

 If you come across a good Modigliani, Matisse,
Picasso, Renoir or any of these first men—even if they
are expensive—I would like to hear about them.

 How is your painting coming along? Are you coming

back in September and are you planning to give a show in New York? If you are giving a show, will it be held at Rehns?[6]

I hope you and your wife are in the best of health and enjoying your stay in Paris. I am looking forward to seeing you both again when you return.

My family joins me in sending you all of the best.
Sincerely,
[signed]

Botkin to Gershwin,
18 villa Seurat, Paris, May 10, 1931:

Dear George:

I have just mailed you twenty odd photos of various paintings as you suggested in your cable. It is unfortunate that you cannot see these pictures personally yourself as never can a photo do justice to the canvas, & sometimes the better the painting the worse the reproduction.

I have had as many as eight different dealers with their various associates look in all corners of Paris for something that would appeal to you both in price & quality as well as subject. George, you have no idea how difficult it is to get pictures of real value & importance. There are so few things for sale by the important men, it is amazing. You just can't get hold of Renoir, Modigliani, Mattisse [sic], Picasso, etc. etc. without paying about $6,000 to $10,000 a canvas.

The things I have found are really the best possible at present & represent unusual bargains. I can get plenty of Utrillos & all other men, but Pascin & others I mentioned are terribly scarce.

The finest things I found, pictures that are true jewels, are 1A Renoir, 110,000 francs, 20A Renoir 85,000 francs, 15A Renoir 75,000 francs, Modigliani, 17A 55,000 francs, Derain 19A 45,000 francs, Utrillo 5A 65,000 francs, 10A Bonnard 46,000 francs. These are marvelous things—perfect in quality & price.

The Modigliani (17A) is the best on the market. Most of them start with 100,000 francs. If you want one by this painter, this is a bargain.

The Renoir 1A is a masterpiece & not at all expensive. It's truly one of his finest & even better than some in the Louvre. The Renoirs 20A, 15A are also beauties & considerably cheaper.

Every canvas that is reproduced is a fine thing. In some cases as 11A (two of them) I show you the price as a comparison to the ones I recommend. In the case of Utrillo, let me select one of the three you prefer, so I can make sure of the best, as they do not show up in the photos.

The two pictures you bought are excellent examples by the artists. The Derain is highly important & could go into the biggest museum. The Pascin is most unusual as he has practically done no men. It is large, well painted & an important piece. In both cases the prices are most reasonable & I got them by considerable bargaining. Most pictures are figured so closely you can't reduce them. I could have saved about $250 if you had bought the Renoir I suggested

in my first batch, as they belonged to one man. I am getting frames changed & things attended to with the two purchased & am awaiting your check. I have not found out how much it costs to ship & insure them.

I have worked many days on this task & am more than pleased to do it as it gives me a great deal of pleasure to know you are to have a collection & also that I can be of help.

I have had dealers go into private homes & the biggest collections to make sure they have covered everything. Later I may find more, but good bargains are almost impossible to get. People sell their jewels, women pawn their furs, but the paintings remain with them.

Cable me of your selections by number & subject & painter to avoid mistakes. The money for the Derain & Pascin I promised at once.

I hope all this is clear & will be helpful in your selection. Cable me even though you are not interested as soon as you decide. In some cases others are considering purchase of ones listed.

Will write again. Best regards to yourself & the rest of the family.

[Harry]

p.s. One Renoir photo was sent separately. All paintings are carefully examined for condition & each one is guaranteed as a first-class example. All Utrillos are from the 1911-1914 period, his very best.

Enclosure (Document Incomplete)

20A Renoir *	85,000 francs	My first choice
15A Renoir *	75,000 francs	My first choice
18A Soutine	22,000 francs	
21A Derain +	26,000 francs	My second choice
19A Derain *	45,000 francs	My first choice
16A Utrillo	45,000 francs	My second choice
11A Modigliani *	55,000 francs	My first choice
10A Bonnard	46,000 francs	My first choice
4A Bonnard *	80,000 francs	My first choice
9A Bonnard	45,000 francs	My second choice
6A Utrillo +	35,000 francs	My second choice
7A Utrillo +	35,000 francs	My second choice
8A Utrillo +	35,000 francs	My first choice
5A Utrillo *	65,000 francs	My first choice
1A Renoir *	110,000 francs	My first choice
2B Bonnard +	30,000 francs	My first choice as a bargain (not painting)
3A Renoir	70,000 francs	My first choice
11A Renoir * (small photo)	170,000 francs	My first choice but not cheap
12A Utrillo	40,000 francs	My second choice
11A Renoir (big photo).	130,000 francs	My second choice

* Marked in this manner are the masterpieces of painting.
\+ Marked [in] this manner greatest bargain for money

1A. RENOIR: 1900: A finished masterpiece of the painter, worthy to figure next to Velasquez, Titian

and the greatest painters of any period. Background brick red; blouse dark red with light stripes for the pleats. The face a brownish dark pink. The hair auburn. A picture on which the artist must have worked for a long time and with infinite love. Dimensions unframed: 36 × 49. Framed: 58 × 73. *110,000 francs.* Painted about 1900.

3A. RENOIR: Hair russet, face pink, blouse sky [blue]. Background greyish green. Price: 70,000 frs. Dimensions: 41 × 33 cms. unframed.

2B. BONNARD: Montmartre. 47 × 47 cms.

House in background white cream. House in foreground brown. Pavement lead blue. Horse brown. Dresses grey, red, and white striped. The corner of the photo is a photographer's fault. The picture is *entirely* finished. Price: 30,000 frs.

These are from the same gallery where I bought the *Derain & Pascin.*

Botkin telegram to Gershwin,
Paris, received May 16. 1931:
RECEIVED LETTER ESPECIALLY URGE PURCHASE RENOIR A1 ABSOLUTE MUSEUM MASTERPIECE MARVELOUS OPPORTUNITY RECEIVED MONEY WRITING CABLE REGARDS
HARRY

Botkin telegram to Gershwin,
Paris, May 19, 1931:
BUY UTRILLO NUMBER FOUR PERFECT BEAUTY THIRTYFIVE THOUSAND FRANCS BARGAIN OTHER UTRILLO NOT BETTER EXORBITANT CABLE IMMEDIATELY HAVE MATISSE ROUAULT BARGAINS WRITING REGARDS
HARRY

Gershwin telegram to Botkin,
New York, n.d. [ca. May 19, 1931]:
CAN YOU BUY UTRILLO NUMBER FOUR FOR ABOUT ONE THOUSAND DOLLARS ALSO LIKE NUMBERS TWO AND THREE WHAT ARE THEIR PRICES STOP WOULD LIKE GOOD ROUAULT PLEASE SEND PHOTOS OF ANY OTHER PICTURES YOU FANCY REGARDS
GEORGE

Gershwin to Botkin,
33 Riverside Drive, New York, May 19, 1931:
Dear Harry,

It is all very exciting, this starting up a picture collection, and I must tell you again how much I appreciate all the trouble you are going to to see that I get only first-rate stuff. I have been talking with several people in New York who know the situation very well and I am trying to use all the information I get to best advantage.

I met a man the other day named Maurice Sachs, who represents a very big concern dealing with modern pictures, both here and in France. I had him come up to the house and look over the photos that you sent. He seems to know the business from A to Z. He knows the Derain that I bought and likes it very much. He also likes the Utrillos, numbers two and three and, possibly, four. He says that the more white stone and the fewer trees there are in a Utrillo picture the more value it will have.

He is having the biggest exhibition of Modigliani in America next season that has ever been given, and he says that in Paris they are trying to lower the Modigliani market so that they can acquire as many of his better pictures as possible for the American exhibition. You can take this for what it is worth.

He also likes all the new artists' work, Rouault, and Soutine, after 1920.

He tells me that Renoir, in his so-called "Red" period, which was his latest period, is not so good as ten or fifteen years before that. Of course I, personally, would like to have a Renoir, but unless I got a very good one I'd rather not have one.

It seems to me that I will have to pick out some of the newer artists that are not so expensive, and string along with them.

Rouault seems to be in special favor at present in New York, also Duffey [sic], although I must admit, outside of some of his pictures of race-tracks, he leaves me a little cold.

I am awaiting eagerly the new photos that you are sending, and hope to find some that strike my fancy.

I went on Saturday to look at some pictures at the Dudensing, and one other, Gallery. I saw some very nice pictures and was very interested in learning the prices. They ask $6000 for a very nice Modigliani head; $3000 or $4000 for a lovely landscape by Segonzac; $1800 for a lovely Utrillo; $900 for an abstract painting by Léger; $1800 for a woman's head by Rouault; $250 for a pen-and-ink watercolor by Gromaire. These are the ones that I remember. Of course, they are all very good examples, as you must admit the American market gets perhaps the best choice. These are, of course, the asking prices and I am sure that from anywhere from twenty-five percent up can be cut off these figures. I imagine the same thing holds true in Paris as, you know, money is very scarce and picture dealers are most anxious to sell.

The Renoir you wanted me to buy may have been a beautiful picture, but the head did not appeal to me.

Now that I have several large canvasses, it might be a good idea to find smaller ones that have quality.

I feel I am very lucky in having you to help me start my collection, as I trust your sincerity and ability and know that you would not want me to have anything but the best.

I expect to finish the orchestration of my second Rhapsody in about a week and then Ira and I have to dig in and get some new songs ready for an Aarons and Freedley[7] show.

We are all in pretty good health, and hope the same is true of you and your wife.

With appreciative thanks and best wishes, I am
Sincerely,
[signed]

p.s. My friend, Maurice Sachs, says it is not unusual to have pictures sent on approval. Is this feasible?

Gershwin to George Pallay,
33 Riverside Drive, New York, May 19, 1931:
I am rather excited these days about a picture collection which I am starting. I have just bought three paintings through my cousin, Harry Botkin, who is in Paris, and I am impatiently awaiting their arrival. It isn't that I'm flush with money that I am doing this, but that I feel this is a good time to start a hobby which I have wanted to do for years, as the market for buying is very low. I have bought pictures by Derain, Pascin and Utrillo—three modern French painters, and all first-rate.

Gershwin telegram to Botkin,
New York, n.d. [May 1931]:
WANT BUY SUBURBS UTRILLO MODIGLIANI SEVENTEEN A AND POSSIBLY BONNARD FOUR A PLEASE WRITE IMMEDIATELY LOWEST POSSIBLE PRICE THESE THREE BUYING NOTHING MORE AT PRESENT REGARDS
 GEORGE

Botkin telegram to Gershwin,
Paris, May 22, 1931:
BOUGHT UTRILLO MODIGLIANI EIGHTYTHREE BUYING BONNARD SIXTYEIGHT THOUSAND AMAZING QUALITY BARGAINS CONGRATULATIONS WIRE OK IMMEDIATELY REGARDS
 HARRY

Gershwin telegram to Botkin,
New York, May 25, 1931:
SENDING EIGHTY THREE THOUSAND FOR UTRILLO MODIGLIANI WOULDNT IT BE WISER BUY FOUR FIVE PICTURES NEWER MEN FOR THE PRICE OF BONNARD WHEN SENDING PICTURES
 GEORGE

Botkin telegram to Gershwin,
Paris, May 26, 1931:
PURELY PERSONAL PREFERENCE FAMOUS BONNARD WONDERFUL BOY UNLESS SUBSTITUTED BY ROUAULTXYZ [sic] GROMAIRE TWENTY DUFY TWENTYEIGHT CHIRICO TWELVE SHIPPING SOON ANSWER
 HARRY

Gershwin to Botkin,
33 Riverside Drive, New York, May 26, 1931:
Dear Harry:
 I am sending you eighty-three thousand francs for the Utrillo and the Modigliani which you bought for me.
 So far, I think the four pictures I have bought are good in value as well as lovely pictures.
 I have been thinking about the Bonnard a great deal, however, and I would like you to look at it from my angle, which is this: The Bonnard looks like a masterpiece, but $2700 is a lot of money, and

buying the Bonnard would stop all picture-buying for the present. My friend, Maurice Sachs, who is a connoisseur of modern paintings tells me that although Bonnard will eventually get very big prices, for the next year and a half, or two years, he will remain about the same. So, I can get a good Bonnard at a fair price the next time I have some surplus cash.
 Somehow I feel that it would be more fun—although, perhaps, a little more dangerous—to buy some other young men, and string along with them without laying out a lot of dough. With a little luck one might find painters in Paris today who fetch as low as $150 or $200 for the paintings of the future.
 I am terribly anxious—can hardly wait—to see the pictures I have bought, in the flesh, so to speak. If they are not coming over immediately, please write me a detailed description of each.
 Awaiting your answer to my suggestion on Bonnard and newer men, and with kindest regards, I am
 Sincerely,
 [signed]

JUNE 1931

Gershwin telegram to Botkin,
New York, June 1, 1931:
OFFER THOUSAND TO TWELVE FIFTY FOR ROUALT [sic] CLOWN
 GEORGE

Botkin telegram to Gershwin,
Paris, June 1, 1931:
BOUGHT WITH GREAT DIFFICULTY FROM WEALTHY COLLECTOR TWELVE HUNDRED FIFTY DOLLARS EXCEPTIONAL BARGAIN WHAT OTHER PICTURES CABLE REPLY MONEY REGARDS
 HARRY

Gershwin telegram to Botkin,
New York, June 3, 1931:
SENDING MONEY HAPPY ABOUT ROUALT [sic] INTERESTED ONLY IN SMALLER INEXPENSIVE PICTURES NOW HAVE YOU SENT PICTURES REGARDS
 GEORGE

Gershwin telegram to Botkin,
New York, June 8, 1931:
WOULD LIKE TRADE PASCIN AT ABOUT FIFTEEN HUNDRED FOR RENOIR NUMBER FIFTEEN PLEASE ADVISE REGARDS
 GEORGE

Botkin to Gershwin,
Pension Brise de Mer, Golfe Juan, France,
June 15, 1931:
Dear George:
 Well here we are on the Riviera, right alongside of Juan les Pins, swell bathing, swell scenery & material for painting. We have a lovely place with a glorious

garden & all is ideal. Our place is facing the beach & the water is about a dozen yards away. We did a bit of traveling before settling here, & it seems a telegram which you sent to Paris just traveled all over the country until I got it.

I was rather surprised at its contents, & feel it is not wise to trade the Pascin in. He, above all, will be the one hard man to get hold of in the future. Any Pascin that you would want to replace this would cost from $1500 upwards. I do realize however that Pascin does not count alongside of Renoir, but he should be amongst your others. Some critics feel he will be proven a big man in the future.

I will write to Paris & get the dope on whether the deal would be possible. The picture could be sent back, if it were managed.

I am anxiously awaiting word from you on your reactions when the pictures arrive. I am sure you will be wild about them all, Pascin included.

I have about four big dealers scouting around in the private collections for you & it will be a good opportunity to get at pictures with a little more time. I will be sending you photos of some things I saw before leaving Paris & I trust by Sept. you will be able to spend some more dough, & I will be traveling back with some new fine things. Above all I would be most anxious for you to get a Renoir, & if possible a Bonnard. These are two men you cannot go wrong with. Matisse, I'd forget about for the present—his prices are *inflated* & all out of proportion to what he offers.

By seeing your pictures before you—living with them a while—your enthusiasm will increase more & more. Don't try & judge the canvases when they first arrive. They will grow on you with time.

I am going to send an itemized bill for the different items that were extra—two frames (Rouault & Modigliani), packing, insurance, cables & photos. Meanwhile here are receipts & guarantees on the pictures bought.

If possible don't buy anything till you tell me about it. I want to be sure you are getting the real things at real prices.

Hope all is going well with Mother & the family. How is Ira & Lee, yourself & the new show?

We played some of your things last night in the garden so you are represented at all times in these parts.

Give our best regards to all, George, from Rhoada & myself.

Harry

[p.s.] Write to: PENSION BRISE DE MER, GOLFE JUAN (A.M.), FRANCE
You must have past [sic] this place lots, driving by. We are a step from Cannes & Juan les Pins.

Will be making a few trips to Paris soon before the end of the summer so should you need anything, write.

Can get some swell primitive [sic] Negro sculpture cheap. Do you like them?

Gershwin telegram to Botkin,
New York, June 19, 1931:
THRILLED WITH PICTURES stop AM WRITING THANKS REGARDS
 GEORGE

Central Cable Office, 40 Broad Street, New York,
telegram to Gershwin, June 20, 1931:
YOUR CABLE MESSAGE JUNE 19TH 14 WORDS ADDRESS LCO HARRY BOTKIN AMERICAN EXPRESS NICE ADDRESSEE LEFT MESSAGE MAILED ADVICE FROM NICE

Gershwin to Botkin,
33 Riverside Drive, New York, June 20, 1931:
Dear Harry,

The pictures arrived and got past the customs without any extra charges. I did pay $58.00 for various small charges to the Hudson Shipping Company, but that was all.

The pictures are as you said they would be, much more beautiful than the photographs could possibly show, and, from now on, I appoint you my official framer of pictures, because I think the frames are beauties.

I believe that each picture is a fine example of the artist. The two favorites of most of the people who have seen them, so far, seem to be the Modigliani and the Rouault.

The Rouault is a gorgeous painting, although it is a little darker in tone than I thought it would be. The Rouault gives me great pleasure as a painting and I hope you will find some more of his work to send to me.

The suburbs by Utrillo is painted with a much more vigorous brush than some of the ones I have seen in America. It is a very luminous picture. It seems to throw out its own light. I am crazy about it, and it fits in perfectly in my living room.

The Derain is a masterpiece of simple color and the Pascin, while the least exciting of the five, has a strange quality that seems to grow on me.

Before the pictures arrived I sent you a cable which, unfortunately, did not reach you as you had already left for Nice. I wanted you to find out how much I would have to pay for the Renoir picture of two women in the doorway. In the cable I believe I made an offer of $1500, plus the Pascin as a trade-in.

Last week I met Maurice Sterne at the Lewisohns' country home, and I had the photographs with me. He complimented me greatly on my selection and you on your advice. He urged me to get this Renoir that I speak of.

Well, the pictures are all hung in my living and dining rooms and will give you a big welcome when you come over next time.

I am extremely happy that I have finally gotten started on a collection and, although it has been rather expensive, I feel that I am off to a flying start.

Please do not hesitate to send any photographs at any time, as I derive great pleasure out of seeing them.

I trust you are in Nice to combine pleasure and work, and I hope you get your full share of both.

On Friday of this week I am getting fifty-five musicians together to try over my new Rhapsody for me. I will let you know how it turns out.

Please remember me to your wife, and the entire Gershwin, Bruskin, Wolpin family send their best to you and your wife.

Your cousin,

[signed]

Gershwin to Botkin,
33 Riverside Drive, New York, June 30, 1931:

Dear Harry,

I received your letter and was glad to know you are settled on the Riviera . . . you lucky dog!

Ira and I are here in the hot city, waiting for Aarons and Freedley to send us a book for the new show. This is the time of the year our penthouse roof comes in handy.

Last Friday I had a private rehearsal of my new Rhapsody, at the National Broadcasting Studios. I was very happy to find that it came out just as I expected, and perhaps a little better. I think it is a big advance in orchestration over anything else I have done, and I think, from a structural standpoint, it is also ahead of any of my other works.

I am very anxious for you to hear it.

At Weyhe's Gallery the other day, I saw a half-a-dozen Rouault lithographs, hand-colored by the artist himself. They are beautiful pictures and the man told me they had been reduced from $1500 to $1200 for the six. I offered $500 for three, if he would let me choose the three that I wanted. He said he would think it over. They are very lovely pictures, with extremely bright color. What do you think of this proposition?

I am very anxious to get a few more Rouaults, as I feel he is one of the most powerful painters living. So please keep your eyes open for some of his work.

I am impatiently awaiting the photographs you promised to send of more pictures, of more painters, old and new.

I can only use a few more large pictures and the rest will have to be small, if I expect to hang them in this apartment. However, if you find some beautiful pictures that are good, I wouldn't mind putting them away until I can hang them at some later date.

If you see any Negro sculpture that you think I would fancy, and if it is extremely cheap as you say, why not get a few examples of it?

I hope the summer will be a very pleasant one for you and your wife, and also hope you are turning out some Botkin masterpieces.

Regards from everybody here, to everybody there.

Your cousin,

[signed]

JULY 1931

Botkin telegram to Gershwin,
Paris, July 25, 1931:

MUCH BARGAINING RENOIR WANTED NOW TWENTY TWO HUNDRED DOLLARS SEARCHING ROUAULTS CABLE AMEXCO NICE REGARDS

HARRY

Gershwin to Botkin,
33 Riverside Drive, New York, July 31, 1931:

Dear Harry,

I received your cable mentioning the Renoir at $2200 and also that you are looking for some new Rouaults.

I would love to have a picture by Renoir, as he is undoubtedly a great master, but unless I got something very special in quality and in price, I really wouldn't be interested. Because you know money is scarcer than hen's teeth these days and the depression is in full force, with nobody seeming to know when it will stop.

Therefore, the only reason for buying any work of art today would be on account of the extremely low price, as nobody seems to have any cash these days.

Maurice Sterne was up to my house last night for dinner. I showed him some of your watercolors and one or two oils and he seemed very impressed with your work, and he wants to meet you when you come to America.

He is crazy about the Rouault that I have. Thinks it is one of the best he has ever seen.

What about some of the photographs you said you were going to send, of some of the lesser-known painters? I understand Coubine is a very good man. He is being collected by Leo Stein, who was one of the men to first appreciate Picasso.

A week from Monday I am playing at the City College Stadium again, with the Philharmonic Orchestra on an all-American program. I am not playing my new Rhapsody because it would be unwise to play a new work for the first time in the open air, so I am saving it for next winter, with the possibility of having Toscanini or Stokowsky conduct it. I feel this new Rhapsody of mine is at least as good as my former works.

It has been terribly hot in New York the last few weeks, so Ira and I haven't really gotten started on our new shows as yet. The first couple of weeks of work in a new season are always the hardest, anyway.

I am glad to know that you are enjoying your stay in the south of France and that your wife is also having a fine time.

Your father was up to see us the other day. He looks well, but is looking for something to do and wanted to know if I could in any way assist him. If there is any way that I can help him I will naturally do it.

My mother is away with father at Tannersville, the Catskills, and although she is feeling a little better she is far from well.

Frankie has left with her husband, Leo, for Rochester, where Leo is going to work for the Eastman Kodak people and they will settle there for about two years but will occasionally make trips to New York.

I hope you are painting a lot and will come back with at least one hundred new canvasses, or maybe two hundred.

Are you planning an exhibition in New York next season? I think you should and I have a feeling it will go over well.

Take care of yourself and drop me a line soon.

Don't forget about the photographs.

Best regards to your wife and yourself.

Sincerely,

[signed]

AUGUST 1931

Botkin to Gershwin,
Venice, August 21, 1931:
Dear George,

Got your letter in answer to the Renoir & was glad to hear from you. I had always wondered whether my cable had gone astray & had planned to write you again regarding the picture. I can see your point about spending so much for a picture at this time & feel you are quite justified, although the canvas is at a very low figure & a good buy.

I have had many exchanges of letters about new photos for you & am sending some under separate cover. Many collectors are away on vacation & the pictures, especially good ones & low prices, are terribly few.

The younger painters such as Coubine, Friesz, Vlaminck & even smaller ones are so numerous that one does not know where to begin. The galleries are not anxious to send photos to such a distance on such inexpensive purchases & have suggested you give me a few hundred dollars, say around $500 & I could surely get you the best possible examples of the painters you desired. To get a real bargain one must see a picture that is desired, get it to its lowest figure & pay cash on the moment. This way one is sure to get a real value.

I can get things from $80 up to $200 or more of the younger group & in each case I have a choice from hundreds of pictures. Just tell me whether you want a Coubine landscape, figure composition or still-life, & in the same way of the other painters. In the case of some excellent young painters whose names are not known to you, let these items to me as they are only about $75 a canvas. I feel this is the best way to get the lesser painters as sending photos of their work is not like sending over Derains, Renoirs etc. where there are examples in New York to guide one's eye & imagination as to the real appearance of the work.

The Rouaults I am sending are in a few cases difficult to judge from the photo, but the Nos. 2, 7, 1, 8 seem about the best. In each case the prices could be lowered a little. It's absolutely surprising to see how hard it is to get hold of a Rouault, & finding these that I am sending took several months of hunting. I hope that you find something to your liking.

We are having a swell time in Italy & each city has been a revelation, though this is my second visit to most places. Rome, Florence, Naples all have marvelous things to offer. Find Venice a real fairyland & our stay here will not be forgotten soon. We had a fine year & it has been a fine trip. We still have the Italian lakes, Switzerland & London before we sail. Will be in Paris Sept. 1 & will have about three weeks there to settle details of your new additions.

All your news of home is swell though I am terribly sorry about Mother's health. I shall certainly be happy to meet Maurice Sterne & hope to have a few nice things to show. No, I will not have a hundred canvases. Good things are rare, as you know.

What is new with Ira & Lee? Rhoada & I will sure be tickled to hear that new rhapsody, & we are looking forward to it. Rhoada by the way has been actively interested in aiding me to get your pictures, & we have been around together picking them out.

Am hoping you will let me know at once about the pictures I am sending should they interest you. Wire 18 Villa Seurat.

Will sail for U.S.A. about Oct. 1. Give our best to the family & write soon. Rhoada sends her best.

Sincerely,

Harry

SEPTEMBER 1931

Botkin to Gershwin,
Hôtel Delambre, 35 rue Delambre, Paris,
September 4, 1931:
Dear George,

I am waiting for a reply to my last letter which I sent from Italy with some photographs, so that I may possibly purchase some inexpensive pictures, should you desire them, before my return [at] the end of this month.

We are once again in Paris, after the most delightful trip thru the Italian lakes & Switzerland. Paris looks good to us, though the weather is quite moist. I am clearing up several business matters preparing for my departure and am including some unpaid bills, which I am sending, with the hopes of settling them before I leave. I am enclosing them on a separate paper.

We are looking forward eagerly to our return to America, though business prospects are very decidedly funk, as would be natural.

I am terribly anxious to see you & the family & to see those pictures on your walls. We shall have lots to talk about—you, Ira & I—& I am hoping to launch a serious campaign to try & *put over*, as much as possible, my latest efforts. Will you help me?

Let me hear from you, & if there is anything at all that I can attend to for either you or Ira, let me know. I would like to get you about $200 worth of marvelous primitive [sic] Negro sculpture. How about it? Shall write you as soon as I get further word from you.

This bill *3,378 francs* that I am enclosing represents the expenses involved in the purchase of the pictures. Where frames were purchased, the others were so lousy, I just had to get new ones. They are a good investment.

The packing and insurance is clear. The cables & photos I hope are also clear.

Hope all is well with you & all the rest.

Our best regards to you & the bunch,

Harry

[p.s.] Write to Hotel Delambre, 35 Rue Delambre, Paris 14e.

Various Items Paid for Relating to the Purchase of the Paintings for George Gershwin

1 frame (antique) — 500 frs. (for the Modigliani)

7 cables ranging from 25 to 32 words each — 280 frs. (sent by me personally)

62 photos especially taken which were to be paid for. Others should be returned. (Prices ranged from 18 to 25 francs each.) — 1364 francs (sent by eight separate galleries)

Bill for items submitted by Van Leer (enclosed) — 2634.10 frs. (includes Pottier bill)

500 frs.
280 frs.
1364 frs.
———

TOTAL: 4778.10 frs.

A sum was left over & I had as a balance to one of your first purchases. 1400
——————

3378.10 frs. due

All these items have been clearly necessary, & I have cut over 600 francs for items that several dealers wanted paid. Had [Galerie] Van Leer write to N.Y. on your charges there & they reported that a letter to you from the Hudson Shipping Company showed that you were satisfied with their bill. I had planned not to pay so much.

I trust this is all clear George, & would appreciate a check the same way that you sent money for the pictures.

H.B.

Gershwin to Botkin,
33 Riverside Drive, New York, September 9, 1931:
Dear Harry,

I received the pictures you sent of the Rouault pictures. It is very difficult to judge these pictures by the photos, but I am quite sure that two or three of them are beauties. Oddly enough, the two that you wrote on, numbers two and eight, are the ones I like the most, too. I like number two, the picture of the two ladies, but it is too expensive. If I were going to spend that much money, I think I would be wiser to get an example of some other painter's work, instead of having two Rouaults. On the other hand, if I could get a good Rouault very reasonably, I would love to have it. I will leave it up to you, Harry.

When you come back to America in October, please bring me a few pictures that you think I would like, if they are inexpensive. I will leave it entirely to your judgment, as I feel, by now, you know my tastes pretty well. They don't have to be large, but they must be absolutely first rate in quality. Please don't fail me in this, as I would like to add to my collection. Cable me, at my expense, any ideas you have on the subject.

The theatrical season has started, but Ira and I are not doing a show for the early part of the season, as Aarons and Freedley have not been able to find a suitable book. In all probability, they will not do a show this year at all. We are working, however, on a George Kaufman book for a show to be produced by Sam Harris later in the season.

My parents came back from the country a couple of weeks ago and I am glad to report that Mother is feeling quite a bit better. For the rest, we are all in pretty good health. Frankie, who lives in Rochester now, with her husband, comes down to visit us every couple of weeks. She and her husband are happy and healthy.

I am glad to know you had such a nice summer, and that you and your wife enjoyed yourself as much as you did.

If you want me to, I can send you a thousand dollars for you to pick up some bargains for me or you can lay out whatever is necessary and I'll reimburse you when you arrive here.

Looking forward to seeing you and your wife again, I am

Sincerely,

[signed]

Gershwin telegram to Botkin,
New York, September 16, 1931:
SENDING ONE THOUSAND DOLLARS FOR BILLS AND SOME PICTURES USE YOUR BEST JUDGEMENT PLEASE WIRE PROSPECTIVE BUYS REGARDS

GEORGE

Botkin to Gershwin,
18 villa Seurat, Paris, September 29, 1931:
Dear George,

Your cable, including money, has been with me for many many days & though I had planned to cable you, I was not quite ready to give you an idea of what I could obtain for the smaller amounts we had planned on.

I want you to feel it is not my intention to get mere little scraps of pictures having no merit—just another canvas with a signature. It's for this reason, George, that I have been working very hard to get real quality works—things that could be hung alongside of your Rouault without a word of apology or explanation. I am buying a *few* things—three canvases, several fine drawings or watercolors, some African sculpture etc. To get all this, especially with names—not beginners, but established painters, like Chagall & Laprade etc.—

it's a job. I am not writing or wiring. I'll simply show you & you will agree that I have done a great job.

I have a chance to get three or four Rouaults—small but lovely things for about $250 apiece, real originals, some even done in 1904, his best period. If you want these, *cable* me when you get this letter. This is an extra item if you are interested. The other things are apart, as I want you to have new men & new subjects.

This is a hurried scribbly note to tell you of what's doing.

It looks as if I will be here until Oct. 15, even a bit later, as my plans are now. Want to be home now, but just can't make it.

Hope all is well & things are humming again. Will have a lot to tell you when I get home. Won't say much now as I am rushing to get this on a fast boat.

Don't forget to cable if you want the Rouaults. I can get one, or three, as you wish, about $250 apiece, the size [of] about this paper, but framed—about as big as those old etchings you used to have.

With best regards to yourself, Ira, Lee, Mother, Dad & the rest, from us
Les Botkins
(Harry)

Gershwin telegram to Botkin,
New York, September 30, 1931:
HAVE YOU BOUGHT ANYTHING WITH ADDITIONAL MONEY WHEN ARE YOU RETURNING
GEORGE

OCTOBER 1931

Stephan Bourgeois, Bourgeois Galleries, New York,
to Gershwin, October 2, 1931:
When I saw you last summer at one of the Stadium concerts you mentioned that you had made in the last years a collection of Modern paintings and that you wanted me to see them. Here I am back from Europe and at your disposal whenever it suits you.

Botkin telegram to Gershwin,
Paris, October 3, 1931:
BOUGHT CHAGALL AND LAPRADE OTHERS EXCELLENT VALUES STILL SEARCHING LETTER ARRIVING EXPLAINING ROUAULT CABLE REPLY REGARDS
HARRY

Carl Zigrosser, Weyhe Gallery, New York,
to Gershwin, October 3, 1931:
This summer you were considering three of the Rouault pastels which we had, and you made us an offer of five hundred dollars for the three. Mr. Weyhe is now back and I discussed the matter with him. He is willing to accept your offer if you still wish to get them.

Patricia O'Brien telegram to Gershwin,
New York, October 8, 1931:
LETTER FROM BOTKIN ASKING YOU CABLE HIM AT EIGHTEEN VILLA SEURAT PARIS IF YOU ARE INTERESTED THREE SMALL BUT LOVELY ROUALTS [sic] REAL ORIGINALS SOME DONE IN HIS BEST PERIOD stop ONE OR ALL OF THESE AT TWO HUNDRED FIFTY DOLLARS APIECE FRAMED stop SAYS THEY ARE AS BIG AS THOSE OLD ETCHINGS YOU USED TO HAVE stop THESE APART FROM THE PICTURES HE IS BUYING WITH MONEY ALREADY SENT stop WINFIELD SHEEHAN WIRES THAT STEERAGE SEQUENCE AND HOME OF RUSSIAN TROUPE LOOK VERY GOOD stop THAT GAYNOR GIVING BEST CHARACTERIZATION OF HER CAREER AND THAT ENTERTAINMENT IS SPLENDIDLY PICTURED IN ALL DAILY RUSHES stop GOOD LUCK TO YOU AND TO GIRL CRAZY
PATRICIA O'BRIEN

Botkin telegram to Gershwin,
Paris, October 13, 1931:
FORGETTING ROUAULTS NEED ADDITIONAL HUNDRED FIFTY DOLLARS EXCEPTIONAL PURCHASE BOUGHT FOUR BARGAINS CABLE MONEY IMMEDIATELY SATISFACTORY REGARDS
HARRY

Gershwin to Stephan Bourgeois,
33 Riverside Drive, New York, October 14, 1931:
I received your letter and will be very glad to see you some time and have you look over a few pictures that I have recently acquired. I will get in touch with you some time later on, as at present I am very busy finishing the music for a new show which goes into rehearsal in about two weeks.

Gershwin telegram to Botkin,
New York, October 22, 1931:
WOULD LIKE IMPORTANT SOUTINE INSTEAD LAPRADE
GEORGE

Botkin telegram to Gershwin,
Paris, October 23, 1931:
HAVE TWO MARVELOUS IMPORTANT SOUTINES EACH ABOUT THOUSAND DOLLARS STOP MAY ACCEPT LAPRADE ALREADY PURCHASED TWO HUNDRED DOLLARS CABLE IMMEDIATELY
HARRY

Gershwin telegram to Botkin, New York,
October 24, 1931:
FIVE HUNDRED LIMIT FOR SOUTINE WHEN DO YOU RETURN
GEORGE

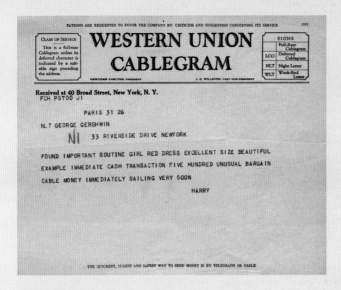

Fig. 64. Henry Botkin telegram to George Gershwin, October 26, 1931

Botkin telegram to Gershwin, Paris, October 26, 1931:
FOUND IMPORTANT SOUTINE GIRL RED DRESS EXCELLENT SIZE BEAUTIFUL EXAMPLE IMMEDIATE CASH TRANSACTION FIVE HUNDRED UNUSUAL BARGAIN CABLE MONEY IMMEDIATELY SAILING VERY SOON
 HARRY

NOVEMBER 1931

Botkin note of accounting to Gershwin, November 29, 1931:
To George Gershwin—
Balance due on Paintings, Frames, Shipping, & expenses = $74.58
 (as itemized on other side)
 Due $74.58
 Note: This covers all items & is balance of bill *in full* for all paintings & expenses for G. G. to date. H.B.
 Henry Botkin

Bill to George from Harry on Paintings
Due on previous bills		3378 frs.
Painting	Laprade	6600 frs.
Painting	Krémègne	2000 frs.
Painting	Chagall	5500 frs.
Painting	Walkowitz	1250 frs. (no bill)
Painting	Vlaminck	3000 frs.
Painting	Dufy	5500 frs.
Painting	Billette	900 frs.
Total		28,128 frs.

Frame	Krémègne (part payment)	225 frs.
Frame	Chagall (part payment)	300 frs.
Frame	Walkowitz (full payment)	175 frs.
Frame	Vlaminck (part payment)	175 frs.
Frame	Dufy (full payment)	500 frs.
Frame	Billette (part payment)	150 frs.
Total		1525 frs.

Additional Expenses
Recanvassing Chagall	125.00 frs.
Two cables	75.50 frs.
One cable	51.00 frs.
Backing and case	375.00 frs.
Consular Invoice	67.00 frs.
Delivery and Train	75.00 frs.
Shipping Paris-Havre-N.Y.	450.00 frs.
Shipping pier to home	150.00 frs.
Tips, Customs & Express	50.00 frs.
Total	1418.50 frs.

Grand Total Spent		31,071.50 frs.
Had Received	First check	25,417 frs.
	Second check	3790 frs.
		29,207 frs.
Total spent		31,071.50 frs.
Received		29,207.00 frs.
Due		1864.50 frs.
		or $74.58

DECEMBER 1931

Handwritten note, perhaps by Gershwin's secretary, on the above note of accounting, December 1, 1931:
Paid check #1190, 12-1-31

JANUARY 1932

Louis Causse, Balzac Galleries, New York, to Gershwin, January 22, 1932:
I am sending you herewith photograph of the painting by Gromaire, of which I spoke to you last night. . . . I trust you will be able to spare a few moments to come and see it.

APRIL 1932

Hecht, Newhouse Paintings, New York, to Gershwin, April 15, 1932:
I am very sorry to have missed your visit yesterday. . . . I am enclosing a copy of *The Bridge* by Peter Blume for your files. You may know that this canvas is the property of a private collector and has just been offered for sale thru these galleries. . . . I am familiar with some of the canvases you have acquired and feel that an important example of Blume's work has a definite place in your collection.

Botkin to Gershwin, Paris, April 18, 1932:
Dear George:

Back again in the ol town & if there is depression, the quarter is still the same. One feels the bad conditions though, but things have not come down, & the cafes are still quite full. The trip was O.K. & the crossing fine. I managed to acquire a little color as the sun was with us a good part of trip. I hope things are going nicely & that you are planning some fine things for the future. Am anxious about your dad & want to hear about him.

Got on the job about the pictures & there are some fine bargains to be had. A few Rouaults are to [be] had & I shall send pictures. They are really low in price & excellent in quality. Getting Derain & the others we talked of. Of course real important pictures at good prices are still no cinch to locate, but I am sure you will be lucky. In some cases $300 will buy a *very fine* picture. I think I can get a 1st class Rouault, very large size canvas, for around $1000. Of course these are museum pieces. Smaller ones are much less. Am working hard to find the best & on the next boat you shall have some photos. Quick action will result in better buys as it's the immediate cash that will produce a better buy around here.

How is Ira & Lee & what is new in your painting, or is that put aside for a while? Am terribly busy working on pictures for Mrs. [Edith] Halpert & I am not having much time for fun as yet.

Will write in a few days with the dope on the various things.

With best wishes to you all.
Sincerely,
Harry

Botkin to Gershwin, Liberia-Hotel, 9 rue de la Grande-Chaumière, Paris, April 22, 1932:
Dear George,

Am enclosing or sending separately a number of photos of the various things available at present. There will [be] more soon but this batch includes a few which I think should prove real attractive buys.

The picture situation is in a funny way. There are bargains, but one has to wait till someone has a canvas worthwhile & who needs money. A *quick transaction* usually means a real low price. In most cases the pictures offered are not 1st quality so that in our case they would not be the kind we would do business with.

Ever since I wrote my first letter to Paris for you these dealers hunted for your paintings. The reason they did not answer was because they did not find what we wanted. Four months' work resulted in 2 *Rouaults*—I mean real examples—early 1904 etc., not these late circus posters of 1930. An Italian Period landscape of Derain (1921) the period the most rare (20 in the entire epoch) is so hard it's almost impossible—the museums have them—we have found one, which I enclose.

I have 3 Rouaults which are perfect examples & wish you could take all. It would be simply marvelous to have a collection of Rouault that would include the best period & these are of that kind. These are also *bargains*—about 50% cheaper than a year ago.

(No. 8) For example the peasant woman can be had for the price of what they asked for colored lithographs, about 6500 frs. about $250. It's a marvel, beautifully painted & better than any one of those 18 or 20 Rouaults we saw in N.Y.

(No. 1) Head of Clown by Rouault is the most beautiful one imaginable. It's *very colorful*, absolutely gay & fresh, in contrast to the tone of your present one. This is a real *master* piece & 15,000 frs. is cheap. Framed it would be as big as your Modigliani, maybe a trifle smaller. If you saw it, *you would grab it. One finds a picture like this only by chance.*

(No. 12) The big head is the one I told you about. It's a real *Museum* piece & the most important of all. It's very big (about like your Pascin) & a head, so you can imagine the impressive beauty it possesses. It's in brown, blue & white, in oil (palette knife) & the *very best* of that period (1920).

No. 13 This Utrillo is a *white one* & *a beauty*. It's the best period & marvelous in quality. It is a painting that called for 35,000 frs. on my *last trip*.

No. 2 This Rousseau was so hard to find, & we had to beg the man to release it. It's one we would have to pay $5000 or $6000 in N.Y. today at *reduced prices*. I can get it for $2200. It's very rare & again here is a chance to get a truly important painting, the kind you really want.

No. 14 This Derain is the one I want you to get— it's the type of picture you won't find again & it's a bargain 15,500 frs. Other Derain landscapes of today can be had for 7000 frs.

I would get at least the 2 Rouaults No. 12, No. 1. They are perfect. The 3rd we could add $100 & give in the Laprade. So for over $2000 you could get 3 *Rouaults* all perfect or get one Rouault, the Derain landscape (No. 15), Utrillo No. 13. Will have a Picasso, about 40,000 francs, next week. Hope this is all clear.

Have been spending a lot of time getting these things together & hope you profit by it. All these pictures I marked with * are the things I feel are the most important, as bargains & as pictures.

Hope all is well at home. Write me about Dad. Have been terribly busy, rented my big studio right away. Paris is lovely, but I am [too] occupied to enjoy it.

Cable me if you want any of these. All prices are reduced already & can be trimmed very little. Would buy *at least* $2000 worth of this batch, in fact, the Rouaults, Derain landscape & Utrillo are all perfect buys.

Write to me immediately kid & tell me what's what.

Am looking for other pictures.

Best regards to Ira, Lee Mother Dad & yourself.

Harry

p.s. Am rushing to get this on the boat. Write to 18 Villa Seurat

*No. 1. Head of clown by Rouault, 15,000 frs. (a perfect beauty)—one you will never regret getting).

*No. 2. Landscape, Douanier Rousseau 52000 frs. *Most important*—very hard to get even at twice this price.

No. 3. Church by Utrillo, 32,000 frs. A marvelous picture but too much for Utrillo (too expensive for now).

No. 4. A clown Rouault, 20,000 frs. Not nearly as good as the others. I don't recommend it.

No. 5. Landscape by Utrillo, 10,000 frs. A beauty of this kind—cheap too.

No. 6. Roses by Chagall, 18,000 frs. The flower & landscape picture beauty for color & very important.

No. 7. Bridal couple Chagall, a fine one & cheap, 13,000 frs.

*No. 8. Peasant woman Rouault 6500 frs. *Get this picture.*

No. 9. Renoir (didn't get the photo) too expensive— 41,000 frs.

*No. 10. Fish by Vlaminck 6000 frs. A marvel for painting. Please take it in exchange for your Laprade.

No. 11. Chagall, 9000 frs. A good one if you like it.

*No. 12. Clown by Rouault 30,000 frs. Just as important as your present one & *more* impressive.

*No. 13. Utrillo 17,500 frs. A bargain—this is *the Utrillo to get.*

*No. 15. Derain 15,500 A *perfect buy—the* picture by Derain.

No. 14. Derain, a bargain 9000 frs.

Marked with * I especially urge the purchase of *these*.

Enclosure on Letterhead of
Galerie Van Leer, 41 rue de Seine, Paris

No. 1: Head of a clown, 42 × 34 cm. This picture, though not a big one, is considered by Rouault to be his best head of a clown. Painted round about the year 1910, the picture is painted in a lighter harmony than most other works of the artist in whites, blues and different shades of red. The tragic expression of the face contrasts strangely with the delicacy of the color.

No. 2: Landscape of the Douanier Rousseau 46 × 36 in his very best technique and painted round about 1906. The upper part of the sky is in cerulean blue. The clouds are of a warm greyish blue. The lower part is of a lighter blue, a sky as could only have been painted by the Douanier. The roof of the house in front is of a subdued brick color, whereas the windows and the house on the right are of a very warm brown. The little gate is of darker brown. The stream and the trees are dark green. The edges are of a lighter shade. Was exhibited at several exhibitions, amongst others at the Marie Harriman show. A picture of a haunting harmony, comparable with no other artist's work and breathing an infinite repose.

No. 3: The church of *La Ferte-Milon* by Utrillo. 81 × 65 The church itself innumerable variations of whites, greys and very light blues. The trees a brown russet color, interrupted by different shades of green. Down the slope the village pink with red roofs. The wall to the left different shades of grey and white. The little square beige and in the left corner green. A majestic work of a quality of which there can be only very few in America. 1912.

No. 4: A clown by Rouault. 69 × 55 Painted round about 1910. The browns reds, the face and the stick blues and blacks. A warm harmony and a lively rhythm.

No. 5: Landscape of the *Butte Pinson* by Utrillo, dated about 1907. 46 × 36 In the Master's impressionistic manner. Subdued in key like all works of this period. Predominating harmony green and brown. The foreground blue. The two trees in the foreground with green and yellow blossoms. The far distance and the sky in lighter tone than the rest. Through the trees one can see the church and the village, different reds, yellow and slades. An excellent example of his impressionistic period.

No. 6: Chagall. 92 × 73 The roses different shades of red and pink. The bowl in a light brown key. The leaves different shades of green. The house and landscape in the background predominantly blue and very light and delicate in tone. 1928.

No. 7: Chagall. 81 × 65 The bridal couple. The bride light blue and white, bridegroom dark blue. The bird in all the colors of the rainbow. The hill and animals wine red. The top part pink. 1928. Both Chagalls very typical works showing at the same time the exquisite touch and the "baroque" element of his art.

No. 8: A peasant woman by Rouault. 37 × 24 The background is in a rich green, the face and figure in warm blues, greens, reds and browns. A work of which the sober strength makes one think of a Daumier.

No. 9: Girl on the grass by Renoir. 39 × 25 The girl's hat a bright yellow softened by brown, with pink roses. The hair dark golden. The blouse a beautiful warm red. The skirt in white, interrupted by grey shadings. The rest of the picture predominantly in greens and browns. The whole giving a feeling of summer and happiness.

No 10: Fish by Vlaminck. 65 × 54 The background is of greyish reddish brown, the lower part of the fish in silvery whites and greys, the upper part in dark browns, slade with yellow spots. The fish is reposing on green grass of different shades. The top part of the work of bright red, setting off the other colors. A picture with all the sparkle and virtuoso handling of the artist.

Botkin telegram to Gershwin, Paris, April 30, 1932:
FOUND LARGE RARE PICASSO WOMAN ABSINTH [sic] DRINKER 1902 IMPORTANT COLLECTION YOUR ROUAULT SIZE BLUE WITH RED SIMILAR PLATE FOUR RAYNAL PICASSO BOOK FIVETHOUSAND DOLLAR PICTURE PRICE AROUND EIGHTEENHUNDRED UNUSUAL BARGAIN CABLE
HARRY

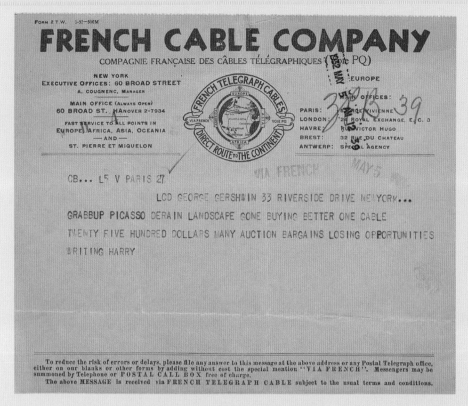

MAY 1932

Fig. 65. Henry Botkin telegram to George Gershwin, May 5, 1932

Botkin telegram to Gershwin, Paris, May 5, 1932:
GRAB UP PICASSO DERAIN LANDSCAPE GONE BUYING BETTER ONE CABLE TWENTY FIVE HUNDRED DOLLARS MANY AUCTION BARGAINS LOSING OPPORTUNITIES WRITING HARRY

Gershwin telegram to Botkin, New York, May 5, 1932:
OFFER $2000.00 NO MORE PICASSO AND DERAIN LANDSCAPE GET CHAGALL 7 OR ROUAULT 1 FOR LAPRADE AND LITTLE EXTRA INTERESTED FUKISHIMA [sic] ROUAULT.
 GEORGE

Botkin to Gershwin, 18 villa Seurat, Paris, ca. May 5, 1932 [misdated as May 4]:
Dear George:

Have just sent a cable in answer to your offer on Picasso & Derain landscape. I must say you are lucky because I was sure there was nothing doing. In fact the Derain was sold about three days ago for a higher figure than I quoted you. With the Picasso I was successful as the dealer is satisfied with only $40 commission. As we have another Derain landscape found very luckily, even a *better buy*, you will still be able to almost make it, or it will be about $2075 or so. I am sure you will find your Derain as a gift—as your Picasso in Paris today is worth over that as a *dealer's* price. Picasso runs from 4 to 10 times higher in price than Rouault, depending on the period, & as this picture is larger than your Rouault & of his most important (blue period) epoch you can most certainly be proud of your purchase, especially when no Picassos are available.

As the dealer who is handling these pictures makes only a small commission & does not own the Picasso & Derain, he cannot accept the Laprade in a Chagall trade.* The large clown head of Rouault could be managed with the Laprade. It's the same *marchand*. I will trade the Laprade in anyway but now I cannot manage it, until I do the proper business to make it worthwhile.

The [Shigetaro] Fukushima Rouaults are *out*. He has been busy promoting the Chinese Japanese war & making a pretty penny on it & does not want to sell. We are doing *something better*, getting into the [Ambroise] *Vollard Collection*, the *choicest Rouaults possible*. It's very hard, but we have worked *very hard*, even been thrown out of places to get your pictures. The Vollard Rouaults will not be *bargains*, but the rarest things can be had, especially the ones you want.

How much do you offer for the Renoir—*the two women* in the doorway that you nearly bought last year? *Cable this* as it's a fine chance. It can be had for less now I guess.

Am going to try the auctions with my dealer (the one that sold you most of your pictures) & I can get good values. It's a good bet, since one can really buy real things at marvelous prices. Don't you think it's a good idea? Have asked for extra money for this purpose.

Of the pictures I am sending, the Rouault Clown No. 3 is the beauty. It's better than yours, in oil paint & now in the Amsterdam Museum show. It's really the *best* to *be had*. The Pascin is the best quality & a good bet. The landscape Rouault No. 2 & the No. 1 are both in Switzerland, but are dear.

Am waiting to hear from you—regarding the pictures—by letter.

George! My *best* congratulations to you & Ira on the Pulitzer prize. *Pretty special what!* How are things—are you working on something? What is new about Dad? Still serious?

Have been terribly busy. Sent 8 pictures back to Mrs. Halpert last week. See my pictures there, about May 16.

Write to me & give my best to Ira & Lee & the family. Tell Ira I am writing. Best of bests,
 Harry

* The Rouault No. 1 head is a *beauty—buy it.*

Botkin telegram to Gershwin, Paris, May 7. 1932:
HAVE PASCIN LARGER THAN YOURS BALZAC PASCIN QUALITY SIXTEEN YEAR GIRL SEATED HALF NUDE SUPERBLY CHARMING ONE PRICE FOUR HUNDRED SEVENTY DOLLARS CABLE
 HARRY

Gershwin telegram to Botkin, New York, May 9, 1932:
WHAT HAVE YOU ALREADY BOUGHT OFFER 400 PASCIN WOULD LIKE PHOTO TRADE LAPRADE WITH EXTRA FOR SEGONZAC LANDSCAPE STILL INTERESTED ROUAULT CHAGALL

Gershwin to Botkin, 33 Riverside Drive, New York, May 11, 1932:

Dear Harry:

Just received your letter and the new photos you sent. I am happy to know that you are so enthusiastic about the Picasso I bought. I feel my collection should be much more complete with that fine picture. I can't wait till I see it. Are you going to send it or bring it with you?

I am also very anxious about the Derain landscape. I hope that it is of the 1920 period. You know the kind I mean. Please send me a photo of it or else a complete description.

Did you manage to see the Fukushima collection of Rouaults? And did you speak with him about them? The Rouaults you have sent me recently are very difficult to judge from the photos and I am determined not to buy any pictures that don't appeal to me greatly even from the photograph. If I am to buy another Rouault I think it would be wise for me to buy one that is in contrast to the one I have, perhaps one showing another phase of the man's art. The No. 3 photo that you sent called *Pierrot* looks like a very attractive picture but it is darned expensive. It is very hard for me to judge No. 6 the landscape of Versailles, or No. 1. Do you ever think about my idea of getting Rouault to paint the Last Supper? It might be worth investigating.

I would love to have you get, if possible, one of the Rabbi pictures of Chagall. I'd like to own another picture by this mystic painter.

If you happen across a Dufresne, something like the one in the Reinhardt Galleries show, I should be interested in it.

The Pascin picture you sent lately looks like a very nice one. I am a little sorry that there are no flowers depicted in it as Pascin paints those so beautifully. However, I am sure I can trust your judgment in the selection of that picture.

I am certainly in favor of your going to auction sales as I am sure that pictures can be gotten there at the best possible prices.

Remember, Harry, I am leaving it to your good judgment to get only masterpieces by these artists and if those are not available we should not take second best. Also, money is very scarce during these depressing times and one must be ten times as careful of what he spends.

I am sorry to tell you that my father has not improved. He remains about the same and there is very little encouragement coming from the doctors.

Ira is painting quite a bit these days, and I have just finished a self-portrait in evening clothes. The picture has been admired by Maurice Sterne and Mrs. Reinhardt and I am anxious for you to see it.

Please write me often and send photos. Are you looking after the framing of the new pictures? Take care of yourself, don't work too hard, and I'll be looking forward to seeing you soon. Ira and Lee and the family join me in sending all the best to you.

As ever,
[signed]

Botkin to Gershwin, Paris, May 12, 1932:

Dear George:

Expected a letter from you on the S. S. Bremen yesterday but none came. Have been racing around a great deal, busy at all times looking for your pictures. It's not an easy task George, especially to get *important* pieces. Four dealers & their agents are constantly working for me & in the weeks I am here, very little has come up. No one wants to sell good things at bargain prices. They know it will come back again. Besides these people *do not* need money. The dealers need the dough but do not have the things I want.

I have been lucky—in fact you are extremely fortunate George—so far the things we have are *marvelous things* & extremely low prices.

I have lined up several Rouaults. Saw the man yesterday. This was after four visits—my dealer was almost kicked out the first time, trying to persuade him to sell. He has about *seven gems*. I am going to make a final offer tomorrow & *grab them*. They are beauties—small, but important—all in oil paint & subjects that you will love—dancer, clown, & dancer & dog etc. etc.

There are two auctions to be had here—one [May] 23rd & the other June 1st. I would like to have at least $1000 for these sales. I will surprise you. I have bought one thing thru a dealer at the last sale—a Modigliani *Caryatid*—for less than $200. This was sold by mistake—it was to go at twice that, & now the person is suing for the difference. They wanted to buy it back at a profit from me.

At these auctions, I do not bid myself. I have three or four people working for me. It pays to give them each a commission as they are on the inside & will positively get the thing, in fact fix it for me.

Each sale of 150 pictures has five important pieces. Fifty to one hundred dealers go for them. If they knew I was buying the price would go way up, but thru a dealer we fix the thing & practically make sure of the price. I shall send a list of things that will go on sale, but please trust my judgement & those working for me. You *will never* go *wrong*.

There is a whole collection of Rouaults in Zurich, Switzerland—can be had for very little. It might be [worth] the trip there—am waiting for a wire tomorrow. Gee kid, I got the whole town working for you, so please do not turn down a picture the last minute for $50 or $75 less. It does not pay.

I want to hear of what's new at home & what has been happening with you & Ira. Saw a few of your friends here. Have been terribly busy, so please excuse these hurried letters. Want to be leaving town here about June 2nd or 3rd. With best of bests to you all,

Harry

[p.s.] The Picasso you have is an absolute masterpiece.

Julien Levy to Gershwin, Paris, May 12, 1932:
Mr. Botkin told me that he has bought several fine things already for your collection. . . . I have seen the painting by Eugene Berman which you selected from the photographs at my Gallery. I find that it is probably the finest that Berman has made to date. The dominant tonality is a light brick red-orange against a blue sky, beautifully painted with a fine rendering of light and atmosphere, and with a sense of "style" and tradition which, even in his early dark canvases, has been the predominant quality of Berman's work. It is difficult to describe, but I promise you it is an important picture. However, it has been painted as one of a pair, the other painting being equally fine, and composed to supplement the first, and Berman refuses to permit either to be sold separately. Before seeing the painting myself I asked you $125. for it, so I am willing to let you have the pair for $250. If you want them framed here in Paris where frames are so reasonable I could get frames for about $10. each, and all shipping charges would be paid by me as I can bring the pictures with my own shipment in June The two are really the finest Berman has made recently in his new manner. . . . Hoping to hear from you soon.

Gershwin telegram to Julien Levy, New York, May 20, 1932:
CAN I SEE PHOTOS HAS BOTKIN SEEN THEM SOUNDS INTERESTING REGARDS
 GEORGE GERSHWIN

Botkin telegram to Gershwin, Paris, May 24, 1932:
AFTER COMBING PARIS FOR ROUAULTS BOUGHT TWO EXCEPTIONALLY IMPORTANT EXAMPLES EXTREMELY LARGE COMPOSITION BATHERS ALSO THREE CIRCUS PERFORMERS TWELVE HUNDRED DOLLARS MANY AUCTION BARGAINS BONNARD BRAQUE RENOIR NEED EXTRA THOUSAND ALREADY POSSESS FOUR MASTERPIECES
 HARRY

Gershwin telegram to Botkin, New York, May 24, 1932:
CABLING FINAL THOUSAND PLEASE WIRE PURCHASES SO FAR LIKE DESCRIPTION BEFORE BUYING WANT NO DOUBTFUL PICTURES REGARDS
 GEORGE

Botkin telegram to Gershwin, Paris, May 30, 1932:
PURCHASED PICASSO DERAIN MODIGLIANI TWO ROUAULT COUBINE MASTERPIECES NEED FIVE HUNDRED COMPLETE SALES CHOOSING TCHELICHEW OR CHAGALL DUFRENNE CABLE IMMEDIATELY REGARDS
 HARRY

JUNE 1932

Gershwin telegram to Botkin, New York, June 1, 1932:
CABLED MONEY TERRIBLY ANXIOUS TO KNOW DETAILS OF EACH PICTURE PLEASE ARRANGE FRAMING WHEN DO YOU RETURN
 GEORGE

Gordon B. Washburn, The Buffalo Fine Arts Academy, Albright Art Gallery, Buffalo, New York, to Gershwin, June 15, 1932:
This letter brings our deep appreciation for your kindness in loaning your picture by Pascin at the time of our Twenty-sixth Annual Exhibition of American Art this past month. Due to your generosity we were able to exhibit a notable collection of the works of this master, which was universally admired. Your own picture, *Portrait of a Man*, was of the finest quality, and it was a great pleasure to place it in the exhibition.

AUGUST 1932

Accounting memo prepared by Botkin
PRICES OF PAINTINGS PURCHASED
FOR GEORGE GERSHWIN

All purchase prices include the various commissions and special expenses involving sale.

Derain	Landscape	$360.00
Coubine	Landscape	$130.00
Picasso	Woman	$1700.00
Modigliani	Nude	$225.00
Rouault	Three Figures	$400.00
Rouault	Bathers	$800.00
Rouault	Peasant (with La Prade)	$43.00
Chagall	Man	$265.00
Lahner	Landscape	$40.00
Lahner	Flowers	$30.00

Paintings total:	$3995.00
Frames total:	$181.00
Other expenses	$85.00
Total	$4261.00
Received from N.Y.	$4000.00
* Due H. Botkin.	$261.00

Handwritten note on memo: * Paid Aug. 5, 1932

FOR FRAMES AND SPECIAL MATS

Derain	painting	$16.00
Picasso	painting	$22.00
Coubine	painting	$14.00
Modigliani	painting	$16.00
Rouault	painting small	$15.00
Rouault	painting small	$15.00

Rouault	painting large	$35.00
Chagall	painting	$20.00
Lahner	painting	$10.00
Lahner	painting	$14.00
Special finish on small frame		$4.00
Total		$181.00
Shipping—Studio to Havre to New York		$32.00
Packing—expressing		$17.00
Consular Invoice		$2.50
Cables (Botkin)		$7.00
Cables (Galleries)		$11.50
Special Fee for M. Aaronson to search for Rouaults		$6.00
Cables to Zurich, Photos, Taxes for galleries		$10.00
		$85.50

Louis L. Horch, International Art Center of Roerich Museum, New York, to Gershwin, August 29, 1932:
We are planning to open our season, in October, with a fine portrait show. . . . We understand that in your splendid collection, Mr. Gershwin, there is a portrait of Kisling by Derain, and are writing to ask whether you would be kind enough to lend it to us for our exhibition.

SEPTEMBER 1932

Gershwin's secretary Eleanor Baldwin to Louis L. Horch, New York, September 13, 1932:
Mr. Gershwin will be very glad to lend his Derain portrait of Kisling for your exhibition in October.

OCTOBER 1932

Louis L. Horch, International Art Center of Roerich Museum, New York, to Gershwin, October 12, 1932:
We take great pleasure in inviting you to the special opening of an Exhibition of Portraits of Artists at the International Art Center of Roerich Museum, on Saturday afternoon, October 22nd. As one who is so keenly interested in the development of art we would also be glad to have you serve as a member of our Honorary Committee of Patrons on this occasion.

NOVEMBER 1932

Edith Halpert, The Downtown Gallery, New York, to Gershwin, November 1, 1932:
Several days ago I talked with Max Weber and during our conversation your name was mentioned in connection with the painting called *Cellist* in which you are interested. . . . I shall be glad to send you the picture on approval so that you may see it in your own surroundings and in connection with other fine paintings in your collection. . . . If you are really interested, as you say, in acquiring a great work by a great artist, this is a rare opportunity—an opportunity which you as a collector cannot overlook. . . . In closing may I say that although we are always glad to make a sale I am urging this matter for your benefit and this is not sales hokum.

MARCH 1933

Botkin to Gershwin, Liberia-Hotel, 9 rue de la Grande-Chaumière, Paris, March 24, 1933:
Dear George:
 Well kid—here I am in Paris once more, & it looks quite good too. Had a good crossing—nice friends—& met a close friend of Kay & Jim Warburg, Sam Barlow. I think you know him—he is a composer & has an opera that the Opéra Comique plans [on] doing with Mary Garden. The weather has been grand & I have been hopping around with my various activities to attend to.
 This brings me to pictures—
 The letters I have written the past few months regarding possible pictures for you has resulted in something *GRAND!!!!!*
 Really kid for a *starter* I have [a] group of marvelous buys, & you will see by the photos that I am not stretching it by getting enthusiastic.
 These photos were taken with extra expense & care but in *no way* show up the true beauty of color & quality these canvases have.
 I am truly surprised & you would be too, if you saw the activity & bustle in the galleries. They are actually *busy*. Dealers are taking very small profits but selling many more pictures in the last year. Besides collectors refuse to put pictures on the market knowing they would have to sell at low prices.
 All these pictures I am sending come from nine or ten various collectors, galleries only owning about three or four. They are all from the best & important perlods of the artists & this is important. Besides most are from *famous* collections & are reproduced in books & magazines that I had no time to look up.
 No. 1. The one you must buy *at once without hesitation* is the Bonnard—a perfect beauty—about the size of your Modigliani portrait & absolutely *dirt cheap*. $550. For the subject, period, quality & rare appeal it's a prize. It's marvelous color, lovely reds, greys, blacks, yellows, & looks like a Picasso of an early period.

No. 2. The Rousseau is the most precious of all for sheer beauty, that I am enclosing. It's small—an inch or two bigger than the photo—but framed with the mat & frame, it comes a bit larger than the picture of your Grandma's head. This is one that was in Marie Harriman's famous Rousseau show 2 yrs. ago. It just sparkles with beauty & honestly this little canvas has more charm than Mrs. Lewisohn's huge jungle picture. You will never for many years get one like this. Rousseau is the *hardest* man to buy. Always mounting in price & never for sale. The price is *$750* which I am sure is ¼ of what Mrs. Harriman would ask. It's perfect in subject—little figures, Seine, bridge & Eiffel Tower—real Paris.

No. 3. Renoir. A real Marie Harriman picture—perfect in subject, color, period (in between the early, & later epoch) & grand in every way. An amazing blond with red hat & red blouse. One of the best Renoirs I have yet been able to get in your range. *$1700* is the price (about your Modigliani portrait size).

No. 4. Your much desired *white Utrillo*. A real museum piece—one I think would even surpass your present one in beauty. It's the rarest & most expensive period & about the same size as yours. The price *$1000*. Can get many other beauties for $500, but this is the $5000 kind of a few years ago.

No. 5. Matisse. A real *bargain*—as big as your Derain Portrait of Kisling & a very fine example—not the usual striped interior that one sees dozens of, but a grand work of his early period, in beautiful liquid tones, really dirt cheap, for size & importance—*$1500*. Dudensing today at a very low price would ask around $4000.

No. 6. Pascin—little girl. Never did you see a more charming picture, amazing in subject & price—even better than the one you wanted to get from the Balzac Galleries. It was in the famous Bernheim Jeune collection & one of his masterpieces. *$575—very cheap*.

No. 7. Gauguin!!! And a self portrait. The Modern Museum would be proud of it. Full of color, done in a sort of fresco style, oil & egg tempera. Absolutely genuine & given away for nothing, *$350*. This seems almost ridiculous in price—a Cézanne self-portrait this size is easily $10,000. It's as large as your small Rouault Peasant head.

No. 8. *MODIGLIANI MASTERPIECE* But is $2400 so why *rave*. It's very big, about the size of your Pascin & exactly like that big marvel Dudensing has. This used to sell at *$10,000*. Dudensing today would ask $6000.

No. 9. *Dufy* A real beautiful canvas—large & gorgeous in color—*$350*—absolutely 1/5 of its value.

No.10. Pissarro watercolor, & real Knoedler piece—*1st class* quality—of that rare Max Jacob quality, about as large as your big Rouault clown—*$350*.

No.11. Soutine Blue Background period—his most expensive. This was $3500 2 yrs. ago, *$700 now*. Rare *quality*.

No.12. Utrillo's early grand period of your favorite Paris street scene—a rare canvas though I prefer the white one—*$1350*. Utrillo is bringing amazing prices today.

No.13. A Grand Modigliani—best quality—a beautiful work $750. When I bought yours, this was $2500.

No.14. A Beautiful Pissaro [sic]—Durand Ruel quality—$1000.

Of all these pictures George, I would grab the Bonnard & Rousseau. Even if the latter is small, someday you will get a bigger one & this is a *jewel*. Both of these 1st rank painters to be had for the price of that *Weber* (I still love the Weber & think you should someday get it).

The Gauguin at $350 should be grabbed—it's absolutely a ridiculous price. *Please don't* turn this down. About the others I can't say, as all but a few are worth grabbing. The Renoir, the Matisse, & the white Utrillo.

It's a good thing you are *not* here George. You would *buy* the big $2400 Modigliani & 6 others. In other words you couldn't leave without spending $7000 or $8000.

Please cable an answer. Dealers have worked on this since we first talked of coming to Paris together, months back. All these prices have been cut.

But don't fail to buy at least $1200 worth as they are *amazingly* cheap & 1st quality museum pieces. Not one canvas would be out of place at Knoedler's, Marie Harriman or the finest museum.

Hope you are busy kid & well. Tell Ira I'll write to him, & also say to Eleanor *her Paris* is grand but damned expensive. CABLE at once, as many many people have cooperated & I have promised a prompt reply. CABLE—LIBERIA HOTEL 9 RUE GRANDE CHAUMIERE.

[Harry]

p.s. You might let Kay & Jim Warburg see the pictures. They might be interested at these prices. Excuse the horrid, hurried scrawl. Am trying to make the boat.

Botkin to Gershwin, Paris, March 30, 1933:

Dear George:

I am waiting to hear from you regarding those pictures I sent last week. I do know you will be surprised when you get them, as they were an amazing collection.

At least three of them should be bought *at once* & hope you agree with me—especially since they are extremely low priced.

Pictures in Paris are *not* easy to get. That batch I sent represents the efforts of many many men—hunting for me since I wrote to them almost a half year back.

While people would like to sell they realize they must sell at *depression* prices & for this reason prefer holding on.

I have my fingers on *everything* in the picture market in Paris. I can produce & quote prices on thousands of museum pieces, but George as you know we can't be interested at this time. For example I can get a *huge* forest scene of Rousseau (like the Lewisohn size) for about $6000 or so—it was $20,000—& many other similar items.

But with your needs at present, I am trying for pictures like your first Rouault & Picasso piece—for importance & for even a lower price.

You will agree with me that you have some *rare* buys & if you could only see the original works you would be far more enthusiastic.

For example, these Renoir drawings I am enclosing are the *choicest* & *grandest* things that can be bought—they are real *masterpieces*. But $1200 is a lot for drawings (though they are framed as paintings). That is why your Renoir painting that I sent is an amazing *buy*.

The Matisse nude, No. 3. is a fine picture, but too much like others. That makes your 1st Matisse, which is twice the size, better in every way. It's *individual* & not like fifty others that are done in *series*. I only want pictures for you George, that are not only the best in *quality* & *price* but absolutely *rare* & *outstanding* as *great museum pieces*.

This brings me to two Derains 4 & 5. No. 4 is a *masterpiece* & when I say that I am not exaggerating a bit. It's just one of those rare pictures an artist does in a life time & all other things look insignificant by comparison.

It is as big as your Pascin & amazing in quality. It's similar to that beauty that we saw at Sam Lewisohn—the Italian lady—white tonality. But this is more rare than that.

I like it *much more* than your Kisling portrait—the dealers agree.

You must buy it. Even if this is the one & only picture. It's $850—*lowest price* & absolutely a bargain. Your [Derain portrait of] Kisling was $1800 & this is worth in size & importance $3500 today. It's the price that Dudensing figured your Derain landscape to be & honestly, this picture alongside of the other is no comparison.

$850 is the *last price* & not a cent less will they take.

The still life No. 5 is a beauty & I just can't *see you miss this too*. Again I repeat George—if you were here, you would be tempted to spend *$10,000* which I would certainly not want you to do. I have found some *amazing* things. This still life beats anything of this type done by this painter. It's a beautiful piece of color & would be your *only* still life next to a Cézanne worth buying.

It's $775, & if you bought the *two* I *might* get a small reduction.

No. 7. Vlaminck is a *rare* example—one out of 200 that I would pick. $225—the price of the youngest painter in America.

8. The Chagall is a bargain & the best I can get. Much much worse are going at $700 or $800. It's individual & has that peculiar fantasy that you like so much. It's $375 (lowest price) & as large as your Segonzac.

9. The Pascin is the same as your other in price & size. Excellent quality.

George please cable a reply on these, as we can reserve these [no] more than a week. I *want* you to

own this *Derain portrait* at least. Trust you will find my search has proved of some benefit, & am still hunting. Will get some early Picasso abstraction *papier collé* (Harriman type).

Am anxious to hear from you & what you are doing. Best regards to all,

Harry

p.s. Always rush these letters to get the boat train. Excuse it.

Gershwin telegram to Botkin, New York, March 31, 1933:

BUY GAUGUIN OFFER 450 PASCIN BUY ROUSSEAU UNLESS BETTER ONE AVAILABLE LIKE UTRILLO STREET PRICE HIGH WOULD PAY AROUND 800 WANT PINK PICASSO

APRIL 1933

Botkin telegram to Gershwin, Paris, April 1, 1933:

BOUGHT ROUSSEAU PASCIN GAUGIN [sic] CABLE MONEY HUNTING PICASSOS EVERYWHERE FORGET UTRILLO SENT DERAIN MASTERPIECES EUROPA GRAND OPPORTUNITY

HARRY

Botkin to Gershwin, Liberia-Hotel, 9 rue de la Grande-Chaumière, Paris, Tuesday, [April 4. 1933], received April 12, 1933:

Dear George:

Am waiting for a letter from you, in answer to the pictures. Am glad to see you liked the Pascin, Rousseau & Gaugin [sic]. They are *beauties*. The Gaugin [sic] can be sold to the Metropolitan Museum tomorrow & at $2500 it would be given away. The dealers just can't understand how I got it. It's absolutely authentic (six dealers all experts saw it) & it's a marvel of a work.

The Rousseau I had already raved about & it's the only one for sale in Paris today, unless you want to pay around $4000 to start. *No one* wants to sell Rousseau. You can buy Cézanne, Seurat & the others plenty, but Rousseau is *treasured* & not on the market. It's worth double in France today.

The Pascin is a beautiful work & the subject *superb*. The idea of a child subject makes it worth $300 or $400 more, as it's really rare, as compared to the regular Pascin female figure subject.

Have hunted all over the place for Picassos. They are *not to* [be] *had* & when you find them the price is ridiculous. Dudensing is cheap by comparison. Terrible things are offered for 3 & 4 thousand. The reason is that Picasso, backed by two of the biggest dealers, holds the price way up.

Those 2 Derains can be had for ½ price of a *poor Picasso*. George—*grab them!!* They are beauties & can never be bought again so cheaply.

That Renoir I sent was a beauty—it's a half of a poor Picasso & a darn fine picture. We will find Picasso at

another time—just now it's like reaching for the moon.

I want to buy at least $100 or $150 of fine Negro primitive [sic] sculpture. They are magnificent things & $150 will buy 6 excellent *museum examples*. $5 will buy a little fake, but $30 will buy a real $100 example. *Cable this* when you cable about pictures, whether you [will spend] $100 or $150 or *less*.

Am buying some *wonderful* young painters to average around $45 or so apiece, but *real works of art* (men of 20 yrs. experience).

Will get *your* Derain either in trade with a big priced picture (as part of the payment) or in exchange for another piece. So far the dealers have made only *$40 or $50* profit on each picture & I can't ask much yet. In each case the pictures came from private collections.

I forgot to say your Pascin was *$500*. Could not cut it a penny less. I decided I could not lose it, as your Gaugin [sic] was for *nothing*. No one will believe you when you tell them what you paid.

Am trying to get a Braque thru an auction. Also a few other things—of this I am not certain. If I can *fix* it O.K., we can buy.

Please have your *Segonzac* & *Derain landscapes* (purchased from Dudensing) measured for me again. It can be in inches or centimeters. I measured *once* but want to make sure for the frames. Measure the *canvas*, as it's stretched *only* (nothing else). *Cable this!* I measured

82 × 55½ cent	Segonzac
61½ × 46	Derain

I am sure this is *O.K.* but if you can verify it (in inches) it will [be] O.K. (Cable the word O.K.)

Ask Eleanor if she *really* wants a $50 picture for a friend. A word in a cable will be sufficient.

Kid, I am anxious to hear from you—what you are doing & what has happened since I left. Have had two weeks of real hard work here—my house & your pictures—but both have worked out grand.

Cable me news of anything important. Best to Ira & Lee yourself & the rest, also to Eleanor,
Harry

Botkin telegram to Gershwin, Paris, April 10, 1933:
PICASSOS UNAVAILABLE HAVE AMAZING UTRILLO LIGHTHOUSE REFER PHOTOS EIGHT FIFTY DOLLARS GETTING BRAQUE MASTERPIECE FIVE HUNDRED CABLE IMMEDIATELY
 HARRY
Handwritten note on this telegram: Vlaminck (I.G.)

Gershwin telegram to Botkin, New York, April 11, 1933:
WANT ONE MASTERPIECE WOULD YOU CONSIDER LAST YEAR'S BONNARD WILLING TO SPEND 1500 DOLLARS PLEASE TAKE YOUR TIME LOOK AROUND SEND PHOTOS BUY VLAMINCK FOR IRA
 GEORGE

Botkin to Gershwin, Liberia-Hotel, 9 rue de la Grande-Chaumière, Paris, April 12, 1933:
Dear George:
 Just a hurried note to catch the boat in answer to your cable of today, regarding Utrillo, & your inquiry of an important picture.

George, I have *hunted* & have had six dealers & their various cohorts *comb* the market thoroughly. Absolutely nothing can be had. Expensive pictures that people paid around 75,000 frs. cannot be had for small prices. No one, especially those that have paid huge prices, wants to sell at a big sacrifice. Your Rousseau was actually given as a *favor* to the dealer. She did not want to sell it at any price.

Your Bonnard of last year was sold at around 60,000 frs.—that ends that.

Picassos & Braques seem a mystery. *None to be had* & when they are for sale they go over 50,000 frs. to begin with. To get a good Picasso I would have to pay at least $3000.

The Utrillo I [wrote] about in cable—*The Lighthouse*—which I sent a photo of a couple years back, is a *masterpiece* & *a bargain*. $850 is dirt cheap. The companion to it, painted about 2 weeks later, in the same place, is the windmill subject* with several small houses. They want 35,000 frs. for that. I am still working on that however & if I can [get] it for about $1300 I'd grab it.

I bought you a marvelous white Derain still-life. Lovely size, lovely epoch—a real gem—pale blue, white, pink etc. for $350. I just had to grab it, as it's your first still life of importance & a $1300 *picture*.

Your Renoir head I sent, & your Derain Paul Poiret are the *2 perfect bets to consider*. They are *both masterpieces*. Honestly that Derain P. Poiret is absolutely a beauty—*please buy it*.

Tell Ira to cable (night letter) on how much he wants to spend on books. Also let me know how much to spend on Negro masks & sculpture.

Am trying to get a good deal on *your* Derain.

George, I leave the 26th on the Bremen but will search up to nearly the last few days. Your request of $1500 for a masterpiece is not easy to fill. The Renoir & Derain come the closest, together with Utrillo. Bonnard is hard to buy—one extreme or the other.

Am waiting for a letter from you. Hope all is O.K. *chez vous*.

Paris has been heavenly, but will be glad to return.

Cable *at once* after this letter & tell me what to do.
Regards to all & yourself,
 Harry
 * in your Utrillo book

Gershwin to Botkin, 33 Riverside Drive, New York, April 12, 1933:
Dear Harry:
 I have just received your third letter and feel a little guilty at not having written you before, but consider my various cables as short letters to the point.

From your description of the three paintings I have bought I am terribly anxious to see them, as I feel that they will make a really notable addition to my collection.

Zborovski [sic] came up one day and I showed him the photographs you had sent. He urged me to get the Rousseau and also, almost tearfully, asked me to consider the Zborovski [sic] portrait by Modigliani. He went so far as to offer to buy it half-and-half as a joint investment. He said that he could get it cheaper than the price you mentioned. However, I feel that I have two good Modiglianis and if I were to get another one I should like to get one of his maid subjects, rather than another portrait of a man.

I am very much disappointed at not being able to get a pink Picasso. I am simply crazy about those pictures.

You mention that you have a Braque masterpiece. I wouldn't think of buying a Braque without seeing a photograph of the subject, as many of his things leave me cold.

In my last wire to you I suggested that you take your time and find me one masterwork. I think that is a wise decision, as I don't want to clutter up my collection with too many small items. I would rather do some concentrating.

I am glad that Ira has decided to buy the Vlaminck as I am sure that he will enjoy it, and it seems like a good price.

One of the reasons I didn't take the Derain portrait of Paul Poiret was because I do not want to have a collection of portraits of men. The still life Derain looks like a very rich painting but I don't particularly like the Cubistic manner in which it is done.

There is nothing new here except that my mother returned from Arizona and unfortunately isn't feeling very much better. I am planning to take her to Dr. Hay's Sanitarium in Mt. Pocono, Penn., next week.

I have painted one picture which everyone seems to like, and I will try to have at least two more by the time you return.

I hope everything goes well with you and that you are in good health. Everybody here sends love.

[George]

Botkin to Gershwin, Paris, April 14, 1933:

Dear George:

Am enclosing a photo of a Bonnard which is a *masterpiece*. It is one of those big impressive, beautiful works which rarely can be obtained these days. It was painted about ten years ago, & is positively precious in color—lovely pastel shades—not too colored & at the same time very rich & luminous as Bonnards are. This is a picture which would be the most impressive of your collection. It is perhaps even better than the Bonnard you wanted—the one which was sold—as it's *more* Bonnard & less something else. The other was so black & white & early it could have been several other painters.

I prefer this one much to the other & it's a *great* bargain $1800. This is a tremendous piece & if you take my advice, I'd buy it as *the* picture, the one real work. Bonnard is the best man to buy today. He is very old, produces nothing good now & a canvas of this kind cannot be duplicated at twice the price. Utrillo & Bonnard should be bought now. Picasso is inflated & so is Braque.

Am leaving April 26th, & I want to take this with me. Buy this Bonnard George, it's a rare beauty. The photo does not begin to do it justice.

Will cable before this reaches you, as I must make a quick decision. It's a $5000 picture. With best regards,

Hurriedly,

Harry

[p.s.] Have bargained this to the lowest price. Cable at once George—not much time.

Botkin to Gershwin, Paris, [April 18, 1933], received April 24, 1933:

Dear George:

Sent you a cable but those things cost too much money & you say darn little so here goes an added note.

Kid! Your lil cousin Harry has just worn his shoes out looking for those masterpieces—especially that $1500 kind. They are either $1350 or $1750—so what am I to do? Honestly kid I have truly gone thru this town with a fine comb & if I missed a worthwhile buy it's not my fault or that of my 10 cohorts that have been burning up taxi meters helping me. The thing is simple: Picasso is just too darn unreasonable. $2500 buys nothing. Your canvas is cheap at $5000 to what I have seen. Bonnard & early Utrillos with good early Derains & possibly Pissarro are the best bets. Bonnard is *the* best buy for you—as you have none & he has one foot in the grave. Let that guy die & good Bonnards start at $4000 each. Your last year Bonnard was sold last October for a *fat* price. I found one (the one I wrote about & cabled today) that's even better—larger, better period, better subject & more *important* piece. I hope to *Gawd you buy it*—it's worth every *sou* & you won't be disappointed. The photo I sent *does not begin to do it justice*. Ignore that!! Other Bonnards less than ½ that size cost $1350 & are not nearly as important. Your canvas is one of the finest you can buy & I have seen at least 100 by that gentleman.

Utrillo in his early period is most important to buy. They are low in price—& he is leaving for the angels very very soon too—he is quite batty you know. $1200 buys a masterpiece, $800 buys an excellent example & so it goes. I *bought* you a swell Kandinsky & a swell Masson abstract (he also had a show at Dudensing), *both* of these about $180. I did not think you would mind. Those paper abstractions of Picasso—also jumped to a $1000 too—& I just had to buy an abstract picture to start you! So dear Boy—I spent about $550 (with your Derain still life) which is a *darn* good investment. Having a heck of a time swapping your Derain—selling a picture today or even swapping is tough. All your pictures were bought in different places & a profit of about $40 was had on each—so when I mention your Derain I get very ugly looks.

75

However I have not given up. Kid—I am booked to leave the 26th on the Bremen—only a most urgent call for another masterpiece will force me to sail a few days later. If I don't sail the 26th it will be on the 29th Aquitania.

Hoping this clears things a bit. Have not been asking what's new we have been so business like.

Lots of best—to you & the gang,
Harry

Botkin telegram to Gershwin,
Paris, April 18, 1933:
YOUR BONNARD SOLD PURCHASE GREATER MASTERPIECE SIMILAR PAGE HUNDRED ONE BONNARD BY TERRASSE YOUR LARGEST MAGNIFICENT CANVAS SEVENTEEN HUNDRED FIFTY SMALLER IMPORTANT EXAMPLES THIRTEEN FIFTY CABLE IMMEDIATELY SAILING SOON
HARRY

Gershwin telegram to Botkin,
New York, April 19, 1933:
SEEMS TOO MUCH FOR BONNARD WILL NOT BUY ANYTHING WITHOUT SEEING PHOTO WHEN ARE YOU RETURNING REGARDS
GEORGE

Botkin telegram to Gershwin,
Paris, April 20, 1933:
POSITIVELY PURCHASE BONNARD FORMERLY FIVE THOUSAND LOUSY PHOTO BERENGARIA BONNARD PLATE TWELVE CRES EDITION THIRTEEN HUNDRED MARVELOUS REPRODUCED UTRILLO WINDMILL TWELVE FIFTY ANSWER IMMEDIATELY STAYING WEEK
HARRY

Botkin telegram to Gershwin,
New York, April 22, 1933:
MARVELOUS MASTERPIECE UTRILLO PAGE HUNDRED THREE TABARANT BOOK TWELVE HUNDRED ABSOLUTELY PURCHASE BONNARD OR UTRILLO PACKING THURSDAY CABLE NINE HUNDRED IMMEDIATELY
HARRY
Handwritten note on this telegram: Eleanor phone G.G. to describe this picture.

Gershwin telegram to Botkin,
New York, April 24, 1933:
OFFER EIGHT HUNDRED TO ONE THOUSAND UTRILLO WINDMILL REGARDS
GEORGE

Botkin telegram to Gershwin,
Paris, April 25, 1933:
PURCHASED UTRILLO CABLE THOUSAND IMMEDIATELY DOLLAR DROPPING
HARRY

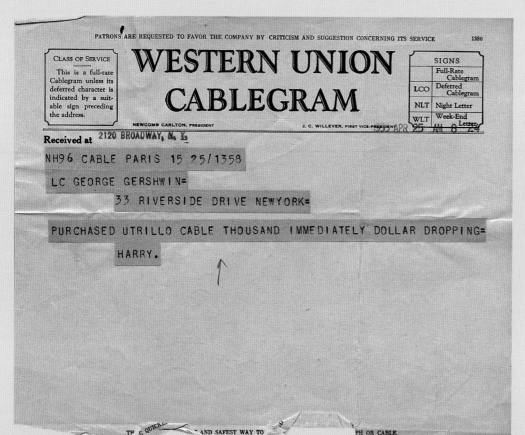

Fig. 66. Henry Botkin telegram to George Gershwin, April 25, 1933

Botkin to Gershwin,
Paris, April 25, 1933:
Dear George:

Since I will arrive in person five days after this letter, not much of an explanation is necessary. However, since I know you are quite excited about your purchases, I will give you a little idea of things.

Your cable to buy the Utrillo windmill was *grand news*. I just hoped you would select it since I always remembered it as a beauty—a real masterpiece. The reason you have heard nothing about it before was because of the *price*—$1500. After much terrible work of bargaining, I got it to $1200, but of course your offer of $800 to $1000 was impossible. I won't tell you of the dirty work, but I almost let the darn thing go—they would not come down—& only because of the dealer passing up his profit do you possess it. It will cost you $1100 though, because of the exchange. It cost an extra $100 because of the drop in the dollar—almost 13% difference in exchange. If the old Utrillo cost you nearly $1500, this is worth $2000 at the lowest bargain price. It's a *beauty!* Just wait till you see it—$1100 is dirt cheap for the finest Utrillo I would want to buy. I have seen 50 beauties in an exhibition & I insist this would be in the first 3.

George, pictures are more valuable today & harder to get than ever. Each picture bought for you (outside of the younger painters) was bought with a *struggle*. Your Rousseau is a jewel! Saw it in its new frame—very tiny but absolutely superb—much better than those huge decorative things.

Tell Eleanor there was no time for photos, but I have a swell landscape by a well-known painter. Also bought a beauty for you by the same artist.

Had an idea the Bonnard would be a bit too high for the moment, but it was a *gem* & we may get it next year.

So far I have found nothing good for your Derain landscape & prefer to bring it back, either to give to Zborowski to sell (he can surely do it) or return again with it when dollar is at last stable. (If I bought the Bonnard the dealer was to take it.)

This drop in the dollar made a difference of about $100 on the Vlaminck, Derain, & the other younger painters. I squeezed the dealers some more & cut it to a half—about $50—or $5 to $10 on each picture, not much at that. George old top—I delayed my sailing from the Bremen to the Aquitania & am due back May 5, & I have worked like the devil on your things (6 separate trips to the framers to see all is so) & know you will be *very very happy!* Also when I think that Gaugin [sic], Rousseau, Derain, Utrillo & Pascin "*bests*" were bought for around $600 each, even less, I feel very happy. That's the price of a *bad Brooks!* I have Ira's books & prints—a *marvelous* group of Negro sculpture for you & all is set. Am glad it's over too. It was very very hard, George, to get these swell things at these prices.

Get the people that cleared our pictures the last time ready. Am bringing the things in my name for ease. Am so anxious to see you, Ira, & the rest! My love to all,
Harry

CIRCA MAY 1933

Botkin note of accounting sent to Gershwin

PAINTINGS PURCHASED FOR GEORGE GERSHWIN
PARIS—APRIL 1933

Rousseau	$750.00
Gauguin	$350.00
Pascin	$500.00
	$1600.00
Received by cable	$1550.00
Balance due	$50.00
Tchiltian	$55.00
Derain	$350.00
Hayden	$100.00
Masson	$95.00
Kandinsky	$95.00
Pailes	$78.00
Krémègne	$30.00
Four pieces Negro sculptures (less in exchange included)	$110.00
	$913.00
Received by cable	$900.00
Balance due	$13.00
Utrillo ($100 extra due to exchange)	$1100.00
Received by cable	$1000.00
Balance due	$100.00

FRAMES

Rousseau	$28.00
Gauguin	$27.00
Pascin (with other frame)	$18.00
Hayden	$17.00
Tchiltian	$10.00
Derain	$35.00
Pailes	$20.00
Utrillo	$20.00
Segonzac	$35.00
Derain (Landscape)	$22.00
	$232.00
Krémègne	$16.00
	$248.00
3 bases and mounting sculpture	$10.00
	$258.00

Paintings purchased for George
Gershwin — Paris April 1933

	$
Rousseau — — — — — — —	750.00
Gauguin — — — — — — —	350.00
Pascin — — — — — — — —	500.00
	$1600.00
Received by cable	1550.00
Balance due	$50.00

	$	
Tchiltian — — — — — — —	55.00	25
Derain — — — — — — —	350.00	6/453
Hayden — — — — — — —	100.00	55
Masson — — — — — — —	95.00	100
Kandinsky — — — — — — —	95.00	95
Pailes — — — — — — —	78.00	95
Kremengne — — — — — —	30.00	78
Four pieces negro Sculpture — —	110.00 ← (loss in exchange included)	30
	913.00	453
Received by cable — — —	900.00	
Balance due —	13.00	

	$
Utrillo — — — — — — — —	1100.00 ($100 extra due to exchange)
Received by cable	1000.00
Balance due —	100.00

EXPENSES

six cables	$16.00
Packer	$25.00
Invoice	$2.50
Express Paris-Cherbourg-NY	$29.00
	$72.50

IRA

Books, Prints	$25.00
Vlaminck (Exchange & Frame Included)	$237.00
	$262.00

Balance due 1st group of paintings	$50.00
Balance due 2nd group of paintings	$13.00
Balance due Utrillo	$100.00
11 Frames & 3 Sculpture Bases	$258.00
Various Expenses	$72.50
Ira	$262.00
Loss in exchange on Derain-Hayden-Pailes-Masson-Kandinsky at 5%	$35.90
Total sum due:	$791.40

EARLY 1936

Art collection layout in apartment of George Gershwin, 132 East 72nd Street Memo in an unknown hand [perhaps Zenaide Hanenfeldt]

OFFICE

The Beach	Ben Shahn
Portrait of Mr. Botkin	George Gershwin
Wind Orchestra, Barrère	Max Weber

BEDROOM

Portrait of a Young Man	Chaim Soutine
Three Crows	Vernon Smith
Woman with a Flower	Boris Aronson
Cherry Lane	Glenn O. Coleman
Caryatid	Amedeo Modigliani

SIQUEIROS STUDIO

Street Scene	Raymond Billette
Woman Washing	Erwin Hoffman
Benares	Maurice Sterne
Gloucester Landscape	Boris Aronson
Children [Nina Madre]	David Alfaro Siqueiros
8 Paintings	Gershwin
Self Portrait	Gershwin

UPPER HALL

Landscape	André Derain
Landscape with Figures	Henri Hayden
Girl in Red Dress	Soutine

Bathers	Georges Rouault
Portrait of a Young Man	Jules Pascin
Landscape	Charles Logasa
Beach	Raoul Dufy
La Famille Pauvre	Pavel Tchelitchew
La Comédie Française	Max Jacob
Plaza Theatre	Louis Eilshemius
Light House	Henry Botkin
Landscape	Pinchus Krémègne
Grandmother	Gershwin
Father	Gershwin
Negro sculpture	Gershwin
Wife of the Artist	Isaac Pailes
Negroes	Botkin

STUDIO

Prayer Meeting	George Bellows
Riverfront #2A	Bellows
Dempsey Through the Ropes	Bellows
Between Rounds	Bellows
Loaned sculpture	
6 watercolors	
Harpist	James Chapin [or Chaplin]
African Mask	
Statuette of Negro	
Nude seated	
Folly Beach	Gershwin
African head	
Man and Horse	Pablo Picasso

STORE ROOM

Butcher Shop	Marc Chagall
The River—Landscape	Émile Lahner
Peasant Woman	Georges Rouault
Street Scene Paris	Maurice de Vlaminck
Red Horse	David Burliuk
Arrangement	Abraham Walkowitz
Shells & Fisherman	Burliuk
The Cloud	Burliuk
Keansburg, N.J.	Burliuk
Reed Street, N.Y.C.	Burliuk
Harlequin	John Graham
Son of Woman	Max Perper
Pianist	Perper
Portrait of Kisling	Modigliani
Portrait	Modigliani
White Church	Graham
Child	Perper
Wrestlers	Botkin
In the Park	Botkin
Cows	Botkin

LIVING ROOM

South Salem	Alexander Brook
Road Through the Forest	Derain
Fête Religieuse	Jacob
Absinthe Drinker	Picasso
Ile de la Cité	Henri Rousseau
La Marne	André Dunoyer de Segonzac

Fig. 67. List of paintings purchased for George Gershwin, April 1933

Ouessant	Maurice Utrillo
Woman at Table	Max Weber
Invocation	Weber
Sinking of the Vestris	Eugene Higgins
Portrait of Dr. Devaraigne	Modigliani
Paysage	Camille Bombois
Praying for Rain	Yasuo Kunioshi
Drawings	Modigliani

LIBRARY

Rabbi	Chagall
Portrait of Kisling	Derain
Head of a Woman	Modigliani

DINING ROOM

Still life	Derain
Abstraction	André Masson
Portrait of a Young Girl	Pascin
Still life Arrangement	Tchiltian
Suburbs	Utrillo
Portrait of Mrs. Paley	Gershwin
Orchids	Gershwin
Screen	Botkin

HALL

Clown	Rouault
Two Clowns and a Dancer	Rouault
Mother and Child, Bali	Maurice Sterne
La Pauvre Eglise	Rouault
Rue de l'Avenir	Rouault
Le Banlieu	Rouault
Portrait of Gershwin	Isamu Noguchi
Proletarian Victim	Siqueiros
Mexican Prison	Hoffman
Mother and Child	Papazian
Black Boy	Noguchi
2 etchings	Zlitz

BAR

Burlesque	Thomas Hart Benton
Arrangement [Linie-Fleck]	Vassily Kandinsky
Screen	Botkin
Deux Personnages	Rouault

IRA GERSHWIN

Composition with Figures [Lagune]	Eugene Berman
Horses and Derrick	Auguste Chabaud
[Unnamed work]	Bellows

KAY SWIFT

Spring Landscape	Othon Coubine
Basket of Fruit	Raoul Dufy

OUT

Self-Portrait	Paul Gauguin—Fogg Museum until 5/20
My Grandfather	Gershwin—Independent Artists
Self-Portrait	Gershwin—Independent Artists
Give Us This Day	
Our Daily Bread	Walter Quirt—Rochester (Sister)
Landscape	Logasa—Contemporary Arts (Mother)
4 Pieces of Negro sculpture	Memorial Art Gallery, Rochester 4/24

THE GEORGE GERSHWIN COLLECTION OF MODERN ART

Fig. 68. Illustration by Constantin Alajálov (American, b. Russia, 1900–1987) from *George Gershwin's Song-Book*, 1932

Note: Captions preceded by * indicate objects included in the exhibition.

1.

Artist Unknown
Portrait of Gauguin, ca. 1890
Gouache and watercolor on card,
10¼ × 8¼ in.
Private collection

Provenance
Galerie Van Leer, Paris; George Gershwin (1898–1937); by descent to Rose Gershwin (1876–1948; by descent to Frances (1906–1999) and Leopold Godowsky Jr. (1900–1983); Sotheby's, New York, May 12, 1999, lot 367 (as "attributed to Charles Filiger"); private collection.

Exhibition History
(exhibited in all cases as a self-portrait of Gauguin)
 Chicago. Arts Club of Chicago. *Exhibition of the George Gershwin Collection of Modern Paintings*, November 10–25, 1933, no. 17.
 New York. Museum of Modern Art. *Modern Works of Art: Fifth Anniversary Exhibition*, November 20, 1934–January 20, 1935, no. 14.
 New York. Wildenstein & Co., Inc. *Paul Gauguin, 1848–1903*, March 20–April 18, 1936; Cambridge, MA. Fogg Art Museum, Harvard University. May 1–21, 1936; Baltimore. Baltimore Museum of Art, May 24–June 5, 1936, no. 30.
 New York. Museum of Modern Art. *Private Collection*, July 27–September 6, 1936.
 Hartford, CT. Wadsworth Atheneum. *Connecticut Collects: An Exhibition of Privately Owned Works of Art in Connecticut*, October 4–December 3, 1957, no. 17.
 Hartford, CT. Wadsworth Atheneum. *The Music Makers: The Private Collections of Mr. & Mrs. Richard Rodgers and Mr. & Mrs. Leopold Godowsky Including Paintings from the Collection of George Gershwin*, July 9–August 9, 1959, no. 25.

Literature
(as self-portrait of Gauguin except where noted)
 Botkin, Henry. "A Composer's Pictures: George Gershwin, the Musician, Is a Collector of Modern Paintings." *Arts and Decoration* 40, no. 3 (January 1934): 48–50, ill.
 Cunningham, Charles. *Connecticut Collects*. Hartford, CT: Wadsworth Atheneum, 1957, no. 17. Exhibition catalog.
 ———. *The Music Makers: The Private Collections of Mr. & Mrs. Richard Rodgers and Mr. & Mrs. Leopold Godowsky Including Paintings from the Collection of George Gershwin*. Hartford, CT: Wadsworth Atheneum, 1959, no. 25, plate VI, ill. Exhibition catalog.
 Museum of Modern Art. *Modern Works of Art: Fifth Anniversary Exhibition*. New York: Museum of Modern Art, 1934, no. 14, ill. Exhibition catalog.
 Sotheby's. *Impressionist and Modern Art, Part II*. New York: Sotheby's, 1999, lot 367, 181, ill. (color) (as "attributed to Charles Filiger").
 Wildenstein & Co. *Paul Gauguin, 1848–1903*. New York: Wildenstein & Co., Inc., 1936 (with similar catalogues printed for Cambridge and Baltimore venues), nos. 30, 34. Exhibition catalog.

"He was in love with color, and his palette in paint closely resembled the color of his music. Juxtaposition of greens, blues, sanguines, chromes, and grays, fascinated him."
—Merle Armitage, *George Gershwin and His Time*

2.

George Bellows (American, 1882–1925)
Between Rounds #2, 1923
Lithograph, 18¾ × 15⅛ in.
Collection Marc Gershwin

Provenance
Emma S. Bellows; George Gershwin (1898–1937); by descent to Rose Gershwin (1876–1948); by descent to Arthur (1900–1981) and Judy (1917–2013) Gershwin; by descent to Marc Gershwin.

Exhibition History
Chicago. Arts Club of Chicago. *Exhibition of the George Gershwin Collection of Modern Paintings*, November 10–25, 1933, no. 53.

Literature
De Santis, Florence Stevenson. *Gershwin*. New York: Treves Publishing Company, 1987, 14.
 Goldberg, Isaac. "Music by Gershwin." *Ladies Home Journal*, February 1931, 12–13, 149, 151, ill.
 Greenberg, Rodney. *George Gershwin*. London: Phaidon, 1998, 115, ill.
 Jablonski, Edward, and Lawrence D. Stewart with an introduction by Carl Van Vechten. *The Gershwin Years*. Garden City, NY: Doubleday & Company, Inc., 1973, 184, ill.
 Kimball, Robert, and Alfred Simon. *The Gershwins*, New York: Atheneum, 1973, 110, 111, ill.
 Mason, Lauris. *The Lithographs of George Bellows: A Catalogue Raisonné*. Hillwood, NY: KTO Press, 1977, no. M. 144, 186, ill.
 Pollack, Howard. *George Gershwin: His Life and Work*. Berkeley, Los Angeles, London: University of California Press, 2006, 284–85, ill.

Fig. 69. Gershwin had childhood dreams of becoming a prize fighter.

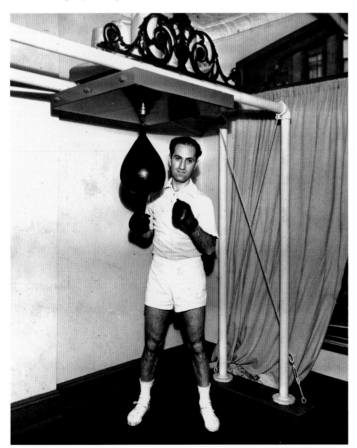

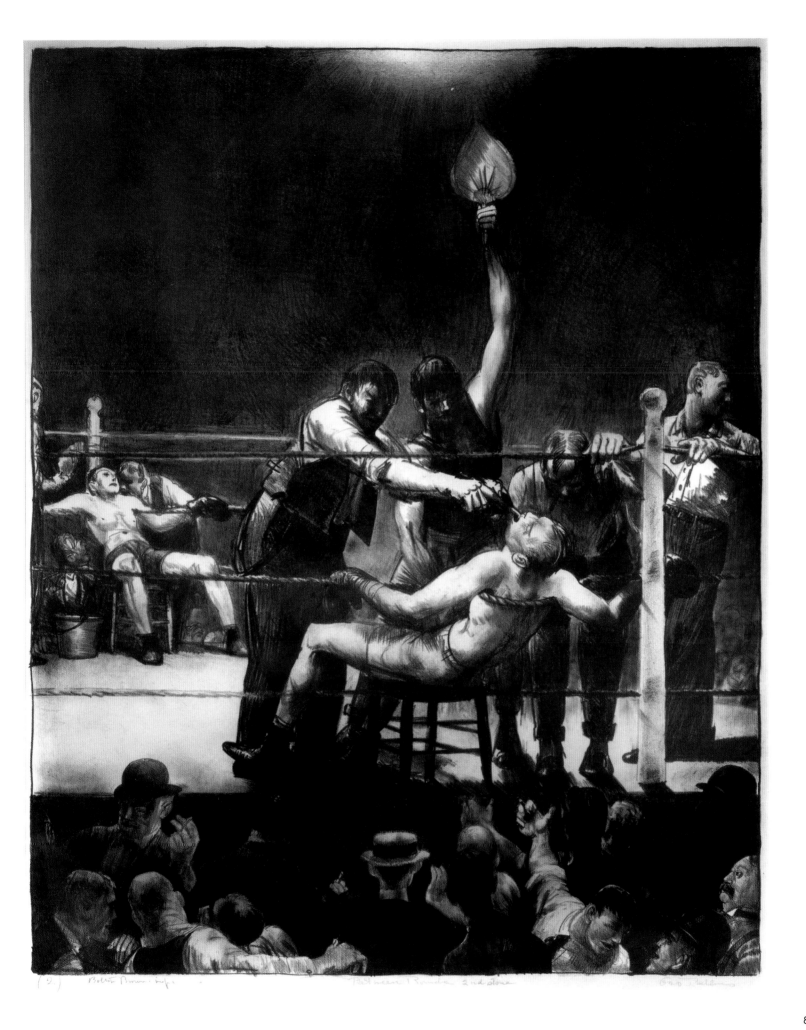

3.

George Bellows (American, 1882–1925)
Dempsey Through the Ropes, 1923
Lithograph, 17⅞ × 16½ in.
Collection Marc Gershwin

Provenance
Emma S. Bellows, wife of the artist;
George Gershwin (1898–1937);
by descent to Rose Gershwin
(1876–1948); by descent to Arthur
(1900–1981) and Judy (1917–2013)
Gershwin; by descent to Marc
Gershwin.

Exhibition History
Chicago. Arts Club of Chicago.
*Exhibition of the George Gershwin
Collection of Modern Paintings*,
November 10–25, 1933, no. 52.

Literature
Boswell, Peyton Jr.., with photo
research and bibliography by
Aimée Crane. *George Bellows*. New
York: Crown Publishers, 1942, 60, ill.
 Mason, Lauris. *The Lithographs
of George Bellows: A Catalogue
Raisonné*. Hillwood, NY: KTO Press,
1977, no. M. 182, 223, ill.

Fig. 70
George Gershwin (American, 1898–1937)
Prize Fighter, n.d.
Oil on canvas
Museum of the City of New York

"In fifth grade George was a tough, dirty little boy.
He was roller-skate champion of Seventh Street,
wanted to be a great prize-fighter, acted as rough
as he could, and far preferred playing on the
sidewalk to going to school."
—Rosamond Walling Tirana, "George Gershwin
(1898–1937)"

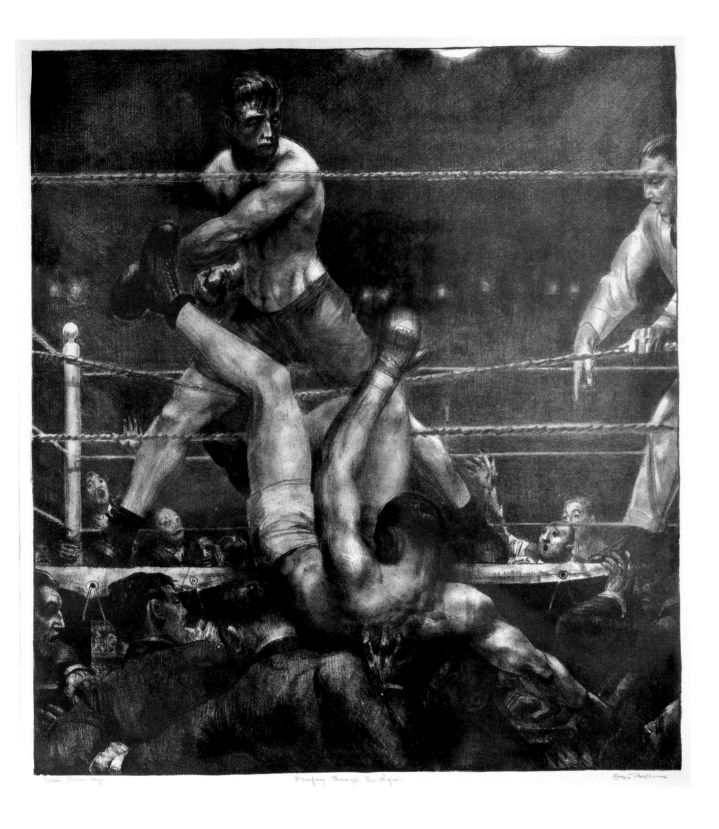

Introducing through the Ref.

4.

George Bellows (American, 1882–1925)
Prayer Meeting No. 2, 1916; edition 37 of at least 47
Lithograph on Chine applique paper,
sheet: 21¼ × 24⅞ in., image: 18¼ × 22⅛ in.
Los Angeles County Museum of Art, Los Angeles, CA,
Gift of Mr. and Mrs. Ira Gershwin, 57.36.1

Provenance
Emma S. Bellows; George Gershwin
(1898–1937); by descent to Rose
Gershwin (1876–1948); by descent
to Ira (1896–1983) and Leonore
Gershwin; given to the Los Angeles
County Museum of Art, 1957.

5.

George Bellows (American, 1882–1925)
Splinter Beach, 1916; edition of 70
Lithograph, sheet: 19⅛ × 23¾ in., image: 14¾ × 19⅝ in.
Los Angeles County Museum of Art, Los Angeles, CA,
Gift of Mr. and Mrs. Ira Gershwin, 57.36.2

Provenance
Emma S. Bellows; George Gershwin
(1898–1937); by descent to Rose
Gershwin (1876–1948); by descent
to Ira (1896–1983) and Leonore
Gershwin (1900–1991); given to the
Los Angeles County Museum of
Art, 1957.

**Other work by Bellows owned
by George Gershwin:**
River-Front, 1923–24
Lithograph
Location of Gershwin's impression
unknown

Provenance
Emma S. Bellows; George Gershwin
(1898–1937); by descent to Rose
Gershwin (1876–1948).

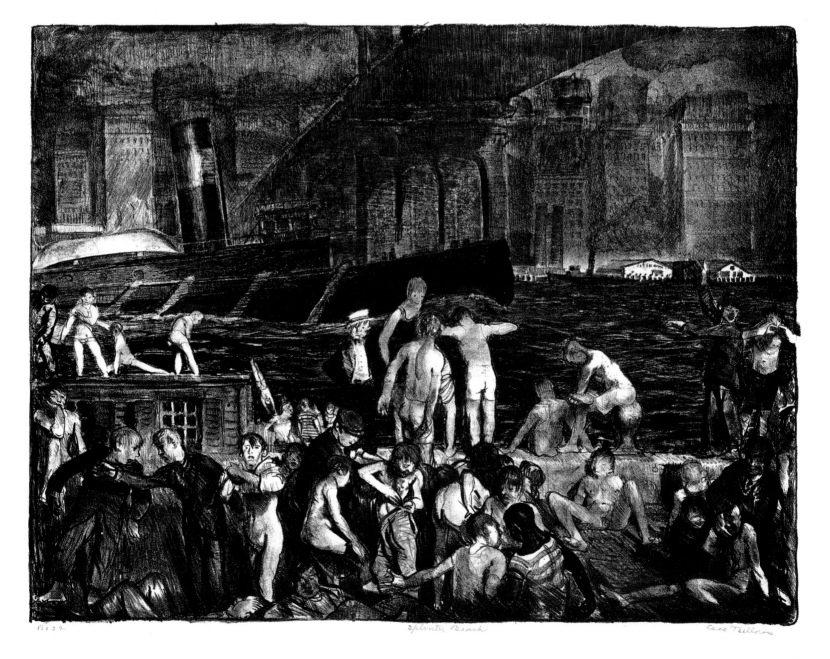

6.

Thomas Hart Benton (American, 1889–1975)
Burlesque, ca. 1930
Tempera with oil glazes on canvas, mounted
on pressboard, 18³⁄₁₆ × 25⅛ in.
Los Angeles County Museum of Art, Los Angeles, CA,
Gift of Mr. and Mrs. Ira Gershwin, M.80.104

Provenance
Sidney Ross Gallery, New York;
George Gershwin (1898–1937); by
descent to Rose Gershwin (1876–
1948); by descent to Ira (1896–1983)
and Leonore (1900–1991) Gershwin;
given to the Los Angeles County
Museum of Art, 1980.

Exhibition History
New York. Sidney Ross Gallery.
*The Theatre in Art: Drama, Motion
Picture, Vaudeville, Circus, Dance,
Opera, Burlesque,* March 30–April
17, 1932.
 Chicago. Arts Club of Chicago.
*Exhibition of the George Gershwin
Collection of Modern Paintings,*
November 10–25, 1933, no. 1.
 New York. Museum of Modern
Art. *Private Collection,* July 27–
September 6, 1936.
 Los Angeles. Los Angeles City
Hall Tower Gallery. *The Collection
of Mr. and Mrs. Ira Gershwin,* March
19–April 18, 1952.

Literature
Jablonski, Edward, and Lawrence
D. Stewart with an introduction by
Carl Van Vechten. *The Gershwin
Years.* Garden City, NY: Doubleday
& Company, Inc., 1973, 185, ill.
 Kresh, Paul. *An American
Rhapsody: The Story of George
Gershwin.* New York: E. P. Dutton,
1988, 111, ill.
 Sidney Ross Gallery. *The Theatre
in Art: Drama, Motion Picture,
Vaudeville, Circus, Dance, Opera,
Burlesque.* New York: Sidney Ross
Gallery, 1932. March 30–April 17,
1932, ill. Exhibition catalog.
 Time, "Theatre: Burlesque Suit,"
May 2, 1932.

Fig. 71. Gershwin's penthouse apartment at
33 Riverside Drive, New York. Thomas
Hart Benton's *Burlesque* hangs between
Gershwin's *Self-Portrait in Evening Clothes*
and an unidentified painting. The custom-
made bookcase resembles Paul Frankl's
"skyscraper bookcase" and may have been
designed by him.

Other work owned by George Gershwin:

Eugene Berman (American, b. Russia, 1899–1972)
Lagune, 1931
Oil on canvas, 21½ × 32 in.
Santa Barbara Museum of Art, 1956.5.3

Provenance
Lefebvre-Foinet, Paris; Julien Levy Gallery, New York; George Gershwin (1898–1937); by descent to Rose Gershwin (1876–1948); by descent to Ira (1896–1983) and Leonore (1900–1991) Gershwin; given to the Santa Barbara Museum of Art in 1956.

Exhibition History
New York. Julien Levy Gallery. 1932
 Chicago. Arts Club of Chicago. *Exhibition of the George Gershwin Collection of Modern Paintings*, November 10–25, 1933, no. 2.
 Santa Barbara. Santa Barbara Museum of Art. *American Modernism 1910–1945*, April 4–26, 1981.

7.

Camille Bombois (French, 1883–1970)
Paysage (Le vieux moulin en avril), n.d.
Oil on canvas, 23¼ × 31½ in.
Collection Marc Gershwin

Provenance
George Gershwin (1898–1937);
by descent to Rose Gershwin
(1876–1948); by descent to
Arthur (1900–1981) and Judy
(1917–2013) Gershwin; by descent
to Marc Gershwin.

8.

Henry Botkin (American, 1896–1983)
An American in Paris, ca. 1930
Screen, ca. 8 feet × 10 feet
Possibly no longer extant

Unfortunately the screen is lost, and no good color image of it has come to light.

Provenance

George Gershwin (1898–1937); by descent to Rose Gershwin (1876–1948); Emanuel Alexander.

Literature

De Santis, Florence Stevenson. *Gershwin*. New York: Treves Publishing Company, 1987, 14, ill.

Feinstein, Michael, with Ian Jackman. *The Gershwins and Me*. New York: Simon and Schuster, 2012, 107, ill.

Goldberg, Isaac. "Music by Gershwin." *Ladies Home Journal*, February 1931, 12–13, 149, 151, ill.

Jablonski, Edward, and Lawrence D. Stewart with an introduction by Carl Van Vechten. *The Gershwin Years*. Garden City, NY: Doubleday & Company, Inc., 1973, 185, ill.

Kimball, Robert, and Alfred Simon. *The Gershwins*. New York: Atheneum, 1973, 110, ill.

Kresh, Paul. *An American Rhapsody: The Story of George Gershwin*. New York: E. P. Dutton, 1988, 108, ill.

New York Times. "The Steinway, 'Instrument of the Immortals,' is Quite Within Reach of the Modest Income." January 19, 1930, 95, ill.

Schwartz, Charles. *Gershwin: His Life and Music*. Indianapolis and New York: The Bobbs-Merrill Company, Inc., 1973, 197, ill.

Suriano, Gregory R., ed. *Gershwin in His Time: A Biographical Scrapbook, 1919–1937*. New York Gramercy Books, 1998, 53, ill.

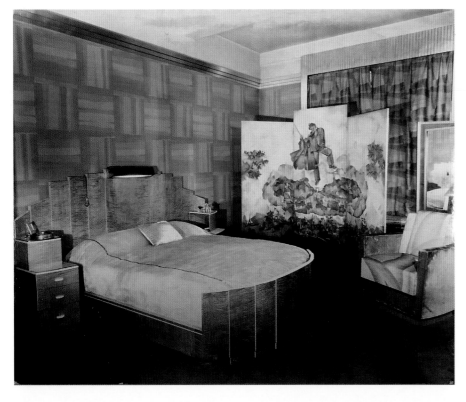

Fig. 72. The bedroom in Gershwin's penthouse apartment at 33 Riverside Drive, New York, with Botkin's colorful screen, *An American in Paris*, commissioned by the composer. The art deco bedroom furniture was likely designed by Paul Frankl.

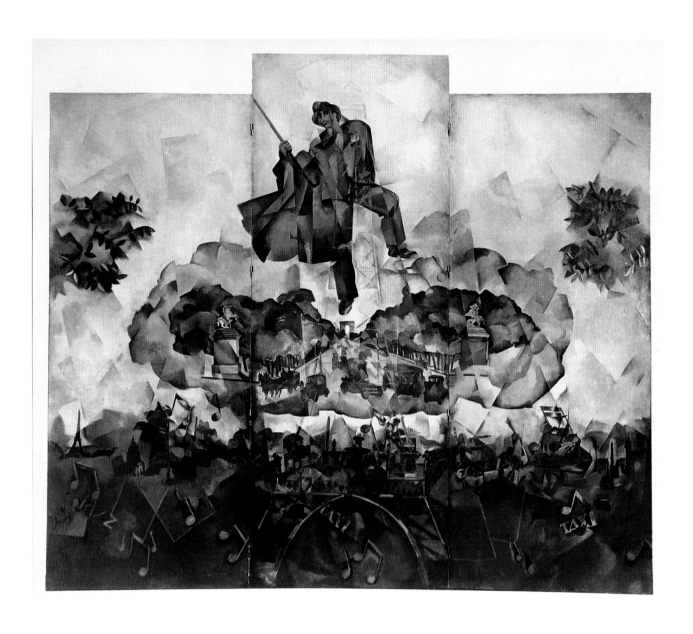

9.*

Henry Botkin (American, 1896–1983)
The Musician, ca.1930
Oil on canvas, 20⅝ × 17½ in.
Collection Marc Gershwin

The works on these pages are
presumed to have been once owned
by George Gershwin.

10.*

Henry Botkin (American, 1896–1983)
Reclining Nude, n.d.
Oil on canvas, 8½ × 16⅞ in.
Collection Marc Gershwin

Fig. 73. Installation view of the north wall, large gallery. *Exhibition of the George Gershwin Collection of Modern Paintings,* Arts Club of Chicago, November 10–25, 1933.

Botkin's painting *The Musicians*, location unknown, is the second painting from the left.

11.*

David Burliuk (Ukrainian, 1882–1967)
Countryside, 1933
Oil on canvas, 17⁷⁄₁₆ × 23¼ in.
Collection Marc Gershwin

Provenance
Dorothy Paris, New York;
George Gershwin (1898–1937);
by descent to Rose Gershwin
(1876–1948); by descent to
Arthur (1900–1981) and Judy
(1917–2013) Gershwin; by
descent to Marc Gershwin.

**Other works by Burliuk owned
by George Gershwin:**

The Cloud, ca. 1933
Oil on canvas
Location unknown

Reed Street, N.Y.C., ca. 1933
Oil on canvas
Location unknown

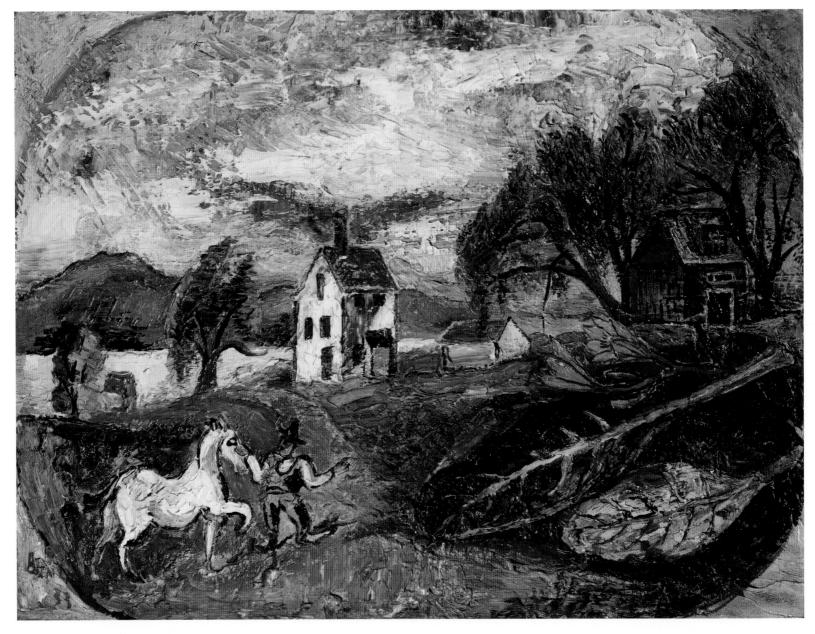

12.*

David Burliuk (Ukrainian, 1882–1967)
Keansburg, N.J., 1930
Oil on canvas, 17½ × 23½ in.
Collection Elaine Godowsky

Provenance
Dorothy Paris, New York;
George Gershwin (1898–1937);
by descent to Rose Gershwin
(1876–1948); by descent to
Frances (1906–1999) and Leopold
Godowsky Jr. (1900–1983);
by descent to Elaine Godowsky.

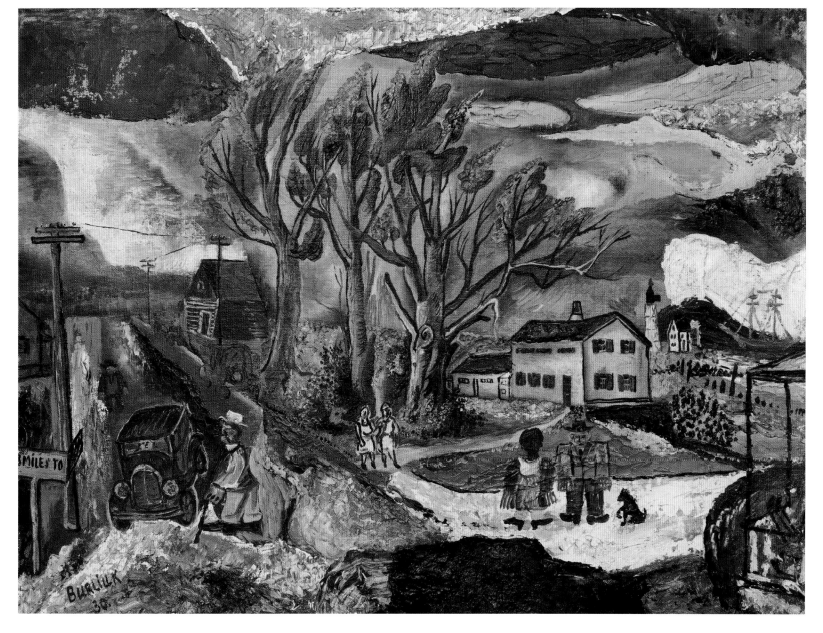

13.*

David Burliuk (Ukrainian, 1882–1967)
Red Horse, 1931
Oil on canvas, 12¹¹⁄₁₆ × 16¾ in.
Collection Elaine Godowsky

Provenance
Dorothy Paris, New York;
George Gershwin (1898–1937); by
descent to Rose Gershwin (1876–
1948); by descent to Frances (1906–
1999) and Leopold Godowsky Jr.
(1900–1983); by descent to Elaine
Godowsky.

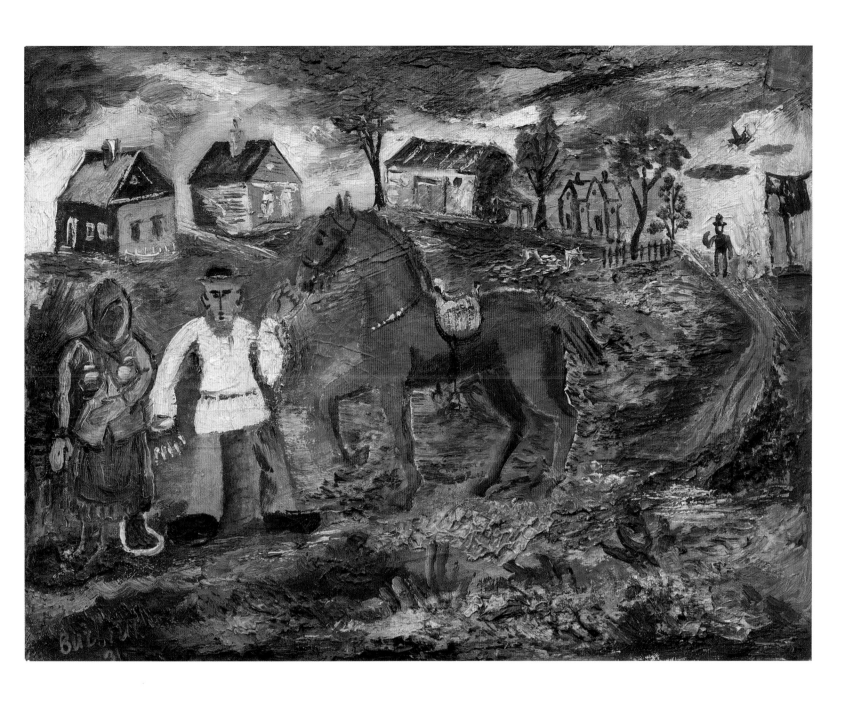

14.

John Carroll (American, 1892–1959)
Black Venus, 1936
Oil on canvas, 50 × 30 in.
Santa Barbara Museum of Art, Gift of
Mr. and Mrs. Ira Gershwin, 1956.5.1

Provenance
George Gershwin (1898–1937); by
descent to Rose Gershwin (1876–
1948); by descent to Ira (1896–1983)
and Leonore (1900–1991) Gershwin;
given to the Santa Barbara
Museum of Art, 1956.

Exhibition History
Los Angeles. Los Angeles City Hall
Tower Gallery. *The Collection of Mr.
and Mrs. Ira Gershwin*. March 19–
April 18, 1952.
 Omaha. Joslyn Art Museum.
*The Thirties Decade: American
Artists and Their European
Contemporaries*. October 10–
November 28, 1971, no. 25.

Literature
Alden, Edward. "Carroll's
Recognizable Style." *Art Digest* 10
(February 1, 1936): 16.
 Art Digest. "John Carroll Exhibits
Recent Canvases." *Art Digest* 12,
no. 7 (January 1, 1938): 9, ill.
 Feinstein, Michael, with Ian
Jackman. *The Gershwins and Me*.
New York: Simon and Schuster,
2012, 192, ill.
 Joslyn Art Museum. *The Thirties
Decade: American Artists and Their
European Contemporaries*. Omaha:
Joslyn Art Museum, 1971, 17, 60, no.
25, ill. Exhibition catalog.
 Pantages, Lloyd. "Gershwin Buys
Painting Called 'Black Venus.'"
Pittsburgh Sun-Telegraph, March
18, 1937, 18.

"George Gershwin seems to be starting an art collection for himself. His first
Hollywood purchase in the sensational and widely discussed 'Black Venus,' by
the American painter John Carroll, for which he planked down fifteen
hundred bucks, which isn't so high when you consider there is a very good
chance it will be worth from $5,000 to $10,000 in a very few years."
—Lloyd Pantages, *Pittsburgh Sun-Telegraph*

Marc Chagall (French, b. Belarus, 1887–1985)
L'Abattoir (The Slaughterhouse), 1911
Oil on canvas, 18¼ × 25⅝ in.
Location unknown

Provenance
Désiré Kellerman, Paris; George
Gershwin (1898–1937); by descent
to Rose Gershwin (1876–1948); by
descent to Ira (1896–1983) and
Leonore (1900–1991) Gershwin;
Christie's, New York, November 7,
2007, lot 427.

Exhibition History
Chicago. Arts Club of Chicago.
*Exhibition of the George Gershwin
Collection of Modern Paintings.*
November 10–25, 1933, no. 8.
 Los Angeles. Los Angeles City
Hall Tower Gallery. *The Collection
of Mr. and Mrs. Ira Gershwin.* March
19–April 18, 1952.
 Dallas. Dallas Museum of Art (on
extended loan), 1993–99.

Literature
Christie's. *Impressionist and
Modern Art.* New York: Christie's,
November 7, 2007, 180–83, ill.
 Encyclopedia Britannica.
"Chagall." 1965.
 Meyer, Franz. *Marc Chagall: Life
and Work.* New York: Abrams, 1964,
215, 741.

Fig. 74. Constantin Alajálov (American, b. Russia, 1900–1987).
Illustration from *George Gershwin's Song-Book*, 1932.

The dancing figure in the artwork on the wall is
inspired by the figure in red in Chagall's *L'Abattoir*.

16.*

Marc Chagall (French, b. Belarus, 1887–1985)
Untitled (Old Man with Beard), ca. 1931
Gouache and watercolor over charcoal or graphite on paper, 24¼ × 19 in.
The Jewish Museum, New York, NY, Gift of Frances Gershwin Godowsky and family in memory of George Gershwin, 1999-77

Provenance
George Gershwin (1898–1937); by descent to Rose Gershwin (1876–1948); by descent to Frances (1906–1999) and Leopold Godowsky Jr. (1900–1983); given to the Jewish Museum, New York, 1999.

Exhibition History
Chicago. Arts Club of Chicago. *Exhibition of the George Gershwin Collection of Modern Paintings*, November 10–25, 1933, no. 9 (as "Rabbi").
 New York. Museum of Modern Art. *Private Collection*, July 27–September 6, 1936 (as "Rabbi").
 Los Angeles. Los Angeles City Hall Tower Gallery. *The Collection of Mr. and Mrs. Ira Gershwin*. March 19–April 18, 1952.
 Hartford, CT. Wadsworth Atheneum. *The Music Makers: The Private Collections of Mr. & Mrs. Richard Rodgers and Mr. & Mrs. Leopold Godowsky Including Paintings from the Collection of George Gershwin*, July 9–August 9, 1959, no. 23.
 New York. The Jewish Museum. *Culture and Continuity: The Jewish Journey*, November 1999.
 New York. The Jewish Museum. *Marc Chagall: Years of War and Exile*. September 13, 2013–February 2, 2014.

Literature
Berger, Maurice, and Joan Rosenbaum, eds. *Masterworks of the Jewish Museum*, New Haven, CT: Yale University Press, 2004, 52–53, ill.
 Clarke, Gerald. "Broadway Legends: George Gershwin, The Celebrated Composer's Manhattan Penthouse." *Architectural Digest*, November 1995, 192–95, 270, ill.
 De Santis, Florence Stevenson. *Gershwin*. New York: Treves Publishing Company, 1987, 50, ill.
 Greenberg, Rodney. *George Gershwin*. London: Phaidon, 1998, 129, ill.
 Jablonski, Edward, and Lawrence D. Stewart, with an introduction by Carl Van Vechten. *The Gershwin Years*. Garden City, NY: Doubleday & Company, Inc., 1973, 185, ill.
 Kimball, Robert, and Alfred Simon. *The Gershwins*. New York: Atheneum, 1973, 111, ill.
 Kresh, Paul. *An American Rhapsody: The Story of George Gershwin*. New York: E. P. Dutton, 1988, 112, ill.
 Schwartz, Charles. *Gershwin: His Life and Music*. Indianapolis and New York: The Bobbs-Merrill Company, Inc., 1973, 176, ill.

"I would love to have you get, if possible, one of the Rabbi pictures of Chagall. I'd like to own another picture by this mystic painter."
—George Gershwin letter to Henry Botkin

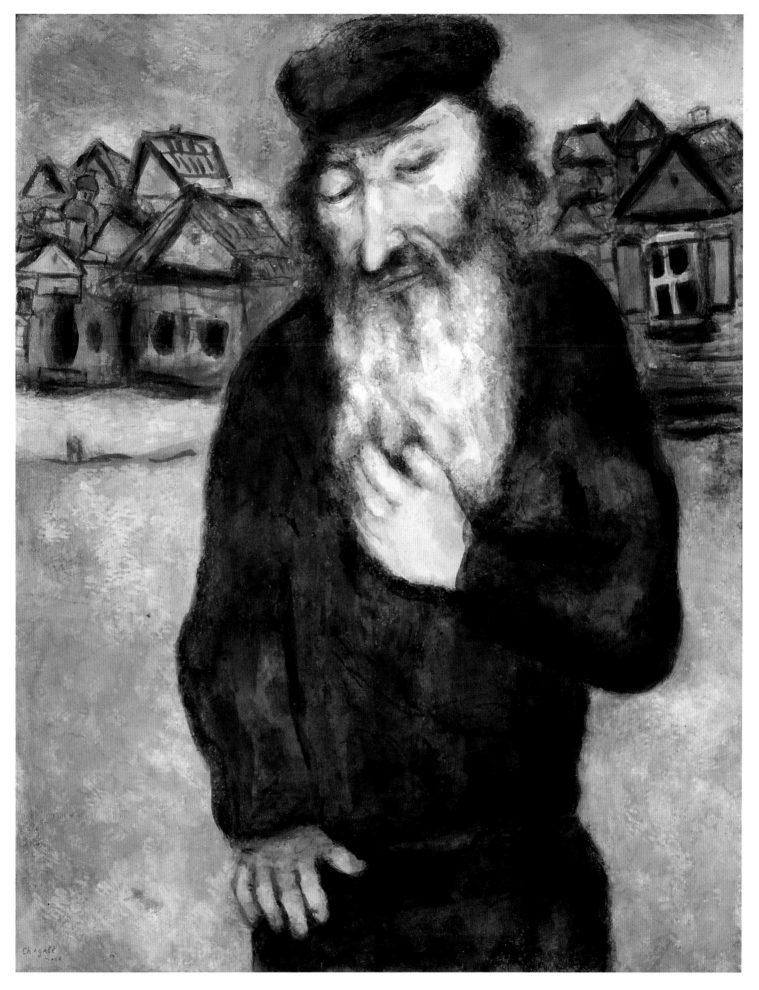

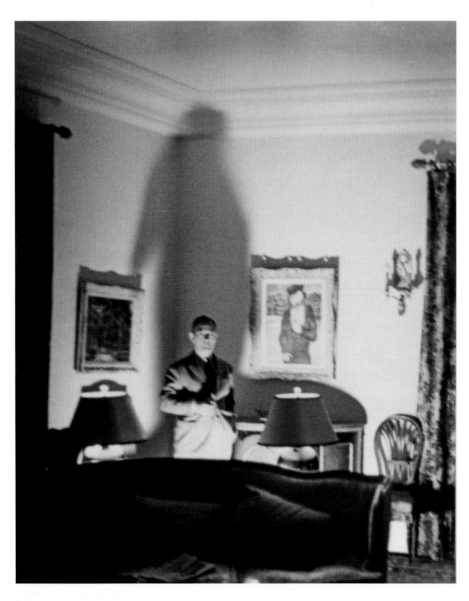

Fig. 75. Ira Gershwin at 1019 Roxbury Drive, Beverly Hills, California, with dramatic shadow, as photographed by George Gershwin, 1936–37. Behind him are Derain, *Road Through the Forest*, and Chagall, *Untitled (Old Man with Beard)*.

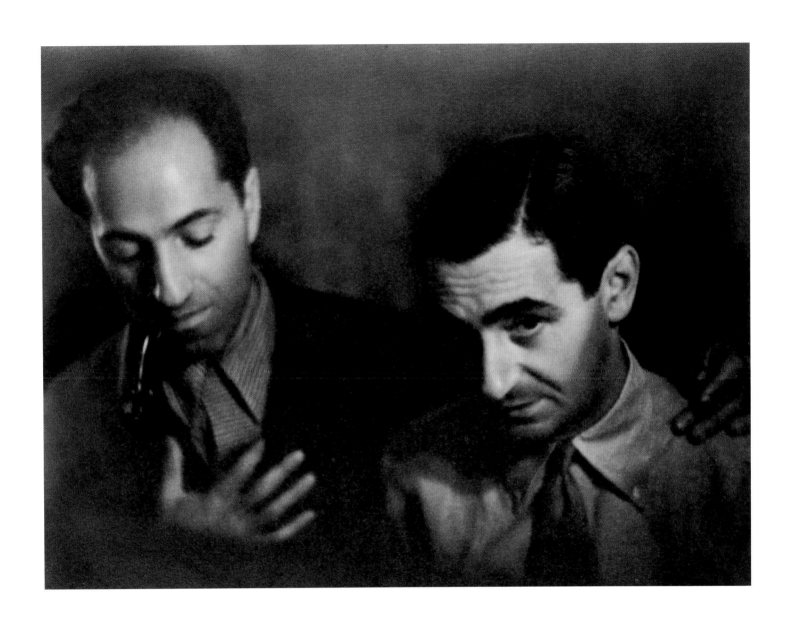

Fig. 76.* George Gershwin (American,
1898–1937)
Self-Portrait with Irving Berlin, ca. 1937
Gelatin silver print, 7 ¼ × 9 ¼ in.
Library of Congress, Washington, DC

Gershwin's pose is modeled on the pose in
the Chagall painting.

17.

Glenn O. Coleman (American, 1887–1932)
Cherry Lane, 1926
Oil on canvas, 11 × 15⅛ in.
Private collection

Provenance
Downtown Gallery, New York;
George Gershwin (1898–1937); by
descent to Rose Gershwin (1876–
1948); by descent to Ira (1896–1983)
and Leonore (1900–1991) Gershwin;
private collection.

Exhibition History
Chicago. Arts Club of Chicago.
*Exhibition of the George Gershwin
Collection of Modern Paintings*,
November 10–25, 1933, no. 10.
New York. Museum of Modern
Art. *Modern Works of Art: Fifth
Anniversary Exhibition*, November
20, 1934–January 20, 1935, no. 59.
New York. Museum of Modern
Art, *Private Collection*, July 27–
September 6, 1936.

Literature
Museum of Modern Art. *Modern
Works of Art: Fifth Anniversary
Exhibition*. New York: Museum
of Modern Art, 1934, no. 59, ill.
Exhibition catalog.

18.

Othon Coubine (Czech, 1883–1969)
Spring Landscape, n.d.
Oil on canvas, 21 × 25½ in.
Location unknown

Provenance
George Gershwin (1898–1937); Kay Swift; by descent to Katharine Weber; Artcurial, Paris, December 8, 2021, lot 321.

Exhibition History
Chicago. Arts Club of Chicago. *Exhibition of the George Gershwin Collection of Modern Paintings*, November 10–25, 1933, no. 11.

"What about some of the photographs you said you were going to send, of some of the lesser-known painters? I understand Coubine is a very good man. He is being collected by Leo Stein, who was one of the men to first appreciate Picasso."
—George Gershwin letter to Henry Botkin

19.

André Derain (French, 1880–1954)
Road Through the Forest (Le Bois), 1919–20
Oil on canvas, 18 × 24 in.
Collection Marc Gershwin

Provenance
Paul Guillaume, Paris; Valentine Gallery, New York; Duncan Phillips, Washington, DC; George Gershwin (1898–1937); by descent to Rose Gershwin (1876–1948); by descent to Arthur (1900–1981) and Judy (1917–2013) Gershwin; by descent to Marc Gershwin.

Exhibition History
Chicago. Arts Club of Chicago. *Exhibition of the George Gershwin Collection of Modern Paintings*, November 10–25, 1933, no. 14.
 New York. Museum of Modern Art. *Private Collection*, July 27–September 6, 1936.
 Los Angeles. Los Angeles City Hall Tower Gallery. *The Collection of Mr. and Mrs. Ira Gershwin*, March 19–April 18, 1952.

Literature
Phillips, Duncan. "Derain and the New Dignity in Painting." *Art and Understanding* 1, no. 1 (November 1929): 79–91, ill.

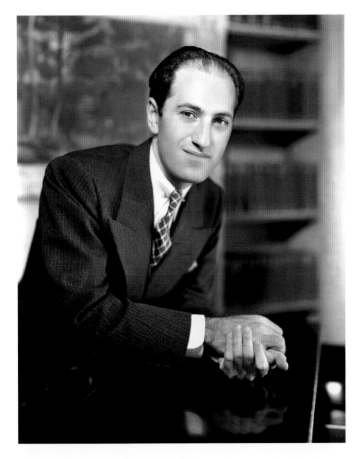

Fig. 77. Gershwin at 132 E. 72nd Street, New York, 1934, in front of Derain's *Road Through the Forest*.

20.

André Derain (French, 1880–1954)
Moïse Kisling, 1921
Oil on canvas, 29¼ × 23¾ in.
The Metropolitan Museum of Art, New York, NY,
Gift of Leonore S. Gershwin Trust, 1993, 1993.89.1

Provenance
Alfred Flechtheim Collection, Berlin; Daniel-Henry Kahnweiler, Paris; Galerie Van Leer, Paris; George Gershwin (1898–1937); by descent to Rose Gershwin (1876–1948); by descent to Ira (1896–1983) and Leonore (1900–1991) Gershwin; given to The Metropolitan Museum of Art, New York, by the Leonore S. Gershwin Trust, 1993.

Exhibition History
New York. International Art Center of Roerich Museum. *Portraits of Artists*, October 22–November 15, 1932, no. 10.
 Chicago. Arts Club of Chicago. *Exhibition of the George Gershwin Collection of Modern Paintings*, November 10–25, 1933, no. 15.
 New York. Museum of Modern Art. *Modern Works of Art: Fifth Anniversary Exhibition*, November 20, 1934–January 20, 1935, no. 70.
 New York. Museum of Modern Art. *Private Collection*, July 27–September 6, 1936.
 New York. The Metropolitan Museum of Art. *Recent Acquisitions: 1993–95*, curated by William S. Lieberman, July 28–September 24, 1995.

Literature
Clarke, Gerald. "Broadway Legends: George Gershwin, The Celebrated Composer's Manhattan Penthouse." *Architectural Digest*, November 1995, 192–95, 270, ill.
 De Santis, Florence Stevenson. *Gershwin*. New York: Treves Publishing Company, 1987, 50, ill.
 Einstein, Carl. *Die Kunst des 20 Jahrhunderts*. Berlin: Im Propylaen-Verlag, 1926.
 Jablonski, Edward. *Gershwin Remembered*. London and Boston: Faber and Faber, 1992, 64–65, ill.
 Jablonski, Edward, and Lawrence D. Stewart, with an introduction by Carl Van Vechten. *The Gershwin Years*. Garden City: Doubleday & Company, Inc., 1973, 185, ill.
 Kimball, Robert, and Alfred Simon. *The Gershwins*. New York: Atheneum, 1973, 111, ill.
 Kellermann, Michel. *André Derain, Catalogue raisonné de l'oeuvre peint*. Paris, Éditions Galerie Schmit, 1996, 133, ill.
 Kresh, Paul. *An American Rhapsody: The Story of George Gershwin*. New York: E.P. Dutton, 1988, 112, ill.
 Museum of Modern Art. *Modern Works of Art: Fifth Anniversary Exhibition*. New York: Museum of Modern Art, 1934, no. 70, ill. Exhibition catalog.
 Salmon, André. *André Derain: Vingt-six reproductions de peintures précédées d'une étude critique par André Salmon*. Paris: Éditions de la Nouvelle Revue française, 1924, 49, ill.
 Schwartz, Charles. *Gershwin: His Life and Music*. Indianapolis and New York: The Bobbs-Merrill Company, Inc., 1973, 176, ill.
 Wilenski, R. H. *Modern French Painters*. London: Faber & Faber, 1940/1944, 297.

"The Derain is a masterpiece of simple color."
—George Gershwin letter to Henry Botkin

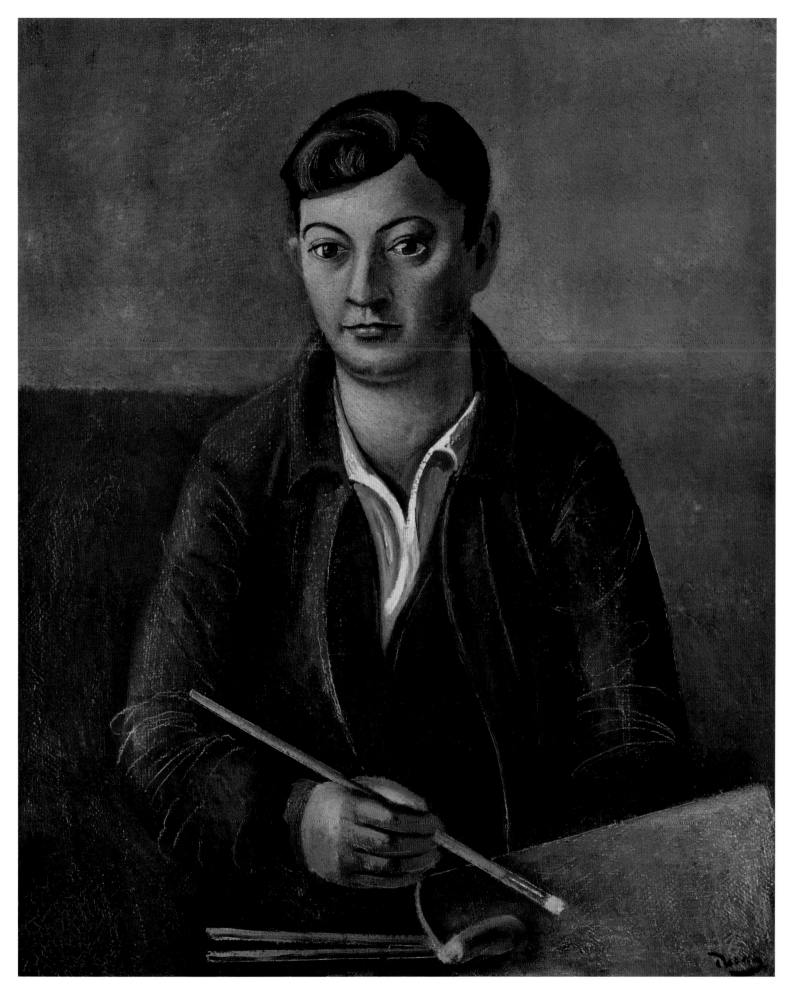

21.

André Derain (French, 1880–1954)
Paysage aux environs de Martigues, 1908
Oil on canvas, 21¼ × 25⅝ in.
Location unknown

Provenance
Galerie Kahnweiler, Paris; George Gershwin (1898–1937); by descent to Rose Gershwin (1876–1948); by descent to Ira (1896–1983) and Leonore (1900–1991) Gershwin; Lee V. Eastman, New York; Christie's, New York, November 2, 2005, lot 309.

Exhibition History
Chicago. Arts Club of Chicago. *Exhibition of the George Gershwin Collection of Modern Paintings*, November 10–25, 1933, no. 13.
 Los Angeles. Los Angeles City Hall Tower Gallery. *The Collection of Mr. and Mrs. Ira Gershwin*, March 19–April 18, 1952.

Literature
Christie's. *Impressionist and Modern Art (Day Sale)*. New York: Christie's, November 2, 2005, lot 309, 18–19, ill. (color).
 Kellermann, Michel. *André Derain, Catalogue raisonné de l'oeuvre peint*. Paris: Éditions Galerie Schmit, 1996, 1:93, 150, 93, ill.

Other work by Derain owned by George Gershwin:

Nature-morte (Still-Life), n.d.
Oil on canvas, 31 × 16 inches
Location unknown

Provenance
George Gershwin (1898–1937); by descent to Rose Gershwin (1876–1948).

Exhibition History
Chicago. Arts Club of Chicago, *Exhibition of the George Gershwin Collection of Modern Paintings*, November 10–25, 1933.
 New York. Museum of Modern Art, Private Collection, July 27–September 6, 1936.

22.

Raoul Dufy (French, 1877–1953)
Compotier (Basket of Fruit), n.d.
Gouache on paper, 19 × 23 in.
Location unknown

Provenance
George Gershwin (1898–1937); Kay Swift; by descent to Katharine Weber; Stoppenbach and Delestre, London, sold at Maastrich Art Fair, March 2005.

Exhibition History
Chicago. Arts Club of Chicago. *Exhibition of the George Gershwin Collection of Modern Paintings*, November 10–25, 1933, no. 56.

Literature
Raoul Dufy Catalogue Raisonné, no. As-1092. https://catalogue-raisonne-raoul-dufy.fr/oeuvres/compotier/.

Fig. 78. Installation view of the large and small galleries taken from the reception hall. *Exhibition of the George Gershwin Collection of Modern Paintings*, Arts Club of Chicago, November 10–25, 1933.

Note the Dufy *Compotier (Basket of Fruit)* on the left side.

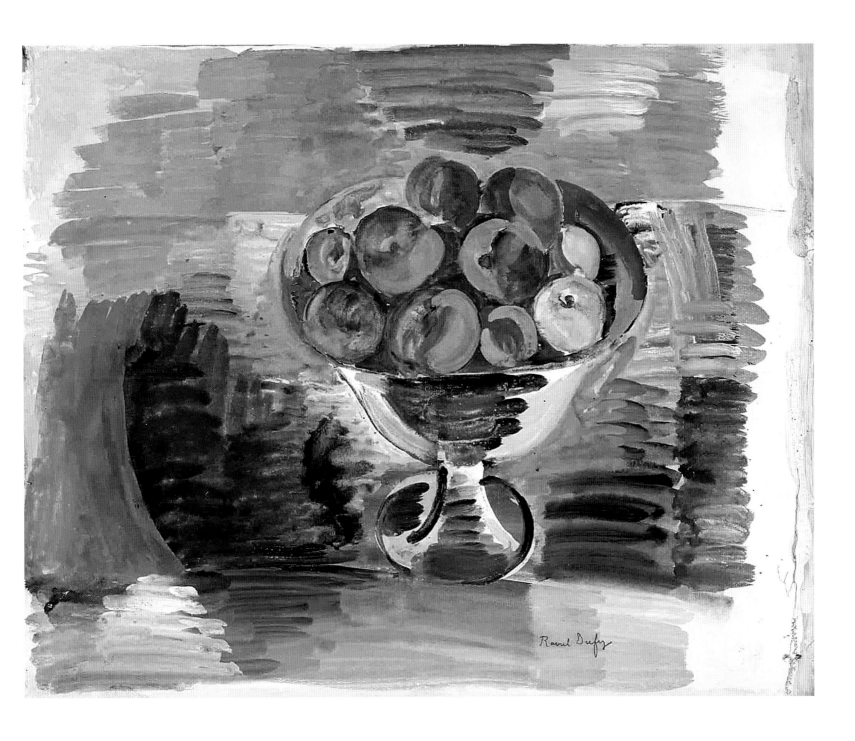

23.

Raoul Dufy (French, 1877–1953)
Cérès au Bord de la Mer (Ceres by the Sea), 1928
Watercolor on paper, 19½ × 25 in.
Location unknown

Provenance
Désiré Kellerman, Paris; George Gershwin (1898–1937); by descent to Rose Gershwin (1876–1948); by descent to Frances (1906–1999) and Leopold Godowsky Jr. (1900–1983); Sotheby's New York, May 12, 1999, lot 373.

Exhibition History
Chicago. Arts Club of Chicago. *Exhibition of the George Gershwin Collection of Modern Paintings*, November 10–25, 1933, no. 55 (as "Beach").

 Hartford, CT. Wadsworth Atheneum. *The Music Makers: The Private Collections of Mr. & Mrs. Richard Rodgers and Mr. & Mrs. Leopold Godowsky Including Paintings from the Collection of George Gershwin*, July 9–August 9, 1959, no. 24.

Literature
Cunningham, Charles. *The Music Makers: The Private Collections of Mr. & Mrs. Richard Rodgers and Mr. & Mrs. Leopold Godowsky Including Paintings from the Collection of George Gershwin*. Hartford, CT: Wadsworth Atheneum, 1959, no. 24, pl. V, ill. Exhibition catalog.

 Raoul Dufy Catalogue Raisonné, no. As–1330. https://catalogue-raisonne-raoul-dufy.fr/oeuvres/ceres-au-bord-de-la-mer/.

 Sotheby's. *Impressionist and Modern Art*, Part Two. New York: Sotheby's, May 12, 1999, lot 373, 185, ill. (color).

24.

André Dunoyer de Segonzac
(French, 1884–1974)
La Marne, 1926
Oil on canvas, 21 × 32 in.
Private collection

Provenance
Galerie Marseille, Paris; Duncan
Phillips, Washington, DC; George
Gershwin (1898–1937); by descent
to Rose Gershwin (1876–1948);
by descent to Ira (1896–1983) and
Leonore (1900–1991) Gershwin;
private collection.

Exhibition History
Chicago. Arts Club of Chicago.
*Exhibition of the George Gershwin
Collection of Modern Paintings*,
November 10–25, 1933, no. 38.
 New York. Museum of Modern
Art. *Private Collection*, July 27–
September 6, 1936.
 Los Angeles. Los Angeles City
Hall Tower Gallery. *The Collection
of Mr. and Mrs. Ira Gershwin*, March
19–April 18, 1952.
 Los Angeles. UCLA Art Gallery.
Collectors Exhibition, January 8–
February 26, 1956.

25.

Louis Michel Eilshemius (American, 1864–1941)
Plaza Theatre, 1915
Oil on composition board, 30½ × 40½ in.
Santa Barbara Museum of Art, Gift of Mr. and
Mrs. Ira Gershwin, 1956.5.2

Provenance
Valentine Gallery, New York;
George Gershwin (1898–1937); by
descent to Rose Gershwin (1876–
1948); by descent to Ira (1896–1983)
and Leonore (1900–1991) Gershwin;
given to the Santa Barbara
Museum of Art, 1956.

Exhibition History
New York. Valentine Gallery.
Eilshemius, January 1932.
Chicago. Arts Club of Chicago.
*Exhibition of the George Gershwin
Collection of Modern Paintings*,
November 10–25, 1933, no. 16.
New York. Museum of Modern
Art. *Art in Our Time: An Exhibition
to Celebrate the Tenth Anniversary
of the Museum of Modern Art and
the Opening of Its New Building,
Held at the Time of the New York
World's Fair*, 1939, no. 110.
Los Angeles. Los Angeles City
Hall Tower Gallery. *The Collection
of Mr. and Mrs. Ira Gershwin*, March
19–April 18, 1952.
New York. Bernard Danenberg
Galleries. *The Romanticism of
Eilshemius*, April 3–28, 1973, no. 28.

Literature
Barr, Alfred, Jr. *Art in Our Time:
An Exhibition to Celebrate the
Tenth Anniversary of the Museum
of Modern Art and the Opening of
Its New Building, Held at the Time
of the New York World's Fair*, New
York: Museum of Modern Art, 1939,
no. 110, ill. Exhibition catalog.
Bernard Danenberg Galleries. *The
Romanticism of Eilshemius*. New
York: Bernard Danenberg Galleries,
1973, no. 28, 12, ill. Exhibition
catalog.
Karlstrom, Paul J. *Louis Michel
Eilshemius*. New York: Harry N.
Abrams, Inc., 1978, 64–65, no. 197.
Larkin, Oliver W. *Art and Life in
America*. New York: Rinehard &
Company, Inc., 1949, 390.
Santa Barbara Museum of Art.
*Two Hundred Years of American
Painting*, Santa Barbara: Santa
Barbara Museum of Art, 1961, no. 85.
Schack, William. *And He Sat
Among the Ashes: A Biography
of Louis M. Eilshemius*. New York:
American Artists Group, Inc., 1939.
Stix, Hugh. *Masterpieces of
Eilshemius*. New York: The Artists
Gallery, 1959.

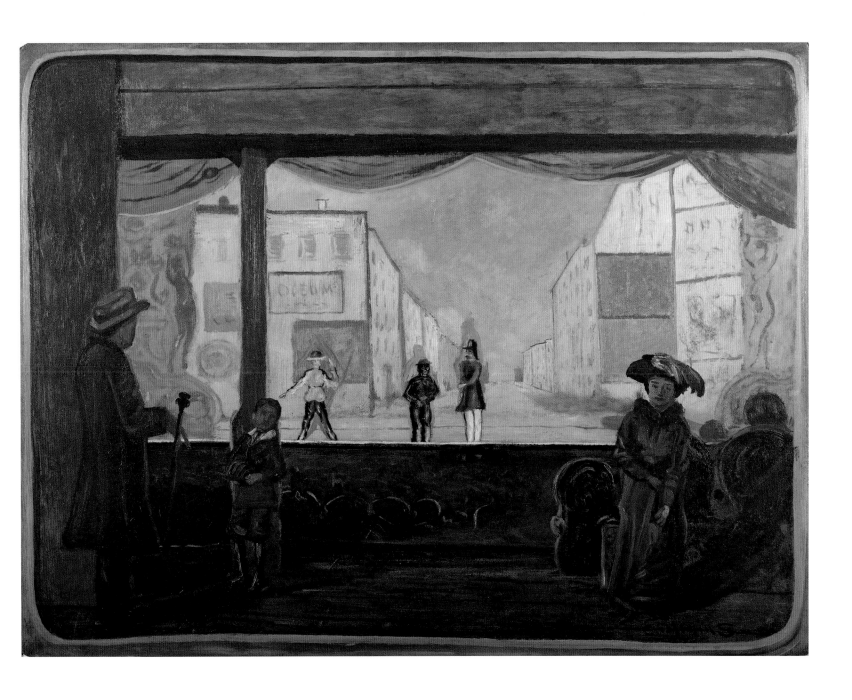

26.*

John Graham (American, b. Ukraine, 1886–1961)
Harlequin, 1928
Oil on canvas, 36⅛ × 25¾ in. (framed)
Picker Art Gallery Collections, Gift of Ira and
Leonore Gershwin, x236

Provenance
George Gershwin (1898–1937); by
descent to Rose Gershwin (1876–
1948); by descent to Ira (1896–1983)
and Leonore (1900–1991) Gershwin;
Picker Art Gallery, Colgate
University, Hamilton, NY.

127

27.

Eugene Higgins (American, 1874–1958)
Sinking of the Vestris, ca. 1926
Oil on panel, 10½ × 14½ in.
Location unknown

Provenance
Kleeman Galleries, New York;
George Gershwin (1898–1937);
by descent to Rose Gershwin
(1876–1948); by descent to Frances
(1906–1999) and Leopold Godowsky
Jr. (1900–1983); Parke-Bernet
Galleries, Inc., New York, June 3,
1953, lot 59; Doyle, New York, June
23, 2004, lot 5037; Link Auction
Galleries, St. Louis, December 6,
2014, lot 139.

Exhibition History
Asia Foundation Asian–Pacific Rim
tour, dates unknown.

28.*

Max Jacob (French, 1876–1944**)**
La comédie française, n.d.
Oil on canvas, 18½ × 24½ in.
Private collection

Provenance
George Gershwin (1898–1937); by
descent to Rose Gershwin (1876–
1948); by descent to Ira (1896–1983)
and Leonore (1900–1991) Gershwin;
private collection.

**Other work by Jacob owned
by George Gershwin:**

Fête religieuse, n.d.
Oil on canvas
Location unknown

Vassily Kandinsky (Russian, 1866–1944)
Line-Spot, 1927
Oil on pressed pulp board, 17¾ × 26¼ in.
Santa Barbara Museum of Art, Gift of Mr.
and Mrs. Ira Gershwin, 1956.5.4

Provenance
Galerie Van Leer, Paris; George
Gershwin (1898–1937); by descent
to Rose Gershwin (1876–1948); by
descent to Ira (1896–1983) and
Leonore (1900–1991) Gershwin;
given to the Santa Barbara
Museum of Art, 1956.

Exhibition History
Chicago. Arts Club of Chicago.
*Exhibition of the George Gershwin
Collection of Modern Paintings*,
November 10–25, 1933, no. 23.
 Santa Fe. Museum of New
Mexico. *Romantic Modernism: 100
Years*, June 4–July 31, 1994.

Literature
Doll, Nancy, Robert Henning, Jr..,
and Susan Shin-tsu Tai. *Santa
Barbara Museum of Art Selected
Works*. Santa Barbara: Santa
Barbara Museum of Art, 1991, no.
72, 62, ill. (color).
 Grohmann, Will. *Wassily
Kandinsky: Life and Work*. New
York: Harry N. Abrams, Inc., 1958,
no. 271, ill.
 Oregon Festival of American
Music. *Gershwin Transformations*.
Eugene: Oregon Festival of
American Music, 2002, Eugene, OR,
34, ill. Festival brochure.

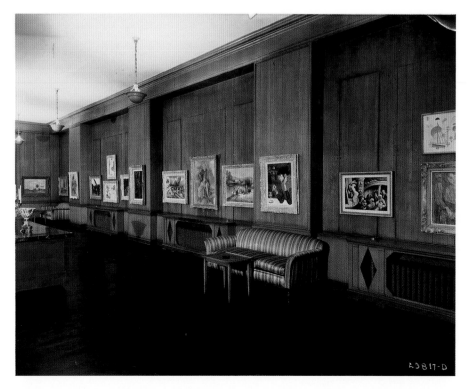

Fig. 79. Installation view of the south wall,
large gallery. *Exhibition of the George
Gershwin Collection of Modern Paintings*,
Arts Club of Chicago, November 10–25, 1933.

The Kandinsky painting, seen at the far
right, caused the greatest commotion with
the press and public of any of the artworks
in the collection, including the nudes.

30.

Paul Klee (Swiss, 1879–1940)
Albumblatt für einen Musiker
(Album leaf for a Musician), 1924
Ink and watercolor on paper, 10 × 12 in.
Hiroshima Prefectural Museum of Art,
Hiroshima, Japan

This work is mentioned in a letter from the
art dealer Galka Scheyer to Paul and Lili Klee
sent from Hollywood, Califonia, dated March
19, 1937. She announces that it has been
acquired by "the musician Gershwin" through
an unnamed friend of his, namely, the book
designer and impresario Merle Armitage.
After the composer's untimely death, his
brother Ira Gershwin returned this piece to
Armitage as a memento of their friendship.

Provenance
F. W. Brass, Hagen i.W.; Galka
E. Scheyer, Los Angeles; Merle
Armitage; George Gershwin (1898–
1937); Merle Armitage; Abraham
and Margit W. Chanin, New York;
Galerie Tarica, Geneva/Paris;
Lambeth Arts Limited, London;
Mathew Prichard, Cowbridge, UK;
Waddington Galleries Ltd., London;
Satani Gallery, Tokyo.

Exhibition History
Tokyo. Satani Gallery. *Paul Klee
(1879–1940)*. January 10–March 10,
1990, no. 17, ill. (color).
 Utsunomiya City. Utsunomiya
Museum of Art; July 5–September
6, 2015; Kobe. Hyogo Prefectural
Museum of Art. September 19–
November 23, 2015, *Paul Klee:
Spuren des Lächelns*, no. 12, ill.
(color).

Literature
Kagan, Andrew. "Paul Klee's
'Polyphonic Architecture.'" *Arts
Magazine* 54, no. 5 (1980): 154–57,
ill.
 ———. *Paul Klee. Art & Music*.
Ithaca, NY: Cornell University
Press, 1983, 119, ill.
 Kakigi, Nobuyuki. "Viewing the
Paul Klee exhibition 'this is just
between ourselves' (Utsunomiya
Museum of Art, Japan)." *Zwitscher-
Maschine / Journal on Paul Klee* 1
(Winter 2015–16): 31–33, ill.
 Paul-Klee-Stiftung, ed.
Catalogue raisonné Paul Klee 4,
1923–1926, Kunstmuseum Bern,
Bern 2000, no. 3556, ill.
 Popia, Maria F. "L'estetica
musicale di Paul Klee." PhD diss.,
Università degli Studi di Genova,
1999/2000, 266.

"After studying a Klee watercolor with a magnifying glass,
 [Gershwin] stopped abruptly and exclaimed that his music
 would not stand up under that kind of scrutiny."
—Merle Armitage

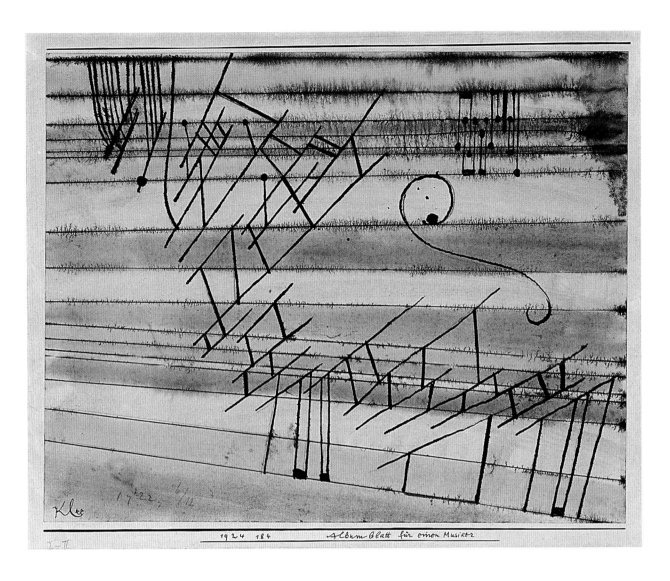

31.*

Oskar Kokoschka (Austrian, 1886–1980)
Pyramids at Gizeh, 1929
Oil on canvas, 34⅝ × 51⅛ in.
The Nelson-Atkins Museum of Art,
Kansas City, Missouri. Gift of the Friends
of Art, 54-89

Provenance

Galerie Paul Cassirer, Berlin; Max and Anna Glaeser, Eselsfürth, Germany; Galerie Buck, Mannheim, Germany, by 1937; [Berta Sanders]; George Gershwin (1898–1937); by descent to Rose Gershwin (1876–1948); Museum of Modern Art, New York; Curt Valentin Gallery, New York; The Nelson-Atkins Museum of Art, Kansas City, Missouri. Gift of the Friends of Art, 54-89, 1989.

Exhibition History

Mannheim, Germany. Städtische Kunsthalle. *Oskar Kokoschka: Das Gesammelte Werk*, January 18–March 1, 1931, no. 82.

Chicago. Arts Club of Chicago. *Oskar Kokoschka: Paintings, Drawings and Prints*, October 1–31, 1956, no. 15.

Munich. Haus der Kunst. *Oskar Kokoschka*, March 14–May 11, 1958, no. 92; Vienna. Künstlerhaus. May 19–July 13, 1958, no. 90; The Hague. Gemeentemuseum. July 31–October 1, 1958, no. 62.

Columbus, OH. Columbus Gallery of Fine Arts. *German Expressionism*, February 10–March 9, 1961, no. 44.

London. Tate Gallery. *Kokoschka*, September 14–November 11, 1962, no. 104.

Hamburg. Kunstverein. *Oskar Kokoschka*, December 8, 1962–January 27, 1963, no. 50.

Dallas. Southern Methodist University. *Works of Oskar Kokoschka*, October 3–31, 1965, no. 11.

Cleveland, OH. The Cleveland Museum of Art. *Fifty Years of Modern Art: 1916–1966*, June 14–July 31, 1966, no. 48A.

Vienna. Österreichische Galerie im Oberen Belvedere. *Oskar Kokoschka zum 85. Geburtstag*, April 27–June 16, 1971, no. 55.

New York. Galerie St. Etienne, *Richard Gerstl-Oskar Kokoschka*, March 17–May 9, 1992, no. 68.

Literature

Arts Club of Chicago. *Oskar Kokoschka*. Chicago: Arts Club of Chicago, 1956. Exhibition catalog.

Asher, Michael. *Painting and Sculpture from the Museum of Modern Art: Catalog of Deaccessions, 1929 through 1998*. New York: Museum of Modern Art, 1999, 10.

Columbus Gallery of Fine Arts. *German Expressionism*. Columbus, OH: Columbus Gallery of Fine Arts, 1961, 10, 13, ill. Exhibition catalog.

Etzdorf, Karin von. *Oskar Kokoschka*. Munich: Haus der Kunst, 1958, 59, 125, ill. Exhibition catalog.

Field Enterprises Educational Corporation. *Look Again: The 1968 Childcraft Annual*. Chicago: Field Enterprises Educational Corporation, 1968, 82–83, ill.

Galerie Georges Petit. *Exposition Oskar Kokoschka*. Paris: Galerie Georges Petit, 1931. Exhibition catalog.

Hoffmann, Edith. *Kokoschka: Life and Work*. London: Faber and Faber Ltd., 1947, 328.

Kallir, Jane. *Richard Gerstl—Oskar Kokoschka*. New York: Galerie St. Etienne, 1992, ill. Exhibition catalog.

Kokoschka. London: The Arts Council, 1962, 41.

Kokoschka, Oskar. *My Life*, New York: MacMillan Publishing, 1974, 142.

Kunstverein in Hamburg. *Oskar Kokoschka*. Hamburg: Der Kunstverein, 1962, ill. Exhibition catalog.

"Oskar Kokoschka: Die Geschichte der Schmiedin," *Das Kunstblatt* 15 (1931): 35, ill.

Oskar Kokoschka. Vienna, 1958, 59, 123, ill.

Oskar Kokoschka, The Hague, 1958.

Österreichische Galerie. *Oskar Kokoschka zum 85. Geburtstag, Wien, 1971*. Vienna: Österreichische Galerie im Oberen Belvedere, 1971, 48, ill. Exhibition catalog.

Scheffler, Karl, "Kokoschkas Landschaften," *Kunst und Künstler* 29 (1931): 192, ill.

Städtische Kunsthalle Mannheim.
*Oskar Kokoschka: Das Gesammelte
Werk*. Mannheim, Germany:
Städtische Kunsthalle, 1931, 15, 82,
ill. Exhibition catalog.

Wingler, Hans Maria, *Oskar
Kokoschka: Das Werk des Malers*,
Salzburg: Galerie Welz, 1958, no.
242, ill. Exhibition catalog.

Winkler, Johann and Katharina
Erling, *Oskar Kokoschka: Die
Gemälde 1906–1929*. Salzburg:
Verlag Galerie Welz, 1995, no. 251,
144. Exhibition catalog.

32.

Pinchus Krémègne (French, b. Belarus, 1890–1981)
Street Scene, n.d.
Oil on canvas, 31½ × 35⅝ in.
Private collection

Provenance
George Gershwin (1898–1937); by
descent to Rose Gershwin (1876–
1948); by descent to Ira (1896–1983)
and Leonore (1900–1991) Gershwin;
private collection.

Exhibition History
Chicago. Arts Club of Chicago.
*Exhibition of the George Gershwin
Collection of Modern Paintings*,
November 10–25, 1933, no. 24 (as
"Landscape").

33.

André Masson (French, 1896–1987)
Verres et cartes postales, ca. 1922–23
Oil on canvas, 18½ × 21¾ in.
Location unknown

This painting is one of five works of
art that Ira Gershwin lent to be used
as props in the 1944 film *Rhapsody
in Blue* starring Robert Alda in the role
of George Gershwin.

Provenance
Galerie Van Leer, Paris; George
Gershwin (1898–1937); by descent
to Rose Gershwin (1876–1948); by
descent to Ira (1896–1983) and
Leonore (1900–1991) Gershwin;
given to the Los Angeles County
Museum; Sotheby's, New York,
May 14, 1986, lot 260.

Exhibition History
New York. Museum of Modern Art.
*Summer Exhibition: Painting
and Sculpture*, July 10–September
30, 1933.
 Chicago. Arts Club of Chicago.
*Exhibition of the George Gershwin
Collection of Modern Paintings*,
November 10–25, 1933, no. 27.

34.

Henri Matisse (French, 1869–1954)
Small Crouching Nude without an Arm,
original model 1908; this cast 1922
Bronze, 5 × 2⅝ × 3⅝ in.
The Baltimore Museum of Art: The Cone Collection,
formed by Dr. Claribel Cone and Miss Etta Cone of
Baltimore, Maryland, BMA1950.432

In 1929, as he was learning to draw, Gershwin used
this tiny figurine as an artist's model, rendering it in
pencil from all sides. These drawings are in Gershwin's
sketchbook in the collection of the Museum of the
City of New York.
 The cast reproduced here is identical to the one
owned by Gershwin, although the current location of
Gershwin's cast is unknown.

Provenance of Gershwin's cast
Arthur B. Davies (1862–1928);
American Art Association, New
York, April 16–17, 1929, lot 444
(as "Bronze statuette—Impression
of a half-kneeling figure");
George Gershwin (1898–1937).

Literature
American Art Association. *The
Arthur B. Davies Art Collection;
Modern Drawings, Print, Paintings
and Sculptures, Ancient Bronzes,
Pottery & Fabrics, French Furniture
and Tapestries.* New York: American
Art Association, 1929, 100.
 Duthuit, Claude, and Wanda de
Gubriant. *Henri Matisse: l'Oeuvre
Sculpt.* Paris 1997, no. 37, 96.
 Elsen, Albert E. *The Sculpture of
Henri Matisse.* New York: Harry N.
Abrams, 1971, no. 125.
 Monod-Fontaine, Jacques. *The
Sculpture of Henri Matisse.* London,
1954, no. 29.
 Musée Matisse. *Matisse,
sculptures—dessins, dialogue.*
Paris: Musée Matisse, Musée
départemental Le Cateau-
Cambrésis, 1993, 59, no. 46, ill.
Exhibition catalog.

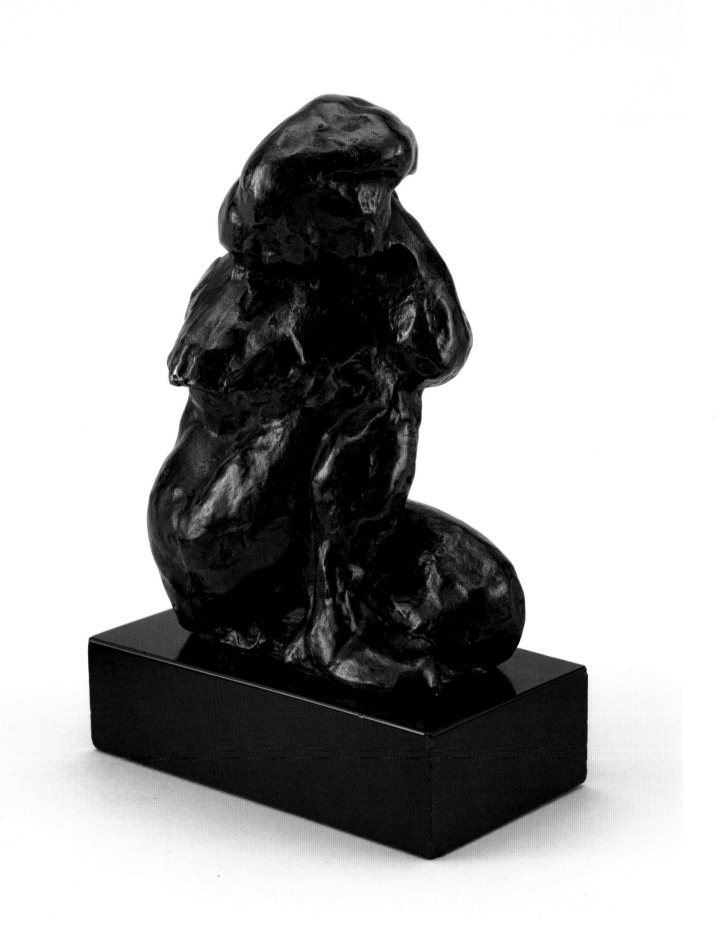

35.

Amedeo Modigliani (Italian, 1884–1920)
Caryatid, ca.1916
Oil on canvas, 22½ × 19 in.
Location unknown

Provenance
Probably Hôtel Drouot, Paris;
George Gershwin (1898–1937); by
descent to Rose Gershwin (1876–
1948); Parke-Bernet, New York,
June 27, 1972, lot 135.

Exhibition History
Chicago. Arts Club of Chicago.
*Exhibition of the George Gershwin
Collection of Modern Paintings*,
November 10–25, 1933, no. 29.
 New York. Museum of Modern
Art. *Modern Works of Art: Fifth
Anniversary Exhibition*, November
20, 1934–January 20, 1935, no. 116.
 New York. Museum of Modern
Art. *Private Collection*, July 27–
September 6, 1936.

Literature
Botkin, Henry. "A Composer's
Pictures: George Gershwin, the
Musician, Is a Collector of Modern
Paintings." *Arts & Decoration* 11, no.
3 (January 1934): 48–50, ill. (color).
 Museum of Modern Art. *Modern
Works of Art: Fifth Anniversary
Exhibition*. New York: Museum of
Modern Art, 1934, no. 116.

Other works by Modigliani
owned by George Gershwin:

Buste d'homme, n.d.
Pencil on paper, 17 × 10⅜ in.
Location unkown

Sotheby's. *Impressionist and
Modern Art, Part II*, New York,
Wednesday, May 12, 1999, lot 368,
182, ill. (color).
Hartford, CT. Wadsworth
Atheneum. *The Music Makers:
The Private Collections of Mr. &
Mrs. Richard Rodgers and Mr. &
Mrs. Leopold Godowsky Including
Paintings from the Collection of
George Gershwin*, July 9–August
9, 1959, no. 33 (as "Portrait of a
Young Man").

Etude de nu, n.d.
Pencil on paper, 17 × 10⅜ in.
Location unknown

Sotheby's. *Impressionist &
Modern Art, Part Two*, New York,
Wednesday, May 9, 2001, lot 505,
214, ill. (color).
Hartford, CT. Wadsworth
Atheneum. *The Music Makers:
The Private Collections of Mr. &
Mrs. Richard Rodgers and Mr. &
Mrs. Leopold Godowsky Including
Paintings from the Collection of
George Gershwin*, July 9–August 9,
1959, no. 32 (as "Male Nude").

Man with a Pipe, n.d.
Pencil on paper, 11 × 9½ in.
Location unkown

Wight, Frederick S., with a
foreword by William S. Lieberman.
Modigliani, Paintings & Drawings.
Museum of Fine Arts, Boston, and
Los Angeles County Museum, 1961,
78, no. 83.

Portrait de femme, n.d.
Pencil on paper, 17¼ × 10⅜ in.
Location unkown

Sotheby's. *Impressionist and
Modern Art, Part II*, New York,
Wednesday, May 12, 1999, lot 371,
184, ill. (color).
Hartford, CT. Wadsworth
Atheneum. *The Music Makers:
The Private Collections of Mr. &
Mrs. Richard Rodgers and Mr. &
Mrs. Leopold Godowsky Including
Paintings from the Collection of
George Gershwin*, July 9–August 9,
1959, no. 34 (as "Woman").

Portrait of Kisling, 1915–16
Pencil on paper, 17 × 10⅛ in.
Location unkown

Sotheby's. *Impressionist &
Modern Art, Part Two*, New York,
Wednesday, May 9, 2001, lot 506,
214, ill. (color).

"Those who like the art of the moderns like this painting especially.
If they heartily dislike the moderns, they hate this particularly."
—George Gershwin on Modigliani's *Caryatid*

36.*

Amedeo Modigliani (Italian, 1884–1920)
Portrait of Doctor Devaraigne, 1917
Oil on canvas, 21½ × 18 in.
Private collection

This painting is one of five works of art that Ira Gershwin lent to be used as props in the 1944 film *Rhapsody in Blue* starring Robert Alda in the role of George Gershwin.

Provenance
Paul Guillaume, Paris; Chester H. Johnson Galleries, Chicago; American Art Association, Anderson Galleries, Inc., New York, November 14, 1934, lot 67; George Gershwin (1898–1937); by descent to Rose Gershwin (1876–1948); by descent to Ira (1896–1983) and Leonore (1900–1991) Gershwin; Michael and Jean Strunsky; Sotheby's, New York, November 11, 1999, lot 135; private collection, US; Sotheby's, New York, November 4, 2004, lot 49; private collection.

Exhibition History
New York. Museum of Modern Art. *Private Collection*, July 27–September 6, 1936.
 Los Angeles. Los Angeles City Hall Tower Gallery. *3: A Century of Painting and Sculpture by Jewish Artists*, co-sponsored by the Department of Municipal Art and the Los Angeles Jewish Community Council in honor of the third anniversary of the State of Israel, May 15–June 21, 1951.
 Los Angeles. Los Angeles City Hall Tower Gallery. *The Collection of Mr. and Mrs. Ira Gershwin*, March 19–April 18, 1952.
 Los Angeles. Los Angeles County Museum; Boston. Museum of Fine Arts. *Modigliani, Paintings & Drawings*, March 29–April 30, 1961, no. 13.
 Los Angeles. Paul Kantor Gallery; Beverly Hills, Frank Perls Gallery. *50 Years of Beverly Hills*, April 25–26, 1964.

Literature
Ceroni, Ambrogio. *Amedeo Modigliani, dessins et sculptures*. Milan, 1965, no. 184, 44, ill.
 —— and Françoise Cachin. *Tout l'oeuvre peint de Modigliani*. Paris: Flammarion, 1972, no. 183, ill.
 The Chester H. Johnson Galleries, Chicago, Collection of Paintings. New York: American Art Association, Anderson Galleries, Inc., November 14, 1934, lot 67, 26, ill.

Jablonski, Edward, and Lawrence D. Stewart, with an introduction by Carl Van Vechten. *The Gershwin Years*. Garden City, NY: Doubleday & Company, Inc., 1973, 267, ill.
 Knight, Arthur, with photographs by Eliot Elisofon, *The Hollywood Style*. London: The Macmillan Company, 1969, 130, ill.
 Lanthemann, Joseph. *Modigliani, 1884–1920—catalogue raisonné, sa vie, son oeuvre complet, son art*. Barcelona: Gráficas Condal, 1970, no. 200, 213, ill.
 Millier, Arthur, with a preface by Kenneth Ross. *3: A Century of Painting and Sculpture by Jewish Artists in Honor of the Third Anniversary of the State of Israel*, Los Angeles: Municipal Art Gallery, 1951, n.p., ill.
 Patani, Osvaldo. *Amedeo Modigliani, catalogo generale*. Milan: Leonardo, 1991, no. 189, 200, ill.
 Pfannstiel, Arthur. *Catalogue présumé de l'oeuvre de Modigliani*. Paris: Éditions Marcel Seheur, 1929, 17 (as "Le Beau Major").
 ——. *Modigliani et son oeuvre, étude critique et catalogue raisonné*. Paris; Bibliothèque des Arts, 1956, no. 199.
 Sotheby's. *Impressionist & Modern Art Part One*. New York: Sotheby's, Thursday, November 11, 1999, lot 135, 112–13, ill. (color).
 ——. *Impressionist and Modern Art, Evening Sale*. New York: Sotheby's, November 4, 2004, lot 49.
 Wight, Frederick S., with a foreword by William S. Lieberman. *Modigliani, Paintings & Drawings*. Boston: Museum of Fine Arts, and Los Angeles: Los Angeles County Museum, 1961, 37, no. 13, ill.

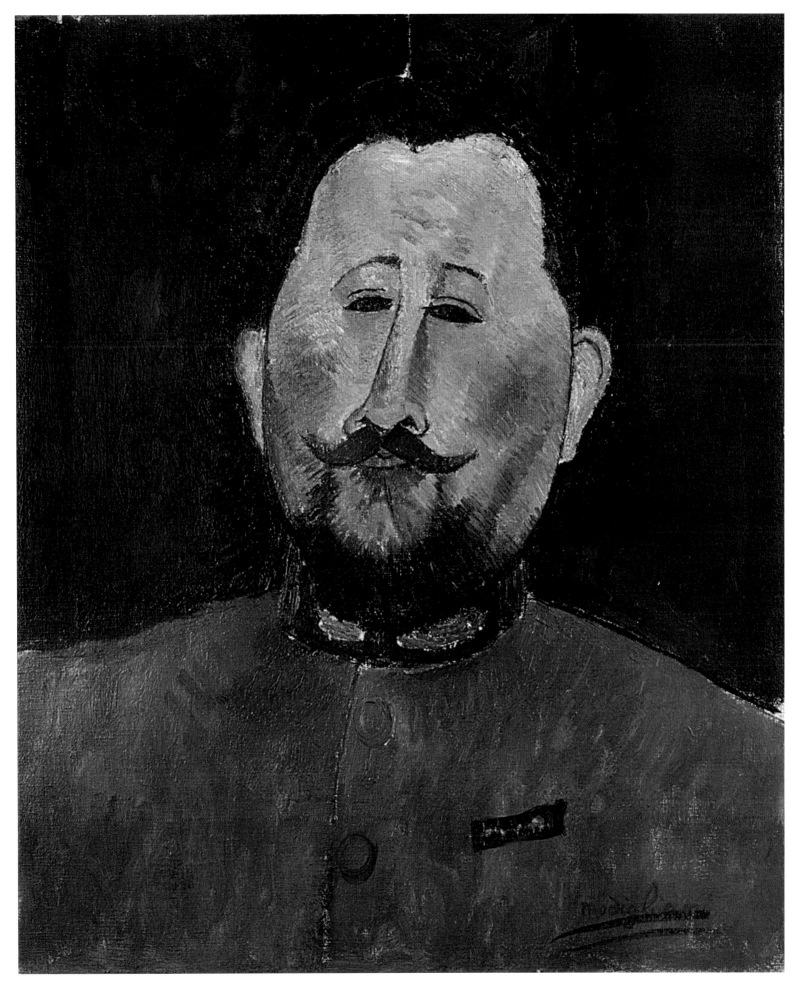

37.*

Attributed to Amedeo Modigliani
(Italian, 1884–1920)
Bust of a Young Woman, purportedly from 1919
Oil on canvas, 22 × 17 in.
Private collection

Provenance
Purportedly Collection [Romain] Rolland, Paris; Leopold Zborowski, Paris; George Gershwin (1898–1937); by descent to Rose Gershwin (1876–1948); by descent to Ira (1896–1983) and Leonore (1900–1991) Gershwin; private collection.

Exhibition History
Chicago. Arts Club of Chicago. *Exhibition of the George Gershwin Collection of Modern Paintings*, November 10–25, 1933, no. 28.

New York. Museum of Modern Art. *Private Collection*, July 27–September 6, 1936.

Los Angeles. Los Angeles County Museum; Boston. Museum of Fine Arts. *Modigliani, Paintings & Drawings*, March 29–April 30, 1961, no. 39.

Literature
Greenberg, Rodney. *George Gershwin*. London: Phaidon, 1998, 129, ill.

Knight, Arthur, with photographs by Eliot Elisofon. *The Hollywood Style*. London: The Macmillan Company, 1969, 129, ill.

Wight, Frederick S., with a foreword by William S. Lieberman. *Modigliani, Paintings & Drawings*. Boston: Museum of Fine Arts; Los Angeles: Los Angeles County Museum, 1961, 61, pl. 30, ill.

Fig. 80. George Gershwin and William Daly in Gershwin's penthouse apartment at 33 Riverside Drive, New York, 1931. On the wall are *Bust of a Young Woman* and Chagall's *Untitled (Old Man with Beard)*. On the floor is a modernist rug, perhaps designed by Jean Lurçat.

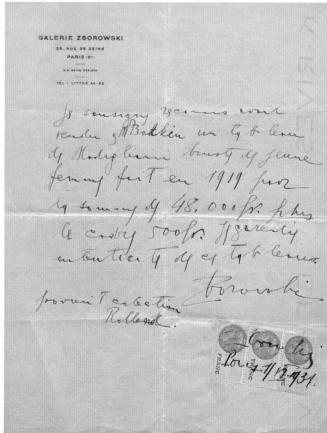

Fig. 81. Sales slip for Modigliani's *Head of a Woman* from Galerie Zborowski, Paris, 1931. After the artist's death in 1920, his dealer, Léopold Zborowski, trafficked in both authentic and forged Modiglianis.

38.

Isamu Noguchi (American, 1904–1988)
Black Boy, 1934
Ebony, 53⅜ × 14⅝ × 9⅛ in.
Private collection

Provenance
Marie Harriman Gallery, New York;
George Gershwin (1898–1937); by
descent to Rose Gershwin (1876–
1948); by descent to Ira (1896–1983)
and Leonore (1900–1991) Gershwin;
private collection.

Exhibition History
New York. Marie Harriman Gallery.
Isamu Noguchi, January 29–
February 16, 1935.

Literature
Eglington, Laurie. "Noguchi: Marie
Harriman Gallery." *Art News* 33
(February 1935): 8.
 Isamu Noguchi. New York: Marie
Harriman Gallery, 1935.
 Jewell, Edward Alden. "Noguchi
Sculpture in Metal Exhibited; Grim
Portrayal of Lynching Is Among
Subjects at Marie Harriman
Gallery." *New York Times*, January
31, 1935, 17.
 "Social Theme Developed by
Noguchi in Show." *The Art Digest* 9,
no. 9 (February 1, 1935): 9.

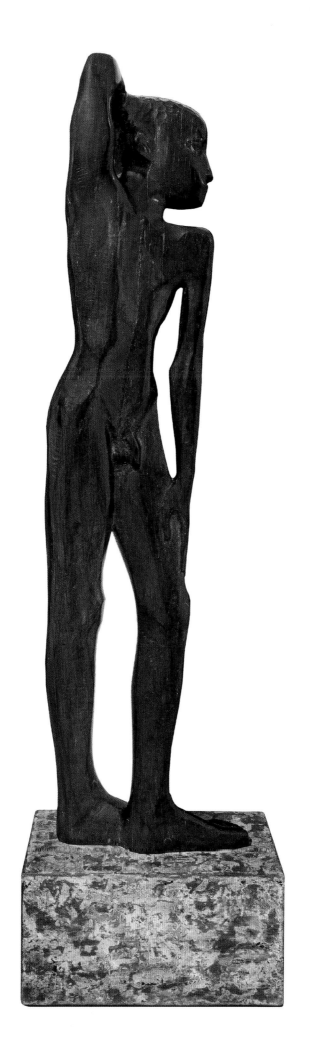

39.*

Isamu Noguchi (American, 1904–1988)
Portrait of George Gershwin, 1929
Bronze, height: 18 in.
Israel Museum, Jerusalem, Gift of the artist, 1966

The cast reproduced here and included in the exhibition was made in 1966 and is the second of two known casts of this work.

Provenance of Gershwin's cast
George Gershwin (1898–1937); by descent to Rose Gershwin (1876–1948); by descent to Arthur (1900–1981) and Judy (1917–2013) Gershwin; by descent to Marc Gershwin.

Exhibition History of Gershwin's cast
New York. Marie Sterner Galleries. *Fifteen Heads by Isamu Noguchi*, February 1–14, 1930.
Chicago. Arts Club of Chicago. *Sculpture by Isamu Noguchi*, March 26–April 9, 1930.
Cambridge, MA. The Harvard Society for Contemporary Art, 1930.
Chicago. Arts Club of Chicago. *Exhibition of the George Gershwin Collection of Modern Paintings*, November 10–25, 1933, no. 67.
New York. Museum of Modern Art. *Modern Works of Art: Fifth Anniversary Exhibition*, November 20, 1934–January 20, 1935, no. 183.
San Francisco. San Francisco Museum of Art. *Isamu Noguchi*, July 1942.
Los Angeles. Los Angeles City Hall Tower Gallery. *The Collection of Mr. and Mrs. Ira Gershwin*, March 19–April 18, 1952.
New York. Philharmonic Hall. *Exhibit of Paintings and Drawings by George Gershwin*, June 1963.
New York. Museum of the City of New York. *George the Music, Ira the Words*, May 6–September 2, 1968.
Brooklyn. Brooklyn College. *Celebrating the Gershwins: An Exhibition and Entertainment*. March 8–April 5, 1982.
East Hampton, NY. Guild Hall. *Ira—The Words, George-The Music—A Tribute to the Gershwin Brothers*, August 10–September 21, 1986.
Washington, DC. National Portrait Gallery, Smithsonian Institution. *Isamu Noguchi: Portrait Sculpture*, April 15–August 20, 1989.
New York. Whitney Museum of American Art at Philip Morris. *Isamu Noguchi: Portrait Sculpture*, October 6–December 6, 1989.

Literature
Apostolos-Cappadona, Diane, and Bruce Altshuler. *Isamu Noguchi Essays and Conversations*, New York: Harry N. Abrams in association with the Isamu Noguchi Foundation, 1994, 22–23, ill.
Arts Club of Chicago. *Sculpture by Isamu Noguchi*. Chicago: Arts Club of Chicago, 1930. Exhibition brochure.
Buettner, Stewart, and Reinhard G. Pauly. *Great Composers, Great Artists, Portraits*. Portland, OR: Amadeus Press, 1992, 146–47, ill.
Clarke, Gerald. "Broadway Legends: George Gershwin, The Celebrated Composer's Manhattan Penthouse." *Architectural Digest*, November 1995: 192–95, 270, ill.
De Santis, Florence Stevenson. *Gershwin*. New York: Treves Publishing Company, 1987, 14, 107, ill.
Feinstein, Michael, with Ian Jackman. *The Gershwins and Me*. New York: Simon and Schuster, 2012, 107, ill.
Filler, Martin. "Talking Heads: Noguchi's portrait busts bring to life two decades of America's creative elite." Review of *Isamu Noguchi Portrait Sculpture at the National Portrait Gallery*, Smithsonian Institution, Washington DC. *Home and Garden*, May 1989, 62.
Gibson, Eric. "Reviews: District of Columbia, Noguchi and Brancusi National Portrait Gallery, Washington, D.C. The Museum of Modern Art, New York." *Sculpture* (November/December 1989): 42, ill.
Goldberg, Isaac. "Music by Gershwin," *Ladies Home Journal*, February 1931, 12–13, 149, 151, ill.
Greenberg, Rodney. *George Gershwin*. London: Phaidon, 1998, 115, ill.
Grove, Nancy. *Isamu Noguchi: Portrait Sculpture*. Washington, DC: National Portrait Gallery, Smithsonian Institution, 1989, cover, 44, 45, ill. Exhibition catalog.
Grove, Nancy. *Isamu Noguchi: Portrait Sculpture*. New York: Whitney Museum of American Art at Philip Morris, 1989, 4, ill. Exhibition brochure.

Harvard Society for Contemporary Art, The. 1930. Exhibition brochure.

J., E. A. "Work by Six Japanese Artists." *New York Times*, February 9, 1930.

Jablonski, Edward, and Lawrence D. Stewart, with an introduction by Carl Van Vechten. *The Gershwin Years*. Garden City, NY: Doubleday & Company, Inc., 1973, 184, ill.

Kimball, Robert, and Alfred Simon. *The Gershwins*. New York: Atheneum, 1973, 111, ill.

Kimmelman, Michael. "Noguchi as a Master of Portrait Sculpture." *New York Times*, May 17, 1989. Review of *Isamu Noguchi Portrait Sculpture* at the National Portrait Gallery, Smithsonian Institution, Washington DC, ill.

Marie Sterner Galleries. *Fifteen Heads by Isamu Noguchi*. New York: Marie Sterner Galleries, 1930.

Museum of Modern Art. *Modern Works of Art: Fifth Anniversary Exhibition*. New York: Museum of Modern Art, 1934, no. 183, ill.

New York Times. "Brooklyn College Sets Gershwin Show." February 14, 1982.

———. "A Portrait Bust of George Gershwin, by Isamu Noguchi." February 9, 1930, ill.

Noguchi, Isamu. "Portrait." In *George Gershwin*, edited by Merle Armitage. New York: Longmans, Green & Co., 1938, 209–10.

People's World, "Evacuee Shows Sculptures for Democracy at S. F. Museum." Ca. July 1942.

Pollack, Howard. *George Gershwin: His Life and Work*. Berkeley, Los Angeles, London: University of California Press, 2006, 284–85, ill.

Schwartz, Charles. *Gershwin: His Life and Music*. Indianapolis and New York: The Bobbs-Merrill Company, Inc., 1973, 176, ill.

Suriano, Gregory R., ed. *Gershwin in His Time—A Biographical Scrapbook, 1919–1937*. New York Gramercy Books, 1998, 101, ill.

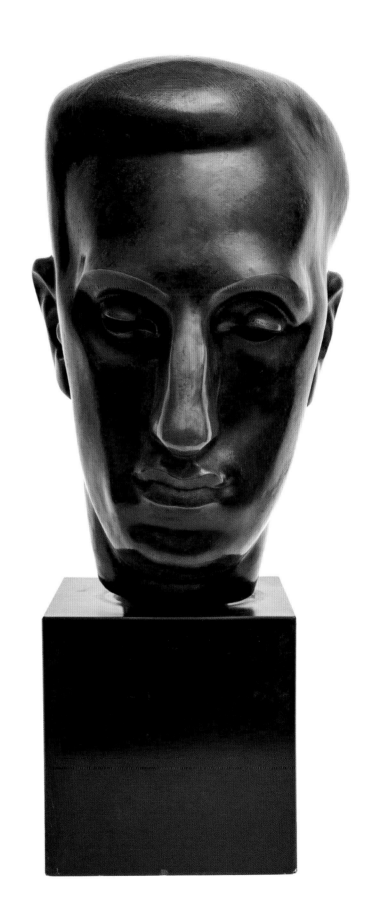

Jules Pascin (American, b. Bulgaria, 1885–1930)
Girl with a Kitten, ca. 1926
Oil and charcoal on canvas, 31⅜ × 25¼ in.
The Metropolitan Museum of Art, New York, NY,
Gift of Leonore S. Gershwin Trust, 1993, 1993.89.2

Provenance
Galerie Bernheim-Jeune, Paris;
George Gershwin (1898–1937); by
descent to Rose Gershwin (1876–
1948); by descent to Ira (1896–1983)
and Leonore (1900–1991) Gershwin;
given to the Metropolitan Museum
of Art, New York, by the Leonore S.
Gershwin Trust, 1993.

Exhibition History
Chicago. Arts Club of Chicago.
*Exhibition of the George Gershwin
Collection of Modern Paintings*,
November 10–25, 1933, no. 32.
 New York. Museum of Modern
Art. *Private Collection*, July 27–
September 6, 1936.
 Los Angeles. Los Angeles City
Hall Tower Gallery. *3: A Century of
Painting and Sculpture by Jewish
Artists*, co-sponsored by the
Department of Municipal Art and
the Los Angeles Jewish Community
Council in honor of the third
anniversary of the State of Israel,
May 15–June 21, 1951.
 Los Angeles. Los Angeles City
Hall Tower Gallery. *The Collection
of Mr. and Mrs. Ira Gershwin*, March
19–April 18, 1952.
 New York. The Metropolitan
Museum of Art. *Recent
Acquisitions: 1993–95*, July 28–
September 24, 1995.
 New York. The Metropolitan
Museum of Art. *Pascin on Paper*,
March 9–June 13, 1999.
 New York. The Metropolitan
Museum of Art. *Painters in Paris,
1895–1950*, March 8–December 31,
2000, extended to January 13, 2001.
 Kyoto and Tokyo. Japan, *Picasso
and the School of Paris: Paintings
from The Metropolitan Museum
of Art*. Kyoto Municipal Museum,
September 14–November 24, 2002,
and Bunkamura Museum of Art,
Tokyo, December 7, 2002–March
9, 2003. Catalogue in Japanese
and English edited by William S.
Lieberman.

Literature
Brodzky, Horace. *Pascin*. London:
Nicholson & Watson, 1946, no. 28,
ill. (as "Little Girl with White Cat").

De Santis, Florence Stevenson.
Gershwin. New York: Treves
Publishing Company, 1987, 75, ill.
 Feinstein, Michael, with Ian
Jackman. *The Gershwins and Me*.
New York: Simon and Schuster,
2012, 231, ill.
 Greenberg, Rodney. *George
Gershwin*. London: Phaidon, 1998,
90, ill.
 Hemin, Yves, et al. *Pascin:
Catalogue raisonné, peintures,
aquarelles, pastels, dessins*, volume
1, Paris: A Rambert, 1984, no. 508,
273, ill. (as "Portrait de fillette").
 Hyland, William G. *George
Gershwin: A New Biography*.
Westport, CT, and London: Praeger,
2003, 122–23, ill.
 Jablonski, Edward, and Lawrence
D. Stewart, with an introduction
by Carl Van Vechten. *The Gershwin
Years*. Garden City, NY: Doubleday
& Company, Inc., 1973, 263, ill.
 Lieberman, William S. *Painters
in Paris 1895–1950*. New York: The
Metropolitan Museum of Art, 2000,
99, ill. (color).
 ———. *Picasso and the School
of Paris: Paintings from The
Metropolitan Museum of Art*.
Japan: Yomiuri Shimbun, 2002, 111.
Exhibition catalog.
 Millier, Arthur, with a preface
by Kenneth Ross. *3: A Century of
Painting and Sculpture by Jewish
Artists in Honor of the Third
Anniversary of the State of Israel*.
Los Angeles: Municipal Art Gallery,
1951, n.p., ill.
 Morand, Paul. *Pascin*. Paris:
Éditions de Chroniques du Jour,
1931, no. 1, ill. (dated as 1924).
 Pascin. Paris: Comité Pascin and
Éditions Paradox, 2017, volume 2,
no. 2866, 850, ill.
 Pollack, Howard. *George
Gershwin: His Life and Work*.
Berkeley, Los Angeles, London:
University of California Press, 2006,
604–05, ill.
 Richter, Larry. "Toward a Go-To
Gershwin Edition." *New York Times*,
September 13, 2013, ill.
 Schwartz, Charles. *Gershwin:
His Life and Music*. Indianapolis
and New York: The Bobbs-Merrill
Company, Inc., 1973, 272, ill.

Fig. 82. Gershwin at 132 E. 72nd Street, New York,
with Utrillo's *Moulin à Ouessant, Bretagne* and
Pascin's *Girl with a Kitten* behind him, 1934.

153

41.

Jules Pascin (American, b. Bulgaria, 1885–1930)
Portrait of a Young Man (Portrait of the Painter Ascher), ca. 1926
Oil and charcoal on canvas, 36 × 29 in.
Collection Marc Gershwin

Provenance
Galerie Van Leer, Paris; George Gershwin (1898–1937); by descent to Rose Gershwin (1876–1948); by descent to Arthur (1900–1981) and Judy (1917–2013) Gershwin; by descent to Marc Gershwin.

Exhibition History
Berlin. Cassirer Gallery, 1930.
 Buffalo. The Buffalo Fine Arts Academy, Albright Art Gallery. *Twenty-Sixth Annual Exhibition of American Art*, 1932.
 Chicago. Arts Club of Chicago. *Exhibition of the George Gershwin Collection of Modern Paintings*, November 10–25, 1933, no. 31.
 New York. Museum of Modern Art. *Private Collection*, July 27–September 6, 1936.

Literature
Clarke, Gerald. "Broadway Legends: George Gershwin, The Celebrated Composer's Manhattan Penthouse." *Architectural Digest*, November 1995: 192–95, 270, ill.
 Feinstein, Michael, with Ian Jackman. *The Gershwins and Me*. New York: Simon and Schuster, 2012, 107, ill.
 Schwartz, Charles. *Gershwin: His Life and Music*. Indianapolis and New York: The Bobbs-Merrill Company, Inc., 1973, 176, ill.
 Suriano, Gregory R., ed. *Gershwin in His Time: A Biographical Scrapbook, 1919–1937*. New York Gramercy Books, 1998, 101, ill.

"You will notice that the two pictures that I have chosen, namely, the Derain and Pascin, although modern in feeling, were a little more understandable than some of the others you sent, and I think, for a while, my tastes will run along these lines."
—George Gershwin letter to Henry Botkin

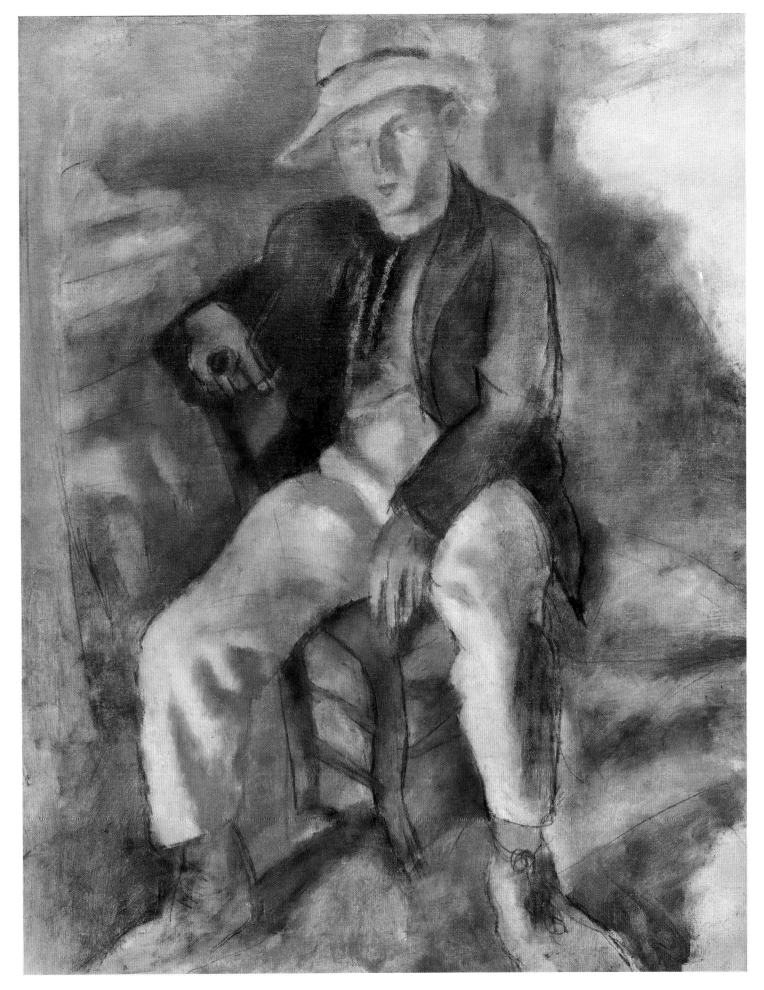

42.

Pablo Picasso (Spanish, 1881–1973)
The Absinthe Drinker, 1901
Oil on cardboard, 25¾ × 20½ in.
Private collection

"I am happy to know that you are so enthusiastic about the Picasso I bought. I feel my collection should be much more complete with that fine picture. I can't wait till I see it."
—George Gershwin letter to Henry Botkin

Provenance

Paul Guillaume, Paris; Galerie Van Leer, Paris; George Gershwin (1898–1937); by descent to Rose Gershwin (1876–1948); John Hay Whitney, New York, by 1951; Wildenstein & Co., New York; William Jaffe and Evelyn Annenberg Jaffe, New York, acquired May 1, 1958; Evelyn Annenberg Jaffe Hall; Christie's, New York, November 1, 2005, lot 25; private collection. On loan to the Musée d'Orsay, Paris, approx. 2011–19.

Exhibition History

Paris. Ambroise Vollard Gallery. *F. Iturrino and P. R. Picasso*, June 25–July 14, 1901.
New York. Museum of Modern Art. *Summer Exhibition: Painting and Sculpture*, July 10–September 30, 1933.
Chicago. Arts Club of Chicago. *Exhibition of the George Gershwin Collection of Modern Paintings*, November 10–25, 1933, no. 33.
New York. Museum of Modern Art. *Private Collection*, July 27–September 6, 1936.
New York. M. Knoedler & Co., Inc. *Picasso before 1907*, October–November 1947, no. 9.
New Haven, CT. Yale University Art Gallery. *Pictures Collected by Yale Alumni*, May–June 1956, no. 132.
New York. M. Knoedler & Co., Inc. *Picasso: An American Tribute*, 1962.
Dallas. Dallas Museum of Fine Art. *Pablo Picasso: A Retrospective Exhibition*, 1967.
Washington, DC. National Gallery of Art. *Picasso: The Early Years, 1892–1906*, March 30–July 27, 1997.
London. Royal Academy of Art; New York. The Solomon R. Guggenheim Museum. *The Year 1900: Art at the Crossroads*, January–September 2000, 223, 438, no. 154, ill. (color).
Paris. Musée d'Orsay. *Picasso: Blue and Rose*, September 18, 2018–January 6, 2019.
Basel. Fondation Beyeler. *The Young Picasso—Blue and Rose Periods*, February 3–May 26, 2019.

Literature

Art News, February 1987, 99, ill.
 Bouvier, Raphael, ed. *Picasso: The Blue and Rose Periods*. Berlin, Hatje Cantz, 2019, 52–53, ill. (color).
 Clarke, Gerald. "Broadway Legends: George Gershwin, The Celebrated Composer's Manhattan Penthouse." *Architectural Digest*, November 1995, 192–95, 270, ill.
 Cowling, Elizabeth. *Picasso: Style and Meaning*, London: Phaidon, 2002, 79, 685, no. 54, ill. (color).
 Daix, Pierre. *Picasso: Life and Art*. New York: Icon, 1993, 23, 437.
 —— and G. Boudaille. *Picasso: The Blue and Rose Periods, A Catalogue Raisonné, 1900–1906*. Rev. ed. London: Evelyn Adams & Mackay, 1967, 157, 164, ill.
 Feinstein, Michael, with Ian Jackman. *The Gershwins and Me*. New York: Simon and Schuster, 2012, 107, ill.
 Jablonski, Edward. *Gershwin Remembered*. London and Boston: Faber and Faber, 1992, 64–65, ill.
 ——, and Lawrence D. Stewart, with an introduction by Carl Van Vechten. *The Gershwin Years*. Garden City, NY: Doubleday & Company, Inc., 1973, 221, ill.
 Lieberman, William. *Pablo Picasso*. New York: Harry N. Abrams, 1954, pl. 10.
 Life, "The Art Acquired by Yalemen: Six Pages of Color on an Alumni Show, Representing Classes from '67 to '51," May 28, 1956, 70–76, ill. (color). Caption: "John Hay Whitney '26. At Yale "Jock" Whitney combined his interests in horse racing and art by buying sporting prints. Graduating to paintings, he collected racing scenes by Impressionists, then switched into nonsport scenes like Picasso's *The Absinthe Drinker*, painted in 1901."
 McCully, Marilyn, ed. *Picasso, The Early Years, 1892–1906*, Washington, DC: National Gallery of Art, 1997, object 54, 153., ill. (color). Exhibition catalog.
 Merli, Joan. *Picasso*. Buenos Aires: El Ateneo, 1942, 143.
 Palau i Fabre, Josep. *Picasso: The Early Years 1881–1907*. New York: Rizzoli, 1981, 235, 534, no. 596, ill.

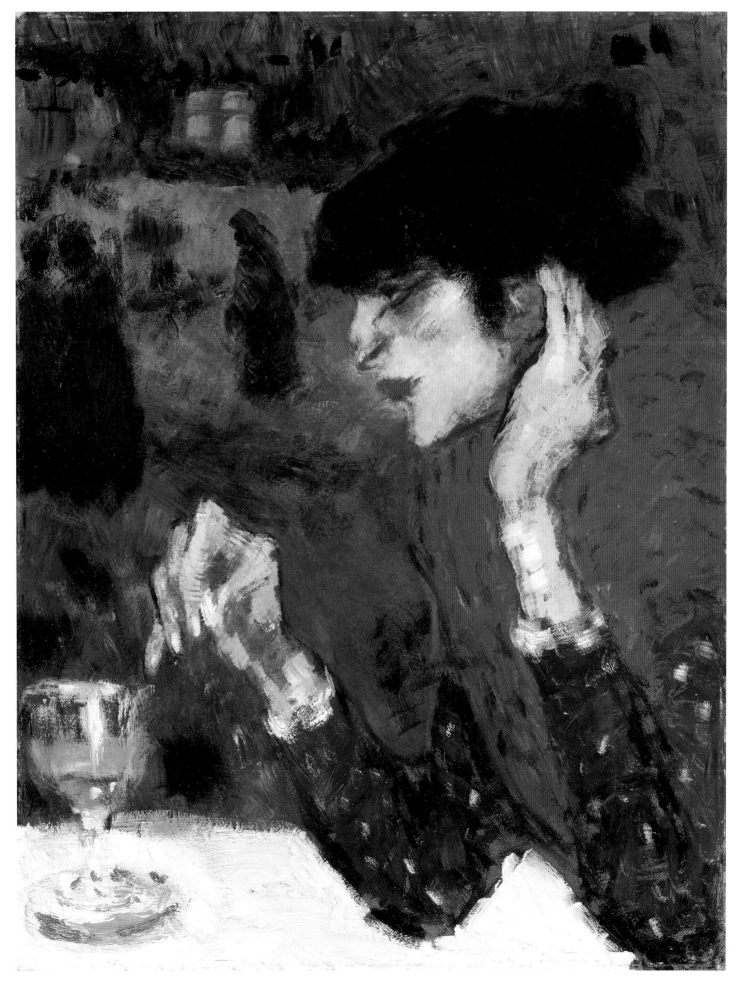

Rewald, John. "French Paintings in the Collection of Mr. and Mrs. John Hay Whitney." *Connoisseur*, April 1956, 138.

Salmon, André. "Absinthe." *Vanity Fair*, March 1934, 32–33, ill. (color).

Schwartz, Charles. *Gershwin: His Life and Music*. Indianapolis and New York: The Bobbs-Merrill Company, Inc., 1973, 176, ill.

Suriano, Gregory R., ed. *Gershwin in His Time: A Biographical Scrapbook, 1919–1937*. New York: Gramercy Books, 1998, 101, ill.

Wilenski, R. H., *Modern French Painters*. London: Faber & Faber, 1940/1944, 166.

Zervos, Christian. *Pablo Picasso*. Paris: Cahiers d'art, 1932, vol. I:62, no. 29, ill.

Other work by Picasso owned by George Gershwin:

Nude Boy on Horseback, ca. 1906
Drawing
Location unknown

Provenance
Probably Leo Stein Collection, Paris; Neuman (Picasso scholar); George Gershwin (1898–1937); by descent to Rose Gershwin (1876–1948); by descent to Arthur (1900–1981) and Judy (1917–2013) Gershwin.

Exhibition History
Chicago. Arts Club of Chicago. *Exhibition of the George Gershwin Collection of Modern Paintings*, November 10–25, 1933, no. 58 (as "Man and Horse").

Literature
Jablonski, Edward, and Lawrence D. Stewart, with an introduction by Carl Van Vechten. *The Gershwin Years*: Garden City, NY: Doubleday & Company, Inc., 1973, 402.

"George Gershwin was acutely conscious of his own importance. Once, after buying a Picasso painting, he got the uneasy feeling that it was a fake. He sent a photo of the picture to the artist, along with a note requesting authentication. Several weeks passed and he received no answer. He sent a second note. This time he got a reply from the painter, who assured him that the canvas was indeed a genuine Picasso. When Gershwin showed the reply to a friend, the latter said: 'I wonder why he didn't answer when you wrote him the first time.' 'No doubt, shrugged the composer, he wanted two Gershwin autographs.'"
—"Famous Fables," *The Sentinel*

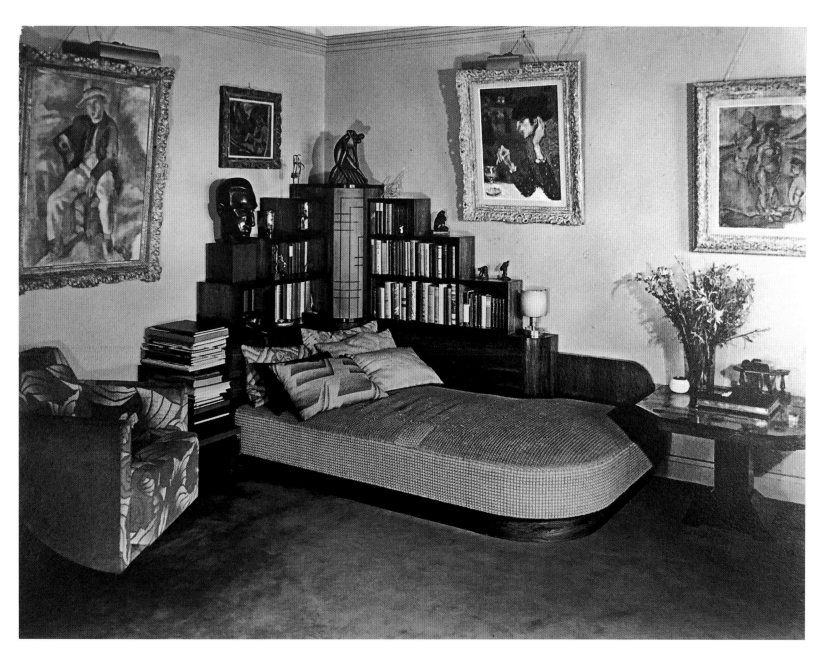

Fig. 83. Custom-made art deco day bed in the living room of Gershwin's penthouse apartment at 33 Riverside Drive, New York, probably designed by Paul Frankl. The day bed includes a vertical built-in lamp between the shelving. The artworks include Pascin's *Portrait of a Young Man (Portrait of the Painter Ascher)*; Noguchi's bust of Gershwin; Sterne's *Mother and Child, Bali*; Matisse's *Small Crouching Nude without an Arm*; Picasso's *The Absinthe Drinker*; and Rouault's *Bathers*.

Fig. 84. Gershwin and Botkin examine a new addition to the art collection in Gershwin's 132 E. 72nd Street apartment in New York City. Over Gershwin's shoulder is Picasso's *The Absinthe Drinker*. The other visible painting is likely by Botkin.

Walter Quirt (American, 1902–68)
*Terrorization of the Poor thru Religion
(Give Us this Day our Daily Bread)*, 1935
Oil on Masonite panel, 12½ × 18⁹⁄₁₆ in.
Wadsworth Atheneum Museum of Art,
Hartford, CT, Gift of Mr. and Mrs. Leopold
Godowsky, 1957.203

Provenance
Julien Levy Gallery, New York; George
Gershwin (1898–1937); by descent
to Rose Gershwin (1876–1948); by
descent to Frances (1906–1999) and
Leopold Godowsky Jr. (1900–1983);
given to the Wadsworth Atheneum
Museum of Art, Hartford, CT, 1957.

Exhibition History
New York. Julien Levy Gallery, 1936.

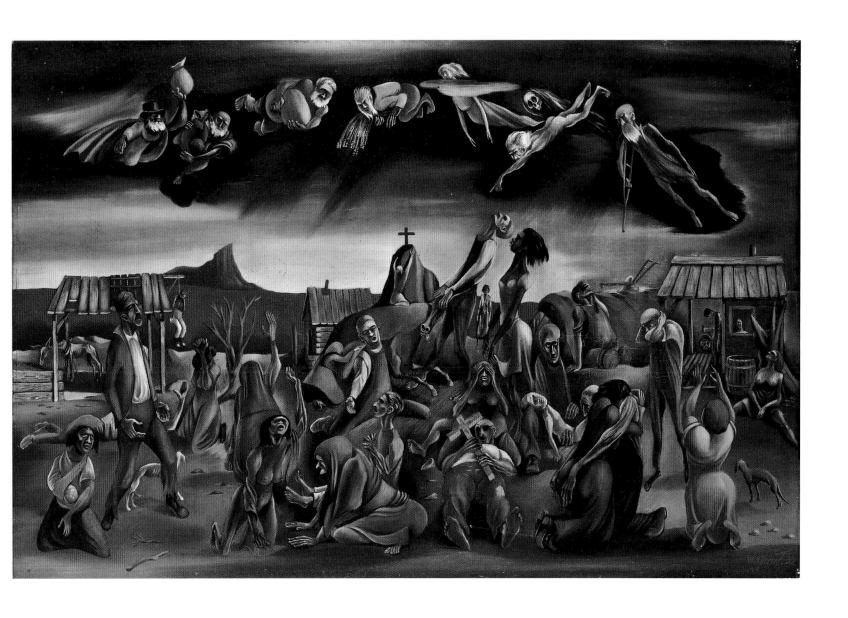

44.

Georges Rouault (French, 1871–1958)
Bathers, 1912
Oil thinned with turpentine on cardboard,
24½ × 38¾ in.
Location unknown

Note that this is a black-and-white image
of a color painting.

Provenance
Sold at Hôtel Drouot, Paris, by
Maître Bellier and Jos. Hessel,
December 9, 1929; Galerie Vignon,
Paris; George Gershwin (1898–1937);
by descent to Rose Gershwin
(1876–1948).

Exhibition History
Chicago. Arts Club of Chicago.
*Exhibition of the George Gershwin
Collection of Modern Paintings*,
November 10–25, 1933, no. 36.
 Hartford, CT. Wadsworth
Atheneum. *The Music Makers:
The Private Collections of Mr. &
Mrs. Richard Rodgers and Mr. &
Mrs. Leopold Godowsky Including
Paintings from the Collection of
George Gershwin*, July 9–August 9,
1959, no. 35.

Literature
Botkin, Henry. *Exhibition of the
George Gershwin Collection of
Modern Paintings*. Chicago: Arts
Club of Chicago, 1933, no. 36.
Exhibition brochure.
 Cunningham, Charles. *The Music
Makers: The Private Collections of
Mr. & Mrs. Richard Rodgers and Mr.
& Mrs. Leopold Godowsky Including
Paintings from the Collection of
George Gershwin*. Hartford, CT:
Wadsworth Atheneum, 1959, no.
35, pl. V, ill. Exhibition catalog.

"Oh, if only I could put Rouault into music!"
—George Gershwin, as quoted in Sidney Jerome,
"Porgy, Botkin and Bess," *Village Chatter*

45.

Georges Rouault (French, 1871–1958)
Clown (or *Le vieux clown*), 1904
Aquarelle gouache, 28.5 × 19 in.
Location unknown

Provenance
Galerie Van Leer, Paris; George Gershwin (1898–1937); by descent to Rose Gershwin (1876–1948); by descent to Ira (1896–1983) and Leonore (1900–1991) Gershwin; Galerie Beyeler, Basel; private collection, 1969; Sotheby's, New York, May 8, 2008, lot 129.

Exhibition History
New York. Museum of Modern Art. *Summer Exhibition: Painting and Sculpture*, July 10–September 30, 1933.
New York. Museum of Modern Art. *Modern European Art*, October 4–25, 1933.
Chicago. Arts Club of Chicago. *Exhibition of the George Gershwin Collection of Modern Paintings*, November 10–25, 1933, no. 34.
Wellesley, MA. Smith College Museum of Art, November 1935.
New York. Museum of Modern Art. *Private Collection*, July 27–September 6, 1936.
Los Angeles. Los Angeles City Hall Tower Gallery. *The Collection of Mr. and Mrs. Ira Gershwin*, March 19–April 18, 1952.
New York. Museum of Modern Art. 1952.
Basel. Galerie Beyeler. *Présence des Maîtres*, June–September 1967.

Literature
Dorival, Bernard, and Isabelle Rouault. *Rouault: L'oeuvre peint*. Monaco: Éditions André Sauret, 1988, vol. I, no. 109, 48.
Galerie Beyeler. *Présence des Maîtres*. Basel: Galerie Beyeler, 1967, no. 46, ill. (color).
Wilenski, R. H. *Modern French Painters*. London: Faber & Faber, 1940, no. 59, ill. (color).

Other Rouault works owned by Gershwin:

Augures, 1923
Etching and aquatint on paper, 20 × 17 in.
Location of Gershwin's impression unknown

Nous Sommes Fous, 1922
Etching and aquatint
Location unknown

Peasant Woman, n.d.
Location unknown

Rue de l'Avenir, n.d.
Location unknown

46.

Georges Rouault (French, 1871–1958)
Dancer with Two Clowns, 1929
Oil on canvas, 11½ × 15 in.
The Metropolitan Museum of Art, New York, NY,
Gift of Leonore S. Gershwin 1987 Trust, 1993,
1993.89.3

Provenance
George Gershwin (1898–1937); by
descent to Rose Gershwin (1876–
1948); by descent to Ira (1896–1983)
and Leonore (1900–1991) Gershwin;
given to the Metropolitan Museum
of Art, New York, by the Leonore S.
Gershwin Trust, 1993.

Exhibition History
New York. Museum of Modern
Art. *Summer Exhibition*, July 10–
September 30, 1933 (as "Three
Heads").
 New York. Museum of Modern
Art. *Modern European Art*, October
4–25, 1933 (as "Three Heads").
 Chicago. Arts Club of Chicago.
*Exhibition of the George Gershwin
Collection of Modern Paintings*,
November 10–25, 1933, no. 37.
 New York. Museum of Modern
Art. *Private Collection*, July 27–
September 6, 1936.
 Los Angeles. Los Angeles County
Museum. *Retrospective Exhibition:
Rouault*, July 3–August 16, 1953.
 Roslyn Harbor, NY. Nassau
County Museum of Art. *Art and
Entertainment*, November 18,
2007–February 3, 2008.

Literature
Barr, Alfred H. "Summer Show."
*Bulletin of the Museum of Modern
Art* 2 (October 1933): 2–4, ill.
 Los Angeles County Museum.
"Retrospective Exhibition: Rouault."
*Bulletin of the Art Division, Los
Angeles County Museum* 5, no. 3
(Summer 1953): 31.

"Do you ever think about my idea of getting Rouault to paint
the Last Supper? It might be worth investigating."
—George Gershwin letter to Henry Botkin

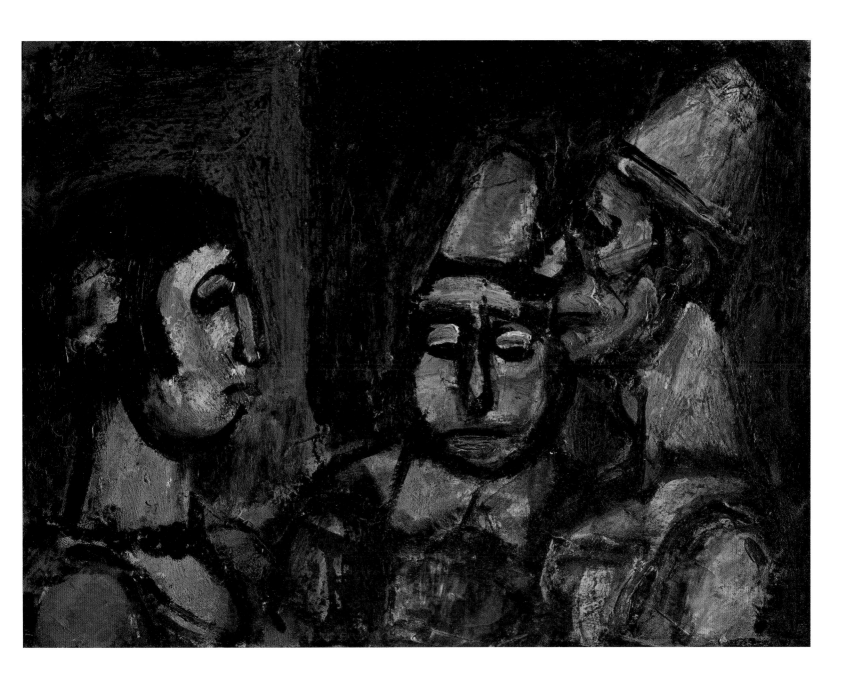

Georges Rouault (French, 1871–1958)
Deux Soldats Prussiens, 1915
Gouache and watercolor on paper,
mounted on paper, 16½ × 12⅜ in.
Location unknown

Provenance
George Gershwin (1898–1937); by
descent to Rose Gershwin (1876–
1948); by descent to Frances (1906–
1999) and Leopold Godowsky Jr.
(1900–1983); Sotheby's, New York,
May 12, 1999, lot 381; Sotheby's,
New York, May 9, 2001, lot 450.

Exhibition History
New York. Museum of Modern
Art. *Private Collection*, July 27–
September 6, 1936.
 Hartford, CT. Wadsworth
Atheneum. *The Music Makers:
The Private Collections of Mr. &
Mrs. Richard Rodgers and Mr. &
Mrs. Leopold Godowsky Including
Paintings from the Collection of
George Gershwin*, July 9–August 9,
1959, no. 36.

Literature
Cunningham, Charles. *The Music
Makers: The Private Collections of
Mr. & Mrs. Richard Rodgers and Mr.
& Mrs. Leopold Godowsky Including
Paintings from the Collection of
George Gershwin*. Hartford, CT:
Wadsworth Atheneum, 1959, no.
36. Exhibition catalog.
 Sotheby's. *Impressionist and
Modern Art, Part Two*. New York:
Sotheby's, May 9, 2001, lot 450,
pp.154–55, ill. (color).
 Sotheby's. *Impressionist and
Modern Art, Part Two*. New York:
Sotheby's, May 12, 1999, lot 381.

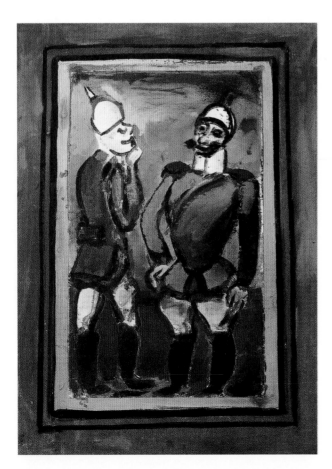

48.

Georges Rouault (French, 1871–1958)
La Pauvre Famille, 1929
Pastel over lithograph on paper, image 13½ × 9 in.
Location unknown

Provenance
George Gershwin (1898–1937);
by descent to Rose Gershwin
(1876–1948); by descent to Frances
(1906–1999) and Leopold Godowsky
Jr. (1900–1983); Sotheby's, New
York, May 12, 1999, lot 380.

Exhibition History
Chicago. Arts Club of Chicago.
*Exhibition of the George Gershwin
Collection of Modern Paintings*,
November 10–25, 1933, no. 63.

Literature
Chapon, François, and Isabelle
Rouault. *Rouault: Oeuvre gravé*,
Monte Carlo: Éditions André Sauret,
1978, 320, no. 346, ill.

"At Weyhe's Gallery the other day, I saw a half-a-dozen
Rouault lithographs—hand-colored by the artist
himself. . . . They are very lovely pictures, with
extremely bright color. I am very anxious to get
a few more Rouaults, as I feel he is one of the most
powerful painters living. So please keep your eyes
open for some of his work."
—George Gershwin letter to Henry Botkin

49.

Georges Rouault (French, 1871–1958)
La Pauvre Eglise, 1929
Pastel over lithograph on paper, image 11⅝ × 9 in.
Location unknown

Provenance
George Gershwin (1898–1937);
by descent to Rose Gershwin
(1876–1948); by descent to Frances
(1906–1999) and Leopold Godowsky
Jr. (1900–1983); Sotheby's, New
York, 12, 1999, lot 379.

Exhibition History
Chicago. Arts Club of Chicago.
*Exhibition of the George Gershwin
Collection of Modern Paintings*,
November 10–25, 1933, no. 60.

Literature
Chapon, François, and Isabelle
Rouault. *Rouault: Oeuvre grave*.
Monte Carlo: Éditions André Sauret,
1978, 323, no. 349, ill.

50.

Henri Rousseau (French, 1844–1910)
Île de la Cité, 1910
Oil on canvas, 6 × 9 ½ in.
Location unknown

Provenance
Paul Guillaume, Paris; George Gershwin (1898–1937); by descent to Rose Gershwin (1876–1948); by descent to Frances (1906–1999) and Leopold Godowsky Jr. (1900–1983); Sotheby's, New York, May 9, 2002. lot 190A.

Exhibition History
Paris. Galerie Bernheim-Jeune. *Collection Paul Guillaume*, 1929.
 New York. Marie Harriman Gallery, 1931.
 Chicago. Arts Club of Chicago. *Exhibition of the George Gershwin Collection of Modern Paintings*, November 10–25, 1933, no. 39.
 New York. Museum of Modern Art. *Private Collection*, July 27–September 6, 1936.
 New York. Museum of Modern Art. *Masters of Popular Painting: Modern Primitives of Europe and America*, April 27–July 24, 1938, no. 72.
 Hartford, CT. Wadsworth Atheneum. *The Music Makers: The Private Collections of Mr. & Mrs. Richard Rodgers and Mr. & Mrs. Leopold Godowsky Including Paintings from the Collection of George Gershwin*, July 9–August 9, 1959, no. 37.

Literature
Botkin, Henry. "A Composer's Pictures." *Arts and Decoration* 40, no. 3 (January 1934): 48–50, ill.
 Cahill, Holger, et al. *Masters of Popular Painting: Modern Primitives of Europe and America*. New York: The Museum of Modern Art, 1938, no. 72, ill. Exhibition catalog.
 Cunningham, Charles. *The Music Makers: The Private Collections of Mr. & Mrs. Richard Rodgers and Mr. & Mrs. Leopold Godowsky Including Paintings from the Collection of George Gershwin*. Hartford, CT: Wadsworth Atheneum, 1959, no. 37, pl. IV, ill. Exhibition catalog.
 Sotheby's. *Impressionist Art, Part Two*, New York: Sotheby's, May 9, 2002, lot 190A, ill. (color).

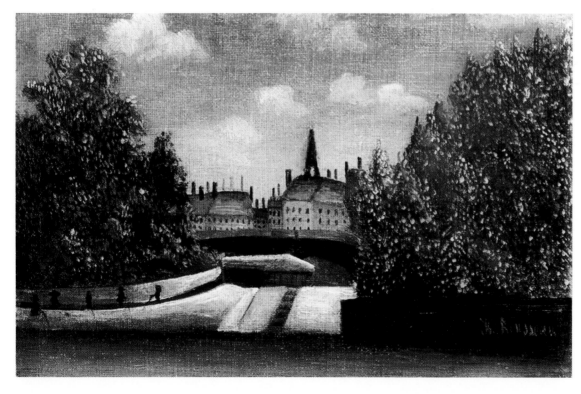

51.

Hélène Sardeau (American, b. Belgium, 1899–1969)
Figure of a Singer, 1928
Height: 10½ in.
Location unknown

Provenance
George Gershwin (1898–1937);
by descent to Rose Gershwin
(1876–1948); by descent to Arthur
(1900–1981) and Judy (1917–2013)
Gershwin; Estate of Judy Gershwin,
2013; Doyle, New York, June 19,
2013, lot 370.

Literature
Jablonski, Edward, and Lawrence
D. Stewart, with an introduction
by Carl Van Vechten. *The Gershwin
Years*. Garden City, NY: Doubleday
& Company, Inc., 1973, 184, ill.
 Kimball, Robert, and Alfred
Simon. *The Gershwins*. New York:
Atheneum, 1973, 111, ill.

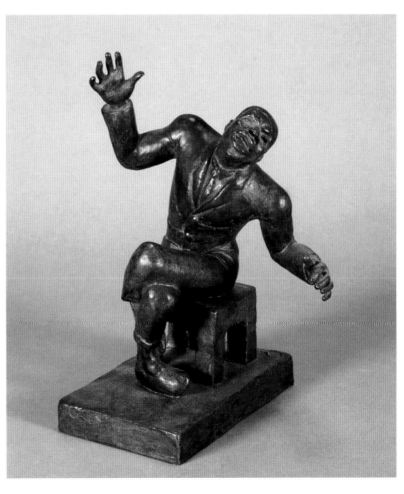

52. *

Ben Shahn (American, b. Lithuania, 1898–1969)
The Beach, ca. 1930
Oil on canvas, 15 × 24 in.
Wadsworth Atheneum Museum of Art, Hartford, CT,
Gift of Mr. and Mrs. Leopold Godowsky, 1957.204

Provenance
Downtown Gallery, New York; George
Gershwin (1898–1937); by descent
to Rose Gershwin (1876–1948); by
descent to Frances (1906–1999) and
Leopold Godowsky Jr. (1900–1983);
given to the Wadsworth Atheneum
Museum of Art, Hartford, CT, 1957.

Exhibition History
Chicago. Arts Club of Chicago.
*Exhibition of the George Gershwin
Collection of Modern Paintings*,
November 10–25, 1933, no. 40.

Fig. 85. Invoice for works by Alexander Brook,
Ben Shahn, and Glenn Coleman from the
Downtown Gallery, New York, February 9, 1932

53.*

David Alfaro Siqueiros (Mexican, 1896–1974)
Autorretrato con Espejo (Self-Portrait with Mirror), 1937
Cellulose nitrate paint on board coated
with phenolic resin, 30 × 24 in.
Museum of Fine Arts, Boston, Charles H. Bayley
Picture and Paintings Fund, Sophie M. Friedman
Fund, Ernest Wadsworth Longfellow Fund, Tompkins
Collection—Arthur Gordon Tompkins Fund, Williams
Francis Warden Fund, and Gift of Jessie H. Wilkinson—
Jessie H. Wilkinson Fund, 2017.3900

Provenance
George Gershwin (1898–1937);
by descent to Rose Gershwin
(1876–1948); by descent to Arthur
(1900–1981) and Judy (1917–2013)
Gershwin; by descent to Marc
Gershwin; Marie-Anne Martin Fine
Art, New York; Museum of Fine
Arts, Boston, 2017.

Literature
Herner, Irene. *Siqueiros from
Paradise to Utopia*. Mexico City:
MAPorrúa, 2010.
———, with the collaboration
of Mónica Ruiz and Grecia Pérez.
"David Alfaro Siqueiros, *Self-
Portrait with Mirror*." *Mary-Anne
Martin Fine Art*, June 15, 2017,
https://mamfa.com/david-alfaro-
siqueiros-self-portrait-with-
mirror-1937.
 Hurlburt, Laurance P. "The
Siqueiros Experimental Workshop:
New York, 1936." *Art Journal* 25, no.
3 (Spring 1976): 246, n13.
 Tibol, Raquel. *Palabras de
Siqueiros*. Mexico: Fondo de Cultura
Económica, Mexico, 1996, cover, ill.

David Alfaro Siqueiros (Mexican, 1896–1974)
Niña Madre, 1936
Duco enamel on Masonite, 30.1 × 24 in.
Maria Rodriguez de Reyero, New York

Provenance
George Gershwin (1898–1937); by descent to Rose Gershwin (1876–1948); by descent to Ira (1896–1983) and Leonore (1900–1991) Gershwin; given to the Santa Barbara Museum of Art; Christie's, New York, November 21, 1989, lot 16; Maria Rodriguez de Reyero, New York.

Exhibition History
New York. Museum of Modern Art. *Private Collection*, July 27–September 6, 1936 (as "Mexican Children").

Literature
Harten, Jurgen. *Siqueiros/Pollock, Pollock/Siqueiros*. Dusseldorf, Germany: Kunsthalle Dusseldorf; DuMont Buchverlag, 1995, 82–83. Exhibition catalog.

Herner, Irene, with the collaboration of Mónica Ruiz and Grecia Pérez. "David Alfaro Siqueiros, *Self-Portrait with Mirror*." *Mary-Anne Martin Fine Art*, June 15, 2017, https://mamfa.com/david-alfaro-siqueiros-self-portrait-with-mirror-1937.

Hurlburt, Laurance P. *The Mexican Muralists in the United States*. Albuquerque: University of New Mexico, 1989, 231, ill.

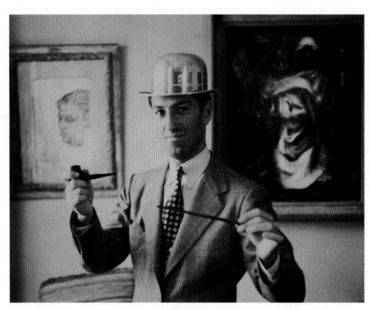

Fig. 86.* George Gershwin
Portrait of Diego Rivera, 1935
Collection Adam Gershwin

This portrait of Diego Rivera was created by Gershwin during his 1935 trip to Mexico. Rivera inscribed it with a dedication to Gershwin at the top left.

Fig. 87. Gershwin with party hat, pipe, and baton in front of his pencil sketch of Diego Rivera and the Siqueiros painting *Niña Madre*. Gershwin Collection, Library of Congress, Washington, DC.

With pipe and baton in hand, Gershwin is portraying himself as both an artist and a musician. Photo at his 132 E. 72nd Street apartment either by Gloria Braggiotti or Gershwin himself, and printed in mirror image.

55.

David Alfaro Siqueiros (Mexican, 1896–1974)
Portrait of George Gershwin in a Concert Hall, 1936
Oil on canvas, 66⅞×90⅝ in.
Harry Ransom Center, The University of Texas at Austin, 94.3

Front row, left side, L–R: David Alfaro Siqueiros, Mabel Schirmer, Leopold Godowsky Jr.., Frances Gershwin Godowsky, Dr. Gregory Zilboorg, Leonore Gershwin, Ira Gershwin

Second row, left side, L–R: Henry Botkin, Oscar Levant

Front row, right side, L–R: Unidentified woman, Morris Gershwin, Rose Gershwin, Arthur Gershwin, Emily Paley, Lou Paley, Kay Swift, William Daly

Second row, right side: Max Dreyfus

At the piano: George Gershwin

Provenance
George Gershwin (1898–1937); by descent to Rose Gershwin (1876–1948); by descent to Ira (1896–1983) and Leonore (1900–1991) Gershwin; Harry Ransom Humanities Research Center, University of Texas at Austin, 1994.

Exhibition History
New York. Museum of Modern Art. *Private Collection*, July 27–September 6, 1936.
 Los Angeles. Los Angeles City Hall Tower Gallery. *The Collection of Mr. and Mrs. Ira Gershwin*, March 19–April 18, 1952.
 New York. The Museum of the City of New York. *George the Music, Ira the Words*, May 6–September 2, 1968.

Literature
Albrecht, Donald, and Thomas Mellins. *Mexico Modern: Art, Commerce and Cultural Exchange, 1920–1945*. Munich: Hirmer Publishers, 2017. Exhibition catalog.
 Deussen, Nancy Bloomer. Letter to the editor. *New York Times*, September 20, 1998.
 Hurlburt, Laurance P. *The Mexican Muralists in the United States*. Albuquerque: University of New Mexico, 1989, 230, ill.
 Kimball, Robert, and Alfred Simon. *The Gershwins*. New York: Atheneum, 1973, 164–65, ill. (color).
 Knight, Arthur, with photographs by Eliot Elisofon. *The Hollywood Style*. London: The Macmillan Company, 1969, 130, ill.
 McLeod, Ray. "George Gershwin in an Imaginary Concert Hall." *Blanton Museum of Art* (blog), July 21, 2014. https://blantonmuseum.org/2014/07/21/george-gershwin-in-an-imaginary-concert-hall-2/.
 Pollack, Howard. *George Gershwin: His Life and Work*. Berkeley, Los Angeles, London: University of California Press, 2006, 604–5, ill.
 Schwartz, Charles. *Gershwin: His Life and Music*. Indianapolis and New York: The Bobbs-Merrill Company, Inc., 1973, 233, ill.
 Weber, Katharine. "In a Painting, Gershwin Packed the House." *New York Times*, August 30, 1998, Section 2, 30, 33, ill.

"Many times Gershwin and I heard sounds in my paintings and also we saw colors and shapes in his music. Often we were surprised to note that a mixture of reds was equivalent almost mathematically to a determinate harmony, and even a specific syncopation."
—David Alfaro Siqueiros

David Alfaro Siqueiros (Mexican, 1896–1974)
Proletarian Victim, 1933
Enamel on burlap, 81 × 47½ in.
The Museum of Modern Art, New York, NY,
Gift of the Estate of George Gershwin, 4.1938

Provenance
George Gershwin (1898–1937);
by descent to Rose Gershwin
(1876–1948); given to the Museum
of Modern Art, New York, by the
Estate of George Gershwin, 1938.

Exhibition History
New York. Museum of Modern
Art. *Modern Works of Art: Fifth
Anniversary Exhibition*, November
20, 1934–January 20, 1935, no. 146.
 New York. Museum of Modern
Art. *Large-Scale Modern Paintings*,
April 1–May 4, 1947.
 Houston. Museum of Fine Arts,
Houston. *David Alfaro Siqueiros:
Portrait of a Decade, 1930–1940*,
June 1–July 20, 1997.
 New York. Museum of Modern
Art. *Making Choices*, March 16–
September 26, 2000.
 New York. Whitney Museum of
American Art. *Vida Americana:
Mexican Muralists Remake
American Art, 1925–1945*, February
17, 2020–January 31, 2021.

Literature
Museum of Modern Art. *Modern
Works of Art: Fifth Anniversary
Exhibition*. New York: Museum
of Modern Art, 1934, no. 146, ill.
Exhibition catalog.

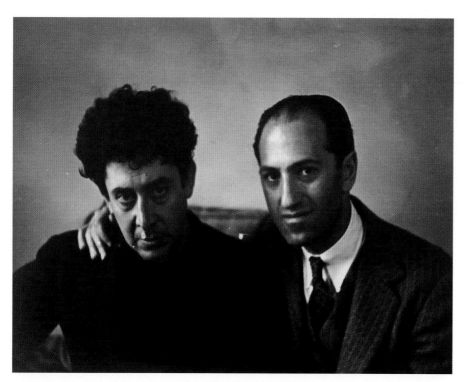

Fig. 88. George Gershwin's self-portrait
with David Alfaro Siqueiros, photographed
around 1936. Gershwin Collection,
Library of Congress, Washington, DC

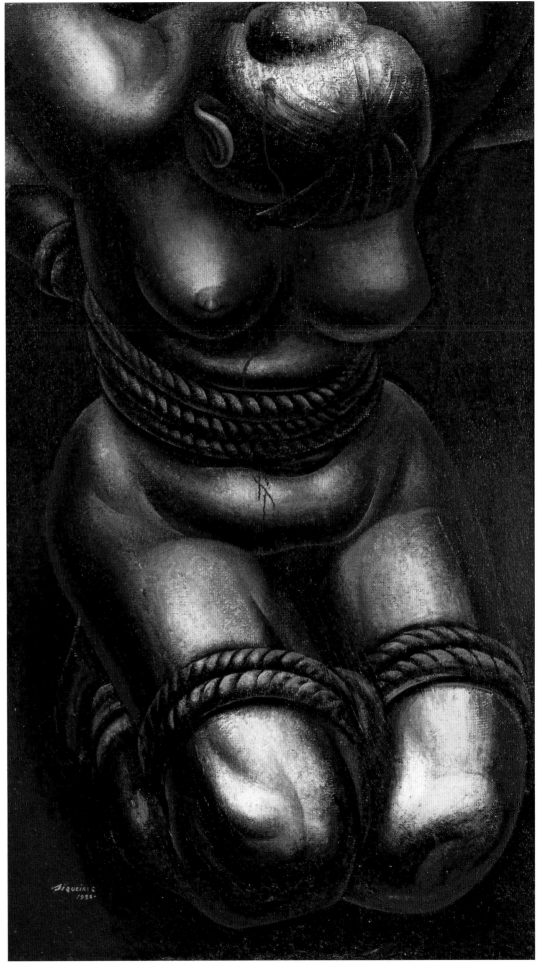

Chaim Soutine (French, b. Lithuania, 1893–1943)
Woman in Red Blouse, ca. 1919
Oil on canvas, 24⅜ × 18½ in.
The Metropolitan Museum of Art, New York, NY,
Gift of the Leonore S. Gershwin 1987 Trust, 1993,
1993.89.4

Provenance
Galerie Van Leer, Paris; George
Gershwin (1898–1937); by descent
to Rose Gershwin (1876–1948); by
descent to Ira (1896–1983) and
Leonore (1900–1991) Gershwin;
given to the Metropolitan Museum
of Art, New York, by the Leonore S.
Gershwin Trust, 1993.

Exhibition History
Chicago. Arts Club of Chicago.
*Exhibition of the George Gershwin
Collection of Modern Paintings*,
November 10–25, 1933, no. 41.
 Chicago. Arts Club of Chicago.
Paintings by Haim Soutine,
December 13–30, 1935.
 Lugano, Switzerland. Museo
d'Arte Moderna. *Chaim Soutine*,
March 12–June 18, 1995, no. 19.
 Céret, France. Musée d'art
moderne de Céret. *Soutine,
Céret: 1919–1922*, June 24–October
15, 2000.

Literature
Soutine, Chaïm, and Esti Dunow.
Soutine: Céret 1919–1922. Céret,
France: Musée d'art modern, 2000,
371, ill. (color). Exhibition catalog.
 Kazanjian, Dodi. "Homegrown
Heroine: With Three Decades of
Experience, Emily Rafferty, the
Met's Newly Appointed President,
Might Just Be Its Best Acquisition
Yet." *Vogue*, March 1, 2005, 532–35,
ill. (color). Caption: "On the Wall:
Soutine's *The Red Blouse* [ca.
1925–27] will hang in Rafferty's new
office."
 Chiappini, Rudy, ed. *Chaim
Soutine*. Milan: Electa and
Lugano, Switzerland: Museo d'arte
moderna,1995, no.19, 47, 159, ill.
(color). Exhibition catalog.
 Tuchman, Maurine, et al. *Chaim
Soutine (1893–1943): Catalogue
Raisonné*. volume 2, Cologne:
Taschen, 1993, no. 18, 546–47, ill.
(color).

**Other work by Soutine owned
by George Gershwin:**

Boy in a Blue Coat, ca. 1919
Oil on canvas, 32½ × 16 in.
Private collection, New York

Exhibition History
Hartford, CT. Wadsworth
Atheneum. *The Music Makers:
The Private Collections of Mr. &
Mrs. Richard Rodgers and Mr. &
Mrs. Leopold Godowsky Including
Paintings from the Collection of
George Gershwin*, July 9–August 9,
1959, no. 39.

"WOULD LIKE IMPORTANT SOUTINE."
—George Gershwin telegram to Henry Botkin

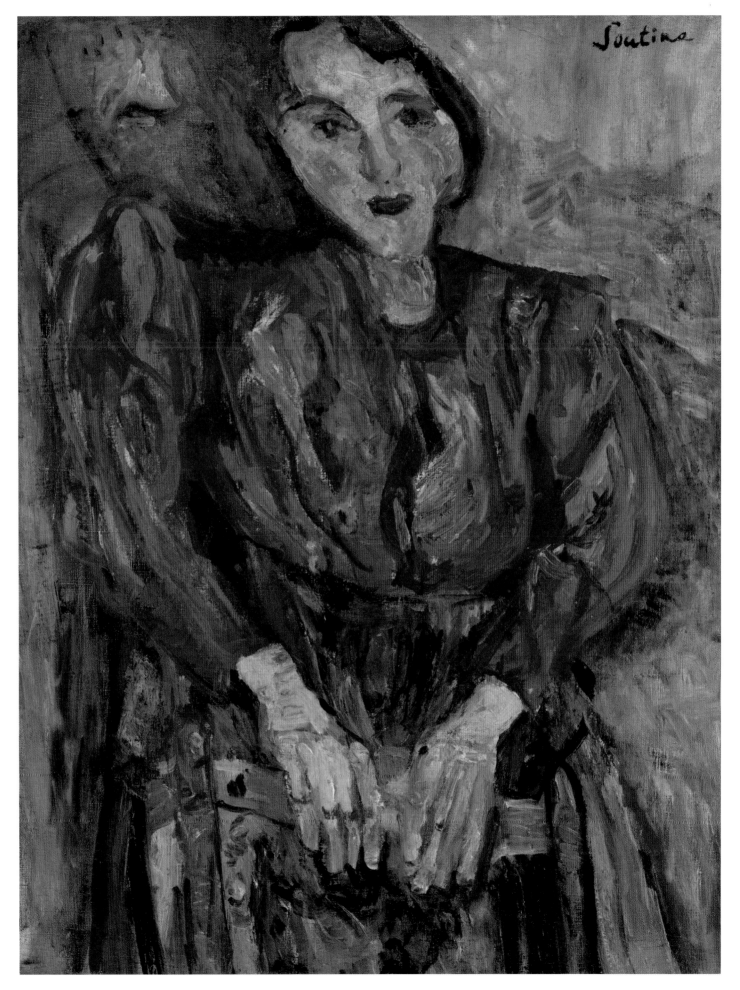

58.*

Maurice Sterne (American, b. Latvia, 1878–1957)
Woman and Child, Bali, 1913
Oil on composite board, 15¼ × 17½ in.
Wadsworth Atheneum Museum of Art, Hartford,
CT, Gift of Mr. and Mrs. Leopold Godowsky,
1957.202

Provenance
George Gershwin (1898–1937);
by descent to Rose Gershwin
(1876–1948); by descent to Frances
(1906–1999) and Leopold Godowsky
Jr. (1900–1983); given to the
Wadsworth Atheneum Museum of
Art, Hartford, CT, 1957.

Exhibition History
New York. Museum of Modern Art.
*Maurice Sterne: Retrospective
Exhibition, Paintings, Sculpture,
Drawings*, February 15–March 25,
1933, no. 23.
 Chicago. Arts Club of Chicago.
*Exhibition of the George Gershwin
Collection of Modern Paintings*,
November 10–25, 1933, no. 43.
 New York. Museum of Modern
Art. *Private Collection*, July 27–
September 6, 1936.

Literature
Botkin, Henry. *Exhibition of the
George Gershwin Collection of
Modern Paintings*. Chicago: Arts
Club of Chicago, 1933, no. 43.
Exhibition brochure.
 Museum of Modern Art. *Maurice
Sterne: Retrospective Exhibition,
Paintings, Sculpture, Drawings*.
New York: Museum of Modern Art,
1933, no. 23.

"Mrs. Lewisohn [has] arranged for me to buy a beautiful
picture of a fine American painter, Maurice Sterne."
—George Gershwin letter to Henry Botkin

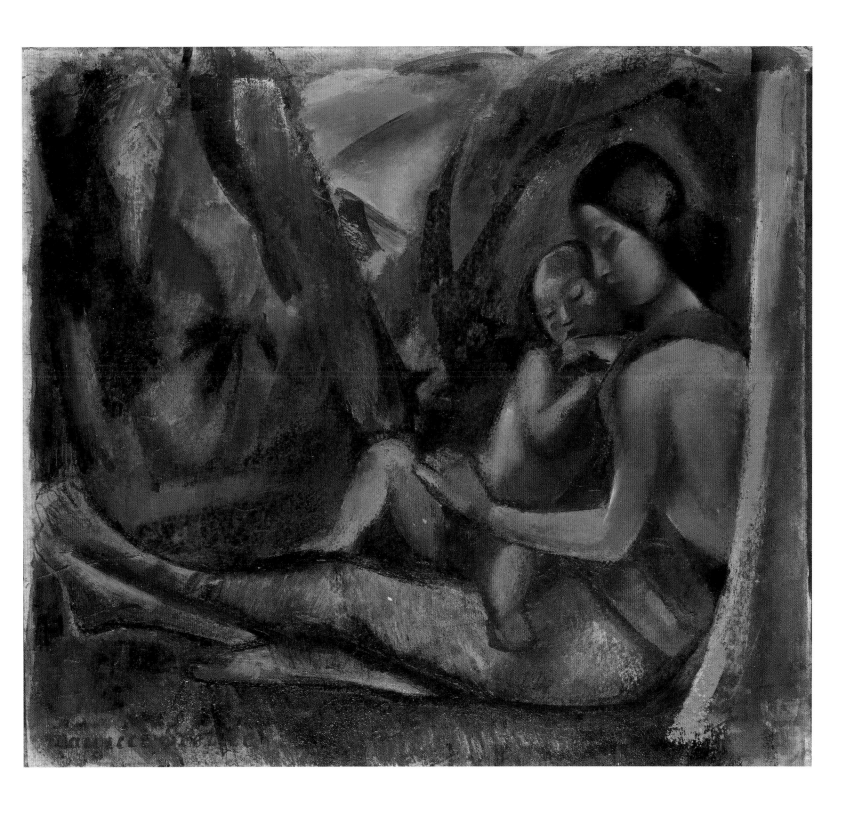

59.

Pavel Tchelitchew (American, b. Russia, 1898–1957)
La Pauvre Famille, 1935
Watercolor and gouache on two-ply cardboard,
25½ × 20 in.
Santa Barbara Museum of Art, 1956.5.6

Provenance
Julien Levy Gallery, New York;
George Gershwin (1898–1937); by
descent to Rose Gershwin (1876–
1948); by descent to Ira (1896–1983)
and Leonore (1900–1991) Gershwin;
given to the Santa Barbara
Museum of Art in 1956.

60.

Maurice Utrillo (French, 1883–1955)
Moulin à Ouessant, Bretagne, ca. 1911–12
Oil on canvas laid down on board,
23⅝ × 31⅞ in.
Location unknown

Provenance
George Gershwin (1898–1937); by descent to Rose Gershwin (1876–1948); by descent to Ira (1896–1983) and Leonore (1900–1991) Gershwin; The Metropolitan Museum of Art, New York; Sotheby's, New York, May 11, 2000, lot 266; Sotheby's, New York, May 9, 2001, lot 415.

Exhibition History
Chicago. Arts Club of Chicago. *Exhibition of the George Gershwin Collection of Modern Paintings*, November 10–25, 1933, no. 46.
 New York. Museum of Modern Art. *Private Collection*, July 27–September 6, 1936.
 Los Angeles. Los Angeles City Hall Tower Gallery. *The Collection of Mr. and Mrs. Ira Gershwin*, March 19–April 18, 1952.
 Los Angeles. Paul Kantor Gallery; Beverly Hills, Frank Perls Gallery. *50 Years of Beverly Hills*, April 25–26, 1964.

Literature
Petrides, Paul. *L'Oeuvre complet de Maurice Utrillo*. vol. 1, Paris: Paul Petrides, 1962, no. 356, 422, ill.
 Sotheby's. *Impressionist & Modern Art, Part Two*. New York: Sotheby's, May 9, 2001, lot 415, 132, ill. (color).

Fig. 89. Gershwin at 132 E. 72nd Street, New York, with Utrillo's *Moulin à Ouessant, Bretagne*, 1934.

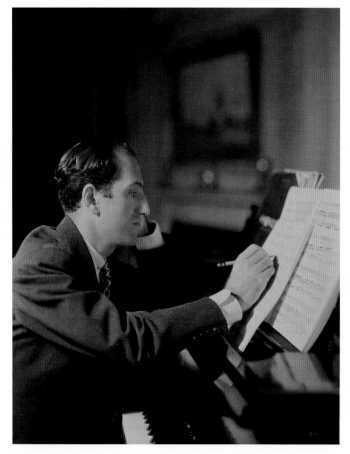

Fig. 90. Oscar Levant at the Gershwin home at 1019 Roxbury Drive, Beverly Hills, California, 1936–37. On the wall are Modigliani's *Portrait of Doctor Devaraigne* and Utrillo's *Moulin à Ouessant, Bretagne*.

61.

Maurice Utrillo (French, 1883–1955)
The Suburbs, ca. 1912–14
Oil on canvas, 24 × 30 in.
Location unknown

Note that this is a black-and-white image of a color painting.

Provenance
Collection Wagner, Berlin;
Collection Lepoutre, Paris;
Collection Libaude, Paris; Galerie
Van Leer, Paris; George Gershwin
(1898–1937); by descent to Rose
Gershwin (1876–1948).

Exhibition History
Chicago. Arts Club of Chicago.
*Exhibition of the George Gershwin
Collection of Modern Paintings*,
November 10–25, 1933, no. 45.
 New York. Museum of Modern
Art. *Private Collection*, July 27–
September 6, 1936.

Literature
Botkin, Henry. "A Composer's
Pictures." *Arts and Decoration* 40,
no. 3 (January 1934): 48–50, ill.
 Schwartz, Charles. *Gershwin:
His Life and Music*. Indianapolis
and New York: The Bobbs-Merrill
Company, Inc., 1973, 176, ill.

Fig. 91. Gershwin's *My Grandfather* and Utrillo's *The Suburbs* in the dining room of Gershwin's penthouse apartment at 33 Riverside Drive, New York. The art deco furnishings were likely designed by Paul Frankl, except for the table lamp, which was designed by Gershwin.

"The suburbs by Utrillo is painted with a much more vigorous brush than some of the ones I have seen in America. It is a very luminous picture. It seems to throw out its own light."
—George Gershwin letter to Henry Botkin

62.

Maurice de Vlaminck (French, 1876–1958)
Environs de Paris, 1925
Oil on canvas, 25¾ × 32¼ in.
Location unknown

This painting is one of five works of art that Ira Gershwin lent to be used as props in the 1944 film *Rhapsody in Blue* starring Robert Alda in the role of George Gershwin.

Provenance
George Gershwin (1898–1937); by descent to Rose Gershwin (1876–1948); by descent to Ira (1896–1983) and Leonore (1900–1991) Gershwin; The Metropolitan Museum of Art, New York; Sotheby's, New York, November 11, 1999, lot 448.

Exhibition History
Chicago. Arts Club of Chicago. *Exhibition of the George Gershwin Collection of Modern Paintings*, November 10–25, 1933, no. 47.

Literature
Sotheby's Impressionist & Modern Art Part Two, New York: Sotheby's, November 11, 1999, lot 448, 254, ill. (color).

Fig. 92. *Environs de Paris* in Ira Gershwin's home, ca. 1960–68.

63.

Abraham Walkowitz (American,
b. Russia, 1878–1965)
Street Scene (Arrangement), 1912
Watercolor, 10¼ × 15¼ in.
Collection Marc Gershwin

Provenance
George Gershwin (1898–1937);
by descent to Rose Gershwin
(1876–1948); by descent to Arthur
(1900–1981) and Judy (1917–2013)
Gershwin; by descent to Marc
Gershwin.

Exhibition History
Chicago. Arts Club of Chicago.
*Exhibition of the George Gershwin
Collection of Modern Paintings*,
November 10–25, 1933, no. 64.

64.*

Max Weber (American, b. Poland, 1881–1961)
Invocation, 1919
Oil on canvas, 48 × 41 ½ in.
Vatican Museums

Provenance
Downtown Gallery, New York;
George Gershwin (1898–1937);
by descent to Rose Gershwin
(1876–1948); Vatican Museum,
Vatican City.

Exhibition History
Chicago. Arts Club of Chicago.
*Exhibition of the George Gershwin
Collection of Modern Paintings*,
November 10–25, 1933, no. 49.

New York. Museum of Modern
Art. *Private Collection*, July 27–
September 6, 1936.

New York. Museum of Modern
Art. *Art in Our Time: An Exhibition
to Celebrate the Tenth Anniversary
of the Museum of Modern Art
and the Opening of Its New
Building, Held at the Time of the
New York World's Fair*, New York,
1939, no. 124.

Literature
American Art Journal 5, no. 2
(November 1973): 72, ill.

Barr, Alfred, Jr. *Art in Our Time:
An Exhibition to Celebrate the
Tenth Anniversary of the Museum
of Modern Art and the Opening of
Its New Building, Held at the Time
of the New York World's Fair*, New
York: Museum of Modern Art, 1939,
no. 124, ill. Exhibition catalog.

———. *Max Weber Retrospective
Exhibition 1907–1930*. New York:
Museum of Modern Art, March 13–
April 2, 1930, 21, pl. 74, ill. Exhibition
catalog.

Botkin, Henry. "A Composer's
Pictures." *Arts and Decoration* 40,
no. 3 (January 1934): 48–50, ill.

———. *Exhibition of the George
Gershwin Collection of Modern
Paintings*, exhibition brochure,
Chicago: Arts Club of Chicago,
1933, no. 49, ill.

Fig. 93. Installation view from large gallery
into corridor. *Exhibition of the George
Gershwin Collection of Modern Paintings*,
Arts Club of Chicago, November 10–25, 1933.
Invocation, seen here, was one of the pillars
of the exhibition.

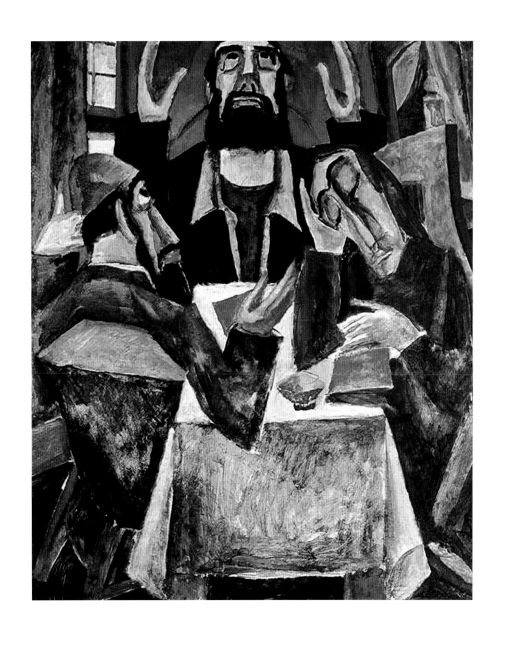

"[*Invocation* is] a deeply wrought picture, tremendously felt [in which] the distortion increases its feeling and adds to the design. Technically, it is a composition of triangles, and in it there is strict absence of line, only color against color. And in the whole there is great movement."
—George Gershwin, as quoted in Henry Botkin, "A Composer's Pictures"

65.

Max Weber (American, b. Poland, 1881–1961)
Wind Orchestra Barrère, n.d.
Work on paper, 7¾ × 10¼ in.
Collection Marc Gershwin

Provenance
Sidney Ross Gallery, New York,
Theatre in Art auction, lot 276;
George Gershwin (1898–1937);
by descent to Rose Gershwin
(1876–1948); by descent to Arthur
(1900–1981) and Judy (1917–2013)
Gershwin; by descent to Marc
Gershwin.

Exhibition History
Chicago. Arts Club of Chicago.
*Exhibition of the George Gershwin
Collection of Modern Paintings*,
November 10–25, 1933, no. 65.

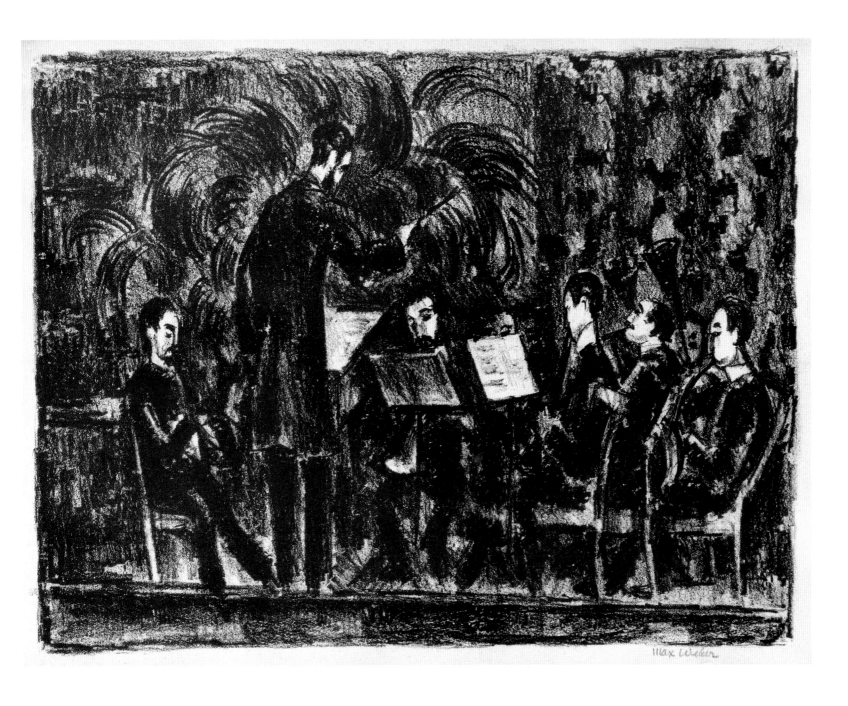

66.*

Max Weber (American, b. Poland, 1881–1961)
Woman at a Table, n.d.
Oil on board, 8 × 4¾ in.
Collection Elaine Godowsky

Provenance
George Gershwin (1898–1937);
by descent to Rose Gershwin
(1876–1948); by descent to Frances
(1906–1999) and Leopold Godowsky
Jr. (1900–1983); by descent to Elaine
Godowsky.

Exhibition History
Chicago. Arts Club of Chicago.
*Exhibition of the George Gershwin
Collection of Modern Paintings*,
November 10–25, 1933, no. 48.
 Hartford, CT. Wadsworth
Atheneum. *The Music Makers:
The Private Collections of Mr. &
Mrs. Richard Rodgers and Mr. &
Mrs. Leopold Godowsky Including
Paintings from the Collection of
George Gershwin*, July 9–August 9,
1959, no. 40.

Literature
Botkin, Henry. *Exhibition of the
George Gershwin Collection of
Modern Paintings*. Chicago: Arts
Club of Chicago, 1933, no. 48.
Exhibition brochure,
 Cunningham, Charles. *The Music
Makers: The Private Collections of
Mr. & Mrs. Richard Rodgers and Mr.
& Mrs. Leopold Godowsky Including
Paintings from the Collection of
George Gershwin*. Hartford, CT:
Wadsworth Atheneum, 1959, no.
40. Exhibition catalog

"I admire profoundly your love of art, and wish you continued
and increasing happiness and growth in your splendid effort to
ennoble and spiritualize your already fine home atmosphere."
—Max Weber letter to George Gershwin

BIBLIOGRAPHY
COMPILED BY OLIVIA MATTIS

I. BOOKS AND ARTICLES

Anniston Star (Anniston, AL). "Gershwin's Drawings are Kept." August 6, 1967, 21.

Apostolos-Cappadona, Diane, and Bruce Altshuler. *Isamu Noguchi Essays and Conversations.* New York: Harry N. Abrams in association with the Isamu Noguchi Foundation, 1994.

Armitage, Merle. *Accent on America.* New York: E. Weyhe, 1944.

———. *Accent on Life.* Ames: Iowa State University Press, 1965.

———. *George Gershwin: Man and Legend.* New York: Duell, Sloan and Pearce, 1958.

———. ed. *George Gershwin.* New York: Longmans, Green & Co., 1938.

———. ed. *Schoenberg.* New York: G. Schirmer, Inc., 1937. Includes Gershwin portrait of Schoenberg.

Auerbach-Levy, William. "The American Seen and Heard, Too: A Distinguished Etcher Who Has Been Making His First Cartoons for the Theatre Section of the *New York Sunday World.*" *Vanity Fair*, June 1926, 47.

Barr, Jr., Alfred H. "Summer Show." *Bulletin of the Museum of Modern Art* 2 (October 1933): 2–4.

Behrman, S. N. "Cameo: Chez Gershwin." *New Yorker*, May 31, 1993, 58–59.

Berger, Maurice, and Joan Rosenbaum, eds. *Masterworks of the Jewish Museum.* New Haven, CT: Yale University Press, 2004.

Berger, Melvin. *Masters of Modern Music.* New York: Lothrop, Lee & Shepard Co., 1970.

Bernstein, Leonard. "A Nice Gershwin Tune." *The Atlantic Monthly*, April 1955, 39–42.

———. "An Appreciation." In *Gershwin: His Life and Music* by Charles Schwartz, xi–xii. Indianapolis and New York: The Bobbs-Merrill Company, Inc., 1973.

Botkin, Henry. "A Composer's Pictures: George Gershwin, the Musician, Is a Collector of Modern Paintings." *Arts & Decoration* 11. no. 3 (January 1934): 48–50, with photographs by Peter Juley; reprinted as "A Composer's Pictures" (with different images) in *Gershwin in His Time: A Biographical Scrapbook, 1919–1937,* edited by Gregory R. Suriano, 101–2. New York: Gramercy Books, 1998.

———. "Painter and Collector." In *George Gershwin,* edited by Merle Armitage, 137–43. New York: Longmans, Green & Co., 1938.

———. "Reminiscence of Henry Botkin." In *The Gershwins* by Robert Kimball and Alfred Simon, 154. New York: Atheneum, 1973.

Brenson, Michael. "Obituary: Henry Botkin Dies; Abstract Painter." *New York Times*, March 5, 1983, 28.

Brooklyn Daily Eagle. "At Home with the Famous," February 10, 1934, 7.

———. "Gershwin Turns to Painting Reviving Boyhood Ambition Checked by Teacher's Laugh." May 19, 1929, 6.

Buettner, Stewart, and Reinhard G. Pauly. *Great Composers, Great Artists: Portraits,* Portland, OR: Amadeus Press, 1992, 146–47.

Buja, Maureen. "Musicians and Artists: Gershwin and Dove." *Interlude*, May 5, 2019. https://interlude.hk/musicians-artists-gershwin-dove/.

Bulletin of the Society for American Music. "Gershwin to Gillespie: Portraits in American Music." *Bulletin of the Society for American Music* 31, no. 3 (Fall 2005): 1, 58.

Bulliet, C. J. "Gershwin in His Role of Art Collector." *Chicago Daily News*, November 11, 1933.

Carnovale, Norbert. *George Gershwin: A Bio-Bibliography.* Westport, CT, and London: Greenwood Press, 2000.

Cassidy, Donna M. "Arthur Dove's Music Paintings of the Jazz Age." *The American Art Journal* 20, no. 1 (1988): 4–23.

Ceroni, Ambrogio, ed. *Tout l'oeuvre peint de Modigliani.* Paris: Flammarion, 1972.

Chasins, Abram, and Irving Kolodin. "Gershwin: Paradox in Blue." *Saturday Review*, February 25, 1956, 37, 39, 60–61, 64–66.

Clarke, Gerald. "Broadway Legends: George Gershwin, The Celebrated Composer's Manhattan Penthouse."

Architectural Digest, November 1995, 192–95, 270.

Cooper, Harry. "Arthur Dove Paints a Record." *Source: Notes in the History of Art* 24, no. 2 (Winter 2005): 70–77.

Corsicana Daily Sun (Corsicana, Texas). "Turning from Piano to Easel Brings Gershwin Relaxation." February 10, 1932, 7. (This article appeared throughout February and March 1932 in local newspapers across the US.)

Cowling, Elizabeth. *Picasso: Style and Meaning.* London: Phaidon, 2002.

Crawford, Richard. *Summertime: George Gershwin's Life in Music.* New York: W. W. Norton and Co., 2019.

Daily News. "Gershwin Exhibit at 'Promenades.'" May 16, 1963, 187.

Daix, Pierre, and G. Boudaille. *Picasso: The Blue and Rose Periods, A Catalogue Raisonné, 1900–1906.* Rev. ed. London: Evelyn Adams & Mackay, 1967.

De Santis, Florence Stevenson. *Gershwin.* New York: Treves Publishing Company, 1987.

Democrat and Chronicle (Rochester, NY). "Gershwin Paintings Shown in Film." October 15, 1943, 10.

Des Moines Tribune. "Gershwin the Painter; Late Musician's Paintings Shown; Cherished Hope to Become Artist." December 10, 1937, 26.

Deussen, Nancy Bloomer. Letter to the editor. *New York Times*, September 20, 1998.

Doll, Nancy, Robert Henning, Jr.., and Susan Shin-tsu Tai. *Santa Barbara Museum of Art Selected Works.* Santa Barbara: Santa Barbara Museum of Art, 1991.

Ewen, David. *The Book of Modern Composers.* New York: Alfred A. Knopf, 1945.

Feinstein, Michael, with Ian Jackman. *The Gershwins and Me.* New York: Simon and Schuster, 2012.

Forbes, Edward W. "Report of the Fogg Art Museum" *Annual Report* (1935–36): 1–26. Gershwin is listed as a lender to a recent exhibition at the Fogg Art Museum on p. 6.

Fortune, Brandon. "George Gershwin and Isamu Noguchi in 1929." *facetoface* (blog), *National Portrait Gallery*, April 30, 2018. https://npg.si.edu/blog/george-gershwin-and-isamu-noguchi-1929.

Forward. "George Gershwin as He Sees Himself." October 30, 1932, Art Section (sect. 3), 5.

Fried, Alexander. "Ricci is Back with Persinger; Gershwin Oils Exhibited; Sibelius is Honored." *San Francisco Examiner*, December 19, 1937, 31.

Genauer, Emily. "Gershwin's Home Is Perfect Reflection of Its Owner and Designer." *New York World Telegram*, April 1, 1933.

——. "It's Gershwin, the Painter, at Lincoln Center." *New York Herald Tribune*, May 29, 1963.

Gershwin, George. *George Gershwin's Song-Book.* New York: Harms, 1932, with illustrations by Constantin Alajálov.

Gershwin, Ira. Letter to the editor. *Newsweek*, October 23, 1944, 14.

Glass, Herbert. "Gershwin on Canvas." *Performing Arts, the Music Center Monthly* 2, vol. 10 (October 1968): 20ff; reprinted in *Performing Arts:*

California's Theatre and Music Magazine, December 1984, 36–40.

Goldberg, Isaac. "Gebrüder Gershwin," *Vanity Fair*, June 1932, 46–47, 62.

——. "Music by Gershwin." *Ladies Home Journal*, February 1931, 12–13, 149, 151; March 1931, 20ff; April 1931, 25ff.

Goldstein, Bluma. "Andy Warhol: His Kafka and 'Jewish Geniuses.'" *Jewish Social Studies*, New Series 7, no. 1 (Autumn 2000): 127–40. Includes a discussion of the Warhol portrait of Gershwin.

Greenberg, Rodney. *George Gershwin.* London: Phaidon, 1998.

Halle, Kay. "The Time of His Life." *Washington Post*, February 5, 1978.

Hauchawout, Ida. "American in Paris, France," *Vanity Fair*, February 1930, 59, 82.

Henahan, Donal. "Ira Presides at Gershwin Show." *New York Times*, May 6, 1968, 49.

Hurlburt, Laurance P. *The Mexican Muralists in the United States.* Albuquerque: University of New Mexico, 1989.

——. "The Siqueiros Experimental Workshop: New York, 1936," *Art Journal* 35, no. 3 (Spring 1976): 237–46.

Hyland, William G. *George Gershwin: A New Biography.* Westport, CT, and London: Praeger, 2003.

Independent Press-Telegram (Long Beach, CA). "Gershwin Brothers' Art Collection Shown in L.A." March 30, 1952, 10.

Jablonski, Edward. *Gershwin Remembered.* London and Boston: Faber and Faber, 1992.

——, and Lawrence D. Stewart, with an introduction by Carl van Vechten. *The Gershwin Years*, Garden City, NY: Doubleday & Company, Inc., 1973.

Jacobi, Frederick. "The Future of Gershwin." *Modern Music* 15, no. 1 (November–December 1937): 2–7.

Jerome, Sidney. "Porgy, Botkin and Bess." *Village Chatter*, June–July 1947, 4–5, 20–22, 25.

Jewell, Edward Alden. "Art of Gershwin Put on Exhibition; Late Composer's Only One-Man Show Reveals Talent of Considerable Promise." *New York Times*, December 21, 1937, 27.

——. "Caricatures Mock Many Celebrities; 'Framed and Hung' Exhibition at A.C.A. Gallery Featured by Some Sharp Barbs." *New York Times*, February 25, 1937, 21.

——. "'Primitive' Works of Art Exhibited; Modern Museum Puts on Show Under Title of 'Masters of Popular Painting.'" *New York Times*, April 27, 1938, 24.

——. "Show at Museum Marks Fifth Year; Modern Galleries Are Devoted to New Exhibition of Wide Range and Variety." *New York Times*, November 20, 1934, 19.

——. "Unusual Art Show Opens at Museum; Display of Paintings, None Less Than Six Feet in Length, Is Offered at Modern Art." *New York Times*, April 2, 1947, 32.

——. "Work by Six Japanese Artists." *New York Times*, February 9, 1930, 147.

Jewett, Eleanor. "Good Exhibit Opens at Arts Club." *Chicago Tribune*, November 11, 1933.

Kagan, Andrew. "Paul Klee's 'Polyphonic Architecture.'" *Arts Magazine* 54, no. 5 (1980): 154–57.

Kazanjian, Dodi. "Homegrown Heroine: With Three Decades of Experience, Emily Rafferty, the Met's Newly Appointed President, Might Just be Its Best Acquisition Yet." *Vogue*, March 1, 2005, 532–35.

Keil, Jennifer Gould. "Ira Gershwin's Famed UWS Penthouse Available for a Song." *New York Post*, October 14, 2015.

Kimball, Robert, and Alfred Simon. *The Gershwins*. New York: Atheneum, 1973.

Kimmelman, Michael. "Noguchi as a Master of Portrait Sculpture." *New York Times*, May 17, 1989.

Knight, Arthur, with photographs by Eliot Elisofon. *The Hollywood Style*. Toronto: Collier-Macmillan Canada Ltd, 1969.

Kober, Arthur. "Some Things About a Young Composer." *New York World*, May 4, 1930.

Kolodin, Irving, with contributions by Leonard Bernstein and Kay Swift. "Jubilee in Blue: Homage to the Gershwins." *Saturday Review World* 14226, October 9, 1973, cover, 16–21.

Kresh, Paul. *An American Rhapsody: The Story of George Gershwin*. New York: E. P. Dutton, 1988.

Lansdale, Nelson. "My Boy George." *Listen*, September 1945, 6–7.

Levant, Oscar. *A Smattering of Ignorance*. Garden City, NY: Garden City Publishing Co., Inc., 1942.

Life. "The Art Acquired by Yalemen: Six Pages of Color on an Alumni Show, Representing Classes from '67 to '51." May 28, 1956, 70–76.

Los Angeles County Museum. "Retrospective Exhibition: Rouault." *Bulletin of the Art Division, Los Angeles County Museum* 5, no. 3 (Summer 1953): 31.

Los Angeles Times. "Exhibit of Gershwins' Art Collections Set." Wednesday, March 12, 1952, 46.

——. "Gershwin Art Arrives." January 13, 1938, 22.

——. "Ira Gershwin to Lend Paintings to Exhibit." May 9, 1951, 30.

M., A. "In the Galleries: Viewpoint of Painters Guide for Gershwins." *Los Angeles Times*, May 30, 1952.

Mattis, Olivia. "Gershwin and Color: How Blue is the Rhapsody?" *OUPblog*, Oxford University Press, September 28, 2015. https://blog.oup.com/2015/09/george-gershwin-art/.; reprinted in *Musicology Now* (blog), American Musicological Society, October 27, 2015. http://www.musicologynow.org/2015/10/.

——. "Scriabin to Gershwin: Color Music from a Musical Perspective." In *Visual Music: Synaesthesia in Art and Music Since 1900*, with contributions by Kerry Brougher, Olivia Mattis, Jeremy Strick, Ari Wiseman, and Judith Zilczer, 210–27. London: Thames and Hudson, 2005.

McBride, Henry. "George Gershwin's Memorial in the Marie Harriman Gallery Is Impressive." *New York Sun*, December 24, 1937.

McCausland, Elisabeth. "Gallery Notes." *Parnassus* 10, no. 1 (January 1938): 44–47.

McLeod, Ray. "George Gershwin in an Imaginary Concert Hall." *Blanton Museum of Art* (blog), July 21, 2014. https://blantonmuseum.org/2014/07/21/george-gershwin-in-an-imaginary-concert-hall-2/.

Miller, Arthur. "Los Angeles." *Art Digest*, April 1, 1952, 15.

Mok, Michel. "Here's Broadway's Herring Barrel Philosopher." *New York Post*, June 27, 1938.

Morning Chronicle (Manhattan, KS). "Gershwin Prefers Painting to Life of a Song Writer." May 14, 1937, 4.

Muray, Nickolas. *Muray's Celebrity Portraits of the Twenties and Thirties: 135 Photographs by Nickolas Muray*. New York: Dover Publications, Inc. and Rochester, NY: International Museum of Photography at George Eastman House, 1978.

Natali, Nadia. *Stairway to Paradise: Growing up Gershwin*. Los Angeles: Rare Bird, 2016.

New York Herald Tribune. "Gershwin Takes up Painting as an Aid to Music; Jazz Composer Finds Brush Inspiring When Muse of Orpheus Deserts Him." May 19, 1929.

New York Sun. "Mr. Gershwin May Paint; At Least His Cousin Says So, but Composer Is Bit Doubtful." April 10, 1929.

New York Times. "Art by Gershwin to be Seen Dec. 18; Posthumous Show Will Be the First of Composer's Work in Career He Began at 21; He Preferred it to Music; Planned to Devote Full Time to Painting—Modern School Appeals to Him." December 8, 1937.

——. "Brooklyn College Sets Gershwin Show." February 14, 1982.

——. "George Gershwin, Composer, is Dead; Master of Jazz Succumbs in Hollywood at 38 After Operation for Brain Tumor; Wrote 'Rhapsody in Blue'; Also Composed 'Porgy and Bess,' 'Of Thee I Sing' and Many Musical Comedies." July 12, 1937, 1, 20.

——. "Gershwin Bust at Carnegie." April 23, 1974, 34.

——. "Gershwin Reveals Himself as Artist; Composer's Painting Will Be on View at Independent Show Opening Saturday." April 22, 1936, 25.

——. "Gets Gershwin Painting: Society to Exhibit Portrait by Philadelphia Artist." July 23, 1942, 16.

——. "Modern Art Museum to Open New Exhibit; Will Begin Fall Season Today with a Showing of Modern European Painting." October 3, 1933, 21.

——. "A Portrait Bust of George Gershwin, by Isamu Noguchi," February 9, 1930.

——. "The Steinway, 'Instrument of the Immortals,' Is Quite Within Reach of the Modest Income," January 19, 1930, 95.

Newsweek. "Posthumous Exhibit Shows that Gershwin Knew Harmony on Canvas Also," December 20, 1937, 28.

Noguchi, Isamu. "Portrait." In *George Gershwin*, edited by Merle Armitage, 209–10. New York: Longmans, Green & Co., 1938; reprinted in *Isamu Noguchi: Essays and Conversations*, edited by Diane

Apostolos-Cappadona and Bruce Altshuler, 22–23. New York: Harry N. Abrams.

Oja, Carol J. "Gershwin and American Modernists of the 1920s," *The Musical Quarterly* 78, no. 4 (1994): 646–68.

Pantages, Lloyd. "Gershwin Buys Painting Called 'Black Venus.'" *Pittsburgh Sun-Telegraph*, March 18, 1937.

Payne, Robert. *Gershwin*, London: Robert Hale Limited, 1960/62.

Penner, Audree. "Note Worthy: Rosamond Walling Tirana '31 was Courted by George Gershwin," *Swarthmore College Bulletin*, March 1999, 30.

Perlis, Vivian, and Libby Van Cleve. *Composers' Voices from Ives to Ellington: An Oral History of American Music*. New Haven, CT, and London: Yale University Press, 2005.

Peyser, Joan. *The Memory of All That: The Life of George Gershwin*. New York: Billiard Books, 1998.

Philadelphia Public Ledger. "Composer Turns Artful." July 31, 1932.

Pittsburgh Press. "Exhibit to Reveal Gershwin as Painter." December 9, 1937, 28.

Pollack, Howard. *George Gershwin: His Life and Work*. Berkeley, Los Angeles, London: University of California Press, 2006.

Pollak, Robert. "Gershwin." *Magazine of Art* 30, no. 9 (September 1937): 531, 588.

Reis, Claire R. *Composers, Conductors and Critics*. Detroit: Detroit Reprints in Music, 1974.

Rewald, John. "French Paintings in the Collection of Mr. and Mrs. John Hay Whitney." *Connoisseur*, April 1956, 138.

Rimler, Walter. *A Gershwin Companion: A Critical Inventory & Discography, 1916–1984*. Ann Arbor, MI: Popular Culture, Ink, 1991.

Robinson, Edward G., with Leonard Spigelgass. *All My Yesterdays: An Autobiography*. London and New York: W. H. Allen, 1974.

Rötlisberger, Marcel. "Les cariatides de Modigliani. Notice critique." *Critica d'Arte* 7, no. 38 (1960), 107, no. 13.

Rushmore, Robert. *The Life of George Gershwin*. New York: The Cowell-Collier Press and London: Collier-MacMillan Ltd., 1966.

Salmon, André. "Absinthe." *Vanity Fair*, March 1934, 32ff.

Salpeter, Harry. "Burliuk: Wild Man of Art." *Esquire*, July 1939, 63, 142, 144, 147.

San Francisco Examiner. "Gershwin Oils, 'Porgy' Due." January 30, 1938, 32.

———. "Noted Americans Exhibit; Gershwin Oils, Drawings Hold Interest," February 13, 1938, 29.

Schiff, David. *Gershwin: Rhapsody in Blue*. Cambridge: Cambridge University Press, 1997.

Schillinger, Joseph. *The Mathematical Basis of the Arts*. New York: Philosophical Library, 1948.

Schneider, Wayne, ed. *The Gershwin Style: New Looks at the Music of George Gershwin*. New York and Oxford: Oxford University Press, 1999.

Schwartz, Charles. *Gershwin: His Life and Music*. Indianapolis and New York: The Bobbs-Merrill Company, Inc., 1973.

Seldes, Gilbert. "Jazz Opera or Ballet?" *Modern Music* 3, no. 2 (January–February 1926): 10–16.

Sentinel (Carlisle, PA). "Famous Fables." February 26, 1972, 4.

Siqueiros, David Alfaro. *Me llamaban el Coronelazo: memorias*. Mexico: Grijalbo, 1977.

Sisk, Sarah. "George Gershwin: Futurist Composer?" *The Gershwin Initiative* (blog), *School of Music, Theatre & Dance, University of Michigan*, June 12, 2018. https://smtd.umich.edu/ami/gershwin/?p=4136.

Skloot, Floyd. "Self-Portrait in Opera Hat." *The North American Review* 280, no. 4 (July–August 1995): 47.

Smithsonian Institution. "Gershwin's Compositions in Paint." *American Art* 7, no. 3 (Summer 1993): 92–94.

Sterne, Katharine Grant. "On View in the New York Galleries." *Parnassus* 3, no. 6 (October 1931): 5–8, 34–37, 39.

Stewart, Lawrence D. *The Gershwins: Words Upon Music*. New York: Verve Records, 1959.

Stinnett, Jack. "Gershwin Prefers Painting to Life of a Song Writer." *Morning Chronicle* (Manhattan, Kansas), May 14, 1937, 4.

Sullivan, Wilson. "Self-Portrait by George Gershwin: The Other Side of the Canvas." *Saturday Review*, June 8, 1963, cover, 18–19.

Suriano, Gregory, ed. *Gershwin in His Time: A Biographical Scrapbook, 1919–1937*. New York: Gramercy Books, 1998.

Swift, Kay. "Gershwin and the Universal Touch." *Music of the West Magazine*, October 1959, 7.

Taylor, Erma. "George Gershwin—A Lament" (1937). In *George Gershwin*, edited by Merle Armitage. New York: Longmans, Green & Co., 1938, 179–80.

Thomson, Virgil. "George Gershwin." *Modern Music* 13 (November–December 1935): 13–19.

Tucker, Judy. "Bucks Man Sculpts Gershwin." *Sunday Bulletin* (Bucks County, PA), December 19, 1971, 1, 10.

Van Vechten, Carl. "George Gershwin—An American Composer Who is Writing Notable Music in the Jazz Idiom." *Vanity Fair*, March 1925, 40.

Vergo, Peter and Olivia Mattis. "Music and Art," *Grove Art Online, Oxford Art Online*. Last modified October 16, 2013. https://doi.org/10.1093/gao/9781884446054.article.T060574.

Weber, Katharine. "Art; In a Painting, Gershwin Packed the House." *New York Times*, August 30, 1998, Section 2, 30.

———. "Gershwin's Self-Portrait in the Mirror with My Mother." *American Imago* 72, no. 4 (Winter 2015): 335–53.

———. *The Memory of All That: George Gershwin, Kay Swift, and My Family's Legacy of Infidelities*. New York: Crown Publishers, 2011.

Weinstock, Matt. "City's High Spot." *Los Angeles Daily News*, April 10, 1952.

Wilenski, R. H. *Modern French Painters*. London: Faber & Faber, 1940/1944.

Woollcott, Alexander. "George the Ingenuous." *Cosmopolitan*, November 1933, 32–33; 122–23.

Wyatt, Robert, and John Andrew Johnson. *The George Gershwin Reader*. Oxford: Oxford University Press, 2004.

Yeide, Nancy H. "The Marie Harriman Gallery (1930–1942)." *Archives of American Art Journal* 39, no. 1/2 (1999): 2–11.

Zilczer, Judith. "Synaesthesia in Popular Culture: Arthur Dove, George Gershwin, and the 'Rhapsody in Blue.'" *Art Journal* 44, no. 4 (Winter 1984): 361–66.

Zimel, Heyman. "Roofs of the East Side." *The Forward*, April 28, 1929, English section, 2.

II. AUCTION CATALOGUES

American Art Association. *The Arthur B. Davies Art Collection; Modern Drawings, Print, Paintings and Sculptures, Ancient Bronzes, Pottery & Fabrics, French Furniture and Tapestries*. New York: American Art Association, April 16–17, 1929.

American Art Association, Anderson Galleries, Inc. *The Chester H. Johnson Galleries, Chicago, Collection of Paintings*. New York: American Art Association, Anderson Galleries, Inc., November 14, 1934.

Artcurial. *Impressionist & Modern Art—Day Sale*. Paris: Artcurial, December 8, 2021.

Bonhams. *African and Oceanic Art*, New York: Bonhams, July 2, 2020.

Christie's. *Impressionist and Modern Art*. New York: Christie's, November 7, 2007.

———. *Impressionist and Modern Art (Day Sale)*. New York: Christie's, November 2, 2005.

———. *Latin American Paintings, Drawings & Sculpture*. New York: Christie's, November 21, 1989.

Doyle. *Doyle at Home*. New York: Doyle, June 23, 2004.

———. *Doyle at Home*. New York: Doyle, June 19, 2013.

———. *Doyle at Home*. New York: Doyle, September 10, 2013.

Sotheby's. *Art of Africa, Oceania, and the Americas*. London: Sotheby's, November 21, 2022.

———. *Impressionist & Modern Art Day Sale*. New York: Sotheby's, May 8, 2008.

———. *Impressionist & Modern Art, Part Two*. New York: Sotheby's, May 9, 2001.

———. *Impressionist & Modern Art, Evening Sale*. New York: Sotheby's, November 4, 2004.

———. *Impressionist and Modern Art, Part II*. New York: Sotheby's, May 12, 1999.

———. *Impressionist Art, Part Two*. New York: Sotheby's, May 9, 2002.

———. *Modern Day Auction*. New York: Sotheby's, November 15, 2022.

III. EXHIBITION CATALOGUES

Albrecht, Donald, and Thomas Mellins. *Mexico Modern: Art, Commerce, and Cultural Exchange, 1920–1945*. Munich: Hirmer Publishers, 2017. Published in conjunction with an exhibition of the same title organized by the Harry Ransom Center at The University of Texas at Austin, September 11, 2017–January 1, 2018.

Barr, Jr., Alfred H. *Art in Our Time: 10th Anniversary Exhibition*. New York: Museum of Modern Art, 1939. Published in conjunction with an exhibition of the same title organized by the Museum of Modern Art in conjunction with the New York World's Fair, May 10–September 30, 1939.

———. *Max Weber, Retrospective Exhibition, 1907–1930*. New York: Museum of Modern Art, 1930. Published in conjunction with the exhibition *Weber, Klee, Lehmbruck, Maillol* organized by the Museum of Modern Art, March 12–April 2, 1930.

———. *Modern Works of Art: Fifth Anniversary Exhibition*. New York: Museum of Modern Art. Published in conjunction with an exhibition of the same title organized by the Museum of Modern Art, November 20, 1934–January 20, 1935.

Bouvier, Raphael, ed. *Picasso: Blue and Rose Periods*. Berlin, Hatje Cantz, 2019. Published in conjunction with the exhibitions *Picasso—Blue and Rose* organized by the Musée d'Orsay, Paris, France, September 18, 2018–January 6, 2019, and *The Young Picasso—Blue and Rose Periods* organized by the Fondation Beyeler, Riehen, Switzerland, February 3–May 26, 2019.

Cahill, Holger, et al. *Masters of Popular Painting: Modern Primitives of Europe and America*. New York: The Museum of Modern Art, 1938. Published in conjunction with an exhibition of the same title organized by the Museum of Modern Art, April 27–July 24, 1938.

Cunningham, Charles. *The Music Makers: The Private Collections of Mr. & Mrs. Richard Rodgers and Mr. & Mrs. Leopold Godowsky Including Paintings from the Collection of George Gershwin*. Hartford, CT: Wadsworth Atheneum. Published in conjunction with an exhibition of the same title organized by the Wadsworth Atheneum, July 9–August 9, 1959.

———. *Connecticut Collects*. Hartford, CT: Wadsworth Atheneum. Published in conjunction with the exhibition *Connecticut Collects: An Exhibition of Privately Owned Works of Art in Connecticut* organized by the Wadsworth Atheneum, October 4–December 3, 1957.

Graham, John D. *Exhibition of Sculptures of Old African Civilizations from the Collections of Frank Crowninshield, Louis Carré, George Gershwin, Ben Hecht, A. Conger Goodyear, Helena Rubenstein, Walt Kuhn, John D. Graham, Mrs. C. Suydam Cutting, Miguel Covarrubias, Edgar Levy*. New York: Jacques Seligmann Gallery. Published in conjunction with an exhibition of the same title

organized by the Jacques Seligmann Gallery, January 4–22, 1936.

Grove, Nancy. *Isamu Noguchi: Portrait Sculpture*. Washington, DC: National Portrait Gallery, Smithsonian Institution. Published in conjunction with an exhibition of the same title organized by the National Portrait Gallery, April 15–August 20, 1989.

Lieberman, William S. *Painters in Paris: 1895–1950*, New York: The Metropolitan Museum of Art. Published in conjunction with an exhibition of the same title organized by the Metropolitan Museum of Art, March 8, 2000–January 13, 2001.

Millier, Arthur, with a preface by Kenneth Ross. *3: A Century of Painting and Sculpture by Jewish Artists in Honor of the Third Anniversary of the State of Israel*. Los Angeles: Municipal Art Gallery, 1951. Published in conjunction with an exhibition of the same title organized by the Municipal Art Gallery, May 15–June 21, 1951.

Stewart, Lawrence D. *Gershwin: George, the Music, Ira, the Words*. New York: Museum of the City of New York. Published in conjunction with an exhibition of the same title organized by the Museum of the City of New York, May 6–September 2, 1968.

Wight, Frederick S., with a foreword by William S. Lieberman. *Modigliani: Paintings & Drawings*. Boston: Museum of Fine Arts and Los Angeles: Los Angeles County Museum, 1961. Published in conjunction with an exhibition of the same title organized by the Museum of Fine Arts and the Los Angeles County Museum, January–April 1961.

IV. PAMPHLETS AND BROCHURES

Arts Club of Chicago. *Sculpture by Isamu Noguchi*. Chicago: Arts Club of Chicago, 1930. Published in conjunction with an exhibition of the same title organized by the Arts Club of Chicago, March 26–April 9, 1930.

Botkin, Henry. *Exhibition of the George Gershwin Collection of Modern Paintings*. Chicago: The Arts Club of Chicago, 1933. Published in conjunction with an exhibition of the same title organized by the Arts Club of Chicago, November 10–25, 1933.

Crowninshield, Frank. *George Gershwin: Painter, 1898–1937, Memorial Exhibition*. Chicago: Arts Club of Chicago, 1938. Published in conjunction with an exhibition of the same title organized by the Arts Club of Chicago, March 15–28, 1938.

——. *George Gershwin, Painter, 1898–1937*. New York: Marie Harriman Gallery, 1937. Published in conjunction with an exhibition of the same title organized by the Marie Harriman Gallery, December 18, 1937–January 4, 1938.

Francesconi, Gino. *Nice Work if You Can Get It: George and Ira Gershwin*. New York: The Rose Museum at Carnegie Hall, 1998. Published in conjunction with an exhibition of the same title organized by the

Rose Museum, May 5–October 4, 1998.

Jablonski, Edward. *Ira—the Words, George—the Music*. East Hampton, NY: Guild Hall, 1986. Published in conjunction with an exhibition of the same title organized by Guild Hall, August 10–September 21, 1986.

Marie Sterner Galleries. *Fifteen Heads by Isamu Noguchi*. New York: Marie Sterner Galleries, 1930. Published in conjunction with an exhibition of the same title organized by Marie Sterner Galleries, February 1–14, 1930.

McGrady, Patrick. *George's Other Muse: Paintings, Drawings, Watercolors, and Photographs by George Gershwin*. University Park, PA: Palmer Museum of Art, The Pennsylvania State University, 1993. Published in conjunction with an exhibition of the same title organized by the Palmer Museum of Art, October 21, 1993–February 20, 1994.

Oregon Festival of American Music. *Gershwin Transformations*. Eugene: Oregon Festival of American Music, 2002. Published in conjunction with a festival of the same title, August 1–10, 2002.

V. ART BOOKS IN GERSHWIN'S LIBRARY (EDITION SPECIFIED WHERE KNOWN)

André, Albert. *Renoir*. Paris: G. Crès & Cie, 1928.

Arts News, The. April 28, 1930.

Arts News, The. May 16, 1931.

Basler, Adolphe. *Maurice Utrillo*. Paris: G. Crès & Cie, 1929.

Bellows, George. *George W. Bellows: His Lithographs*. New York: Alfred A. Knopf. (first edition published in 1927)

Charensol, Georges. *Rouault*. Paris: Éditions des Quatre Chemins, 1926.

Cheney, Sheldon. *A Primer of Modern Art*. (first edition published in 1924)

Cogniat, Raymond. *Rouault*. Paris: G. Crès & Cie, 1930.

Cortissoz, Royal. *The Painter's Craft*. New York: C. Scribners and Sons, 1930.

Craven, Thomas. *Modern Art*. New York: Simon & Schuster, 1934.

Creative Art, November 1932.

Dale, Maud. *Amedeo Modigliani, 1884–1920: Retrospective Exhibition of Paintings*. New York: Demotte, Inc., November 1931.

——. *Picasso*. New York: Knopf, 1930.

D'Ors, Eugenio. *Pablo Picasso*. Paris: Éditions des Chroniques du Jour and New York: E. Weyhe, 1930.

Downtown Gallery. *Max Weber*. New York: Downtown Gallery, 1930.

Ede, Harold S. *A Life of Gaudier Brzeska*. London: W. Heinemann, 1930.

Einstein, Carl. *Die Kunst des 20 Jahrhunderts*. Berlin: Im Propylaen-Verlag, 1926.

Fage, André. *Le Collectionneur de Peintures modernes, comment acheter, comment vendre*. Paris: Éditions pittoresques, 1930.

Faure, Elie. *Soutine*. Paris: G. Crès & Cie, 1929.

Fenollosa, Ernest, F. *Epochs of Chinese and Japanese Art*. two vols. (first edition published in 1912)

Fine Arts Magazine. Christmas edition, 1931.

Foujita, Tsugouharu. *A Book of Cats*. New York: Covici-Friede, 1930.

Galerie Georges Petit. *Henri Matisse*. Paris: Galerie Georges Petit, 1931.

George, Waldemar. *Picasso Dessins*. Paris: Éditions des Quatre Chemins, 1926.

Georges Rouault. Art Lovers Library.

Glück, Gustav. *Bruegels Gemälde*. (first edition published in 1932).

Goll, Yvan. *Pascin*. Paris: G. Crès & Cie, 1929.

Gordon, Ja. *Modern French Painters*. New York, Dodd, Mead and Company, 1923.

Grosz, George. *Die Gezeichneten*, Berlin: Malik, 1930.

Hart, George Overbury, and Holger Cahill. *"Pop" Hart: Recent Drawings of Mexico, Oils, Watercolors, Lithographs*. New York: The Downtown Gallery, 1927.

Isham, Samuel. *The History of American Painting* (first published in 1905).

Jacobs, Michel. *The Art of Color* (first published in 1923).

Jean, René. *Raoul Dufy*. Paris: G. Crès & Cie, 1929.

Jewell, Edward Alden. *Alexander Brook*. New York: Whitney Museum, 1931.

Justi, Ludwig. *Von Corinth bis Klee*, Berlin: Julius Bard, 1931.

Lewisohn, Adolph, and Stephan Bourgeois. *The Adolph Lewisohn Collection of Modern French Paintings and Sculptures*. New York: E. Weyhe, 1928.

Martin, Herbert E. *Color*.

Meier-Graefe, Julius. *Degas*, New York: Knopf, 1923.

———. *Vincent Van Gogh: A Biography* (first published in 1910).

Moreau-Vauthier, Charles. *The Technique of Painting*. New York: Putnam's and London: Heinemann, 1928.

Narodny, Ivan. *American Artists*. New York: Roerich Museum, 1930.

Paintings of George Bellows, The. Art Lovers Library.

Pearson, Ralph M. *How to See Modern Pictures: An Extension of the Design Principle into Three Dimension and an Explanation of Its Basic Application to the Work of the Moderns, Primitives, and the Classics of Both Europe and the Orient*. New York: Dial Press (first published in 1925).

Pennell, Elizabeth Robbins, and Joseph. *The Life of James McNeill Whistler*, two vols. (first published in 1908).

Pfannstiel, Arthur. *Catalogue présumé de l'oeuvre de Modigliani*. Paris: Marcel Seheur, 1929.

Raynal, Maurice. *Modern French Painters*. Translated by Ralph Roeder. New York: Brentano's, 1928.

———. *Picasso*.

Reed, Alma. *Jose Clemente Orozco*. New York: Delphic Studios, 1932.

Salmon, André. *André Derain*, Paris: Éditions de la Nouvelle Revue française, 1924.

———. *Chagall*. Paris: Éditions des Chroniques du Jour, 1928.

Soby, James Thrall. *After Picasso*. 1935.

Scheiwiller, Giovanni. *Modigliani*. Paris: Éditions des Chroniques du Jour, 1928.

Slusser, Jean Paul. *Bernard Karfiol*. New York: Whitney Museum, 1931.

Sterne. Rome: Valori Plastici, 1925 (signed).

Tabarant, Adolphe. *Utrillo*. Paris: Galerie Bernheim-Jeune, 1926.

Uhde, Wilhelm. *Picasso and the French Tradition*. Translated by F. M. Loving. Paris and New York: Éditions des Quatre Chemins and E. Weyhe, 1929.

Vollard, Ambroise. *Recollections of a Picture Dealer*. (first published in 1936)

Weber, Max. *Essays on Art*. New York: William Edwin Rudge, 1916.

Werth, Leon. *Bonnard*. Paris: G. Crès & Cie, 1929.

Wildenstein & Co. *"Collection of a Collector": Modern French Paintings from Ingres to Matisse (The Private Collection of the Late Josef Stransky)*. London: Wildenstein & Co., 1936.

Wilenski, R. H. *Vanity Fair's Portfolio of Modern French Art*. New York: Vanity Fair, 1935.

Zervos, Christian. *Catalogue of Paintings by Amedeo Modigliani 1884–1920 to be Exhibited at De Hauke and Co. Inc., 3 East 51st Street, New York, from Oct. 21st to Nov. 9th 1929*. Paris: Le service typographique, 1929.

———. *Henri Matisse*. Paris: Cahiers d'Art, 1931.

———. *Pablo Picasso*. Paris: Cahiers d'Art, 1932.

VI. ARCHIVAL COLLECTIONS CONSULTED

Arts Club of Chicago Records, Newberry Library, Chicago, IL.

Edward Jablonski Papers, Harry Ransom Humanities Research Center, Austin, TX.

George Gershwin Collection, Music Division, Library of Congress, Washington, DC.

George Gershwin Collection, Museum of the City of New York.

Henry Botkin Collection, Archives of American Art, Washington, DC.

Isamu Noguchi Archives, Isamu Noguchi Museum, Long Island City, NY.

Kay Swift Papers, Yale University, New Haven, CT.

Oral History, American Music (OHAM), Yale University, New Haven, CT.

Peter Juley Photographic Archives, Smithsonian Institution, Washington, DC.

Zentrum Paul Klee, Bern, Switzerland.

Object files of the Jewish Museum, New York; The Metropolitan Museum of Art, New York; the Museum of Modern Art, New York; the Santa Barbara Museum of Art, and the Wadsworth Atheneum Museum of Art, Hartford CT.

NOTES

GERSHWIN'S EYE

1 Sidney Jerome, "Porgy, Botkin and Bess," *Village Chatter*, June–July 1947, 20.

2 Rosamond Walling Tirana, "A photograph of a young man . . .," unpublished typescript, January 9, 1959, 4–5, George and Ira Gershwin collection, Library of Congress, Washington, DC.

3 A notable predecessor as a composer–art collector was Ernest Chausson, who owned major paintings by Carrière, Corot, Degas, Delacroix, Denis, Manet, Morisot, and Puvis de Chavannes, as well as works on paper by Degas, Delacroix, Denis, Gauguin, and Millet, and a large number of Japanese woodcuts. Another composer–art collector was George Frederick Handel. Other composer-painters included Felix Mendelssohn, Arnold Schoenberg, Edgard Varèse, and Paul Hindemith.

4 Robert Kimball and Alfred Simon, *The Gershwins* (New York: Atheneum, 1973), 140.

5 Ibid, 154.

6 Merle Armitage, "George Gershwin and His Time." In *George Gershwin*, ed. Merle Armitage (New York: Longmans, Green & Co., 1938), 14.

7 This was also the image of the composer featured in *Gershwin to Gillespie: Portraits in American Music,* my own exhibition of fifty portraits of famous American musicians by famous American photographers curated for the George Eastman House Museum of Photography and Film in Rochester, NY, which toured nationally from 2005 to 2007.

8 Other portrait subjects in the wide-ranging series are Sarah Bernhardt, Louis Brandeis, Martin Buber, Albert Einstein, Sigmund Freud, Franz Kafka, the Marx Brothers, Golda Meir, and Gertrude Stein.

9 For more on this history see Olivia Mattis, "Scriabin to Gershwin: Color Music from a Musical Perspective," in *Visual Music: Synaesthesia in Art and Music Since 1900*, edited by Kerry Brougher et al (Washington, DC: Hirshhorn Museum and Sculpture Garden, Smithsonian Institution; Los Angeles: Museum of Contemporary Art; and New York: Thames and Hudson, 2005), 210–27. In the nineteenth century, by contrast, music and art were often discussed by critics as "rival sisters," competing for supremacy in the supposed hierarchy between the muses. For more on this subject see James H. Rubin and Olivia Mattis, eds., *Rival Sisters, Art and Music at the Birth of Modernism, 1815–1915* (Surrey, UK, and Burlington, VT: Ashgate, 2014).

10 See Kenneth Peacock, "Instruments to Perform Color-Music: Two Centuries of Technological Experimentation," *Leonardo* 21, no. 4 (1988): 397–406.

11 Matt Micucci, "Duke Ellington and Synesthesia," *In Arte Matt* (blog), April 28, 2020, https://inartematt.com/2020/04/28/duke-ellington-and-synethesia/.

12 Michael Torke, "Ecstatic Orange," accessed June 22, 2023, https://michael-torke.squarespace.com/ecstatic-orange.

13 C. J. Bulliet, "Gershwin in His Role of Art Collector," *Chicago Daily News*, November 11, 1933.

14 Unnamed art dealer, as quoted in Nelson Lansdale, "My Boy George: An Interview with Mrs. Rose Gershwin," *Listen*, September 1945, 6.

15 Kimball and Simon, *The Gershwins*, 231.

16 Kay Halle, "The Time of His Life," *Washington Post*, February 5, 1978.

17 Joseph Schillinger, *The Mathematical Basis of the Arts* (New York: Philosophical Library, 1948).

18 "Mr. Gershwin May Paint; At Least His Cousin Says So, but Composer Is Bit Doubtful," *New York Sun*, April 10, 1929.

19 Charles C. Cunningham, foreword to *The Music Makers: The Private Collections of Mr. & Mrs. Richard Rodgers and Mr. & Mrs. Leopold Godowsky Including Paintings from the Collection of George Gershwin* (Hartford, CT: Wadsworth Atheneum, 1959), 2–3.

20 Henry Botkin, "A Composer's Pictures: George Gershwin, the Musician, is a Collector of Modern Paintings," *Arts & Decoration* 11, no. 3 (January 1934): 48–50; reprinted as "A Composer's

Pictures," in *Gershwin in His Time: A Biographical Scrapbook, 1919–1937*, Gregory R. Suriano, ed. (New York: Gramercy Books, 1998), 101–2. The essay is unsigned, but Botkin reveals himself as its author in a letter to Alice Roullier, Arts Club of Chicago, November 3, 1933, George and Ira Gershwin collection, Library of Congress, Washington, DC.

21 Her mother, Anna Strunsky Walling, was the sister of Ira Gershwin's wife Leonore Strunsky Gershwin.

22 This photograph is now in the collection of the National Portrait Gallery in Washington, DC.

23 Tirana, "A photograph of a young man...."

24 Ibid.

25 George Gershwin to Rosamond Walling, January 19, 1929, George and Ira Gershwin collection, Library of Congress, Washington, DC.

26 Heyman Zimel, "Roofs of the East Side," *The Forward*, April 28, 1929, English section, 2.

27 George Gershwin to Walling, April 29, 1929, George and Ira Gershwin collection, Library of Congress, Washington, DC.

28 Henry Botkin, "As a young boy of eight...," unpublished reminiscence, n.d., Henry Botkin papers, 1917–1979, Archives of American Art, Washington, DC.

29 Kimball and Simon, *The Gershwins*, 154.

30 Tirana, "A photograph of a young man...."

31 Ibid.

32 Prize fight filmed by either George or Ira Gershwin, ca. 1937. https://www.loc.gov/item/mbrs02059949/.

33 Gershwin's ivory figurines were sold by the Gershwin family at the Sheridan Art Galleries in Chicago on December 14, 1949, following the death of Rose Gershwin, the composer's mother and heir. A catalogue accompanying the sale illustrates some of the Gershwin-owned ivories on page 35.

34 A. Conger Goodyear to George Gershwin proposing the exhibition and explaining the policy, July 17, 1936, George and Ira Gershwin collection, Library of Congress, Washington, DC.

35 Henry Botkin to Charles Cunningham, February 7, 1966, Henry Botkin papers, 1917–1979, Archives of American Art, Washington, DC.

36 The occasion for the portrait was to mark the end of Mahler's tenure at the Hofoper in Vienna, a position he had held since 1897, and his move to New York to assume the conductorship of the New York Philharmonic Orchestra.

37 Robert MacCameron, "Auguste Rodin: His Life and Work," *Town and Country*, February 4, 1911, 19.

38 Tirana, "A photograph of a young man...."

39 Nancy Grove, *Isamu Noguchi: Portrait Sculpture* (Washington, DC: National Portrait Gallery, 1989), 44.

40 James Huneker, "Prelude," *The Steinway Collection of Paintings by American Artists Together with Prose Portraits of the Great Composers* (New York: Steinway & Sons, 1919), n.p. The twelve paintings in the volume are: N. C. Wyeth, *Beethoven and Nature* (1917) and *Wagner and Liszt* (1914)—both now at the Brandywine Museum of Art, Chadds Ford, PA; Harvey Dunn, *Berlioz, The Fantastic Symphony* (1918) and *Schubert Composing the Earl-King* (1918); Harry Townsend, *Handel, The Fire Fugue* (1919); Charles E. Chambers, *The Death of Mozart* (1919); A. I. Keller, *Chopin, The Raindrop Prelude* (1919), John C. Johansen, *Franz Liszt* (1918); Carl Anderson, *Felix Mendelssohn, A Midsummer Night's Dream* (1918); Ernest Blumenschein, *Edward MacDowell, The Indian Suite* (1918); Henry McCarter, *Verdi, Aida* (1918) and F. Louis Mora, *Rubinstein Plays for the Czar* (1918). For more on the Steinway collection see: Rhona L. Ferling, "Steinway's Harmonious Collection," *Financial Executive* 10, no. 1 (January–February 1994), 54+.

41 Emily Genauer, "Gershwin's Home is Perfect Reflection of Its Owner and Designer," *New York World Telegram*, Saturday, April 1, 1933.

42 Incredibly, Gershwin's collected correspondence has never been published. Such a volume (or more likely, multivolume work) would be a highly worthwhile contribution to scholarship.

43 Henry Botkin to George Gershwin, April 21, 1931, George and Ira Gershwin collection, Library of Congress, Washington, DC.

44 George Gershwin to Henry Botkin, May 8, 1931, Henry Botkin papers, 1917–1979, Archives of American Art, Washington, DC. By "first men" Gershwin means "first-rate" artists.

45 The sales receipt states: *Je soussigné reconnais avoir vendu à M. Botkin un tableau de Modigliani buste de jeune femme fait en 1919 pour la somme de 48,000 fr. plus le cadre 500 fr. Je garantie autenticité de ce tableau. Zborowski. Provient collection Rolland Paris 11 May 1931.* In art critic Milton Esterow's article about fake Modiglianis he states: "Léopold Zborowski . . . sold many authentic Modiglianis but, one expert told me, 'there are works that he sold that would make people wonder.'" Milton Esterow, "The Art Market's Modigliani Forgery Epidemic," *Vanity Fair*, May 3, 2017, 50. And according to Modigliani scholar Kenneth Wayne, "It has long been suspected that Modigliani's own dealer Léopold Zborowski was involved in having Modigliani paintings produced by Kisling or others in the 1920s as the dealer ran out of stock." Kenneth Wayne, "Validating True Modigliani Paintings and Ensuring His Legacy for Posterity," in *Modigliani and the Modern Portrait* (Roslyn, NY: Nassau County Museum of Art, 2023), 37.

46 See: https://modiglianiproject.org/catalogue-raisonné.

47 George Gershwin telegram to Henry Botkin, June 19, 1931, Henry Botkin papers, 1917–1979, Archives of American Art, Washington, DC.

48 George Gershwin to Henry Botkin, June 20, 1931, Henry Botkin papers, 1917–1979, Archives of American Art, Washington, DC.

49 Ibid.

50 Henry Botkin to George Gershwin, May 5, 1931, Henry Botkin papers, 1917–1979, Archives of American Art, Washington, DC.

51 André Derain, as quoted in Isabelle Monod-Fontaine, *André Derain, An Outsider in French Art* (Copenhagen: Statens Museum for Kunst, 2007), 144.

52 Many thanks to composer Neely Bruce for identifying the score. A cropped version of this photograph appears in *Entertainment Weekly*, April 2, 1993, 45, and in Florence Stevenson De Santis, *Gershwin* (New York: Treves Publishing Company, 1987), 46.

53 Henry Botkin telegram to George Gershwin, October 26, 1931, George and Ira Gershwin collection, Library of Congress, Washington, DC.

54 Henry Botkin to Gershwin, April 21, 1931, George and Ira Gershwin collection, Library of Congress, Washington, DC.

55 Kimball and Simon, *The Gershwins*, 154.

56 Henry Botkin telegram to George Gershwin, April 30, 1932, George and Ira Gershwin collection, Library of Congress, Washington, DC.

57 Henry Botkin to George Gershwin, ca. May 5, 1932, George and Ira Gershwin collection, Library of Congress, Washington, DC.

58 George Gershwin to Henry Botkin, May 11, 1932, Henry Botkin papers, 1917–1979, Archives of American Art, Washington, DC.

59 Henry Botkin to George Gershwin, May 12, 1932, George and Ira Gershwin collection, Library of Congress, Washington, DC.

60 Raphael Bouvier, ed., *Picasso, The Blue and Rose Periods* (Berlin: Hatje Cantz, 2019).

61 "Famous Fables," *The Sentinel* (Carlisle, PA), February 26, 1972, 4.

62 George Gershwin to Henry Botkin, May 11, 1932, Henry Botkin papers, 1917–1979, Archives of American Art, Washington, DC.

63 Maurice Berger and Joan Rosenbaum, eds., *Masterworks of the Jewish Museum* (New Haven, CT: Yale University Press, 2004), 52.

68 Jake Wien, email message to the author, November 7, 2006.

65 He famously owned a rare platinum flute and was the dedicatee of *Density 21.5* for solo flute by Edgard Varèse. (21.5 grams per cubic centimeter is the density of platinum.)

66 Henry Botkin, "Painter and Collector," in Armitage, *George Gershwin*, 13743.

67 Jerome, "Porgy, Botkin and Bess," 5.

68 George Gershwin to Henry Botkin, June 30, 1931, Henry Botkin papers, 1917–1979, Archives of American Art, Washington, DC.

69 Henry Botkin to George Gershwin, received April 24, 1933, George and Ira Gershwin collection, Library of Congress, Washington, DC.

70 Vassily Kandinsky, *On the Spiritual in Art* (original title: *The Art of Spiritual Harmony*) (New York: Dover Publications, 1977), 25.

71 Gershwin, "The Composer in the Machine Age," in Oliver M. Sayler, *Revolt in the Arts: A Survey of the Creation, Distribution and Appreciation of the Arts in America* (New York: Bretano's, 1930); reprinted in Suriano, *Gershwin in His Time*, 84.

72 Kandinsky, *On the Spiritual in Art*, 32.

73 George Gershwin, *George Gershwin's Song-Book* (New York: Harms, 1932), x.

74 William G. Hyland, *George Gershwin: A New Biography* (Westport, CT, and London: Praeger, 2003), 217.

75 Walter Pater, *The School of Giorgione* (London: Macmillan and Co., 1873). Accessible here: https://victorianweb.org/authors/pater/renaissance/7.html.

76 Armitage, *George Gershwin*, 188.

77 Gershwin typescript "*An American in Paris*, 1928," Harry Ransom Humanities Research Center, The University of Texas at Austin.

78 Helen Torr diary entry, December 1, 1926, Henry Botkin papers, 1917–1979, Archives of American Art, Washington, DC.

79 Joan Peyser, *The Memory of All That: The Life of George Gershwin* (New York: Billboard Books, 1998), 211.

80 Max Weber to George Gershwin, May 31, 1933, George and Ira Gershwin collection, Library of Congress.

81 *Max Weber Retrospective Exhibition 1907–1930* (New York: Museum of Modern Art, 1930), 21

82 Botkin, "A Composer's Pictures," 50.

83 Elizabeth "Bobsy" Goodspeed telegram to Gershwin, n.d., George and Ira Gershwin collection, Library of Congress, Washington, DC.

84 Gershwin to Goodspeed, November 14, 1933, George and Ira Gershwin collection, Library of Congress, Washington, DC.

85 Eleanor Jewett, "Good Exhibit Opens at Arts Club," *Chicago Tribune*, November 11, 1933.

86 *Chicago Herald Examiner*, November 15, 1933.

87 Botkin, "A Composer's Pictures," 48–50.

88 Harry Salpeter, "Burliuk: Wild Man of Art," *Esquire*, July 1939, 63, 142, 144, 147.

89 Ibid., 63.

90 For details on the publication go to this link, although the scans are difficult to read: https://ls.vanabbemuseum.nl/B/burliuk/pages/1931CR.htm.

91 In fact, Gershwin was aware that Al Jolson was interested in playing the role of Porgy, but he was opposed to the concept, as he expressed in a letter to DuBose Heyward [Gershwin to Heyward, September 9, 1932, Harry Ransom Humanities Research Center, University of Texas at Austin]. Instead, Gershwin had the legendary bass Paul Robeson in mind for the lead, as he states in another letter to Heyward [Gershwin to Heyward, March 8, 1934, Harry Ransom Humanities Research Center, University of Texas at Austin]. *Porgy and Bess* was not the first modernist musical production to feature an all-African American cast. It was preceded by the opera *Four Saints in Three Acts* (1933) by Virgil Thomson and Gertrude Stein and by King Vidor's film *Hallelujah* (1929). Eva Jessye was the musical director in all three productions (although uncredited in *Hallelujah*). Gershwin attended a performance of *Four Saints in Three Acts*, as he reports in a letter to Heyward [Gershwin to Heyward, February 26, 1934, Harry Ransom

Humanities Research Center, University of Texas at Austin].

92 For a synopsis of the various controversies, see Kai West, "Confronting 'Porgy and Bess,'" Vice President for Communications, Arts & Culture, University of Michigan blog, January 29, 2018, https://arts.umich.edu/news-features/confronting-porgy-and-bess/.

93 Emily Nathan, "Kara Walker's *Porgy & Bess* Libretto," *ARTnews*, March 18, 2014, https://www.artnews.com/art-news/news/kara-walker-creates-porgy-and-bess-libretto-2393/.

94 Henry Botkin, "On My Cousin George Gershwin," undated typescript, George and Ira Gershwin collection, Library of Congress, Washington, DC.

95 American Art Association, Anderson Galleries, Inc, *The Chester H. Johnson Galleries, Chicago, Collection of Paintings* (New York: American Art Association, Anderson Galleries, Inc., 1934), lots 67, 26.

96 Sotheby's, *Impressionist and Modern Art, Part II* (New York: Sotheby's, 1999), 117.

97 Botkin, "A Composer's Pictures," 49.

98 "Gershwin Paintings Shown in Film," *Democrat and Chronicle* (Rochester, New York), October 15, 1943, 10.

99 Moïse Kisling and Henri Troyat, *Kisling, 1891–1953* (Paris: Jean Kisling, 1982). The known portraits of Kisling are listed in volume 2, page 37.

100 Isamu Noguchi to George Gershwin, n.d., George and Ira Gershwin collection, Library of Congress, Washington, DC.

101 His companions on that visit were his psychoanalyst Dr. Gregory Zilboorg, the department store magnate Marshall Field, and Edward M. M. Warburg, cousin of composer Kay Swift's husband. Katharine Weber, "In a Painting, Gershwin Packed the House," *New York Times*, August 30, 1998, 30.

102 Laurance P. Hurlburt, *The Mexican Muralists in the United States* (Albuquerque: University of New Mexico, 1989), 230.

103 David Alfaro Siqueiros, "Paréntesis en Yanquilandia," *Me llamaban el Coronelazo: memorias* (Mexico: Grijalbo, 1977), 299–302. English typescript translation, n.p., George and Ira Gershwin collection, Library of Congress, Washington, DC.

104 Ibid.

105 Letter from an unknown letter writer to Henry Botkin beginning "My dear Mr. Botkin; I am writing this letter just at the moment that I am sailing for Spain" on stationery of the Hotel Piccadilly, 227 W. 45th Street, New York, January 23, 1937, Henry Botkin papers, 1917–1979, Archives of American Art, Washington, DC.

106 Weber, "In a Painting," 30.

107 Ibid.

108 Ibid.

109 Nancy Bloomer Deussen, letter to the editor, *New York Times*, September 20, 1998.

110 Katharine Weber, "Gershwin's Self-Portrait in the Mirror with My Mother," *American Imago* 72, no. 4 (Winter 2015): 335–53.

111 Ibid., 337.

112 Ibid., 347.

113 Carl Van Vechten to George Gershwin, n.d. [1935–36], George and Ira Gershwin collection, Library of Congress, Washington, DC.

114 For more about the relationship between traditional African art and European modernism and later critiques, see Hal Foster, "The 'Primitive' Unconscious of Modern Art," *October* 34 (Autumn 1985): 45–70 and Jonathan Hay, "Primitivism Reconsidered (Part 1): A Question of Attitude," *Res* 67–68 (2016/2017): 61–77.

115 For the relationship between modernism and Mesoamerican objects, see Stacy Goodman, "Modernism and Mesoamerica in The David M. Solinger Collection," *Sotheby's*, November 16, 2022, https://www.sothebys.com/en/articles/modernism-and-mesoamerica-in-the-david-m-solinger-collection.

116 According to The Metropolitan Museum, figures like these would have been mounted on a container holding the relics of important ancestors; they protected these sacred objects from the gazes by women and uninitiated boys.

117 *Exhibition of Sculptures of Old African Civilizations from the Collections of Frank Crowninshield, Louis Carré, George Gershwin, Ben Hecht, A. Conger Goodyear, Helena Rubenstein, Walt Kuhn, John D. Graham, Mrs. C. Suydam Cutting, Miguel Covarrubias, Edgar Levy* (New York: Jacques Seligmann Gallery, 1936).

118 Sotheby's, *Art of Africa, Oceania, and the Americas* (London: Sotheby's, 2022), lot 72.

119 George Gershwin to Zenaide Hanenfeldt, September 8, 1936, George and Ira Gershwin collection, Library of Congress, Washington, DC.

120 George Gershwin to Zenaide Hanenfeldt, September 10, 1936, George and Ira Gershwin collection, Library of Congress, Washington, DC.

121 Lawrence Stewart memo housed with Hardy photographs, n.d., Library of Congress, Washington, DC.

122 George Gershwin to Mabel Schirmer, March 19, 1937, George and Ira Gershwin collection, Library of Congress, Washington, DC.

123 *Pyramids at Gizeh* object label, *The Nelson-Atkins Museum of Art*, accessed June 23, 2023, https://art.nelson-atkins.org/objects/2226/pyramids-at-gizeh.

124 Sigmund Sanders to George Gershwin, October 19, 1936, George and Ira Gershwin collection, Library of Congress, Washington, DC.

125 George Gershwin to Sigmund Sanders, November 5, 1936, George and Ira Gershwin collection, Library of Congress, Washington, DC. Deepest thanks to Michael Owen for bringing this correspondence to my attention.

126 For details of Gershwin's fatal illness and brain surgery see Noah D. Fabricant, M.D., "George Gershwin's Fatal Headache," *The Eye, Ear, Nose & Throat Monthly* 37, nos. 332–34 (May 1958). A reprint of this article is in the Edward Jablonski Collection at the Harry Ransom Humanities Research Center, The University of Texas at Austin.

127 Leonard Bernstein, "An Appreciation," in Charles Schwartz, *Gershwin: His Life and Music* (Indianapolis and New York: The Bobbs-Merrill Company, Inc., 1973), xii.

128 Armitage, "George Gershwin and His Time," in Armitage, *George Gershwin*, 14.

129 Botkin, "A Composer's Pictures," 49.

130 Ibid.

131 Frank Crowninshield in "Introduction," *George Gershwin, Painter, 1898–1937* (Chicago: Arts Club of Chicago, 1938), n.p.

132 Siqueiros, *Me llamaban el Coronelazo: memorias* (English typescript translation), n.p.

133 Armitage, *George Gershwin*, 188.

NOGUCHI ON GERSHWIN

1 Isamu Noguchi, "Portrait," in *George Gershwin*, ed. Armitage, 209–10; reprinted in Diane Apostolos-Cappadona and Bruce Altshuler, eds., *Isamu Noguchi Essays and Conversations* (New York: Harry N. Abrams, 1994), 22–23.

BOTKIN ON GERSHWIN

1 Henry Botkin, foreword to *Exhibition of the George Gershwin Collection of Modern Paintings*, exhibition brochure (Chicago: Arts Club of Chicago, 1933), n.p.

2 Henry Botkin, "On My Cousin George Gershwin," n.d., Henry Botkin papers, 1917–1979, Archives of American Art, Washington, DC.

3 Henry Botkin, "Returning to my relationship…," 1973, Henry Botkin papers, 1917–1979, Archives of American Art, Washington, DC.

SIQUEIROS ON THE GENESIS OF THE PAINTING

1 David Alfaro Siqueiros, *Me llamaban el Coronelazo: memorias* (English typescript translation), n.p.

"A PAST THAT IS MINE": GERSHWIN'S LEGACY IN THE VISUAL ARTS

1 In addition to Gershwin, the subjects of these portraits are other pioneers and iconic figures in their respective fields, including US Supreme Court justice Louis Brandeis, Israeli prime minister Golda Meir, philosopher Martin Buber, writers Franz Kafka and Gertrude Stein, physicist Albert Einstein, psychologist Sigmund Freud, actor Sarah Bernhardt, and entertainers Chico, Groucho, and Harpo Marx (portrayed in a triple portrait as *The Marx Brothers*).

2 Richard Meyer, *Warhol's Jews: Ten Portraits Reconsidered* (New York: Jewish Museum, 2008).

3 In addition to its exhibition at the Jewish Museum, the *Ten Portraits* portfolio was exhibited in two additional museum exhibitions in 1980. One of these was held at the Jewish Community Center of Greater Washington in Rockville, Maryland, and the other at the Lowe Art Museum in Miami, Florida.

4 Hilton Kramer, "Art: Warhol Show At Jewish Museum," *New York Times*, September 19, 1980, section T, page 16.

5 Ibid.

6 Carrie Rickey, "Andy Warhol: The Jewish Museum," *Artforum* 19, no. 4 (December 1980): 72.

7 Ibid.

8 Meyer, *Warhol's Jews*.

9 *Porgy and Bess* was based on the 1927 play *Porgy* by Dorothy and DuBose Heyward, which was in turn based on DuBose Heyward's 1925 novel of the same name.

10 Poet Maya Angelou, who played the role of Ruby in a 1950s international touring production of *Porgy and Bess*, reflected on the opera in a 2010 interview, stating that she was grateful to have been involved with the production and describing it as "great art." (Michel Martin, "1950s 'Porgy and Bess' Castmember Maya Angelou Reflects On Production's Significance," *Tell Me More*, NPR News, April 1, 2010.) Conversely, actor Harry Belafonte declined to play Porgy in the film version of *Porgy and Bess*, describing the production as "racially demeaning," and discouraged Dorothy Dandridge from accepting the role of Bess. (Harry Belafonte, *My Song: A Memoir of Art, Race and Defiance* [New York: Alfred A. Knopf, 2011, chapter 10].)

11 George Gershwin. "Rhapsody in Catfish Row: Mr. Gershwin Tells the Origin and Scheme for His Music in That New Folk Opera Called 'Porgy and Bess.'" *New York Times*, October 20, 1935, pp. 1–2. https://nyti.ms/47dKwPL.

12 Ibid. For example, in his essay Gershwin makes sweeping generalizations about Black Americans when he describes his opinion that *Porgy and Bess* "brings to the operatic form elements that have never before appeared in opera and I have adapted my method to utilize the drama, the humor, the superstition, the religious fervor, the dancing and the irrepressible high spirits of the race." Further, he describes his selection of "Charleston Negroes" as subject matter by saying, "I made sure that it would enable me to write light as well as serious music and that it would enable me to include humor as well as tragedy . . . because the Negroes, as a race, have all these qualities inherent in them." It is unclear what made Gershwin believe that individuals of other races did not possess the qualities of both humor and tragedy.

13 See Daphne A. Brooks; "A Woman Is a Sometime Thing": (Re)Covering Black Womanhood in *Porgy and Bess*. *Daedalus* 150, no. 1 (2021): 98–117 and Ellen Noonan; *The Strange Career of* Porgy and Bess*: Race, Culture, and America's Most Famous Opera* (Chapel Hill: University of North Carolina Press, 2012).

14 Kara Walker, artist's statement in prospectus announcing the

publication of *Porgy and Bess* by Arion Press, 2013.

15 Ibid.

16 A list compiled by the American Repertory Theater in 2011 included Billie Holiday (1936), Ella Fitzgerald and Louis Armstrong (1957), Nina Simone (1958), Billy Stewart (1966), Janis Joplin (1968), The Doors (1970), Diana Ross (1974), Bronski Beat (1984), Sublime (1997), Cher (1994), Fantasia Barrino (2004), and Brian Wilson (2010). "Porgy and Bess Hits the Charts," August 2, 2011, https://americanrepertorytheater.org/media/porgy-and-bess-hits-the-charts.

17 Simone's recording of "I Loves You, Porgy" spent fifteen weeks on the Billboard Hot 100 in 1959, peaking at eighteenth place. "Nina Simone, Billboard, accessed August 16, 2023, https://www.billboard.com/artist/nina-simone/.

18 Gibson discussed the origins of his punching bag series in an interview for the Evening Lecture Series at the New York Studio School on February 28, 2017, https://youtu.be/2X-FcxtAZiw.

19 Interview with Jeffrey Gibson by Dallas Museum of Art, 2021, https://soundcloud.com/dallas-museum-of-art/jeffrey-gibson-on-i-wanna-stay-here-with-you-forever, accessed August 18, 2023.

20 Ibid.

CORRESPONDENCE BETWEEN GEORGE GERSHWIN AND HENRY BOTKIN AND RELATED DOCUMENTATION

1 Isaac Goldberg, "Music by Gershwin," *Ladies Home Journal*, February 1931, 12–13, 149, 151, ill.

2 F. Valentine Dudensing ran the Valentine Gallery in New York City, which sold contemporary European and American art.

3 Frank Crowninshield, editor of *Vanity Fair*, was a respected contemporary art critic and collector.

4 Paul Reinhardt was the head of Reinhardt Galleries in New York City, which specialized in old and modern masters.

5 Margaret Seligman Lewisohn and her husband Sam were major collectors of modern art. They had homes in New York City and Harrison, New York.

6 Frank K. M. Rehn Galleries in New York City specialized in works by American painters.

7 Alex Aarons and Vinton Freedley were major Broadway producers.

CURATORS' ACKNOWLEDGMENTS

This publication and the related exhibition *George Gershwin and Modern Art: A Rhapsody in Blue* are the result of years of work and the steadfast support of many. While the bulk of Gershwin's art collection has been widely dispersed, many pieces remain within the family. First and foremost, we are grateful to the descendants of the various branches of the Gershwin family for allowing us to photograph and borrow many works from their collections, namely Adam Gershwin, Marc Gershwin, Elaine Godowsky, and others who prefer to remain anonymous. We could not have organized this exhibition and publication without their generous collaboration. Other individuals who generously loaned works to this exhibition are Michael Feinstein and Terrence Flannery, and an anonymous (but appreciated) private collector. To all of them we offer our sincerest thanks.

In addition, we are profoundly grateful to the many directors, curators, collections professionals, and others at museums and galleries throughout the United States and around the world for generously lending work from their collections to the exhibition and for providing images for this publication: Katie Briski, Amber Morgan, and Patrick Moore at The Andy Warhol Museum; Agustín Arteaga, Katherine Brodbeck, Tricia Earl, Nicole R. Myers, and Michelle Rich at the Dallas Museum of Art; Efrat Aharon and Denis Weil at the Israel Museum; Darsie Alexander, Katherine Danalakis, Claudia Gould, and Julie Maguire at the Jewish Museum; Janet McKinney and Ray White at the Library of Congress, Music Division; René Paul Barilleaux, R. Scott Blackshire, and Matthew McLendon at the McNay Art Museum; Teresa A. I. Bulgheroni, María Amalia García, and Valeria Intrieri at the Museo de Arte Latinoamericano de Buenos Aires; Erica Hirshler, Ethan Lasser, Janet Moore, and Matthew Teitelbaum at the Museum of Fine Arts, Boston; Sarah Henry and Sheryl McMahan at the Museum of the City of New York; Julie Mattsson, William Keyse Rudolph, and Julián Zugazagoitia at the Nelson-Atkins Museum of Art; Peter Barberie, Amanda Bock, and Sasha Suda at the Philadelphia Museum of

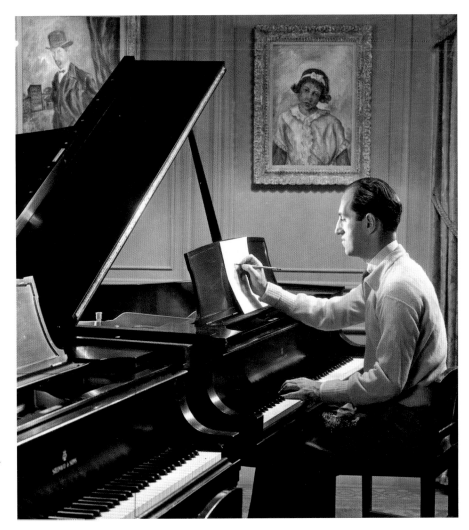

Fig. 95. George Gershwin at his piano with two of his paintings, *My Grandfather* and *Negro Child*, visible behind him, ca. 1935. Library of Congress. One of the two 1933 Steinway pianos in this photograph was donated to the University of Michigan in 2014 by Gershwin's nephew, Marc Gershwin.

Art; Nicholas West and Susanna White at the Picker Art Gallery, Colgate University; Marco Nocella and Burcu Oz at Ronald Feldman Gallery; Barbara Jatta and Isabella Leone at the Vatican Museums; and Mary Busick, Matthew Hargraves, and Erin Monroe at the Wadsworth Atheneum Museum of Art.

Critical assistance in facilitating loans for this exhibition was kindly provided by Cyanne Chutcow, Christie's; Suzanne and Norman Cohn; Audrey Lea Collins, Zach Feuer, and Becky Gochman, Gochman Family Collection; and Meg Malloy, Sikkema Jenkins.

The pianist and Gershwin authority Richard Glazier facilitated numerous introductions and has been a steadfast supporter and friend of this project since the beginning, as has been the writer Katharine Weber, whose grandmother Kay Swift was one of the loves of Gershwin's life. Invaluable guidance and advice were also provided by Michael Owen, biographer of Ira Gershwin, and Mark Clague, director of the Gershwin Initiative at the University of Michigan. The musicologists Rose Rosengard Subotnik, Howard Pollack, and the late Vivian Perlis as well as the art writer Jake Wien provided invaluable feedback along the way.

This stunning publication would not be possible without the efforts of the talented team at Scala Arts Publishers Inc., including Erin Barnett, Tim Clarke, Jennifer Norman, Benjamin Shaykin, and Claire Young. We are also grateful to Tomomi Itakura, Yugon Kim, and their team at design firm TSKP x ikd, for the engaging and inspiring design of the exhibition galleries. Securing the many images for this publication was a monumental project in its own right, and we are particularly grateful to Lisa Ballard, Andrew Budz, Kelsey Dickinson, Joyce Faust, Sharon Kim, Fleur Lennox, and Claire McGowan for their kind assistance.

The talent and commitment of The Baker Museum team has played a vital role in the success of this project, which is one of the most ambitious exhibitions mounted by the museum since its founding in 2000. We are grateful to Megan Crawford, Dianne Brás Feliciano, Libby Harrington, Annie Ladehoff, Elizabeth Monti, Morgan Motes, and Casandra Ruanova, for their critical contributions to this exhibition and publication.

Funding for this project has generously been provided by the Collier County Tourist Development Council, Commerce Trust, Roger and Kathy Marino, Waterside Shops, and Jeri L. Wolfson.

We would be remiss if we did not thank our families, whose support and patience always help to fuel the work on a long-term project such as this one. Olivia extends her gratitude to Daniel and Noémi Mattis, Kenneth Wayne and Gabriel Wayne, and Courtney to her husband Ryan and children Graham, Henry, and Theodore McNeil.

Olivia Mattis Courtney A. McNeil

ARTIS—NAPLES LEADERSHIP

PROGRAMMING

Home of The Baker Museum and the Naples Philharmonic, Artis—Naples is unique among cultural institutions nationwide, equally dedicated to both the visual and performing arts featuring artists of global distinction. Artis—Naples offers more than 800 paid and free events annually across its 8.5-acre Kimberly K. Querrey and Louis A. Simpson Cultural Campus, which is home to five buildings, including two performance halls (Frances Pew Hayes Hall and Myra J. Daniels Pavilion), The Baker Museum, the Toni Stabile Education Building, and the Kohan Administration Building.

To commemorate the one hundredth anniversary of George Gershwin's *Rhapsody in Blue*, a genre-blending masterwork that effortlessly combined the sounds of classical and jazz music, Artis—Naples is celebrating this legendary music and the multidisciplinary legacy of its beloved creator. In addition to The Baker Museum's exhibition *George Gershwin and Modern Art: A Rhapsody in Blue*, Artis—Naples presents this robust slate of multidisciplinary programs throughout the 2023–24 season.

Fig. 96, top left. Artis—Naples, The Baker Museum, south facade.

Fig. 97, top right. Artis—Naples, Norris Garden and The Baker Museum east facade.

Fig. 98, bottom. Alexander Shelley conducts the Naples Philharmonic at Frances Pew Hayes Hall.

November 16, 2023
An Overture to Alexander: A Toast to the Future |
Naples Philharmonic Special Performance
Naples Philharmonic
Alexander Shelley, artistic and music director
 designate

February 11, 2024
Reflections on George Gershwin and Modern Art:
A Conversation with Michael Feinstein
Michael Feinstein, lecturer
Courtney McNeil, host

February 12, 2024
Michael Feinstein: A Tribute to George Gershwin
Michael Feinstein, vocals and piano

February 15, 16, and 17, 2024
Naples Philharmonic Masterworks
Naples Philharmonic
David Robertson, conductor
Orli Shaham, piano
 Schoenberg — Chamber Symphony No. 1
 Gershwin — *Rhapsody in Blue* for Piano and
 Jazz Band
 Schoenberg — Five Pieces for Orchestra, Op. 16
 Gershwin — *Rhapsody in Blue* for Piano and
 Orchestra

February 28, 2024
Musical Paris in the Early 20th Century
Artis—Naples Lifelong Learning Lecture
 Fred Plotkin, lecturer

February 29, 2024
All Gershwin All the Time: Jodie DeSalvo's
Piano Talks
 Jodie DeSalvo, piano
 Mark Sanders, tenor

March 8, 2024
Giordano Dance Chicago
 featuring some of Gershwin's most beloved melodies

March 13, 2024
Gershwin's Eye: The Baker Museum
Exhibition Lecture
 Olivia Mattis, PhD, curator

March 14 and 15, 2024
Naples Philharmonic Masterworks
 Naples Philharmonic
 Alexander Shelley, artistic and music director
 designate
 Jess Gillam, saxophone
 Gershwin — *An American in Paris*
 Anna Clyne — *Glasslands* for Saxophone and
 Orchestra*
 Ravel — *La valse*
 Stravinsky — *The Firebird* Suite
*Artis—Naples co-commission

March 20, 2024
The Musicals of George and Ira Gershwin
Artis—Naples Lifelong Learning Lecture
 Greg Brown, lecturer

May 15, 2024
The Music of George Gershwin
 Naples Philharmonic Jazz Orchestra

CONTRIBUTORS

Dr. Olivia Mattis is the guest curator of the landmark Artis—Naples exhibition *George Gershwin and Modern Art: A Rhapsody in Blue* and the author of the accompanying catalogue. She is an award-winning musicologist specializing in links between music and the visual arts. She co-edited (with the art historian James Rubin) *Rival Sisters, Art and Music at the Birth of Modernism, 1815–1915* (Routledge/Ashgate, 2014) and co-authored (with a team of art historians) *Visual Music: Synaesthesia in Art and Music Since 1900* (Thames and Hudson, 2005). She holds a PhD in musicology from Stanford University and a BA in music from Yale University. Her nationally touring exhibition *Gershwin to Gillespie: Portraits in American Music*, curated for the George Eastman House Museum of Photography and Film, featured fifty portraits of famous American musicians by famous American photographers. Quite apart from her musicological work she is president of the Sousa Mendes Foundation, a Holocaust remembrance organization devoted to the hero who rescued her family and thousands of others from Nazi-occupied Europe in 1940.

Kathleen van Bergen is CEO and president of Artis—Naples, home of The Baker Museum and the Naples Philharmonic. For more than a decade, van Bergen has charted an ambitious course for the multidisciplinary organization, fostering artistic development, ensuring financial stability and nurturing community connections. Under her leadership, Artis—Naples has expanded its programming and reach to embrace a wider range of art forms and audiences. A graduate of the Eastman School of Music, van Bergen has dedicated her life to the arts. Prior to joining Artis—Naples, she held several key leadership roles, including artistic and executive director at the acclaimed Schubert Club in Saint Paul, Minnesota; vice president of artistic planning for The Philadelphia Orchestra; and vice president and director of artistic administration for the St. Louis Symphony Orchestra.

Courtney A. McNeil is director and chief curator of The Baker Museum, a position she has held since 2021. Previously, she served fifteen years in the curatorial department of Telfair Museums in Savannah, Georgia, where some of her many exhibitions included *Spanish Sojourns: Robert Henri and the Spirit of Spain*, *Kahlil Gibran and the Feminine Divine*, *Mickalene Thomas at Giverny*, and *Collecting Impressionism: Telfair's Modern Vision*. She holds a BA in English from Georgetown University and a MA in the history of art from the Courtauld Institute of Art in London.

Alexander Shelley is Sharon and Timothy Ubben artistic and music director designate of Artis—Naples, providing artistic leadership for the Naples Philharmonic, as well as the entire multidisciplinary organization. Shelley is also music director of Canada's National Arts Centre Orchestra and Principal Associate Conductor of London's Royal Philharmonic Orchestra, positions he has held since 2015. He is acclaimed for his inspiration and leadership from the podium, the value he places on the relationship between an arts organization and its community, and his innovative approach to multidisciplinary programming. In 2005, he was unanimously awarded first prize at the 2005 Leeds Conductors Competition.

INDEX

Page numbers for illustrations and captions are in *italics*.

A

A Damsel in Distress (1937 film) 42
Aarons and Freedley (show
 producers) 61, 63, 214 n. 7
African Negro Art exhibition (1935) 4
Alajálov, Constantin 11, 22, 24–5,
 81, 104
Albright Art Gallery, New York 70
Alda, Robert 32, *32,* 144, *192*
Alexander, Emanuel 94
American Art Association 32, 144
Anderson Galleries, New York 32, 144
Angelou, Maya 213 n.10
Aronson, Boris
 Gloucester Landscape 79
 Woman with a Flower 79
Armitage, Merle 11, 27, 45, 82, 132
Arts Club, Chicago 11, 16, 24, *24,* 27,
 29–30, 41, *41,* 120, *130,* 196
Ascher, Fritz 22, *154–5*
Astaire, Fred 42

B

Bach, Johann Sebastian 16
 portrait of 22, *23*
 Riddle Canon, BWV 1087 22
Baldwin, Eleanor 71, 72, 74, 76, 77
Ballets Russes 12
Balzac Galleries, New York 65, 68,
 72
Barlow, Sam 71
Barr, Alfred 16
Barrère, Georges 26, 198, 211 n.65
Beaton, Cecil 12
Beethoven, Ludwig van 16,18
 Fifth Symphony 28
 Sixth Symphony ("The Pastoral") 28
Belafonte, Harry 213 n.10
Bellows, Emma 15, 84, 86, 88, 89
Bellows, George 20

Between Rounds #2 15, 79, 84–5
Dempsey Through the Ropes 15,
 79, *86–7*
Prayer Meeting No. 2, 79, 88
River-Front 79, *89*
Splinter Beach 89
Benton, Thomas Hart
 Burlesque 26, 30, 42, 80, *90–1*
Berlin, Irving 26, 38, 45, *109*
Berlioz, Hector 18, 28
Berman, Eugene 70
 Lagune 80, *92*
Bernheim-Jeune collection 72
Bernstein, Leonard 45
Beyeler Foundation, Basel,
 Switzerland 24
Billette, Raymond
 Street Scene 22, 65, 79
Bliss, Arthur
 A Colour Symphony 12
Blue, Angel 31
Blumberg, Fega
 Water Front Blues 26
Blume, Peter
 The Bridge 65
Bombois, Camille
 *Paysage (Le vieux moulin en
 avril),* 80, *93*
Bonnard, Pierre 57–60, 70–2, 74–7
 Paysage 54
Botkin, Henry 11, 15, 22, 38
 on Barr 16
 correspondence between
 Gershwin and 53–80
 depiction of *21*
 Gershwin and 23, 24, 41, 45
 on Gershwin 20–1, 26–7
 photographs of 20, *159*
 political views 38
 travels with Gershwin 31, 32

watercolors by 32
An American in Paris 13, 18–19, *18,*
 80, 94–5
Cows 79
In the Park 79
Light House 79
The Musician 96
The Musicians 97
Negroes 79
Reclining Nude 97
Wrestlers 79
Bourgeois Galleries, New York 64
Bourgeois, Stephan 64
Braggiotti, Gloria *176*
Brahms, Johannes 16, 28
Braque, Georges 12–13, 70, 74, 75
 Pencil Sketch 15
Brass, F. W. 132
Brook, Alexander
 South Salem 79, *172*
Brooks, Daphne A. 49
Brown, Anne 31
Bubbles, John 30, 31
Buffalo Fine Arts Academy, New
 York 70
Burliuk, David 30–1
 The Cloud, 79, 98
 Countryside 31, *98*
 Keansburg, N.J. 31, 79, *99*
 Red Horse 31, 79, *100–1*
 Reed Street, N.Y.C. 79, *98*
 Shells and Fishermen 79, *98*
Burliuk, Mary 31

C

Calder, Alexander
 Portrait of Edgard Varèse 16
Cariou, André 27
Carnegie Hall, New York 54
Carroll, John

Black Venus 43, 102–3
Castel, Louis-Bertrand 12
Causse, Louis 65
Ceroni, Ambrosio 22
Cézanne, Paul 26, 73
Chabaud, Auguste
 Horses and Derrick 80
Chagall, Marc 11, 53, 63–4, 65,
 67–70, 71, 73
 L'Abattoir 22, 42, 79, 104–5
 Untitled (Old Man with Beard)
 22, 24, 26, 42, 45, 80, 106–7,
 108, 146
Chapin [or Chaplin], James
 The Harpist 79
Charles Filiger Catalogue Raisonné
 project 27
Chausson, Ernest 209 n.3
Chester H. Johnson Galleries,
 Chicago 144
Chirico, Giorgio de 53, 55, 59
Chopin, Fréderic 16, 18
Coleman, Glenn O. 172
 Cherry Lane 79, 110–11
Color and Rhyme (journal) 31, 211
 n.90
color, in music 12, 36, 45
Coubine, Othon 13, 24, 61, 62, 70
 Spring Landscape 80, 112–13
Covarrubias, Miguel 12, 32, 41
 caricature of Gershwin 18
 *George Gershwin, An American
 in Paris* 18, 19
 Rhapsody in Blue 12, 18
Covarrubias, Rosa 32, 34
Crowninshield, Frank 15, 21, 41, 53,
 214 n.3
Cunningham, Charles 13

D
Dahl-Wolfe, Louise
 Portrait of Isamu Noguchi 17
Daly, William 15, 24, 38, 146
Dandridge, Dorothy 213 n.10
Davies, Arthur B. 15, 140
de Segonzac, André Dunoyer 58, 74
 La Marne 42, 79, 123
Dempsey, Jack 15, 86–7
Derain, André 11, 24, 26, 53, 55,
 57–8, 66, 68–70, 74, 77
 Femme aux Fruits 54
 Moïse Kisling 22, 22, 26, 56, 71,
 73, 80, 116–17
 *Paysage aux environs de
 Martigues* 79, 118–19
 Pencil Sketch 15
 Portrait of Paul Poiret 74, 75
 Road Through the Forest (Le Bois)
 42, 79, 108, 114–15
 Still-Life 80, 118

Dove, Arthur Garfield 28
 *George Gershwin—I'll Build a
 Stairway to Paradise* 12, 13
 Rhapsody in Blue, Part I 12, 27, 28
 Rhapsody in Blue, Part II 12, 28
Downtown Gallery, New York 23, 71,
 110, 172, 196
Dreyfus, Max 38
Dudensing, F. Valentine 53, 54, 72,
 73, 114, 124, 214 n.2
Dufresne, Charles 69
Dufy, Raoul 13, 20, 55, 58, 59, 65, 72
 *Cérès au Bord de la Mer (Ceres by
 the Sea)* 22, 79, 122
 Compotier (Basket of Fruit) 80,
 120–1
Duncan, Todd 31
Durand-Ruel Gallery, New York 41

E
*Early African Heads and Statues
 from the Gabon Pahouin Tribes*
 exhibition (1932) 41
Eilshemius, Louis Michel
 Plaza Theatre 26, 79, 124–5
Ellington, Duke
 Black and Tan Fantasy 12
 Black, Brown and Beige 12
 Mood Indigo 12
Elzy, Ruby 30, 31, 41
*Exhibition of Sculptures of Old
 African Civilizations* (1936) 41
*Exhibition of the George Gershwin
 Collection of Modern Paintings*
 (1933) 16, 24, 24, 29–30, 29, 41,
 120, 130, 196

F
Feldman, Ronald 48
Field, Marshall 212 n.101
Fields, Dorothy 36, 38, 178–9
Filiger, Charles 27
Firpo, Luís Angel 15, 86–7
Fitz, Grancel
 George Gershwin 12, 22, 23
Flechtheim, Alfred 116
Folly Island, South Carolina 21, 31–2
Franco, Generalissimo Francisco 38
Frank K. M. Rehn Galleries, New
 York 57, 214 n.6
Frankl, Paul 14, 15, 29, 90, 94, 159, 190
Friesz, Othon 62
Fukushima collection 68, 69
Fuller, Buckminster 18

G
Galerie Ambroise Vollard, Paris 24,
 156
Galerie Bernheim-Jeune, Paris 152,
 170

Galerie Buck, Mannheim 134
Galerie Marseille, Paris 123
Galerie Paul Cassirer, Berlin 134
Galerie Van Leer, Paris 63, 82, 116,
 130, 138, 154, 156, 163, 182, 190
Galerie Vignon, Paris 162
Galerie Zborowski, Paris 146
Garden, Mary 71
Gauguin, Paul 27, 29, 42, 54, 72–4,
 77, 80, 82–3
Gaynor, Janet 64
Genauer, Emily 18
George Gershwin's Song-Book
 (1932) 11, 22, 24–5, 27, 81, 104
Gershwin, Arthur 36, 38, 178–9
Gershwin-Botkin Correspondence
 19, 22, 24, 53–80
 1931 53–65
 1932 65–71
 1933 71–78
 accounting notes 65, 70–1, 77–8,
 78
 bills for art 63
Gershwin Collection, Library of
 Congress 18
Gershwin, George
 art by 11, 14, 26, 190
 drawings 11, 15
 Father 15, 79
 Folly Beach 79
 Grandmother 79
 My Grandfather 33, 42, 80, 190
 Negro Child 30, 215
 Negro Sculpture 79
 Orchids 80
 Portrait of Arnold Schoenberg,
 44–5, 44–5
 Portrait of Emily Paley 15, 35,
 80
 Portrait of Henry Botkin 15
 Portrait of Lou Paley 15, 21
 *Portrait of Mabel and Bob
 Schirmer* 15
 Portrait of a Man 70
 Portrait of Martin Loeffler 15
 Portrait of William Daly 15
 Prize Fighter 15, 86
 Room on Folly Island 32, 32
 *Self-Portrait in a Checkered
 Sweater* 32, 33
 Self-Portrait in Evening Clothes
 8, 32, 90
 Titus 13
 art collector 12–13, 15–16, 20–1
 African art 41, 41, 61, 62, 74
 East 72nd Street apartment
 layout 79–80
 exhibitions 11, 13
 *Exhibition of the George
 Gershwin Collection of*

Modern Paintings (1933) 16, 24, *24*, 29–30, *29*, 41
A Group from a Private Collection, New York 16
The Music Makers 16
Mesoamerican objects 41
modern art 81–201
non-Western art 41, 210 n.33
boxer 15, *84*, *86*
caricature of 42, *43*
depiction in film 32, 144, *192*
Folly Island, South Carolina 21, 31–2
Hollywood period 42–4
homes
 33 Riverside Drive, New York 15, 22, 24, *24*, *90*, *94*, *146*, *159*, *190*, 210 n.41
 132 East 72nd Street, New York 28–9, 36, *152*, *159*, *176*, *188*
 1019 Roxbury Drive, Beverly Hills *33*, 42, *44*, *188*
illness 43, 212 n.126
musical scores/songs
 An American in Paris 9, 11, 15, 28
 Concerto in F 28
 A Damsel in Distress 42
 Embraceable You 8
 I Got Rhythm 13
 Of Thee I Sing 23
 Oh, Lady Be Good 17
 Pardon My English 28
 Porgy and Bess 8, 11, 12, 21, 31, *30–1*, 49–51, *49–51*, 211 n.91
 "My Man's Gone Now" 13, 31, 41, 45
 "Summertime" 31
 Rhapsody in Blue 8, 11, 13, 18, 28, 41, 45, 61
 Second Rhapsody 23
 Shall We Dance 42
 Show Girl 15
 The Man I Love 11
 Three Piano Preludes 28
 Treasure Girl 15
and Noguchi 16–18
painted by Siqueiros 13, 36–8, *36*
photographs of
 at his piano *10*, *24*, *42*, 42, *146*, *152*, *188*
 portraits *12*, *22*, *23*, *33*, *40*, *47*, *114*, *159*, *176*
 self-portraits *26*, *38*, *39*, *45*, *109*, *180*
photography by 34, 38–41
 David Alfaro Siqueiros standing in front of his painting *Portrait of George Gershwin in a Concert Hall* 36, *38*
 Ira Gershwin *108*
 Photograph of Kay Swift's

daughter Kay Warburg *39*
Photograph of Kay Swift's daughters Andrea and Kay Warburg *41*
Portrait of Henry Botkin with Pipe *20*
Portrait of Ruby Elzy *30*
Self-portrait with Andrea Warburg 38, *39*
Self-portrait with David Alfaro Siqueiros *180*
Self-portrait with Irving Berlin 26, 38, 45, *109*
political views 36, 38
Portrait of Diego Rivera *176*
Pulitzer Prize 23, 68
sculptures of 13, 16, *17*, *159*
Warhol portraits 47–9
Gershwin, Ira 132
 art collection 32, *32*, *192*
 depictions of 36, 38, 42, *43*, *178–9*
 Hollywood period 41–3, *42–3*
 lyricist 49, 61
 photographs of 41, 42, *108*
 Pulitzer Prize 23
Gershwin, Leonore "Lee" 32, *36*, 38, *178–9*
Gershwin, Morris 36, 38, *178–9*
Gershwin Room, Library of Congress 29, 32
Gershwin, Rose 36, 38, *178–9*
Gibson, Jeffrey 48, 51–2, *52*
 I Wanna Stay Here With You Forever 46, 52, *52*
Glaeser, Max and Anna 134
Godowsky, Frances "Frankie" Gershwin 16, 36, 38, 62, 63, *178–9*
Godowsky, Leopold Jr. 36, 38, 62, *178–9*
Godowsky, Leopold Sr. 36, 38, *178–9*
Goerg, Édouard 53
Goldberg, Isaac 28
Goodspeed, Elizabeth "Bobsy" *11*, 29–30
Gotfryd, Bernard 49
Graham, John 41
 Harlequin *79*, *126–7*
 White Church *79*
Gromaire, Marcel 53, 55, 58, 59, 65
Grove, Nancy 18
Guillaume, Paul *114*, *144*, *156*, *170*
Gullah Geechee community, South Carolina 31, 49

H
Halle, Kay 13, 18
Halpert, Edith 23, 66, 71
Handel, George Frederick 18, 209 n.3
Hanenfeldt, Zenaide 42

Hardy, Rex 42–3, *42–3*
Harriman, Marie 72, 148
Harris, Sam 63
Harry Ransom Humanities Research Center, University of Texas at Austin 36
Hart, Larry 15
Haussmann, Elias Gottlob
 Portrait of Johann Sebastian Bach 22, *23*
Hayden, Henry
 Landscape with Figures 77, *79*
Hecht, Ben 65
Heyward, DuBose 49
 Porgy 31
Higgins, Eugene
 Sinking of the Vestris 80, *128*
Hindemith, Paul 209 n.3
Hiroshima Prefectural Art Museum in Japan 27
Hirschfeld, Al
 George and Ira Gershwin 42, *43*
Hoffman, Erwin
 Mexican Prison 80
 Woman Washing *79*
Horch, Louis L. 71
Horter, Earl
 Rhapsody in Blue 18, *18*
Hôtel Drouot, Paris 141, 162
Hudson Shipping Company 60, 63
Huneker, James 18

I
International Art Center, Roerich Museum, New York 71

J
Jablonski, Edward, *The Gershwin Years* 42
Jacob, Max 11
 Fête religieuse 42, *79*, *129*
 La comédie française 11, 26, *79*, *129*
Jacques Seligmann Gallery, New York 41
Jerome, Sidney *162*
Jessye, Eva 211 n.91
Jewish Museum, New York 24, 48, 49
 Masterworks of the Jewish Museum 26
Jolson, Al 211 n.91

K
Kahlo, Frida 32, *34*, *35*
Kahnweiler, Daniel-Henry 116, 118
Kandinsky, Vassily 12, 20, 28, 75
 Linie-Fleck (Line-Spot) 27, 30, 77, 79, 80, *130–1*
 On the Spiritual in Art 27

223

Point and Line to Plane 27
Kaufman, George S. 63
Kellerman, Désiré, Paris 104, 122
Kern, Jerome 43
Kisling, Moïse 22, *22*, 26, 53, 55, 56, 71, 73, *116–17*
Klee, Lili 132
Klee, Paul 12, 28, 132
 Albumblatt für einen Musiker 27, *132–3*
Kleeman Galleries, New York 128
Kokoschka, Oskar
 Pyramids at Gizeh 43, *134–5*
Koussevitsky, Serge 23
Kramer, Hilton 48
Krémègne, Pinchus 11, 22, 65
 Street Scene 77, 79, *136–7*
Kunioshi, Yasuo
 Praying for Rain 80

L
Lahner, Émile 24, 71
 The River—Landscape 79
Laprade, Pierre 22, 63, 64, 65, 66, 67–8
Larionov, Mikhail 30
Lawrence, Gertrude 15
Lefebvre-Foinet, Paris 92
Léger, Fernand 12, 58
 Pen Drawing 15
Levant, Oscar 36, 38, *178–9*, *188*
Levy, Julien 70, 92, 160, 186
Lewisohn family 56, 60
Lewisohn, Margaret 56, 72, 184, 214 n.5
Lhote, André 53
Library of Congress 18, 29, 32, 43
Liszt, Franz 16, 18, 22, 28
Loeffler, Martin 15
Logasa, Charles
 Landscape 79
 Landscape 80
Luks, George E.
 Study in Pencil 15
Lurçat, Jean 53, 146

M
MacDowell, Edward 18
Mahler, Gustav 16
Majestic Theater, Broadway 28
Malevich, Kazimir 28
Marie Harriman Gallery, New York 32, 67, 148
Masson, André 13, 75
 Verres et cartes postales 77, 79, 80, *138–9*
Matisse, Henri 13, 53, 55–6, 58, 60, 72–3
 Lithograph 15
 Small Crouching Nude with an

Arm 15, *140–1*, 159
Mendelssohn, Felix 18, 209 n.3
Messiaen, Olivier 12, 45
Metropolitan Museum of Art, New York 73
Meyer, Richard 49
Modigliani, Amedeo 11, 13, 24, 41, 53–60, 70, 72
 Bust of a Young Woman (attrib.) 22, 24–5, 42, 80, *146–7*
 Buste d'homme 142
 Caryatid 69, 79, *142–3*
 Etude de nu 142
 Man with a Pipe 142
 Portrait de femme 142
 Portrait of Doctor Devaraigne 32, *33*, 42, 45, 80, *144–5*, *188*
 Portrait of Kisling 79, 142
 Portrait of Leopold Zborowski 75
Mondrian, Piet 28
Mozart, Wolfgang Amadeus 16, 18
Muray, Nickolas 12
Musée d'Orsay, Paris 24
Museum of Latin American Art in Buenos Aires, Argentina 18
Museum of Modern Art (MoMA), New York 16, 18, 22, 27
 Advisory Board 26
 African Negro Art exhibition 41
 Summer Exhibition: Painting and Sculpture 24
Museum of the City of New York 15
Music Box Theatre, Broadway 23

N
Naples Philharmonic Masterworks series 9
National Broadcasting Studios, New York 61
National Portrait Gallery, Washington, DC 18
Nazi Germany 43
Nelson-Atkins Museum of Art, Kansas City 43
Neuman, Siegfried P 158
New York Philharmonic Orchestra 61
Newhouse Galleries, New York 65
Newton, Isaac, *Opticks* 12
Nicholas Roerich Society 26
Noguchi, Isamu 16–18, 32
 Billy Rose Sculpture Garden 18
 Black Boy 32, 80, *148–9*
 Death (originally *The Lynching*) 32
 Portrait of George Gershwin 13, *17*, *17*, 18, 30, 80, *150–1*, 159
Noonan, Ellen 49

O
O'Brien, Patricia 64
Opéra Comique, Paris 71

P
Pailes, Isaac
 Wife of the Artist 77, 79
Paley, Emily 15, 32, 35–6, 38, *178–9*
Paley, Lou 15, 36, 38, *178–9*
Pallay, George 59
Pantages, Lloyd 102
Papazian
 Mother and Child 80
Paris, Dorothy 98–100
Pascin, Jules 11, 53–7, 59–60, 68–70, 72–4, 77
 Girl with a Kitten 42, *42*, 72, 80, *152–3*
 Portrait of a Young Man (Portrait of the Painter Ascher) 22, 79, *154–5*, 159
Pater, Walter 28
Paul Guillaume Collection 41, 114
Perper, Max
 Child 79
 Son of Woman 79
Peyser, Joan 28–9
Philadelphia Museum of Art 18
Phillips, Duncan 114, 123
Picabia, Francis 28
Picasso, Pablo
 Blue Period 23, 24
 "Famous fables" 24, 158, 211 n.61
 Rose Period 24, 75
 works 53–4, 61, 66–70, 73–4
 The Absinthe Drinker 11, 23–4, *24*, 29, 42, 45, 79, *156–7*, 159
 Man and Horse 79, 158
Pissarro, Camille 72
Poiret, Paul 74, 75
Price, Leontyne 31

Q
Quirt, Walter
 Terrorization of the Poor thru Religion (Give Us this Day our Daily Bread) 80, *160–1*

R
Ravel, Maurice
 La Valse 9
Reinhardt, Mrs. 69
Reinhardt, Paul 54, 214 n.4
Renoir, Pierre-Auguste 53, 55–8, 60–2, 67–8, 70, 72–4
 Guitariste 54
Rhapsody in Blue (1944 film) 32, *144*, *192*, 212 n.98
Rich, Daniel Cotton 30
Rickey, Carrie 48–9
Rimsky-Korsakov, Nikolai 12
Rivera, Diego 32, 34, *176*
Robeson, Paul 211 n.91
Robinson, Edward G. 13

Rodin, Auguste
 Mozart (Portrait of Gustav Mahler) 16, 210 n.36
Roerich Museum, New York 71
Rogers, Ginger 42
Rogers, Richard 16
Rolland, Romain 22, 146
Ronell, Ann 36, 38, *178–9*
Rosinsweet, Josie 56
Rouault, Georges 20, 26–7, 53, 58, 60–4, 66–70, 71
 Augures 163
 Bathers 24, 79, 159, *162*
 Le banlieu 80
 Clown (or Le vieux clown) 22, 59, 80, *163*
 Dancer with Two Clowns 24, 27, 80, *164–5*
 Deux Soldats Prussiens 27, 80, *166*
 La Pauvre Eglise 27, 80, *168–9*
 La Pauvre Famille 27, 80, *167*
 Peasant Woman 24, 79
 Pierrot 69
Rousseau, Henri 11, 66–7, 72–4, 77
 Île de la Cité 11, 42, 79, *170*
Rubinstein, Anton 18

S
Sachs, Maurice 58, 59
Saltpeter, Henry 31
Sanders, Berta 43, 134
Sanders, Sigmund 43
Santa Barbara Museum of Art 26, 27
Sardeau, Hélène 22
 Figure of a Singer 23, *171*
Satie, Erik
 Parade 28
Scheyer, Galka 27, 132
Schillinger, Joseph, *The Mathematical Basis of the Arts* 13
Schirmer, Bob 15
Schirmer, Mabel 15, 36, 38, 43, *178–9*
Schoenberg, Arnold
 as painter 209, no. 3
 depictions of (Gershwin and Weston) 43–5, *44–5*
 Chamber Symphony No. 1
 Die Glückliche Hand 12
 Five Pieces for Orchestra 9
 Pierrot Lunaire 43
Schubert, Franz 18, 28
 Erlkönig 22
Scriabin, Alexander 12, 45
Seurat, Georges 73
Severini, Gino
 Dynamic Hieroglyphic of the Bal Tabarin 18

Shahn, Ben
 The Beach 23, *172–3*
Shall We Dance (1937, film) 42
Shaw, Sam *192*
Sheehan, Winfield 64
Sidney Ross Gallery, New York
 Theatre in Art exhibition and auction 26, *26*, 90, 198
Simone, Nina 51
Siqueiros, David Alfaro 32, 42
 Gershwin and 45, 36–8, 178
 photographs of *36*, *38*, 180
 Autorretrato con Espejo (Self-Portrait with Mirror) *174–5*
 Niña Madre 42, 79, *176–7*
 Portrait of George Gershwin in a Concert Hall 13, 36, *36*, 38, *178–9*
 genesis of the painting 37
 Proletarian Victim 80, *180–1*
Smith, Vernon
 Three Crows 79
Soutine, Chaim 11, 64, 72
 Boy in a Blue Coat, *182*
 Woman in a Red Blouse 22, 79, *182–3*
Spanish Civil War 38, 212 n.105
Steichen, Edward 12, 13, 38, 41
 George Gershwin 10, *12*, 40, 209 n.7
Stein, Gertrude 211 n.91
Stein, Leo 61, 112, 158
Steinway & Sons
 advertisements 18
Steinway Collection of Paintings by American Artists 18, 210 n.40
Sterne, Maurice 13, 20, 56, 60–1, 69
 Benares 79
 Mother and Child, Bali 22, 80, 159, *184–5*
Stewart, Lawrence D., *The Gershwin Years* 41, 42
Stokowsky, Leopold 61
Strauss, Richard 28
Stravinsky, Igor
 The Firebird 9
 The Rite of Spring 12
Sudyekin, Sergey
 "Catfish Row" 12
 The Hurricane Scene, Act II, scene 4, in Porgy and Bess 31
Swift, Kay 11, 13, 36, 38, 39, 41, 71, 72, *178–9*
Sydney Ross Gallery, New York 90, 198
synesthesia 12, 36, 45, 178

T
Tchelichew, Pavel 70
 La Pauvre Famille 79, *186–7*
Tchiltian
 Still Life Arrangement 77, 80

theremin 42
Thomson, Virgil 211 n.91
Torke, Michael
 Bright Blue Music 12
 Ecstatic Orange 12
Torr, Helen 28
Toscanini, Arturo 61

U
Unknown artist
 Portrait of Gauguin 27, 29, 42, 54, 72–4, 77, 80, *82–3*
Utrillo, Maurice 20, 55–60, 66–7, 72, 75–7
 The Lighthouse 74
 Moulin à Ouessant, Bretagne 42, 80, 152, *188–9*
 The Suburbs 22, 80, *190–1*

V
Van Gogh, Vincent 54
Van Norman, Julia 36, 38, *178–9*
Van Vechten, Carl 12, 41
 John Bubbles as Sportin' Life in Porgy and Bess 30
 Portrait of George Gershwin 11
 Ruby Elzy as Serena in Porgy and Bess 30
Varèse, Edgard 16, 209 n.3
 Amériques 28
 Density 21.5 211 n.65
Vatican Museums, Rome 29
Verdi, Giuseppe 18
Vidor, King 211 n.91
Vlaminck, Maurice de 53, 62, 65, 67, 73–5, 77
 14 Juillet 22
 Environs de Paris 79, *192–3*
Vollard, Ambroise 68

W
Wadsworth Atheneum, Hartford, Connecticut 13, 16, 22, 23, 27
Wagner, Richard 16, 18
Walker, Kara 12, 48
 First Light 50
 Porgy and Bess, embracing 51
 Porgy and Bess (updated libretto) 12, 31, 49–51, *50–1*
 Porgy and Crown 51
 Sailboat in Storm, 51
 Strawberry Woman 51
Walkowitz, Abraham 12
 Street Scene (Arrangement) 65, 79, *194–5*
Walling, Rosamond 13, 15, 18, 86
Warburg, Andrea 38, 39, *41*
Warburg, Edward 38, 212 n.101
Warburg, Jim 71, 72
Warburg, Kay 38, 39, 41

Warhol, Andy
 George Gershwin, from *Ten Portraits of Jews of the Twentieth Century* 12, 47, 48, 48–9
 Warhol's Jews: Ten Portraits Reconsidered exhibition (2008) 49
Warner Brothers 42
Washburn, Gordon B. 70
Weber, Katharine 36, 38, *178–9*
Weber, Max 72
 Cellist 71
 Invocation 20, 29, 45, 80, *196–7*
 Wind Orchestra Barrère 26, *198–9*
 Woman at a Table 80, *200–1*
Weston, Edward 43
 Arnold Schoenberg, 45
Weyhe Gallery, New York 27, 61, 64, *167*
Whistler, James McNeil
 Symphony in White 45
Whitney Museum of American Art 16
Wien, Jake 26
Wildenstein Galleries, New York 27
Wilenski, R. H. 42
Wyeth, N. C. 18

Z
Zborowski, Léopold 22, 75, 77, 146, 210 n.45
Zigrosser, Carl 64
Zilboorg, Dr. Gregory 36, 38, *178–9*, 212 n. 101
Zlitz
 Etchings 80

PHOTO CREDITS

This publication is intended to be educational in nature. Every effort was made to locate the copyright holders of the works included herein. When no holder could be located or identified, works have been included under section 107 of the Copyright Act of 1976. We would be pleased to rectify any omissions in subsequent editions should they be drawn to our attention.

All artwork by George Gershwin © The George Gershwin Family Trust

Front cover, Fig. 53: Courtesy of Ronald Feldman Gallery, New York. © 2023 The Andy Warhol Foundation for the Visual Arts, Inc. / Licensed by Artists Rights Society (ARS), New York / Ronald Feldman Gallery, New York. Photo by Richard Goodboy, Inc. Photo: The Jewish Museum, New York / Art Resource, NY

Frontispiece, Figs. 77, 82: CBS Photo Archive via Getty Images

Figs. 1, 3, 27, 29, 37, 86; Plates 2–3, 17, 19, 28, 32, 37, 41, 63, 65–66: Photo by RoseBudz Productions

Fig. 2: RGR Collection / Alamy Stock Photo. © 2023 The Estate of Edward Steichen / Artists Rights Society (ARS), New York

Fig. 4: © The Carl Van Vechten Trust. Courtesy of Library of Congress

Fig. 5: Photograph © 2024 Museum of Fine Arts, Boston

Figs. 6, 19, 51, 80: Bettmann Archive via Getty Images

Figs. 7, 23, 73, 78–79, 93: Collection of the Newberry Library. Courtesy of the Arts Club of Chicago

Fig. 8: © 2023 Calder Foundation, New York / Artists Rights Society (ARS), New York. Digital image © Whitney Museum of American Art / Licensed by Scala / Art Resource, NY

Fig. 9: The Isamu Noguchi Archive, 03705. © 2023 Center for Creative Photography, Arizona Board of Regents / Artist Rights Society (ARS), New York

Fig. 12: © 2023 María Elena Rico Covarrubias

Figs. 13, 18, 21, 24, 33, 38–39, 41, 43, 48, 64–67, 75–76, 81, 85, 87, 89, 95; Plate 54; Back cover: Courtesy of Library of Congress

Figs. 14, 70, 88: Courtesy of Museum of the City of New York

Figs. 15, 71–72, 83, 91: Photographer unknown. Courtesy of Library of Congress

Fig. 17: Photo by Grancel Fitz. Courtesy of Minneapolis Institute of Art

Figs. 20, 68, 74: Art by Constantin Alajálov. Photo by Michael Krasowitz

Fig. 22: Photo © 2019 Christie's Images Limited

Figs. 25–26: © The Carl Van Vechten Trust

Fig. 30: United Archives/Contributor via Getty Images

Fig. 31: The LIFE Picture Collection/Shutterstock

Fig. 32: Lebrecht Music Arts / Bridgeman Images

Figs. 34–36: Courtesy of the Ira and Lenore Gershwin Trusts

Fig. 40: Courtesy Katharine Weber

Fig. 42: © 2023 The Estate of Edward Steichen / Artists Rights Society (ARS), New York. Courtesy of Library of Congress

Fig. 44: Photo by Lawrence D. Stewart. Courtesy of Library of Congress

Fig. 45: Michael Ochs Archive / Stringer via Getty Images

Fig. 46: © The Al Hirschfeld Foundation. www.AlHirschfeldFoundation.org

Fig. 47: Lebrecht Music & Arts / Alamy Stock Photo

Fig. 49: © 2023 Center for Creative Photography, Arizona Board of Regents / Artists Rights Society (ARS), New York. Courtesy of Library of Congress

Fig. 50: © Jeffrey Gibson, courtesy of Sikkema Jenkins & Co., New York; Roberts Projects, Los Angeles; Stephen Friedman Gallery, London. Image courtesy Dallas Museum of Art

Figs. 52, 54: Courtesy of Ronald Feldman Gallery, New York. © 2023 The Andy Warhol Foundation for the Visual Arts, Inc. / Licensed by Artists Rights Society (ARS), New York / Ronald Feldman Gallery, New York

Fig. 55: Bernard Gotfryd / Contributor via Getty Images